The World's Oldest Church

SYNKRISIS

Comparative Approaches to Early Christianity in Greco-Roman Culture

SERIES EDITORS

Dale B. Martin (Yale University) and L. L. Welborn (Fordham University)

Synkrisis is a project that invites scholars of early Christianity and the Greco-Roman world to collaborate toward the goal of rigorous comparison. Each volume in the series provides immersion in an aspect of Greco-Roman culture, so as to make possible a comparison of the controlling logics that emerge from the discourses of Greco-Roman and early Christian writers. In contrast to older "history of religions" approaches, which looked for similarities between religions in order to posit relations of influence and dependency, Synkrisis embraces a fuller conception of the complexities of culture, viewing Greco-Roman religions and early Christianity as members of a comparative class. The differential comparisons promoted by Synkrisis may serve to refine and correct the theoretical and historical models employed by scholars who seek to understand and interpret the Greco-Roman world. With its allusion to the rhetorical exercises of the Greco-Roman world, the series title recognizes that the comparative enterprise is a construction of the scholar's mind and serves the scholar's theoretical interests.

The World's Oldest Church

*Bible, Art, and Ritual
at Dura-Europos, Syria*

Michael Peppard

Yale
UNIVERSITY PRESS
New Haven & London

Yale University Press books may be purchased in quantity for educational, business,
or promotional use. For information, please e-mail sales.press@yale.edu (U.S. office)
or sales@yaleup.co.uk (U.K. office).

Set in Bulmer type by Westchester Publishing Services.
Printed in the United States of America.

Library of Congress Control Number: 2015937851
ISBN 978-0-300-21399-7 (cloth : alk. paper)

A catalogue record for this book is available from the British Library.

This paper meets the requirements of ANSI/NISO Z39.48–1992 (Permanence of Paper).

10 9 8 7 6 5 4 3 2 1

populo Syriae,
primis cunabulis Christianorum

Contents

Acknowledgments ix

Introduction: January 18, 1932, Excavation Block M8 1

ONE

Dura-Europos and the World's Oldest Church 5

TWO

Anointed like David 46

THREE

Lord and Shepherd of the Water 86

FOUR

The Procession of Women 111

FIVE

A Woman at a Well 155

Conclusion: Paradise Restored 202

List of Abbreviations 221
Notes 223
Bibliography 263
Subject Index 285
Index of Ancient Sources 311

Color plates follow page 128

Acknowledgments

When I set out to teach my first university class, I asked Lisa Brody of the Yale University Art Gallery if I could have some digital images of the Dura-Europos house-church for teaching purposes. She graciously obliged with a CD of more than two hundred archival photographs. As I went through them to select the best for a lecture on early Christian rituals, I returned again and again to the photos of female figures processing around the room. It looked like an ancient torch-lit wedding procession. What began as a class lecture became a short article; invitations to lecture on the topic followed; the article became two articles and several different public lectures. And still more remained to be said, which has now become this book. My sincere thanks go first, then, to Lisa Brody and Megan Doyon at the Yale University Art Gallery, without whom my initial sparks would have had no fuel.

The expansion from initial scintillae of thought to full-blown arguments depended, though, on many other gracious colleagues and patrons. Foremost among these is Robin Jensen, who welcomed me into the world of art history as if it had been my primary field all along. She encouraged me to pursue my sometimes wild ideas and helped me to know which were best to chase. Andrew McGowan and Felicity Harley-McGowan were similarly supportive over meals and emails, as were my steering committee colleagues on the Art and Religions in Antiquity group of the Society of Biblical Literature. For other acts of scholarly kindness, I acknowledge Harold Attridge, David Brakke, Stephen Davis, George Demacopoulos, Lucinda Dirven, Ben Dunning, Gail Hoffman, Blake Leyerle, Dale Martin, Candida Moss, Jeanne-Nicole Saint-Laurent, Stephen Shoemaker, Maureen Tilley, Terrence Tilley, Jennifer Udell, and Larry Welborn. I am ever grateful to Christiana Peppard, a consummate scholar and endlessly supportive partner.

Arguments from this book were presented as invited lectures at Columbia University, Yale University, McGill University, and New York

University's Institute for the Study of the Ancient World, along with conferences in the United States, England, and Germany. I am grateful to all those who provided feedback along the way. Portions of chapters 1, 4, and 5 appeared previously in two published articles: "New Testament Imagery in the Earliest Christian Baptistery," in *Dura-Europos: Crossroads of Antiquity* (ed. Lisa R. Brody and Gail L. Hoffman; Chestnut Hill; Chicago: McMullen Museum of Art: dist. by University of Chicago Press, 2011), 169–87; and "Illuminating the Dura-Europos Baptistery: Comparanda for the Female Figures," *Journal of Early Christian Studies* 20 (2012): 543–74.

The editors at Yale University Press, especially Jennifer Banks and Heather Gold, have been enthusiastic and expert in guiding the manuscript forward. Without the financial support of various entities, the research for this book would have gone on much longer than it did. Special thanks go to the Faculty Fellowship program at Fordham University and also for a generous research grant from the E. Rhodes and Leona B. Carpenter Foundation, which enabled an extra semester's leave from teaching.

With that research leave, I had originally planned to spend time in Syria. Although most of the artifacts from Dura-Europos were removed to museums decades ago, I nonetheless wanted to see the site with my own eyes and walk through the western gate of the city with my own feet. I thought I would also make a pilgrimage to the artistic remains at Mar Musa al-Habashi, the monastery refounded as a place of Muslim-Christian prayer and dialogue by Fr. Paolo Dall'Oglio, S.J., whom I had met once in the United States. I had tentative plans to work on my Aramaic and Syriac language skills at the university in Aleppo.

Yet the civil war in Syria raged on. The beginning of my research leave corresponded exactly to the tragic bombings at Aleppo University (January 15, 2013), where I had hoped to study. This book about the oldest church building in Syria was thus written under a dark cloud of despair. I read daily about tragedies both large and small throughout contemporary Syria, even as I wrote daily about its ancient beliefs and cultures. The refugee crisis in Syria and its surrounding environs has reached historic

proportions, the increasing numbers rendering futile our attempts to grasp the burden of suffering on each individual. Even those dedicated to peace building, such as Fr. Paolo—still missing as I write this—have not escaped the war's grasp.

With solemnity, I dedicate this book to the people of Syria, the cradle of Christianity.

The World's Oldest Church

Introduction: January 18, 1932, Excavation Block M8

CLARK HOPKINS REFLECTED on a momentous day in the east Syrian desert and penned in his diary: "In the fresco room in front of the tower south of the Main Gate the dirt came off one section and showed 5 people in a boat—2 standing below, one on a bed on the shore. Above, a god on a cloud."[1]

Over the next three days, Hopkins and Henry Pearson, professors in Yale University's departments of classics and fine arts, respectively, would dig, scrape, and brush away seventeen hundred years of the past. Working with their Armenian foreman, Abdul Messiah, they found that each wall of the rectangular room contained a different painting: a shepherd with a flock of sheep; a male and a female figure near a tree and a serpent. Shortly thereafter, they found the first inscriptions amid the frescoes, one of which read, "Christ, remember me, the humble Siseos."[2] Suddenly the paintings took on a stunning symbolism. That "god on a cloud" was not an image from Syrian or Roman mythology. It was one of the oldest depictions of Jesus Christ. Hopkins and Pearson had uncovered the world's oldest extant Christian church—dating from about the year 250.

As field director of the excavations at Dura-Europos, one of the most successful and revelatory archaeological efforts in the Middle East, Hopkins had become rather used to such discoveries. During several seasons of excavating the fortified city, perched on a cliff above the western bank of the Euphrates River, the teams from the United States and France were uncovering buildings, artwork, artifacts, and inscriptions at a seemingly unprecedented rate. In his letter of January 22 to Michael Rostovtzeff, professor of ancient history and classical archaeology at Yale University,

Hopkins described how "one extraordinary discovery [has] followed another with startling rapidity."[3] But it was not always easy to know *what exactly* they were discovering. In the official buildings, public temples, and private dwellings, there were scenes of sacrifice to unnamed gods, paintings of birds descending toward unidentified regal figures, and processions of men and women on the feast day of—who knows?

Ancient archaeology in general suffers from such unknowns. Doing ancient history is like assembling a borderless jigsaw puzzle for which we have only a small fraction of the pieces and no box lid to provide a picture. Historians work by a combination of scientific data collection and inductive analysis, but even then, occasionally a new puzzle piece emerges that seems to stand alone. Such was the case for Hopkins and Pearson, who had discovered the only extant church building from before the age of Constantine. To what should this place be compared?

While some aspects of the Christian building were correctly identified at first glance, others were not. Consider this excerpt from the diary on January 20: "Pearson and I uncovered frescoes in the morning. The lower right-hand side of the room showed two men, one with a wand like a small palm tree in the right hand and a bowl in the left, the second with a stick or sword in the right, bowl at breast in the left, both advancing left toward large white building, pediment style, with a great star over each gable."[4] This particular painting (plate 1) occupied a major portion of the room that would come to be called the baptistery. It was probably the dominant feature of the church's artistic program. But who are these men, what are they carrying, and where are they going?

In the entry of February 2, Hopkins refers to the painting as the "fresco of the Three Kings," apparently deriving his hypothesis from the starlit building to which the figures were processing.[5] But a different idea was offered on March 14 by M. Henri Seyrig, the director of the Service des Antiquités of Syria and Lebanon. He had come out to the site from Beirut for the *partage*—the division of items from that season's campaign. This painting's men were not men at all, he suggested. Rather, the procession depicted the women approaching the tomb of Christ to anoint his

body on Easter morning.[6] Hopkins was convinced. The deal for the *part-age* was made. Syria kept most of the season's finds, but the Yale team negotiated to keep all the frescoes from the Christian building. Seyrig soon returned to Beirut, but he had left behind a mustard seed of an idea.

The identification of the processing figures in the Dura-Europos baptistery as the women approaching the tomb of Christ—though it had notable skeptics in the 1930s—would eventually come to represent the consensus view of the artistic program. Once the frescoes were taken to the United States, Seyrig's seminal proposal branched out to support further hypotheses and theological interpretations about the meaning of the art in this ritual space. The historical assessment of early Christian initiation became partially rooted in the identification of the motif of death and resurrection at the Dura-Europos baptistery. Through the frescoes' installation in the Yale University Art Gallery, complete with official placards and interpretations, the views on each of the surviving paintings solidified. Encyclopedia entries were written; meanings were anthologized. Who would question an encyclopedia entry or the accuracy of a placard in one of the world's great art museums? Accordingly, the final archaeological report of 1967 seemed to be just that—final. When the humidity of New Haven, Connecticut, rendered the art materially unfit for further display, it was removed from its gallery in the late 1970s. Critical reflection on the consensus views continued to fade away. Fewer than fifty years after it was unearthed, the baptistery seemed to have been reburied.

Yet questions remain. What are the women carrying in their hands? What was thought initially to be a wand, or a stick, or a sword, came to be recognized correctly as a torch. But why are these women carrying torches, when none of the Gospel texts denotes or even implies such a thing? Why do no other artistic depictions of the women at the tomb—from late antiquity to the present—portray them in this way? And to what are they processing? All initial field reports describe the white structure in the fresco as a building, and indeed it is taller than the figures of the women. So why did it come to be seen as a sarcophagus—a coffin (not) containing the corpse of Jesus on Easter morning? What are those stars hovering above the white

structure? Why are the women veiled and dressed all in white? Finally, a question I ask myself: Is it really possible that some paintings from this famous site have not been identified correctly?

In the pages that follow, we return once again to the murals of the third-century Christian building from Dura-Europos. In an auspicious coincidence, some of them are also back on display at the renovated Yale University Art Gallery. A lot has changed since the archaeological report of 1967: new textual sources have emerged; previously spurious patristic texts about Christian initiation are now assigned to legitimate authors; neglected artistic comparanda can be brought to the fore; and noncanonical traditions are treated with greater respect by historians of early Christianity. Methodological changes have been just as important. For example, art historians no longer look primarily for one-to-one correspondences between texts and images but think more creatively about the polyvalent modes and meanings of viewing. Textual scholars no longer presume stable traditions of transmission, nor do we reinforce a firm canonical barrier when investigating pre-Constantinian Christianity. Finally, scholars of both art and text have begun to discern how the presence of ritual in a given space affects our interpretation of surrounding materials.

In other words, the meaning of what appears on these walls may become clear only when we imagine what happened between them.

Dura-Europos and the World's Oldest Church

A Frontier Fort and Its Burial

For Michael Rostovtzeff, Dura-Europos was the archaeological find of a lifetime. The charismatic Russian émigré and Yale classicist was so enamored of the endless riches being unearthed that he labeled it the "Pompeii of the Syrian desert," ennobling it by comparison to the jaw-dropping art and architecture discovered under volcanic rock in Italy.[1] In some ways, the analogy is apt: the excellent state of preservation of some of the buildings, the diversity of the finds, the famous wall paintings. But no Vesuvius buried this Pompeii. To the contrary, portions of this city—including excavation block M8, which contained the house-church—were buried *intentionally*. Who would have done such a thing, and why?

The settlement variously called "Dura" or "Europos"—depending on which empire controlled it at any given time—had always lived on the edge.[2] The medium-sized colony was founded in 303 BCE by the Seleucid dynasty, successors of Alexander the Great, as "Europos," in order to honor the Macedonian birthplace of the dynasty's founder, Seleucus I.[3] During this Hellenistic era, it became a crucial crossroads that connected travel and trade along the Euphrates River with the cities to its west. Placed high above the western bank of the river, the settlement was unassailable from the east and thus helped to define and secure the border between regions held by various empires over the centuries. In fact, the location was so ideal that the Assyrians seem to have used it as a military outpost or fort as early as the second millennium BCE ("Dura" in Semitic languages means "fortress" or "stronghold").[4] Then around 110 BCE Parthians from

Mesopotamia gained control of the region and, by necessity, of Dura-Europos as well. Though descendants of the Hellenistic colonists retained some prominence, new waves of immigration from Palmyra to the west and Mesopotamia to the east brought linguistic and cultural change.[5] Over the next two centuries, the expanding Roman Empire was often knocking on the door of Dura's western gate.[6] Finally in 165 CE, Emperor Lucius Verus took full control of the city, and the Romans held it with the help of auxiliary units from Palmyra.

During its Roman era, which lasted almost one hundred years, Dura-Europos blossomed into a quintessential frontier town, exploding with a diversity of ethnicities, languages, and religions.[7] The street grid was expanded, organized, and flanked by colonnades, although its overall size was by modern standards quite small—the western wall, the city's longest edge, stretched only about 900 meters.[8] Trade with Palmyra continued apace, and new building projects were undertaken. Although the Greek language retained its cultural dominance and Latin became an administrative language, the city also exhibited Hebrew, various forms of Aramaic (including Palmyrene, Syriac, and Hatrian, from eastern Mesopotamia), northern Arabic, and Iranian (including Parthian and middle Persian).[9] A parchment found at the site records the payments of members of the "tribe" of a certain "Zebeinas," which includes names that originated in five different languages.[10] This document offers a rare glimpse of the names of nonelites at Dura during the Roman era, who appear to be as diverse as the other artifacts would lead us to believe.[11]

The religious diversity of Roman-era Dura-Europos can be seen on the recent map of the city, which shows many temples and religious buildings (plate 2).[12] During any given week in the mid-third century, one could have visited buildings and shrines dedicated to the gods of Greece, Rome, Judea, Syria, and Persia. But would anyone have done so? Visited sites of multiple religions? In fact, one of the most important ways to open up modern understanding of religious practice in the ancient world is to realize its nonexclusivity. Tolerance was the rule, intolerance the exception. People frequently belonged to several different religious associations at once. The exception was to belong to one or none.

Dura-Europos was diverse, to be sure, but it was far from unique in having a layout such as this. Most major cities exhibited manifold religious sites. Residents of Corinth in Greece, Ephesus in Asia Minor, or a port city such as Berenike in Egypt lived quite literally in a world full of gods. The influence of gods and other superhuman beings on daily life was accepted and negotiated. One simply could not get from home to work and back again without several divine encounters. Temples and shrines and statues abounded, but on a more basic level, even to buy food for dinner, one would hand over a coin impressed with the image of a divine ruler and receive back meat from an animal sacrificed to a god. Acknowledging the power of divine forces was especially important for frequent travelers. Most travelers brought along piety to their own god or gods from home, but it would have been considered rude, arrogant, or even dangerous if one did not also offer sacrifice to the god or gods of the new location.

Being a frontier town also meant that Dura-Europos was heavily militarized and targeted. The Roman era witnessed the northwest quarter of the city overtaken by the army and buildings to supply its needs. Besides the Roman soldiers stationed here, there is a well-documented record of a cohort of soldiers from Palmyra—likely including a significant unit of archers—who served alongside the Romans.[13] Ample discoveries of papyri and inscriptions from the excavation attest to this mixed *cohors XX Palmyrenorum* near the sanctuary that archaeologists would come to call the Temple of the Palmyrene Gods. In fact, this regiment, though lasting "less than a century and stationed at a distant outpost in the easternmost end of the empire, is today the regiment for which we have the largest body of [Roman] military records of any kind, the most extensive list of personnel, the widest knowledge about (anomalous) internal organization, and about the daily employment of its soldiers."[14]

Excellent examples related to cultic diversity were preserved from the militarized quarter of the city. In a painting from the *pronaos* (the space just in front of the entrance to a main temple area) of the Temple of the Palmyrene Gods, Julius Terentius, a Roman tribune with the Palmyrene cohort behind him and standard bearer in front of him, performs a sacrifice near the altar (fig. 1.1). But to whom? The figures on the lower left are the

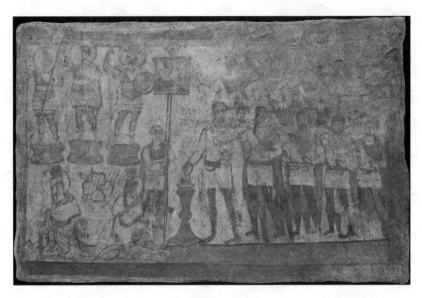

Fig. 1.1. Julius Terentius frieze. Temple of the Palmyrene Gods. Exhibition photograph. (Yale University Art Gallery, Dura-Europos Collection)

Tychai, the guardian spirits, of the cities of Palmyra and Dura-Europos. Since the painting was found in a temple with images of other Palmyrene gods, are the figures in the upper left of this Roman painting particular gods from Palmyra? Or are they perhaps divine Roman emperors or members of the imperial family? It is difficult to be sure because Palmyrene deities, such as Iarhibol, became Romanized and solarized in their appearance at Dura-Europos.[15] In any case, a cohort of soldiers recruited from Palmyra to join the Roman army would require allegiances both to Palmyrene gods and to the cult of the Roman imperial family.[16]

In that same temple was found not just a painting of an altar, but also an altar itself.[17] Here a text is what generates a sense of diversity in language and ritual practice. The inscription's language is Greek; its dedicant from the Roman army has a Latin name (written in Greek), and he is a *chiliarch*, a Greek word meaning "commander of one thousand men." He dedicates

the altar to the Palmyrene god Iarhibol. But there is little doubt that this dedicant also worshipped other gods—the imperial family; probably the god Mithras, who was so popular among the soldiers; and perhaps more. In short, religious diversity at Dura-Europos was a basic fact of life, just as it was in other cosmopolitan cities of the ancient world.

Evidence suggests that the Palmyrene cohort successfully integrated itself with the Roman soldiers to produce a formidable mixed garrison.[18] Two other examples of the solidarity between the Palmyrenes and Romans were found in the excavation. First was the *Feriale Duranum*, the religious calendar of the Palmyrene cohort at Dura, which records festivals for the entire year. Lucinda Dirven observes: "Although it is a festival calendar of a foreign unit, the *Feriale* mentions no gods from the locality of Dura-Europos or Palmyra; it lists only army festivals, Roman gods of public festivals, the cults of the reigning emperor (*divi*), and imperial women . . . as such, this calendar contributed to the Romanization and unification of the army."[19] A second case of fraternity with Roman soldiers was the afore-mentioned devotion to Mithras, a god worshipped especially in the army through stages of ritual initiation.[20] The well-preserved Mithraeum, a subterranean ritual space discovered in the military's quarter of town, contained inscriptions in Greek and Palmyrene dedicated by generals of the archers in the early part of the Roman phase of Dura-Europos.[21]

Alongside this militarized part of the city stood the largest building excavated there: a sprawling complex of more than forty rooms that came to be called the Palace of the Dux Ripae. Before the discovery of Dura, the title Dux Ripae was unknown and is still not otherwise attested. This "commander of the riverbank" is called such by a dedication in one painted dipinto, and it is not certain that other mentions of officials called *dux* refer to one and the same Dux Ripae.[22] Yet regardless of who lived and worked in this palace on the northeast corner of the city, historians can say one thing for sure: he had the city's best view. We might imagine the Dux Ripae looking out at sunrise, through the window of nature's high-rise penthouse. The mighty Euphrates flowed about one hundred meters below the cliff, and the north-by-northeast perspective allowed a perfect view of ships coming from upstream and an endless horizon beyond. From this vantage

point, the city must have felt proud and invincible. But in the third century, just beyond the horizon, an opposing army was gathering—a real rival, in the word's root meaning. Who would control the river?

During the buildup of the city and the garrison in the Roman era, the Sasanid Empire arose as the rival to the east. The Sasanians had conquered the Parthians and, when commanded by Shapur I, had assumed a posture of aggression toward the Roman Empire in the mid-third century. The Roman frontier along the Euphrates had not yet experienced a large-scale invasion from the east, and its cities were not prepared for the size of the Sasanian armies. (Just how unprepared they were was recounted by later historians, who noted an attack of Shapur's archers into the theater of Antioch while a play was still going on!)[23] And yet, even such massive forces east of Dura would not have been able to attack it *from* the east. Set above the cliffs, Dura had the massive force of gravity on its side. From the main Palmyra Gate on the west, however, Dura-Europos was vulnerable.

The Sasanians first conquered regions of Syria west of Dura-Europos—including Antioch-on-the-Orontes—and the attacks that would ultimately destroy the city involved a siege of the western city wall. In the words of Peter Edwell, "fortifications were not designed to withstand significant attacks and were more directed at establishing Roman authority. . . . Roman internal problems, which included poorly disciplined and organized troops in the East, poor knowledge and experience of Sasanian offensive military tactics, and a defensive system not designed to meet large-scale attacks, made an effective defence all but impossible."[24] If the wall were to be breached, the relatively small garrison at Dura—likely never numbering more than three thousand soldiers—would have no chance.[25] In fact, the Sasanian "siege-camp," which has been archaeologically identified west of the city, was by itself larger than the entire city of Dura-Europos.[26] The impending battle pitted a David against a Goliath, but David was trapped.

According to Simon James, whose work in military history chronicles the fate of Dura-Europos, the Roman garrison did everything it could to defend the western wall. The Romans greatly strengthened it with "a steeply sloped mudbrick *glacis* to the front [which enabled a better line of

fire from atop the wall and diminished the possibility of destroying the wall by impact] and a huge mudbrick and earthen rampart behind. . . . these were drastic expedients involving destruction of a great swathe of the interior (while paradoxically also ensuring preservation of many of the city's greatest treasures for archaeology to reveal)."[27] In the year 256, when the final and successful siege happened, the Sasanians thus elected to dig several assault mines simultaneously in order to undermine or "sap" the wall.[28] James uses the layered archaeological evidence—indeed, the only kind of evidence existing for this battle—to narrate the Romans' strategy of countermining to meet the attackers underground. But in what must have been a terror-filled twist of fate, the Sasanians set a fire laced with "bitumen and sulphur crystals" at the soon-to-be-intersection of their mine and the countermine, which had been dug just a bit higher in the earth.[29] The noxious fumes then filled the Roman countermine and killed its soldiers. The evidence "constitutes the earliest-known archaeological testimony for deliberate use of agents in the form of gas or vapor to incapacitate or kill enemy personnel: what we today call chemical warfare."[30] After conquering the wall of the city through these and other tactics, the Sasanians seem to have razed the rest of it, leaving only ruins in the sand.

But the misfortune of that Roman garrison in the third century would become good fortune for historians in the twentieth. The sand hid more than ruins: deep below the western wall's rampart rested significant portions of many buildings, lined along what archaeologists would later call "Wall Street." Cross-sections of private homes, temples, a Jewish synagogue, and a Christian house-church were each packed with earth and sealed with a secure date. This Pompeii of the Syrian desert had, in part, buried itself.

Excavating Christianity on the Euphrates

It was appropriate that a group of soldiers, not professors, first found the ruins at Dura-Europos. Having been buried at the end of one war, it was discovered at the end of another. In the wake of World War I and the dissolution of the Ottoman Empire, the British and the French retained a

tenuous grip on peacekeeping in the Middle East. Although the imaginary
(if consequential) demarcations of new nations had been drawn on maps,
the borderlines on the ground were less straight or narrow. Factions
jostled for land and power in the Middle East, and the situation near Dura-
Europos was unstable. The areas along the middle Euphrates found
themselves, again, to be living on the edge. Just a slight wind can sweep
away lines drawn in the sand.

On March 30, 1920, the British army had been patrolling the Syrian
side of the middle Euphrates when some troops under the command of
Captain M. C. Murphy discovered ancient wall paintings. The command-
ing officer, Lieutenant Colonel Gerard Leachman, forwarded a report from
Murphy up the chain of command, with the following note: "As a result of
our occupation of the old fort at Salihiyah and the digging of trenches, a
certain amount of finds have been made. The paintings to which the at-
tached refers are most interesting & should, I think, be seen by an expert. If
your American archaeologist is still about, it would well repay him to come
& see this. . . . If anyone comes up, it should be soon for obvious reasons."[31]

The requested American archaeologist was James Henry Breasted,
an Egyptologist from the nascent Oriental Institute at the University of
Chicago that was then surveying the upper Tigris for possible excavations.
Breasted "seized the opportunity with the greatest pleasure," and after a
harrowing trip across barely governed deserts—*what is very much of a war
area*," in the words of the British civil commissioner in his cover letter to
Breasted—he and his local assistants arrived at the outpost of the British
frontier.[32] Just how dangerous the area was would become clear shortly after
their arrival, when they learned that Lieutenant Colonel Leachman had
been killed by Arab tribesmen during a trip away from the fort.

On the afternoon of May 3, 1920, Breasted and his assistants observed
the uncovered wall: "Suddenly there rose before us a high wall covered with
an imposing painting in many colors depicting a life-size group of eleven
persons engaged in worship."[33] The next morning, "we saw to our surprise
a small scene in which a Roman tribune was depicted at the head of his
troops, engaged in the worship of what looked like three statues of Roman
emperors painted on the wall. . . . We had before us the easternmost

Romans ever found on the Euphrates, or anywhere else for that matter."[34] This was the now famous Julius Terentius frieze in the Temple of the Palmyrene Gods (see fig. 1.1). The lower-left portion of the painting showed the *Tychai* of Palmyra and "Dura" and thus allowed—on that very first day—identification of the site. Not bad for only one full day of work.

Recall that Breasted needed to make haste from Baghdad to Dura "for obvious reasons." That is to say, they were reasons that would soon become obvious to the rest of the world, for on April 29, 1920, the Treaty of San Remo had authorized a change in the borders of the British and French mandates in the region. During the period around Breasted's visit, the site of Dura-Europos was transferred to French control, and this shift introduced a new archaeologist to the scene. The Belgian Franz Cumont supervised excavations in 1922 and 1923 for the French Academy of Inscriptions and Belles-Lettres, during a time of turmoil and local revolts against French control in Syria and British control in Iraq. His seasons nonetheless uncovered more of the Temple of the Palmyrene Gods, the Temple of Artemis, the city center and *agora,* the Tower of Archers, several well-preserved parchments, and other buildings and tombs.[35] Once peace could be established in Syria, Cumont summarized his "fervent wish" for continued excavation, noting that "there are few ancient sites that may be more fruitful":

> By extraordinary chance, an old Macedonian colony has been preserved on the banks of the Euphrates, scarcely changed by the Roman conquest, without any Byzantine restoration or Moslem rebuilding having ever transformed it. The Greco-Semitic civilization is reflected there just as the inhabitants left it, and a climate unusually favorable has assured the preservation of delicate paintings, parchments, and destructible articles which have disappeared almost everywhere else. The combination of so many favorable circumstances should tempt archaeologists searching for a site that promises to be fruitful. Situated on the frontier of two great empires and at the juncture of two civilizations, Dura-Europos, in revealing its history, will throw a new light on the whole Greco-Roman Orient.[36]

With great anticipation but so much work to be done—and in such a re-
mote location—the site needed a major effort by a well-funded institution.

Enter Michael Rostovtzeff, who, having just assumed his esteemed
post as Sterling Professor at Yale University, was actively seeking a way "to
make a truly significant contribution to American universities as well as to
Classical learning."[37] With him as their champion, the Americans would
team with the French for excavation seasons from 1928 to 1937. Cumont and
Rostovtzeff were the scientific directors, while the field directors were the
Frenchman Maurice Pillet (1928–31) followed by Americans Clark Hopkins
(1931–35) and Frank Brown (1935–37). For the French academy, the former
army captain Le Comte Robert du Mesnil du Buisson was appointed in
1932, whose experience with both archaeology and the French military
made him a perfect liaison with the governing authorities. Some seasons
were distinguished among Middle Eastern expeditions by the presence of
women as archaeologists (not simply assistants): Susan Hopkins, the first
archaeologist to raise a toddler on the site of a dig; and Margaret Crosby,
who broke new ground by being a single woman in rural Middle Eastern
field archaeology.[38] Among many others who could be mentioned, Henry
Pearson stands out: he provided crucial assistance by drawing architectural
plans and replicas of art and artifacts in great detail, many of which have
not been surpassed. In his memoir *The Discovery of Dura-Europos,* Hop-
kins also clearly praises the local crews recruited each season and especially
their Armenian foremen, who supervised most of the spadework.[39]

Rostovtzeff's comparison of Dura to Pompeii may have been hyper-
bolic, but the decade indeed yielded finds of great importance. The mili-
tary quarter revealed several buildings beyond the original Temple of the
Palmyrene Gods, such as the well-preserved Mithraeum now on display at
the Yale University Art Gallery. The remnants of the final siege included a
Sasanian helmet, two complete sets of scale armor for horses, and a mag-
nificent Roman shield. Parchments, papyri, inscriptions, graffiti, and dip-
inti were found in abundance. Large hoards of coins, a Roman bath near
the Palmyrene Gate, paintings, mosaics, and household utensils all revealed
aspects of domestic daily life. The cultic buildings included temples to
Syrian deities, such as Atargatis, and little-known gods from Persia, such as

Azzanathkona. Temples to Greek gods such as Zeus, Adonis, and Artemis emerged from the street grid. In the Roman world, it was common to honor the deities of a crossroads for protection, as with the *Lares compitales* of Augustan Rome, entreated at the *compita* ("crossroads") of neighborhoods and towns.[40] It seems that Dura-Europos, as a kind of "crossroads of antiquity," was no less fervent in its devotion to the gods of those who passed through its gates.

Two of its buildings—arguably the most famous of all—called to mind the deity from Judea: the Jewish synagogue and the Christian house-church, found about 200 meters from each other on Wall Street. The synagogue was the most important evidence of Jewish synagogue art yet discovered, and arguably still is.[41] Its floor-to-ceiling wall paintings were uncovered in 1932, not long after the first ancient synagogue art of any kind had been found at Na'aran (1918) and Beth Alpha (1928) in Galilee. It is difficult to imagine now, but before these and other decorated synagogues from Sepphoris and Hammath Tiberias had been discovered, to name only the most illustrious, historians had presumed that synagogues from antiquity and late antiquity were devoid of imagery. In the words of Steven Fine, "The core assumption that Judaism is aniconic—held for so long by a powerful cultural elite—set the backdrop, if not the agenda, for all twentieth-century scholarship on 'Jewish art.' "[42] But if the mosaic floors of the Galilean synagogues were a bellwether of things to come, the image-covered walls of the Dura-Europos synagogue announced the arrival of a whole new field in the history of Judaism.[43] "The synagogue had quite as radical implications for our knowledge of Judaism as the Dead Sea Scrolls," wrote E. R. Goodenough, "if not far deeper."[44] Here, for the first time, was a program of narrative art from a functioning Jewish liturgical space of the Roman era.

This leads us back to where this chapter began: it was earlier in that same season when Hopkins and Pearson discovered the house-church (fig. 1.2). It too was a singular find, perhaps even more distinctive than the synagogue. Simply put, the Christian building at Dura-Europos remains the only extant nonfunerary ritual space from pre-Constantinian Christianity. What little artistic and architectural remains are available from before the fourth century come mostly from the Roman catacombs or other

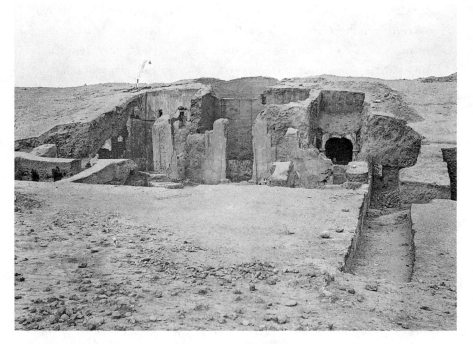

Fig. 1.2. House-church after clearance. Excavation photograph. (Yale University Art Gallery, Dura-Europos Collection)

funerary contexts and thus allow us to imagine only a limited number of ways in which textual and ritual traditions interacted with artistic programs for early Christians. The word "unique" is overused, but in this case, it is entirely accurate.

Like the synagogue and Mithraeum, the Christian church was a converted domestic space. In his book *The Social Origins of Christian Architecture,* L. Michael White explains: "The Dura Christian building is a true *domus ecclesiae,* insofar as it was a converted private house, which after remodeling ceased to be used for domestic functions."[45] On the basis of an inscription "in an undercoat of wet plaster" and architectural analysis, White argues that the house was built in 232/33, renovated for use as a church in 240/41, and thus in use as a church for only about fifteen years before its burial.[46] The plan drawn by Henry Pearson gives a good sense

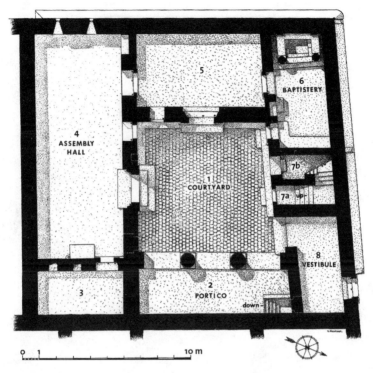

Fig. 1.3. Floor plan of the house-church. (Yale University Art Gallery, Dura-Europos Collection)

of the place, and a reconstruction of how congregants might have occupied the rooms during a meeting provides human proportion (figs. 1.3 and 1.4). The functions of several of the spaces are unknown: evidence of the uses of rooms 3 and 5 and the upstairs level is not preserved. The large assembly hall on the south side of the house originally had a wall bisecting it, which was removed during renovation. With the raised platform on the eastern edge, this was likely the main gathering space for teaching, prayer, and the Eucharist (or Lord's Supper). Approximately seventy-five people might have fit inside for a full assembly. A few graffiti were preserved from this room, but no formal paintings, if there ever were any. Unfortunately, the room's eastern wall, which was likely the focal point of attention, was not preserved during burial. Whether it contained paintings or perhaps a

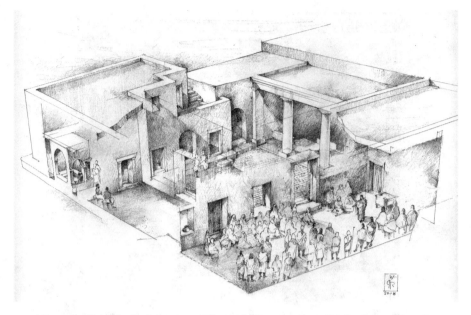

Fig. 1.4. Hypothetical reconstruction with congregants in the house-church. (Wladek Prosol)

niche for holding ritual objects or texts—like the paintings and Torah niche in the western wall of the synagogue—we will never know.

The room in the northwest corner, which came to be called the baptistery, is therefore our main evidence about Christian art and ritual at Dura-Europos. This room underwent significant renovation in the change from house to church: a large basin was dug and installed under a pillared canopy; a niche on the southern wall was reshaped from a rectangle to resemble a canopy; and all four walls were painted with evocative images. The room was tall enough to contain two different panels, each of which apparently presented a different artistic program. Unfortunately, the upper panel is preserved in only one part of the northwestern wall. Pearson's isometric reconstruction demonstrates the slope of the wall as it was preserved through the construction of the rampart (fig. 1.5). Recall that Wall Street is immediately to the west of this building, and so the defensive rampart was constructed to slope upwards from east to west. The western wall was

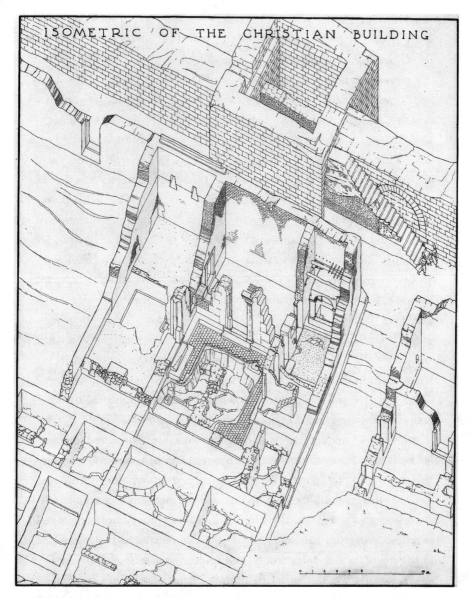

Fig. 1.5. Isometric of the Christian building (house-church). (Yale University Art Gallery, Dura-Europos Collection)

thus preserved almost in its entirety, while the eastern wall shows only the feet from the figures painted on its lower panel. The paintings depict David and Goliath, Adam and Eve, a procession of women, a series of Jesus' miracles, a shepherd watering a flock, and a woman fetching water from a well. More—much more—will be said about each of these precious witnesses to early Christian imagination in the chapters that follow. But first a question must be asked: why were Christians here in Dura-Europos at all?

There is no doubt that Christianity spread quickly and successfully in Syria. The most prominent apostles of Jesus spent time in Antioch and probably Damascus. If apostolic legends have any trace of truth, it is possible that Christianity at Edessa also was born from the first generation of Jesus' followers.[47] Other influential Syrian Christians, such as Ignatius (of Antioch), Tatian (of Assyria), Bardaisan (of Edessa), and Paul (of Samosata) are known from the early second century onward. The satirist Lucian (of Samosata) even saw fit to lampoon certain aspects of Christianity in his writings.[48] And yet the Christian presence at Dura still warrants investigation.[49] One theory conceives of the Christians as in competition with, and perhaps a spinoff from, the Jewish synagogue down the street. Tessa Rajak has proposed that the synagogue art—especially its emphases on salvation imagery and bodily resurrection—would have appealed to those with Christian beliefs.[50] The second and third centuries CE in the Roman Empire were a "marketplace of religions" overall, she writes, and religious interaction and competition were even more likely in a smaller city, where "groups are in fact more interdependent" and "it is harder for people to avoid their neighbors."[51] The connections between synagogue and church are perhaps supported by the discovery of a Hebrew liturgical parchment at Dura-Europos, which some have argued resembles not only a Jewish prayer, but also a mealtime blessing passed down in the *Didache,* an early Jewish-Christian liturgical manual likely from Syria.[52]

One might also defend a reconstruction of Christian origins at Dura that connects them to the strain of thought and practice called Valentinianism.[53] Valentinus was a charismatic Christian theologian, writer, and preacher who flourished in the mid-second century.[54] He can be located in both Egypt and Rome at different times, and it is possible he traveled

beyond that. In any case, his *ideas* traveled: by the late second century, other prominent theologians, such as Irenaeus (of Lyons) and Tertullian (of Carthage) were writing detailed refutations of the teachings of Valentinus and his followers.[55] The connections of his ideas with Syrian Christianity may be supported by textual traditions: for example, the noncanonical *Gospel of Philip* and *Acts of Thomas* share some emphases with Valentinian traditions, and both are thought to have Syrian provenance. Furthermore, Irenaeus's descriptions of the liturgical rites of Valentinians share motifs that may be reflected in Syrian liturgy and even the Dura-Europos baptistery specifically.[56] Finally, the stable presence of Valentinians along the Euphrates is well-attested, at least in the fourth century, when we know that a Valentinian "chapel" (or "meeting place" or "sanctuary") was destroyed by a group of Christian monks near the garrison city of Callinicum on the upper Euphrates.[57] Specific aspects of Valentinian traditions, insofar as they might relate to the evidence from Dura-Europos, will be explored later in this book.

One can never forget that Dura-Europos was primarily a military town during its Roman period, and so a third community perhaps responsible for bolstering the Christian population was the army. With approximately 25 percent (and perhaps as much as 50 percent) of its residents affiliated with the garrison, Dura's population—whether military or civilian—lived amid a militaristic way of life.[58] In the words of C. Bradford Welles's study of the population at Dura, "For the decisive fifty years of the history of Dura a quarter of its area was occupied exclusively by the troops, a considerable part of its remaining space was subject to billeting, much of the remainder was devoted to ministering to the army in one way or another. . . . To a certain extent, Dura was converted into a fortress."[59] It is thus possible that some of the Christians were associated with the military, especially considering the likelihood that many of the private houses in the immediate vicinity of the house-church had been commandeered "to house resident officers of the garrison."[60] In 1969 Jean Lassus traced the connection back further, proposing that Christianity came to Dura with the army, by way of Antioch.[61] Recently, Lucinda Dirven has, without being as specific as Lassus, carried on the view of Carl Kraeling that "the Christians

in Dura were probably people of a gentile background, who were at least partly recruited from men who served as soldiers in the Roman army."[62] Central to these ideas are the four personal names found in the building's graffiti, two of which—Paulus and Proclus—are Latin in origin and were "borne at Dura only by members of the garrison."[63] This Proclus was the dedicant of the David and Goliath scene in the building, a quite militaristic painting unexpected in a baptistery, and he shared a name common in the military records discovered in the excavations.[64] When one adds to this the fact that the only graffiti discovered in the building's assembly hall depicted mounted soldiers, the proposal of some military involvement on the part of Christians at Dura becomes at least likely, if not certain.[65]

In the end, though, any proposal of how Christians came to be in Dura-Europos cannot ignore a basic fact: Christianity in the third century was still for many an experience of conversion. For all but the very wealthy, life in the ancient world was always lived on the edge. Health and safety were tenuous, all the more so in a city on the frontier; healing and salvation were sought from many sources of power. The close bonds of Christian communities provided some level of support and safety, and the efficacy perceived in Christian rituals of forgiveness, rebirth, and anointing led to continued expansion during the third century—even amid the first empire-wide persecution under Decius (250 CE). In short, it is likely that at least some of the Christians at Dura *became* Christians at Dura. Their building's most ornate room was the site of these conversions. Thought at first by some to be a martyrium to commemorate a deceased holy man or woman, it came to be regarded universally as a baptistery.[66] The rituals in this space were not to commemorate the deceased, but to initiate the living into new life. The world's oldest church offers a unique opportunity, then, to imagine early Christian initiation.

Imagining Initiation in Early Christian Syria

The diverse rites of initiation in early Christian churches have been studied with great success by historians of liturgy and art. Many of these will be discussed in later chapters, as appropriate to specific topics under con-

sideration, but here I highlight the work of a few luminaries. Paul Bradshaw is probably preeminent among current historians of Christian ritual. This is not only for his labor in the editing of challenging manuscripts, whether ancient church orders or modern submissions to scholarly journals.[67] He has also done more than anyone to delineate and articulate the core conclusions about early Christian liturgy for which a scholarly consensus has emerged. In his classic work *The Search for the Origins of Christian Worship*, Bradshaw summarizes some of these conclusions:

> 1. That we know much, much less about the liturgical practices of the first three centuries of Christianity than we once thought that we did. . . . 2. That what we *do* know about patterns of worship in that primitive period points towards considerable variety more often than towards rigid uniformity. . . . 3. That the "classical shape of Christian liturgy" that we have so often described is to a very large degree the result of a deliberate assimilation of different Christian traditions to one another during the fourth century rather than the survival of *the* one pattern of Christian worship from the earliest apostolic times, . . . 4. That what emerged in this post-Nicene era is frequently a liturgical compromise, a practice that includes a bit from here with a bit from there modified by a custom from somewhere else.[68]

His approach can be identified especially with point 2 above, which emphasizes the locality of liturgical traditions. Ritual practices, like other cultural practices (e.g., linguistic idioms, dress, cuisine), vary greatly in proportion to distance traveled. Such an insight is all the more important in the ancient world, where few people traveled very far at all and mass communication was limited (save for the highest levels of imperial government). Bradshaw indicates the primacy of place in his work by how he organizes his introduction to Christian initiation: the text is arranged by region (Syria, North Africa, Italy, Gaul and Spain, Egypt).[69]

Maxwell Johnson's study of early Christian initiation offers a complementary approach. In his books *The Rites of Christian Initiation* and

Images of Baptism, Johnson gathers the symbols, motifs, and narratives of
initiation from diverse textual genres and locales in order to present four
of the key condensations of baptismal imagery from early Christianity: as
a participation in the death, burial, and resurrection of Christ; as a new
birth and/or adoption by the Holy Spirit; as the sacrament and seal/stamp
of the Holy Spirit; and as incorporation into the body of Christ.[70] To these
four might be added several others that are prominent in Syrian Christianity
(but less so in other locales): initiation as an illumination, as an enlistment in
an army, or as a wedding.[71] Johnson has also edited a sourcebook of ancient
texts related to initiation, *Documents of the Baptismal Liturgy,* which dem-
onstrates his primarily textual approach to ritual studies.[72] In the work of
both Bradshaw and Johnson, as in many other recent studies of the topic,
the Dura-Europos baptistery is mentioned infrequently, if at all.[73]

Art historian Robin Jensen shares some of Johnson's thematic ap-
proach to the study of Christian initiation, but she foregrounds the mate-
rial evidence, especially extant baptisteries. Through her widely used
textbook *Understanding Early Christian Art,* several authoritative essays,
and the recent *Baptismal Imagery in Early Christianity,* Jensen shows how
Christians developed a "visual exegesis" of images that complemented their
textual exegesis of scripture.[74] She explains the adaptation of classical im-
agery, such as the shepherd, Orpheus, or the sun-god, in early Christian
artistic programs, while also being keen to point out when some aspect of
nascent Christian iconography seems distinctive or unique, such as the fre-
quent narrative images of miraculous healing, which are otherwise virtu-
ally unknown in non-Christian art.[75] Her more technical book on
baptisteries, *Living Water,* provides comparative perspective on several of
these structures from the West, especially Italy, although she discusses the
evidence from Dura-Europos.[76] In her most recent book, Jensen views ini-
tiation as "a synthetic ritual; it comprised multiple purposes and manifold
meanings."[77] Her research thus seeks "to explicate the sensory as well as
spiritual experience by showing how symbols and figures emerged, merged,
and took precedence at various points in the ritual process."[78] She orga-
nizes the various motifs under five headings: baptism as cleansing from sin
and sickness, as incorporation into the community, as sanctifying and il-

luminative, as dying and rising, and as the beginning of the new creation. Under these headings she assesses the specific figures most common across regions and centuries. For example, "baptism as incorporation into the community" gathers symbols of a Christian initiate as a member of a new race, an adopted child, an athlete, a soldier, a priest, and a saint. The prominent imagery of a sheep joining a flock under a shepherd is supported by rites of enrollment and marking with the seal (or stamp or mark) of Christ, just as a shepherd brands a sheep for its identification and protection. Jensen's work overall exhibits attentiveness to textual sources, theological topics, and the ritual dimensions of analysis.

In what follows, I aim to complement her definitive work by employing similar methods—but focusing on one specific site. That is to say, this book is *not* about early Christian theology, art, or ritual *in general*. Rather, it brings all available ancient resources—exegetical, material, ritual—to bear on the interpretation of just one building. I am not the first to offer such a microhistory of the house-church at Dura-Europos. The final archaeological report of 1967 offered a focused and magisterial analysis of the Christian building almost fifty years ago. In some ways its contributions cannot be surpassed; on other crucial matters, however, the time is right for new arguments. The scholar who authored the report bore a name that will appear frequently throughout this book: Carl Kraeling.

Born in 1897 in Brooklyn, New York, Carl Herman Kraeling was educated at Columbia University and the University of Pennsylvania and studied for the ministry at Lutheran Theological Seminary.[79] He subsequently taught at the same seminary before being hired by Yale Divinity School in the 1930s—a move that would come forever to link him with the Dura-Europos excavations. Though hired primarily as a New Testament scholar, he demonstrated international leadership in the archaeology of the Near East and was later named chair of Yale's Department of Near Eastern Languages and Literatures (while still retaining the Buckingham Chair of New Testament Criticism and Interpretation, an impressive straddling of two departments). Away from campus, he directed the excavations at Jerash (Gerasa) in modern-day Jordan and reorganized the American Oriental Society. During 1949–50, Kraeling became the head of *both* the American

Schools of Oriental Research and the Oriental Institute at the University of Chicago, whose founding director had been James Henry Breasted—the man who first identified Dura-Europos. There was an elegant continuity, then, when Kraeling began to interpret and publish the findings related to Judaism and Christianity at Dura. He had published an edition of the fragment of the *Diatessaron* (or "Gospel harmony") from the site already in 1935.[80] Then Kraeling culminated his life's work as the lead author of the final reports on both the synagogue (1956) and the Christian building (1967), the final manuscript of which was sent to press just two weeks before his death in 1966.[81]

It is a testament to his excellence as a scholar that most of Kraeling's judgments about the house-church have not been challenged. As a field archaeologist himself, Kraeling excelled at the task of description. No detail was too small for preservation, since one could not know in advance which ones—color schemes, building materials, unexplained staircases or cellars, illegible graffiti and dipinti—might ultimately aid interpretation. Regarding overall interpretations, his assessment of the likely origin of the Christian community remains the most compelling theory: a core that came from West Syria; numbers bolstered by the army and local conversion; and *not* primarily a splinter group from the Durene synagogue.[82] He had also admirably processed and adopted the still recent theory of Walter Bauer, which emphasized regional differences and local character in the historiography of earliest Christianity.[83] Kraeling was similarly open to the inclusion of noncanonical sources in the service of interpretation. He drew from ancient texts and traditions popular in Syria, such as the *Odes of Solomon* and the *Acts of Thomas,* alongside the Syriac writings of Aphrahat and Ephrem. And though the codices discovered at Nag Hammadi in Egypt were not yet well-integrated into an overall picture of early Christian writings, he nonetheless saw the potential heuristic value of the *Gospel of Thomas* and the *Gospel of Truth* for understanding Durene Christianity, since these newly unearthed texts shared motifs and emphases with materials of secure Syrian provenance. Kraeling resolutely described such writings as not "Gnostic" but "regionally typical," demonstrating an attitude toward the varieties of early Christianity that was rather ahead of its

time.[84] Throughout the volume, the reader is grateful for the life's work of a scholar who was eulogized by William F. Albright in this way: "A brilliant mind, a friendly nature, unusual tolerance of others, and an instinct for diplomatic solutions, made him one of the great savants of our time."[85]

And yet, a lot has changed since 1967. Kraeling's research can be extended in three areas. First, though he cast a relatively wide net for ancient texts that might aid interpretation, he was not yet sufficiently familiar with the full range of noncanonical texts, such as the *Gospel of Philip*, probably of Syrian provenance.[86] This anthology of discrete teachings, discovered at Nag Hammadi, contains substantial reflection on ritual practice and "sacraments," becoming famous for its emphasis on spiritual marriage in the "bridal chamber." Connected to this was a relative neglect of other sources of Syrian provenance, such as the *Didascalia Apostolorum* and *Testamentum Domini* (often labeled "church orders"), that combine to enhance our sense of what rituals might have transpired in the Dura baptistery. Kraeling likely considered it sufficient to draw from better known guides to ritual practice, such as Cyril of Jerusalem's *Catechetical Homilies*. In truth, the fields of ritual studies and liturgical history were in their infancy, and many sources either lacked modern circulation or were, as in the case of John Chrysostom's catechetical homilies, only recently assigned to their proper authors. Finally, Kraeling's method of artistic interpretation, about which I say more below, was not necessarily faulty, but it was not as variegated as the evidence warranted. For example, artistic programs linked directly to ritual actions—whether a baptism, an anointing, or a procession—encourage different types of interpretation than those prepared for viewing alone. Kraeling's search for artistic comparanda for the Dura-Europos program can also be broadened to include types and motifs from later centuries. It is possible that Kraeling's methodological conservatism about artistic interpretation arose to compensate for the overzealous attempts by previous scholars to make Dura-Europos the very linchpin of the history of Near Eastern art. Let us recall that Breasted extrapolated his *Oriental Forerunners of Byzantine Painting* from precisely *one* day of fieldwork at Dura. Yale's own Michael Rostovtzeff was also prone to grand narratives of artistic and cultural migration. In each case where

Kraeling's interpretation might have been broadened, then, one can find a good reason why he bounded it. The frontiers of research on the baptistery remained open for future scholars to explore.

Since Kraeling's report, scholarship has advanced in small steps. The archaeological details have been treated by L. Michael White, Graydon Snyder, and the combined efforts of authors in two recent exhibition catalogs from Boston College and New York University.[87] Writing from institutions in Europe, Dieter Korol and Lucinda Dirven have enhanced our understanding of the David and Goliath and Adam and Eve paintings, respectively.[88] Robin Jensen and Everett Ferguson have both incorporated the evidence from Dura-Europos into their analyses of theology and liturgy during the first five centuries of Christianity.[89] And liturgical historian Dominic Serra offered a small gem of an article about the procession of women and the woman at the well in the baptistery, which to my mind sufficiently reopened debate about Kraeling's identifications of the female figures there.[90]

In addition to these studies, the only full-length book to treat the baptistery on its own has been *Tracing the Bridegroom at Dura,* the published dissertation of Gerasimos P. Pagoulatos.[91] This book draws on three textual traditions—the *Acts of Thomas,* the *Gospel of Philip,* and the *Symposium* of Methodius—because of the likely second- and third-century dates of these works, in order to discuss the relationship between liturgy and artistic viewing in the space.[92] He argues that the Dura-Europos baptistery "hosted an initiation bridal service" that united the participants with the image of Christ in anticipation of the second coming; as such, it was "the earliest known Iconophile service."[93] He connects the proposed third-century ritual to the still-celebrated "Christ the Bridegroom" service of the Orthodox Holy Week, which is not extant in the manuscript tradition before the eleventh century. Although the work is to be commended for its ambitiousness, its use of three texts not always associated with the Dura baptistery, and its entirely correct focus on bridal imagery in early Syrian initiation rituals, it remains yet to be seen how Pagoulatos's bold vision of a millennium-spanning liturgical connection will be incorporated into scholarly assessments of Dura-Europos in its ancient context. The argu-

ment often reads like "a polemical archaeology of origins," in the words of one critical reviewer, for which a broad scope of chronology and methodology was collapsed toward the one focal point of retrieving a primitive origin for a beloved liturgical rite.[94]

That being said, there is no fault in chronological and methodological breadth per se. I too look to later centuries for comparanda. Indeed some of the artistic comparanda I use later in this book were created a thousand years after the paintings in Dura-Europos. I justify such moves in two ways. First, each of this book's arguments attempts to limit the *geographical* catchment area of textual and artistic comparanda, so that even as I use sources from later centuries, I give strong preference to those from Syria, Palestine, and Armenia. Second, some artistic examples (e.g., types of processions of virgins or certain Annunciation scenes) offer such striking *formal similarity* across centuries that I have been compelled to include them in my analysis. It has been precisely such openness to comparanda from the Byzantine era—an attitude that sprang admittedly, at first, from the naive adventurousness of a scholar sojourning in a new field of inquiry—that launched the freshest insights in the book, even as it leaves the arguments potentially vulnerable to criticism. Nevertheless, I maintain as a general methodological principle that iconographic traditions are, like ritual practices, on the whole prone to conservatism. Of course, both iconography and ritual change over time and through the interaction of communities. But even as artistic and ritual traditions evolve and adapt to new environments, they are more likely to add than to subtract features—more likely to highlight a preferred aspect than to eliminate the other one.

By attempting to limit the geographical catchment area for comparative materials to roughly Syria, Palestine, and Armenia, I have not, however, limited myself to a small data set. The history, theology, and ritual of Christians in Syria and its environs offer broad and deep resources for situating the house-church of Dura-Europos.[95] Fifty years ago, Kraeling made use of many of these, especially the fourth-century writings of Ephrem the Syrian and Aphrahat the Persian, along with the *Odes of Solomon* and the *Acts of Thomas,* which were both popular in third-century Syria. These sources will be gleaned in even more detail, and other sources will be

included, such as the *Gospel of Philip* and the writings of Jacob of Serugh. Liturgical "church orders," such as the *Didascalia Apostolorum* and *Testamentum Domini,* will be read in the light of contemporary ritual studies in order to imagine what practices and significations might have occurred in this house-church. Artistic motifs from all available evidence, such as illuminated manuscripts, pilgrimage censers, and reliquaries, will round out our sense of place.

When the geography is thus bounded but the chronology extended, the distinctive motifs of Syrian Christian thought and practice are brought into relief: asceticism and virginity, illumination and anointing, weddings and wells, healing and bodily integrity. I say more about these themes in subsequent chapters. Not only these contents but the genre and tone of Syrian theological writings also leave an impression. There is little argumentation apart from ornamentation. Hymns are more prominent than treatises. In the words of Peter Brown, to engage Syrian authors is to hear "a subtle and mellow voice from the past that has been too long drowned by the articulate and rigid certainties of Western churchmen."[96] Many of these mystical texts are reflections on biblical narratives against the backdrop of liturgical events, and engaging them alongside the artistic traditions thus leads inexorably to a nexus around which the whole of this book revolves: Bible-art-ritual. What happens when we place the Dura-Europos house-church and the people who worshipped there at this nexus? How might *we* imagine the ways in which *they* imagined Christian initiation?

Can We Read the Riting on the Walls?

Like many other ancient buildings, the house-church had writing on its walls. Short texts were either inscribed or painted, and some of them survived until the excavation.[97] A couple of dedicatory inscriptions asked for Christ's mercy on "Proclus" and "the humble Siseos." An anonymous Christian scratched on the doorjamb leading to the baptistery, "One God in heaven." But beyond these precious few texts, scholars have also tried to read the biblical "writing" on these walls. It has become customary to think of the paintings at Dura-Europos, in both synagogue and house-

church, as among the earliest extant "biblical art." The scenes seem to correspond to well-known texts from the Bible, and thus the texts (and their traditional meanings) can sneak surreptitiously to the center of the stage of interpretation.

We misspeak, though, if only slightly, when we call the scenes in the house-church "biblical."[98] Two hundred years after Jesus had died, a stable canon of the New Testament did not yet exist. Narratives of his life, death, and resurrection circulated in diverse oral, liturgical, and written forms. Any analysis of the relationship between biblical texts and images in the baptistery should account for the general instability of Christian textual forms that circulated in the third century and the importance of the *Diatessaron* among Syrian Christians. For example, the healing of a paralytic occurs in all four canonical Gospel traditions, the *Diatessaron,* and several extant homilies; the so-called myrrophores (the women at the empty tomb) are variously described and identified in the canonical texts and are not obviously represented in the painting; the baptistery's central image of shepherd and sheep is hardly a clear representation of the text of the Good Shepherd from the Gospel of John. And whatever might be meant by the depiction of Goliath slain by David, an image not found elsewhere in early Christian art and whose main character was appropriated in a multitude of ways in textual traditions? It is as if the texts with which we try to line up the paintings will not hold still.

One might want to grant such wavering for some textual traditions but retain stability in others. Perhaps the famous biblical dialogue about "living water" will hold still for analysis, since it appears in only one source (John 4). Then at least the painting of the woman at the well makes sense in a baptistery, right? To the contrary, the instability of biblical texts overall should give us pause about even the seemingly stable text-image relationships in the third century. Women visit wells all over the biblical landscape, and chapter 5 shows the varieties in their interpretation. The paintings are thus not allegorical treasures unlocked by one hermeneutical key—the right biblical text. Often, multiple texts "fit," and each opens up a different aspect of a given image. This is neither to slide into relativism nor to claim that texts are irrelevant to the process. Indeed, the importance

of Christian texts for understanding the compositions in the baptistery easily can be shown by contrasting them with those in the Mithraeum from Dura-Europos. Both artistic programs present initiate mythologies, but the lack of an extant Mithraic textual tradition prevents us from understanding most Mithraic art.[99] Without the benefit of detailed oral, liturgical, or textual traditions for Mithraic cults, we are relatively clueless in our attempts to interpret one of the most widespread cultic practices in the Roman world.

We use texts to interpret the baptistery, then, but we do so with two caveats in mind. First, the stability of textual traditions and boundaries—including the canonical boundary—cannot be presumed. Second, the preferred and primary context for the baptistery's artistic program is its ritual context. In other words (and to bend the categories a bit), for interpreting a baptistery's art, one required "text" is the ritual. We are not trying only to read the biblical *writing* on the walls; even more do we seek the liturgical *riting* on the walls. We must then expand the written data set to include more noncanonical texts and liturgical sources (homilies, baptismal catecheses, church orders, pilgrimage evidence). Accessing early Christian rituals through these sources is a challenge, of course, as *they* can be encountered only through texts and art, thereby creating a hermeneutic circle for the historian. That inescapable difficulty is all the more reason why polysemic interpretations are in many cases appropriate.

In situating Dura-Europos at the nexus of Bible, art, and ritual, my research builds explicitly on the work of several other art historians. Robin Jensen, whom I mentioned above, is foremost among them, insofar as her work attends to the "ritual, visual, and theological dimensions" of artistic programs.[100] She is well aware of the potential pitfalls of such interdisciplinarity: on one hand, "text historians may worry about the degree of subjectivity" involved in interpreting visual symbols that "may seem frustratingly ambiguous or dauntingly mysterious"; on the other hand, art historians "are trained to begin with the images and avoid turning to texts as a primary source for their analysis or interpretation, valuing art objects for themselves, apart from the documents, for their essential beauty and independent significance."[101] Although Jensen inveighs against treating biblical

narratives, for instance, as a kind of "lode of definitive, preferential, or even validating data," she presses on with a rigorous interdisciplinarity.[102] In fact, despite the different modes of verbal and visual exegesis, she finds in them similar degrees of subjectivity and variation in meaning:

> Aside from the problems of approach and method, any study that attempts to integrate text and image must confront an essential difficulty—that the spoken or written word undeniably has a different character than the visual image. The two modes are experienced and comprehended in distinct ways. Verbal communication takes place over time. A story, an argument, or an explanation must unfold. Memory plays an important part in following a discourse from beginning to end, and the imagination supplies internal, invisible images that are not externally prescribed. A visual image, by contrast, has an immediacy and concreteness. It is taken in more or less at once and presents only a fragment of a story. The memory and imagination work together to supply the description, explanation, or narrative that the image lacks, and this likewise—and necessarily—varies from viewer to viewer and from time to time. *However, that variance is probably no more than that of readers and hearers. Even though verbal forms differ in nature from images, their meanings are no more or less transparent or obvious.*[103]

An emphasis on memory and imagination leads directly to the ritual dimension of Jensen's work. Because almost all extant early Christian art can be associated with a ritual context (baptism, anointing, pilgrimage, burial, funerary meal, etc.), "effective visual exegesis requires the viewer to make certain connections that were experienced in liturgical performances (sermons, prayers, catecheses, and so forth) or developed in written treatises and commentaries. After all, an image generally, or at least initially, will mean what one has been taught that it means."[104] For instance, the simple image of Noah coming out of the boxlike ark (which Jensen calls the "Jack-in-the-box" style) has been found almost exclusively in funerary

settings, and thus our interpretation of Noah as the individual "Christian rescued from death" is corroborated by a ritual context.[105] One could imagine, though, how the prevalent water imagery in the biblical narrative might engender different interpretations, if the same Noah were to be found mainly in baptisteries (cf. 1 Pet 3:20). Or consider how the imagery of Jonah's ocean adventure is also found mainly in funerary contexts, indicating its symbolism of Christian hope for salvation from the belly of death. If other parts of the Jonah cycle were found mainly depicted on pulpits or book covers, we would rightly interpret the symbol's connection to his preaching to Nineveh as a prophetic call to evangelism—a reminder to preach God's word to those who had not yet heard it. In sum, my own research complements Jensen's: the goal is to provide new possibilities for visual exegesis by opening up the treasury of textual resources from early Christianity and attending to ritual contexts.

Other art historians have also signaled ways forward in the interpretation of ritual spaces in antiquity. Jaś Elsner and Robert S. Nelson stand out as standard bearers for approaches to visuality—ways of seeing—in specific ritualized moments from late antiquity and the Byzantine era. Nelson's objects of study are primarily manuscripts, icons, mosaics, and architecture from the Byzantine to the modern era, but his approach to such materials offers insights for earlier materials.[106] Elsner deals almost exclusively with Greco-Roman antiquity—and in one essay, with Dura-Europos specifically. On the whole, he champions "a ritual-centered attitude to images in antiquity, which influenced both ways of seeing and ways of thinking about art."[107] What he calls ritual-centered visuality "may be defined in many ways—as the putting aside of normal identity and the acquisition of a temporary cult-generated identity, or as the surrendering of individuality to a more collective form of subjectivity constructed and controlled by the sacred site," among other possibilities.[108] In terms of the Dura-Europos house-church, this type of visuality might have temporarily enabled a man to imagine himself as a female virgin initiate or a woman to imagine herself as David, an unexpectedly mighty warrior. Then his or her collective form of subjectivity may be considered constructed in part by the paintings, whether as an indistinguishable member of a flock of sheep or

as an indistinguishably costumed and adorned member of a procession. Elsner continues: "In effect, ritual-centered visuality denies the appropriateness of . . . interpreting images through the rules and desires of everyday life. It constructs a ritual barrier to the identifications and objectifications of the screen of discourse and posits a sacred possibility for vision, which is by definition more significant since it opens the viewer to confronting his or her god."[109] Ritual processes, in other words, prepare viewers to enact visual exegesis in typological, allegorical, and other distinctly theological modes. The everyday rules of visuality for encountering an image of a shepherd, a water well, or a battle scene are temporarily suspended. The viewer draws instead from the narrative and symbolic worlds specifically appropriate for a ritual context—and for which he or she has been both consciously and subconsciously prepared.

By taking seriously the few ancient testimonies about what it meant to see art, alongside examples of the real presence of deities in statues and other objects, Elsner collapses the supposed dichotomy between the real and the imagined, the form and its instantiation, the god and its representation. "The represented is not just *in* the image," he writes, "the represented *is* the image."[110] Elsner uses the first-person descriptions of art and ritual in authors such as Pausanias and Lucian as ways into the ritual-centeredness of Greco-Roman visuality. As a result, he questions the art historian's usual focus on naturalism and aesthetics instead of iconicism and ritual: "Art history has tended to assume that classical art—the art of naturalism and ekphrasis—was much more like Renaissance art and art writing than it was like the arts of the Middle Ages."[111] Most modern historical narratives have tended to link the realistic naturalism of Greek sculpture and its detailed description in literature (*ekphrasis*) with the revival of such modes in the Renaissance. However, our ancient evidence about people's experiences of statues, busts, and portraits indicates that the objects were highly charged with divine power and were encountered primarily through ritualized actions, for example, at the culmination of pilgrimage, fasting, procession, or prayer. All of "the evidence for image and ritual should give us pause for thought. It may in fact be that the sacred images of Byzantium and the medieval West were closer to the arts of

ancient polytheism than either the church fathers or the Renaissance anti-
quarians would have wished or acknowledged."[112]

By this turn to subjectivities in understanding the ritual viewing of
ancient art, Elsner postulates "a shared subjectivity of cult initiation on the
side of viewers," and his historical analyses thus tend toward probabilities,
not certainties.[113] The intersubjectivity of initiates during ancient, secret
rituals is a challenge to reconstruct, to put it mildly. Therefore, like some
of my own proposals in this book, Elsner's essays must employ an imagi-
native process alongside other forms of analysis. In a series of case studies,
he focuses on "the pattern of cultural constructs and social discourses that
stand between the retina and the world, a screen through which the sub-
jects of this inquiry (that is, Greek and Roman people) had no choice but
to look and through which they acquired (at least in part) their sense of sub-
jectivity. Just as that screen—what I am calling 'visuality'—was itself made
up of subjective investments while being limited by the material and ideo-
logical constraints of the ancient cultural context, so our examination of it
must depend upon a certain amount of empathetic imagination as well as
critical analysis."[114] According to Robert Nelson, the socially and ritually
constructed "visuality" defined by Elsner and others is related to "vision"
somewhat analogously to how "sexuality" is related to biological "sex."[115]
Like sexuality, visuality transcends biological givens and dwells in the
domain of the humanities for interpretation. Just as what counts as normal
sexuality is culturally contingent, so too with visuality.

One strong distinction to be made between visuality in antiquity and
modernity is that ancient visuality bore more resemblance to orality and
aurality than it does today. This was especially the case for early Christians,
as James A. Francis has noted. A first point to keep in mind: "Hearing the
text read aloud, particularly in the context of the liturgy, was the funda-
mental way in which all Christians [not only the illiterate] appropriated
Scripture . . . It is a modern prejudice to assume that once people could
read, they would somehow abandon orality and visuality in favor of the tex-
tual and literal; that reading trumps all other modes of reception and com-
prehension."[116] If the oral and liturgical performances have primacy, then
the "fixity" of written texts should be even less of a concern in our histori-

cal work. What is more, such performance of "[a] sacred text, because it was assimilated aurally, lent itself to visuality. The Christians responsible for such works as the catacomb paintings did not use images merely to illustrate their texts; nor did they use texts to justify their images. Rather, both these modes of expression and communication were grounded in a common experience of visuality in which, as with the writers of the Second Sophistic [such as Lucian], the distinction between word and image tends to break down."[117]

The bridging of this verbal/visual dichotomy, along with the previously discussed subject/object dichotomy, leads to a mode of seeing for which scholars offer different names: "Mystic viewing" for Elsner, "empathetic vision" for Nelson, "sacramental perception" for Francis.[118] While their definitions differ slightly, Nelson's subsuming of several ideas under a discussion of icons—admittedly of a later era, though all the scholars mentioned argue that iconic practices are prefigured in late antiquity—gathers together most of the ideas: "The meanings of all icons are completed in the space and the person of the pious beholder"; they are "images that envelope the beholder in the visual dramaturgy on the walls of the church and enfold all into the sacred drama and dogma."[119] The meaning unfolds at the nexus of Bible, art, and ritual.

A final relevant aspect of interpreting art and ritual in late antiquity involves the importance of movement and its representation, especially that which we call procession. Thomas F. Mathews has argued that in late ancient and Byzantine Christian art, "converging processions—that is, a concourse of figures from either side, worshipfully approaching the axis at which is Christ—provide the principal organizing device."[120] He notes that during the fifth and sixth centuries, the "growing proliferation of processions" in art "coincides with the rise of public participatory processions."[121] From grand churches such as St. Apollinaris in Classe and the "new" St. Apollinaris in Ravenna, to carvings on sarcophagi, or the paintings of the Catacombs of Domitilla, examples abound of processional "riting" on the walls. (In the twentieth century, this artistic program was magnificently retrieved in the nave of the new Catholic cathedral in Los Angeles, California.) Sabine MacCormack connects the development of Christian

processions in liturgy and art to the well-known processional rituals of imperial ceremony, especially the *adventus* (arrival) of the emperor.[122]

However, while the imperial connections do illuminate certain aspects of Christian mimicry, in fact processions of all kinds were nearly ubiquitous across cultures in antiquity. "In the Greco-Roman world, figures in peaceful procession were generally understood to be engaged in a religious ritual. It is one of the oldest and commonest forms of worship, and in representations from the Parthenon to the Ara Pacis, the most august expressions of worship assumed a processional mode. . . . In Christian art, moreover, they stood as paradigmatic for the faithful in the endless processions of their cult."[123] Once Christian liturgy fully entered the public square after Constantine, processions spilled out of the churches and into the streets, such that "stational liturgies" can be documented from all over the empire.[124] These then became a "principal organizing device" in the artistic programs of early Christians, but that fact did not distinguish them from other cultic communities. For instance, the "Aventine Mithraeum" in Rome, dating to the third century, contains the image of a procession, and Dionysiac processions are a hallmark of extant representations of those mysteries.[125] At Dura-Europos we find a procession in the aforementioned Julius Terentius frieze (see fig. 1.1) and the "Purim panel" from the synagogue. Several scenes from a contemporaneous mosaic at Jerash (Gerasa) feature a Dionysiac procession.[126] This book's approach to Dura-Europos extrapolates backwards in time, to be sure, but it does so with attention to artistic and ritual continuities in form.

MacCormack's study of imperial ceremony provides one further analogy to my own method. By using the texts of imperial panegyric—formal, public speeches in praise of emperors and their accomplishments—as a resource for understanding "art and ceremony," she deals with some of the same hermeneutical quandaries about text-image-ritual relationships as outlined above. For MacCormack, the texts of panegyric are like liturgical libretti—biased and nondefinitive though they may be—that enable access to central public events which formed civic and religious imagination. Although not primarily visual, the performances of panegyric, like that of scripture, prayer, and song for Christian ritual, played a role in forming

visuality. "Seen in this light, the panegyric will not merely 'reflect' a visual and ceremonial setting by providing valuable but essentially piecemeal evidence for imperial architecture or court etiquette; the panegyric will itself be seen to have drawn its cogency from the context in which it was delivered. . . . Above all, the art of the panegyrist will be assessed by the degree to which he could open himself up to that process of osmosis between sound and vision which was such a constant strand in the sensibility of ancient men, so as to evoke a visual experience in his words."[127] For the evidence from Dura-Europos, we too will imagine what type of visuality was generated by textual traditions, especially in their ritual performances and artistic settings.

Already, processional visuality has been explored as a means of interpreting the Dura-Europos house-church itself. Art historian Annabel Jane Wharton, for example, has emphasized a ritual-centered viewing of the baptistery.[128] She argues that the differences in artistic form and quality between the procession and the other paintings suggest that the image of procession performed a different function than the room's upper panel: "Simply stated, an image like the healing of the paralytic, as a statically placed ideograph, is an easily recognized reference to a biblical salvational narrative; it functions *optically* as a visual sign for a text. In contrast, the procession is *haptic* [physical/bodily] in quality; its meaning is not located elsewhere, in a text, but rather embedded in the physicality of the action of which it was a part. . . . These figures may be read as self-reflective embodiments of the initiates."[129]

Wharton's analyses will be discussed again later. For now, I conclude by noting that "ritual-centered" theories and "processional visuality" are not as newfangled as they sound. Consider the Byzantinist Henri Grégoire, who wrote already in 1938—only a few years after the house-church was discovered—that the processing women at Dura-Europos were *not* primarily painted as literal illustrations of a text. Texts will aid our understanding, but in Grégoire's evaluation the primary "text" is ritualized. His conclusion, published in the journal *Byzantion:* "Above all, the procession symbolizes the illumination of baptism."[130] In other words, what the candidate *saw* on the walls of the baptistery—and what *texts* were imagined

through a constructed visuality—is bound up with what he or she *was:* a member of a procession, a parallel line to a parallel destination, an iteration of initiation.

What Isseos Saw: A Procession of Chapters

Besides the names inscribed in the baptistery—Proclus, Siseos, and perhaps Hera—others found in the excavation have possible markers of Christian identity. Consider, for instance, this marking on a clay vessel: Ἰσσε(ὸς) νεοφιτός, or "Isseos the neophyte."[131] It is possible but not certain that the name is a form of the Semitic "Jesse." Although the jar was not found in the Christian building, scholars have considered the word "neophyte" to be sufficient evidence for regarding Isseos as a Christian.[132] (Recall that the unmistakably Christian parchment of the *Diatessaron* was also found elsewhere at the site.) As a "newly planted" member of the community when his name was etched on the jar, Isseos would have been recently initiated, almost certainly during a ritual of anointing and baptism in the baptistery of the Christian building.[133] Perhaps the jar had contained the water poured over him at baptism or the oil with which he was anointed—a kind of memento from the pilgrimage of his initiation.

In the ensuing chapters of this book I try to reconstruct the visuality of Isseos, to imagine the baptistery as Isseos might have, as he walked through the door and processed around the room toward the font. I argue that he would have entered from the courtyard and stopped for his pre-baptismal anointing just inside the door, in front of the southern wall. Then he proceeded counterclockwise around the room, embodying the right-to-left direction of the procession of women, the narrative action in the upper panel, and indeed, the Semitic languages of Aramaic and Syriac.[134] At each point we will consider what textual memories might have been conjured by the candidate's ritual encounter with an image. Although he would have known much about the mighty deeds of God and God's anointed ones, he knew no canon. Undoubtedly, he would have been catechized with certain texts for this occasion—words to mark his anointing, his baptism, his victory, his marriage, his joining the one flock—but his texts were not ex-

actly the ones that we now study, dissect, and cross-reference. His texts did not hold still. They swirled in his mind that night, as he crossed the threshold into the baptistery, his eyes weary yet focused, because of the requisite fasting. Looking around, here is some of what Isseos saw.

On the center of the southern wall, below a niche that likely held oil for anointing, he saw a painting of David and Goliath. Chapter 2 describes the manifold uses and meanings of anointing oil in early Christian Syria. Our earliest sources that describe rites of initiation in East Syria emphasize the roles of anointing to a degree not found elsewhere in early Christianity. In this chapter, its connection to kings and soldiers also comes to the fore, while subsequent chapters will treat the "seal" marked on sheep (chapter 3), the anointing in preparation for marriage and the kindled flames of a wedding (chapter 4), and the oil as a sign of the Holy Spirit (chapter 5). A painting of David would not generally be unusual in any Christian setting, but scholars have struggled to understand why the particular scene with Goliath was chosen. This chapter argues that the Christian community gathered in Dura-Europos memorialized David as a warrior, a symbolization that also called to mind—surprisingly to our modern ears—the images of shepherding and anointing. Central Christian texts and especially the Psalms of David combine to form a militaristic imaginary that resonates with several other aspects of initiation at Dura-Europos. David was a military icon for a militarized town—one that needed hope if it was to face the Goliath of an opposing army across the Euphrates to the east.

Turning around to the northern wall, Isseos would have faced the baptistery's upper panel. Preserved only on this side of the room, the upper panel appears to have comprised a series of the miracles of Jesus. Chapter 3 combines two upper-panel scenes thought to represent Jesus Christ with a third over the font: the walking on the water with Simon Peter, the healing of a paralytic, and the shepherd with a flock of sheep. The scene of the walking on the water shows Peter as an ideal disciple who imitates the divine power of Christ. In Syrian interpretation, Peter's floundering in the waves was not emphasized; rather, his power over nature was heralded—a power that all Christians hoped to gain for themselves through ritual initiation. The healing scene probably represents that done by the pool of

Bethesda, thus tying a theme of water between the two extant miracles. Jesus' reputation as a healer was widespread in antiquity, but in Syria it was even more of a focus, with "Healer" and "Physician" as prevalent titles for Christ there. The prominent themes of the mighty works cycle, therefore, were empowerment and healing for new initiates—in both body and soul. Turning to the font itself, Isseos would see the painting on the western wall, which portrays a shepherd watering his flock. Many biblical narratives come to mind, including David as shepherd, Christ the Good Shepherd, and the foundational Psalm 23 ("The Lord is my shepherd"). The large number of sheep in the flock signifies the communal aspect of Christian initiation, the incorporation of a "sealed" individual into a community marked with the name of Christ. The flock was a safe haven too, amid a dangerous world. Christ and David were shepherd-warriors, protecting those under their pastoral care from various wolves and Goliaths.

When Isseos stood at the center of the room, to take in the whole artistic program at once, he would have found the procession of women on the eastern and northern walls to predominate. At the heart of his book, chapter 4 labors to survey and critique the usual identification and interpretation of these female figures. While the traditional interpretation of them as the women at the tomb of Christ on Easter morning has arguments to support it, the preponderance of evidence supports our recovering a very old counterproposal, which identifies them as virgins at a wedding. When biblical, artistic, and ritual sources are read with this in mind, the singular importance of marriage motifs in early Syrian Christianity becomes clear. The very closest artistic comparanda from Syria render a biblical wedding procession—that of Jesus' Parable of the Wise and Foolish Virgins—with the same iconography as the figures on Dura's walls. That being said, ritual texts and homilies from the fourth century begin to show metaphorical interference between the imagery of weddings and funerals, and so polysemic interpretations of this procession are certainly warranted. The marriage motif dominates, but does not completely subordinate, the notions of death and resurrection at initiation.

If the baptistery has been usually thought of as a kind of tomb, and now we regard it as a bridal chamber too, chapter 5 aims to show that the

font may yet hold one more concept in tension: it is also a womb. The book reaches here an ambitious climax, arguing that the female figure drawing water from a well in the southwest corner of the room is not the Samaritan Woman, an infamously sinful convert, but more likely the Virgin Mary, the famously holy mother of Jesus. Through detailed analysis of textual sources and an original, extensive survey of artistic depictions of the Annunciation in late ancient and Byzantine art, this chapter proposes that the earliest depiction of Mary outside of the Roman catacombs likely resides now at the Dura-Europos collection in New Haven, Connecticut. Sources from Syria and its environs corroborate the ritualization of spiritual pregnancy and new birth in Christian initiation. Like Mary, these initiates have a divine encounter at a water source and receive the illumination and incarnation of the Holy Spirit. Yet just as in chapter 4, polysemic interpretations may be appropriate in the end. Ancient authors blended their analyses of various virgins, brides, and water-well seekers from biblical narratives, such that the threads of purity, marriage, birth, and death were not often easy to separate.

The conclusion takes up two small fragments of the world's oldest church building: scenes of paradise and Adam and Eve. Focusing on how the primordial couple was understood in early Syrian Christianity enables a recapitulation of some of the themes of the book, while also showcasing the common initiatory ideas of new creation and paradise restored. The book then ends with a reflective reading of one of the earliest Christian collections of "hymns," the *Odes of Solomon*, widely considered to be from second- or third-century Syria. We cannot know for sure exactly what words were on the minds and lips of initiates at Dura-Europos, but many of these odes echo the spiritual themes, biblical narratives, and notions of salvation that were precisely emphasized in this room. They offer a fitting end to a fresh, rigorous, and plausible—albeit sometimes imaginative— historical reconstruction of the Christian community at Dura-Europos.

When Isseos and the reader have finished the procession, my narrative and its accompanying arguments are also sealed. At that culmination, what do I hope this book will have accomplished? Beginning with its simplest goals, the book offers a microhistory of a pre-Constantinian

Christian community in its geographically proximate theological, artistic, and ritual contexts. By updating the scholarship on every aspect of the house-church since 1967, it aims to be a new resource for continued research and teaching about this unique building. The nature of the extant artistic material means that the book also contributes to our understanding of the reception history of biblical narratives—how those textual and oral traditions were vectored through artistic and liturgical practices. New textual and artistic comparanda will corroborate many of the consensus views about presumed rituals, such as anointing and baptism, and the wall paintings surrounding them, especially those treated in chapter 3: the walking on the water, the healing of the paralytic, and the shepherd with his flock.

Beyond this work of consolidation and extrapolation, chapters 2, 4, and 5 advance more ambitious arguments. The painting of David and Goliath is interpreted through a militaristic visuality generated by Christian appropriation of David as warrior, a theme that resonates with the metaphors of the initiation rites, the reception history of the Psalms, and—not least—the militarized status of Dura-Europos. Later in the book, by extending the chronological frame of analysis for the female figures in the baptistery, I demonstrate that many familiar, anthologized interpretations of these paintings require reevaluation or, perhaps, complete revision. In the case of the procession of women on the main panel of the artistic program, my argument retrieves a proposal held rather widely during the 1930s but which faded over time. Though usually interpreted today as the women going to anoint Jesus' body in the tomb, a minority interpretation has seen this painting as a procession of virgins to a wedding. Such a reading resonates with several early Christian texts that promote notions and perhaps ritual enactments of spiritual marriage in a bridal chamber. New textual and artistic comparanda are introduced to enliven and augment a scholarly argument that lay dormant for more than seventy years. In the case of the woman at a well, the book advances a perhaps audacious argument, dramatically revising the possibilities for interpreting her biblical identity and theological signification in the ritual context. Although this figure is almost universally identified—and for some fair reasons—as the Samaritan

"Woman at the Well," I here strengthen my previously published proposal to reidentify this woman at a well as a scene of Annunciation to the Virgin Mary.[135] This would become the earliest securely dateable portrait of the Virgin Mary and recast the figure's role in the baptistery from repentant sinner to archetypal saint. In the course of that argument, which highlights artistic and textual comparanda from Syria and Armenia, the chapter also offers a fresh analysis of artistic forms and types of the Annunciation in late antiquity and the Byzantine era.

Ambitious arguments about the ancient world are usually inductive, multidisciplinary, and cumulative—and mine are no different. The catch-phrase in mind is not "Eureka!" but "What if?" And yet, through several years of research and generous collaborative investment from scholars around the world, some of these tiny "what if" possibilities have compounded into probabilities. In the end, the updating of consensus views and the probable reidentifications of the female figures combine to support the book's primary conclusions. Contrary to commonly held assumptions about early Christian initiation, the rituals at Dura-Europos did not primarily embody notions of death and resurrection. According to my new interpretations of the artistic program in its theological and ritual contexts, the motifs of victory, empowerment, healing, refreshment, marriage, illumination, and incarnation were central to initiation. By returning to these murals with fresh eyes—the visuality of an ancient initiate—we can imagine anew how Bible, art, and ritual functioned at the world's oldest church.

Anointed like David

Crossing the Threshold

Seated on benches in the central courtyard of the house-church, Isseos and other catechumens listen to elder Christians, week in and week out, through the windows of the assembly hall. At least that is how we might imagine their probationary period. They have not yet seen the inside of the locked baptistery.

During the long catechetical lectures, perhaps some of these catechumens were not always paying attention. The plentiful graffiti on the courtyard's walls might be a record of their idle doodling. We find several *abecedaria*—inscriptions of the alphabet—around the walls of the courtyard. For the illiterate, which included almost everyone in the Roman era, the alphabet and one's name were often all one could write. Such *abecedaria* were found in both Greek and Syriac (written in Estrangela script), offering another piece of evidence that Dura-Europos was "a meeting-point of Greek and Syriac" in the third century.[1]

It is also possible that the large number of *abecedaria* (six or seven) found in the house-church manifest more than doodling. They may testify to Christians' "struggle against the astral powers," which were so highly regarded in Roman-era Mesopotamia.[2] Indeed, the earliest extant Christian text from Syria with a secure author, Bardaisan's *Book of the Laws of Countries,* is concerned with refuting arguments about a deterministic view of the relationship between the stars in heaven and fates on earth.[3] Elsewhere in the house-church (room 5), an apotropaic magic bowl was

placed in the wall above a door lintel, likely to ward off the "evil eye," as practiced elsewhere in Syria and Arabia.[4]

These *abecedaria,* then, might be a trace of the candidates' preparatory rituals. From later centuries, we know that the initiation rites of Syria and Palestine were preceded by catechesis that emphasized the confrontation with demonic powers and subsequent rituals that exorcised them. Regarding preparatory exorcistic or cathartic rites for candidates, however, it is not fully clear whether rituals known from fourth-century West Syria and Palestine ought to be imagined here in third-century East Syria.[5]

Equally difficult to assess is the question of *which night* hosted the rites of initiation. While again the late fourth century brims with evidence—by then, calendrical diversity seems to have consolidated to privilege initiation at Easter Vigil—the third century's record is spare. Our most proximate source that attests to dates for initiation in Syria, Palestine, or Armenia comes from Macarius, bishop of Jerusalem in the early fourth century. In his *Letter to the Armenians* (335 CE), which survives only in Armenian, Macarius responds to a written petition delivered by Armenian priests about discrepancies between the performance of baptism and the Eucharist in Jerusalem and Armenia.[6] The relevant excerpt occurs when Macarius explains and defends the three particular days when baptisms were performed in Jerusalem under his care: the feast of the nativity/Epiphany (a combined feast), Easter, or Pentecost.

In any case, whichever night it is, tonight for *these* catechumens in Dura-Europos is different. Tonight that locked door will open.[7] They will cross the threshold and enter a liminal space of ritual conversion. Before they do, it is possible that someone entered the cellar below the staircase, which is accessible from the courtyard and contains, at least, jars of oil.[8] Was the one etched personally for "Isseos the neophyte" among them?

The door opens. We imagine the candidates entering in a torch-lit procession, just as we know initiates did years later in Jerusalem, Antioch, and other locales. With the door now open, they catch their first glimpse of the room's painted interior. The first image they see, directly ahead on the northern wall, bears noting: through the real open door, they see

Fig. 2.1. Computer simulation of the baptistery threshold. (Yale University Art Gallery, Dura-Europos Collection. Model simulation by Glenn Gunhouse.)

another open door—one painted on the wall (fig. 2.1).[9] From the first instant, art and ritual are fused across the threshold: the processional artistic program draws them forward into ritual action.

The jars of oil stored in the cellar just to the east of the baptistery likely played a role in a crucial part of initiation: the rite of anointing or, as it is sometimes called, chrismation. Just after candidates had entered the baptistery, it is highly probable that they underwent a prebaptismal anointing as the first act inside the room. A first reason for this supposition is the prominence given to prebaptismal anointing in our earliest sources of Syrian Christian ritual, about which more will be said presently. In addition, the niche carved in the southern wall (0.88 meters wide by 0.60 meters tall by 0.43 meters deep) was one of the architectural features that was changed in the conversion from domestic space to a *domus ecclesiae*—from house to church (fig. 2.2). The niche was rounded and stylized in preparation to feature some object, and while it could have held anything, no cogent pro-

Fig. 2.2. South wall, in situ. Christian building. (Yale University Art Gallery, Dura-Europos Collection)

posal has yet been offered besides the oil for anointing.[10] Jutting out from the same wall near the floor were found the remains of "a projecting element here, serving as a step or as a ledge or small table."[11] This was likely the designated spot for the anointing. Finally, the painting below the niche and above the ledge—unfortunately the worst preserved of the extant paintings—supplies the third reason (see fig. 2.2, photo, and plate 3, drawing). An image of the biblical David connects perfectly to a ritual of anointing; in the Hebrew Bible, David is the anointed one par excellence. At the synagogue down the street, one panel features a handsome rendition of Samuel anointing David as king of Israel (fig. 2.3; 1 Sam 16:1–13). And yet, why did these Christians in Dura-Europos not imitate the synagogue's art, instead choosing a different event from David's life—a scene from his battle

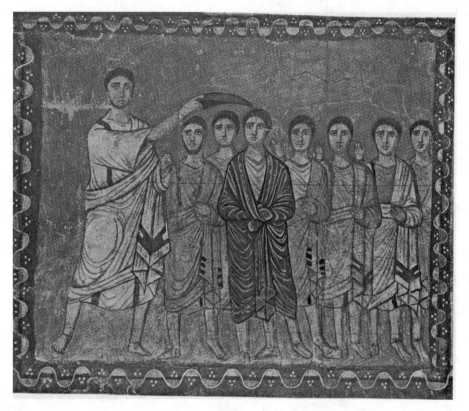

Fig. 2.3. Anointing of David. West wall, synagogue. Exhibition photograph. (Yale University Art Gallery, Dura-Europos Collection)

with Goliath? When we turn from Bible and art to explore the Syrian ritual context, we can begin to answer that question.

Anointing in Early Christian Syria

The anointing of body parts had diverse functions in Mesopotamian, Greek, Jewish, and Roman cultures.[12] The base element of oil brought health to the body through consumption and topical application. Whether encased in an earthenware lamp or poured on the tip of a torch, it was, apart from the sun, the world's primary source of light. When mixed with fra-

grance, oil could bring status to a festive occasion, such as a wedding—or mitigate the stench of a fresh corpse at a funeral. To list the manifold uses and symbolism of oil in antiquity would be almost as futile as trying to capture how a culture understands water or fire. Yet for ancient Israelites and, centuries later, Jews and Christians, one prominent aspect stands out: anointing often called to mind the ritual by which a powerful leader's reign was inaugurated. Priests, prophets, and, above all, kings were marked as such by their anointing—becoming a *messiah* (Hebrew/Aramaic/Syriac) or *christos* (Greek), an anointed one.

Anointing constituted a key part of Christian ritual in most regions for which we have ancient evidence.[13] Among these, sources from Syria—both West Syria (Antioch and environs) and East Syria (along the Euphrates)—have long been identified as bringing special, even unique emphasis to the symbolism of oil. Our earliest sources for Christian liturgy in Syria, the *Didache* and the writings of Justin Martyr, do not attest to ritual anointing, but neither do they provide full treatments of initiation.[14] It is instead with the Syrian apocryphal *Acts* of various apostles that a glimpse of distinctive Syrian rituals begins to come into focus. The *Acts of Thomas* offers particularly rich evidence, narrating five instances of Christian initiation. The first of these, the initiation of King Gundaphorus, is noteworthy in that it consists only of anointing followed by the Eucharist.[15] Because it is the earliest detailed description of ritual initiation from a text of Syrian provenance, I quote it at length:

> When King Gundaphar and his brother Gad had thus been properly disposed by the apostle, . . . they requested of him that they, too, might receive the seal of the word, saying, "Since our souls are ready and eager for God, give us the seal; for we have heard you say that the God you herald recognizes his own sheep through his seal." . . . [The apostle] ordered them to bring him oil, so that through the oil they might receive the seal. So they brought the oil and they lighted many lamps, for it was night. The apostle stood up and sealed them [in the following manner]: The Lord was revealed to them through a voice

saying, "Peace to you, brethren." They only heard the voice, and did not see his form, for they had not yet received the sealing of the seal. The apostle took the oil, poured it over their heads, smeared it, anointed them, and then said:

Come, holy name of the Anointed One, which is above every
 name.
Come, power of the Most High
 and the perfect compassion.
Come, highest charism.
Come, merciful Mother.
Come, fellowship of the male.
Come, Lady who reveals the hidden mysteries.
Come, Mother of the seven houses,
 so that your rest might be in the eighth house.
Come, you who are older than the five members—
 mind, conception, thought, reflection, reason—
 and commune with these young men.
Come, Holy Spirit,
 cleanse their minds and hearts, and seal them
 in the name of the Father, Son, and Holy Spirit.

When they had been sealed, a youth appeared to them carrying a lighted torch, so that even the lamps became faint by the approach of its light. He exited and became invisible to them. The apostle said to the Lord, "Lord, your light is incomprehensible to us, and we cannot bear it, for it's too great for our vision." When the (sun)light appeared and day dawned, he broke bread and made them partakers of the eucharist of Christ.[16]

This ritual narrative focuses the reader's attention on the anointing oil, which is the subject of prayers (*epicleses*) and which enables sacramental vision. Only after being "sealed" with the oil can a recipient see the presence of the Lord, who in this case appears as a youth carrying a blazing

torch. The connection between initiation and a new kind of visuality is emphasized by other sources from Syria and Egypt, such as Ephrem and Clement of Alexandria.[17] And though our modern sensibilities, subconsciously formed by the ubiquity of electricity, might fail to understand the symbolism at first, the narrative makes plain the connection between oil/anointing and light/illumination. Anointed with oil, surrounded by oil lamps, the initiates come to see the Lord, who outshines their lamps with a blazing torch, fueled also by oil.

In three of the other initiation scenes (chs. 121, 131, and 157), the ritual actions include the standard Syrian triad of prebaptismal anointing, baptism, and Eucharist; the episode in chapter 49 differs significantly in Greek and Syriac versions, and its strata cannot confidently be distinguished. Susan Myers provides an apt summary of the rituals in this crucial text: in the four accounts that mention oil, "the apostle prays over the oil, but not over the water; all of the initiation accounts include a eucharist, and three have a prayer over the bread as well. Anointing is given the position of greatest prominence in the *Acts of Thomas* and sharing in the eucharist is of secondary importance. Water baptism is, of the initiatory practices, third in value."[18] The fact that the *Acts of Thomas* was perceived to endorse an anointing-only initiation (probably from the influence of its first example, that of King Gundaphorus) can be shown by a piece of external evidence. In a letter to other Spanish bishops, Turibius, the fifth-century bishop of Asturica (Astorga), Spain, described what he saw as one of the deficiencies in the *Acts of Thomas:* it instructed "not to baptize with water . . . but with oil alone."[19]

The centrality of anointing is corroborated by another main source for understanding ritual in third-century Syria, the *Didascalia Apostolorum*. Likely composed in Greek by a bishop in West Syria for other bishops (though ascribed to earlier apostolic origins), this detailed "church order" survives only in Syriac and Latin versions. Several sections prescribe or allude to rites of initiation, the most famous of which gives explicit instructions about the preferability of same-sex anointings:

[Women who are to be baptized] ought to be anointed by a woman deacon with the oil of anointing; and where there is no

woman at hand, and especially no woman deacon, he who bap-
tizes must of necessity anoint the woman being baptized. But
where there is a woman, and especially a woman deacon, pre-
sent, it is not appropriate that women should be seen by men,
but with the imposition of the hand you should anoint the head
only. As of old, priests and kings were anointed in Israel, so do
you likewise, with the imposition of the hand, anoint the head
of those who receive baptism, whether it be of men or of women;
and afterwards, whether you yourself baptize, or you tell the
deacons or presbyters to baptize, let a woman, a woman dea-
con, anoint the women.[20]

Female deacons are well-documented in the early churches, espe-
cially in the East, and this text clearly explains one of their practical
responsibilities.[21] The (male) bishop provides the prebaptismal anointing
of the head only, but the male and female deacons then administer a
full-body—but still, we think, prebaptismal—anointing. At the most solemn
night of one's sacramental initiation, it would be distracting, to say the least,
to be rubbed down with oil by a member of the opposite sex. (In truth, it
is difficult to imagine being rubbed down with oil by *anyone* and retain fo-
cus on one's prayers.) As Maxwell Johnson reminds us, though, the pre-
baptismal anointing of the head receives the most attention here, just as in
the Syrian *Acts*: "Theologically and ritually, it is *this* liturgical act, inter-
preted *messianically* in relationship to the anointing of priests and kings
in ancient Israel and interpreted, and possibly accompanied, by Psalm 2:7
['You are my son: today I have begotten you'] . . . , which receives the pri-
mary emphasis in the overall initiation rite."[22]

Though it seems clear that the anointing constituted "the very high
point of the entire baptismal rite," in Johnson's words, scholarship on early
Syrian rites has not reached full consensus about their chronological de-
velopment.[23] In her landmark study of terminology used for oil and anoint-
ing in Syria and Armenia, Gabriele Winkler shows how the emphases and
meanings of anointing changed over the course of the second through fourth
centuries.[24] In addition, she draws a firm distinction between the develop-

ments of "western" rites and those of the "East" (Syria, Palestine, Armenia). The early eastern traditions emphasized anointing as (1) participation in the anointing of Christ by the Spirit in the Jordan, which drew on biblical traditions about messianic kings, and (2) a new birth through anointing/Spirit and water, as described in the Gospel of John (ch. 3). The later traditions of Syro-Palestine and the West, on the other hand, focused on (1) prebaptismal rites of purification or exorcism and (2) a "death mysticism" of participation in Christ's death, as described in Paul's letter to the Romans (ch. 6).

Modern observers might find the early eastern emphases surprising because virtually all modern rites of Christian initiation emphasize the "death mysticism" of the ritual, based on Romans 6 ("we have been buried with him by baptism into death," Rom 6:4).[25] Johnson notes, though, that the third-century scholar Origen was "the first and *only*" eastern source to refer to Romans 6 "in relationship to Christian baptism in the first four centuries."[26] And even that was only one of many images Origen used to capture its meaning.[27] We should recall too that Paul himself developed multiple metaphors for initiation, including birth (Phlm 10) and adoption (Gal 4:5; Rom 8:15). In any case, between Paul's crafting of that image in the first century and its recovery in the fourth century, Pauline death mysticism "seemingly had fallen through a hole in the memory of the early church."[28] Some scholars have offered compelling arguments that, before the cessation of persecution (or its possibility) in the fourth century, the motif of participation in Christ's death and resurrection was associated with martyrdom.[29] In addition, the ritual of the Eucharist itself was sometimes seen as a sacrificial reenactment or some other form of participation in Christ's death. In short, one of the "big stories" of pre-Nicene art and ritual is the stunning lack of emphasis—judged against the evidence of later centuries—on the imagery of Christ's death.

Winkler's theses have not gone unchallenged. Bryan Spinks argues not for a chronological development in Syrian ritual but instead for a liturgical diversity from the beginning, which continues through the later centuries.[30] In addition, he argues for more emphasis on the *Gospel of Philip*'s intriguing sacramental system and more probing of possible clues in the

first- and second-century sources, Ignatius of Antioch and the *Didache*. Spinks's most perceptive critique concerns Winkler's emphasis on the Jordan event—Jesus' baptism—as the paradigm for *pre*baptismal anointing rituals. "A better paradigm," he argues, "might be the *incarnation* of Jesus and then his baptism, where the messianic Spirit hovers at conception to bring forth new birth."[31] Since Syrian authors so often connect the Spirit with the womb, why not imagine that Jesus' incarnation in the womb of Mary was the best biblical narrative to call to mind?[32] Indeed, this book's final chapter will offer new evidence to corroborate Spinks's hypothesis.

Johnson concurs that the analogy of incarnation : baptism :: anointing : baptism might better connect biblical narrative to ritual logic, but he also reminds us that Syrian theology already blurs the lines between birth and baptism—both in the paradigmatic life of Jesus and in the rituals of each Christian initiate. Macarius's aforementioned *Letter to the Armenians* makes this quite clear. He explains why January 6—the joint celebration of the nativity and Epiphany in the early eastern church, and *still* the date of the nativity in Armenia—is a fitting day to initiate new Christians:[33] "For on that same salutary day, with the luminous Nativity of Christ, our expiatory birth of the holy font is realized; for on that same day he himself was baptized, condescending to be among us." He later quotes from John's Gospel, "Unless one is born of water and the Spirit, he cannot enter into the kingdom of God" (John 3:5), and then concludes, "In the same fashion as we are born with him, we are baptized with him, on the same holy day of the Nativity of Christ."[34] For this early witness to baptism in Palestine (and presumably Armenia), the motifs of birth, baptism, incarnation, the Spirit, and illumination are difficult to separate. Later observers tend to sort out threads of meaning that for the ancient practitioners were woven together in one tapestry.

These disagreements aside, though, scholars tend to agree on the primary significations of the anointing rituals. At their earliest recoverable root—the prebaptismal anointing on the head—the rituals enacted one's participation in the "messianic" or "Christian" community of "anointed ones," who have become "christs" in the tradition of David and Jesus. Beyond that, other central meanings drawn from oil and anointing by our

ancient authors included symbolization of the Holy Spirit; an incarnation of fire or illumination; a "seal," "stamp," or "mark" of ownership effected by the ritual; adornment for marriage; and preparation for athletic competition or military battle. Some of these can be found as early as the *Acts of Thomas* and *Didascalia;* others are extant only in later texts from East Syria (e.g., the writings of Ephrem and Narsai), West Syria (e.g., the catecheses of John Chrysostom and Theodore of Mopsuestia), and Palestine (e.g., the catecheses of Cyril of Jerusalem and Egeria's pilgrimage account).

The acknowledged dean of Syriac studies, Sebastian Brock, leads off a summary essay on anointing by highlighting its embodiment of the Holy Spirit: "Oil is the dear friend of the Holy Spirit," in Brock's quotation of Ephrem, and "it serves Her, following Her like a disciple." The connection can be shown most plainly by a particular way of expressing the persons of the Trinity in Syriac: anointer, anointed, and anointment.[35] This is an entirely biblical way of looking at things, as Jesus himself shows in a quotation of Isaiah: "The Spirit of the Lord is upon me because he [the Lord] has anointed me" (Luke 4:18 // Isa 61:1). The oil-Spirit unity finds further biblical resonance in the Johannine vision of Christian initiation: one must be "born again" (or born "from above") by "water and Spirit" (John 3:5). The figurative "spirit" (*pneuma*) in the original text implied the literal term for "wind," but with the evolution of the initiatory rite, the Holy "Spirit" came later to be identified with oil. In the noncanonical *Gospel of Philip,* likely a third-century anthology of Syrian provenance, anointing was presented as more important than water baptism because it united one with the Christ: "Chrism has more authority than baptism. For it is from the word 'chrism' that we are called 'Christians,' not because of 'baptism.' And it is because of chrism that the 'Christ' is so called. For the father anointed the son, and the son anointed the apostles, and the apostles anointed us."[36] Anointing also bestowed the Spirit, among other gifts: "Whoever has been anointed possesses everything: the resurrection; the light; the cross; the holy spirit. The father has given it to that person in the bridal chamber, and the person has received it."[37] A fuller examination of the sacramental system implied by this statement would take us too far afield, but for now we focus on the sheer primacy of anointing, a rite

that seems to gather into itself other primary symbols and meanings of initiation. A final connection between oil and Spirit in Syria sometimes occurred through a biblically resonant ritual: the "hovering" of the Spirit over the waters in Genesis—and over the waters of Jesus' baptism—could be ritually enacted by pouring oil into the baptismal font itself.[38] Like Spirit, oil hovers on the water.

Oil also manifests fire, both physically and metaphorically. It fills lamps for tables and flasks for torches, just as pictured on the northern wall of the baptistery. Figuratively, oil incarnates the spark of "illumination" (*phōtismos*), which was one of the primary terms for Christian initiation in the East. For contemporary listeners, ideas of illumination or enlightenment might sound more at home in Buddhism or even "new age" spirituality, but in fact, they were at the heart of early Christian initiation, especially in Egypt, Palestine, Cappadocia, and Syria. For example, when Cyril of Jerusalem describes those preparing for initiation, he often calls them "those about to be illuminated/enlightened" (*phōtizomenoi*).[39] And in Gregory of Nazianzus's oration "On Holy Baptism" (*Or.* 40, Epiphany, 381 CE), the term "baptism" is interchangeable with "illumination," to the extent that Rufinus's Latin translation of this oration usually renders the Greek *phōtismos* as the Latin *baptismus*. In terms of the ritual logic of initiation, oil and fire are inextricable from one another, and they are the two primal elements that proverbially "don't mix" with water, the other primal element of the ritual program. The liminal space of conversion brings together these opposing forces in order to intensify the concentration of sacramental experience. Later in this book, we will explore in depth a key manifestation of the oil-fire-water-Spirit-birth connection, which is a peculiarly Syrian way of imagining the incarnation of Jesus in the womb of Mary.

As we have already seen through the *Acts of Thomas,* early Syrian initiation was frequently described as a "seal" or "stamp" (Greek *sphragis*) or "mark" (Syriac *rushma*).[40] The two metaphors are slightly different, and it is not always clear whether anointing alone or a composite ritual of anointing and baptism is indicated. Yet the base metaphor and its signification seem to be stable: many decades ago, historian Johannes Quasten compiled

dozens of ancient sources that link the "seal" or "mark" directly to the idea of owners' branding their livestock—especially sheep (see chapter 3). In his words, "to be baptized [initiated] meant to be stamped with the indelible mark of the name of Christ. And since baptism [initiation] meant the designation of a human being as God's property, this figure of the branding of animals was borrowed from contemporary custom, and baptism [initiation] was called *sphragis*."[41] In addition, the "mark" could be viewed as a kind of Christian "circumcision," a bodily mark signifying election and covenant with God, or as a sign of adoption by God as Father.[42]

Just as the custom of branding animals offered a handy image for catechesis, so did other common situations of anointing provide fodder for Christian rumination about initiation. Two of these relevant for the analysis of Dura-Europos are anointing as adornment for spiritual marriage between the bride/catechumen and the bridegroom/Christ (see chapter 4), and anointing as preparation for battle, both as an athlete might prepare for the arena and as a soldier might prepare for war. John Chrysostom and Theodore of Mopsuestia provide detailed expansions on the athletic and military imagery of prebaptismal anointing.[43] In a long elaboration of its meaning, Theodore juxtaposes the "seal" on livestock with the "mark" of military enlistment:

> The sign with which you are signed means that you have been [sealed or] stamped *as a lamb of Christ and as a soldier of the heavenly King.* Indeed, immediately as we possess a lamb we stamp it with a stamp [brand] which shows to which master it belongs, so that it may graze the same grass as that which the rest of the lambs of the owner graze, and be in the same fold as that in which they are. A soldier who has enlisted for military service, and been found worthy of this service of the state because of his stature and the structure of his body, is first stamped on his hand with a stamp [tattoo] which shows to which emperor he will henceforth offer his service; in this same way *you also, who have been chosen for the Kingdom of Heaven, and after examination been appointed a soldier to the heavenly King, are*

first stamped on your forehead, that part of your head which is
higher than the rest of your body, which is placed above all your
body and above your face, and with which we usually draw near
to one another and look at one another when we speak. You are
stamped at that place so that you may be seen to possess great
confidence.[44]

This military imagery is a rich adaptation of an understandable social sym-
bol into a spiritual realm. But to whom would it have appealed? One can
easily understand the appeal of martial metaphors in other cults, for exam-
ple, those devoted to the emperor, or Jupiter Dolichenus, or Mithras. In
the Mithraeum of Dura-Europos itself, we might imagine such metaphors
being deployed, as congregants stood before the central tauroctony—
Mithras's mighty slaying of a bull (fig. 2.4). But Jesus was no Mithras. Did
the Christian tradition even *have* a mighty warrior to imagine?

Indeed it did. King David has been remembered, over the centuries,
in myriad ways, but a plain reading of his legacy shows this at its core: Da-
vid, the anointed, was one of the mightiest warriors of all time.

David: Anointed One, Shepherd, Warrior, Psalmist

Homer's *Odyssey* famously begins, "Tell me, O Muse, of that *polytropos*
man"—a man of many travels, many wiles, many modes of being. Odysseus
certainly fit the bill, and the heroic ancestor of the biblical witness, David,
could be characterized equally well by this term. Consider the multifarious
existence of David in the Hebrew Bible, Septuagint, New Testament, and
late antiquity. This one man was memorialized as shepherd, dancer, cov-
enanter; warrior, poet, exorcist (or music therapist); son of God, sexual
predator, perfect penitent; plucker of the lyre, Orpheus, prophet; model of
virtue, faithful to Torah, and prolific posthumous author. Lest we forget, he
was also the ideal king and archetypal *meshiach, christos,* anointed one.

No one historical person could be as *polytropos* as this—but no matter,
because like Odysseus, David is virtually prehistoric. Even the oldest rec-
ord of him in the Bible was *already* crafting a received image from what *to*

Fig. 2.4. Mithras slaying the bull. Mithraeum. Exhibition photograph. (Yale University Art Gallery, Dura-Europos Collection)

those ancient readers was ancient history. David is best understood, then, as a living symbol of the community that remembers him. As a biblical man of many wiles, the figure of David was appropriated and refigured in word and image throughout Christian history.[45]

On the lower panel of the southern wall of the baptistery, this community commemorated David by showing him poised to slay the fallen Goliath. Carl Kraeling called this image "something of a surprise," and art historian Kurt Weitzmann called it "a choice rather unexpected in a Christian baptistery and not easy to explain."[46] In early Christian artistic programs, one finds the scene only on a few sarcophagi, although it appears later in varied media.[47] The example most formally similar to ours comes

from a fresco in Chapel 3 at Bawit, Egypt, which features the decapitation scene in a Davidic cycle.[48] At Dura, as at Bawit, we do not have to debate the identities of the figures (like we do with those on the baptistery's northern wall), since here their names are inscribed in Greek: ΔΑΟΥΙΔ (David), written along his raised forearm, and ΓΟΛΙΟΔ or ΓΟΛΙΘΑ (Goliath), written above his prostrate body.[49] The scene captures the moment from the famous narrative (1 Sam 17) in which, following a crippling slingshot strike, David has taken Goliath's sword and stands poised to decapitate him. Why this particular scene, displayed so prominently in a baptistery?

Out of the broad and deep resources of Davidic tradition, the Christian community that gathered in Dura-Europos imagined David as warrior, a symbolization that also called to mind—surprisingly to our modern ears—the images of shepherding and anointing. A study of David and militaristic motifs in early Christian exegesis and homiletics leads ultimately back to the texts believed in antiquity to have been authored by David himself: the Psalms. The remainder of this chapter shows how central Christian texts and psalms of David combine to form a militaristic imaginary that resonates with several other aspects of initiation at Dura-Europos. In the end, I hope to demonstrate—in response to Kraeling and Weitzmann—that the painting of David and Goliath can indeed be explained and, at Dura-Europos, perhaps even be expected.[50]

In Judaism, David was and is *the* anointed one. For Christians, the "Christ" Jesus became the Son of David par excellence and the new "anointed one" of God. The messianic typology between David and Christ found root in multiple texts, perhaps none more significant than Psalm 89. David, considered at that time to have been the author of the Psalms, claimed divine election and anointing as God's favored son:[51]

> Then you spoke in a vision to your faithful one, and said:
>> "I have set the crown on one who is mighty,
>> I have exalted one chosen from the people.
> I have found my servant David;
>> with my holy oil I have anointed him;
>
> . . .

> He shall cry to me, 'You are my Father,
>> my God, and the Rock of my salvation!'
> I will make him the firstborn,
>> the highest of the kings of the earth." (Ps 89:19–20, 26–27)

The *Didache,* the earliest Christian ritual text from Syria—so early that it is frequently called a "Jewish-Christian" text—distinctively incorporates David into its liturgical prayers, giving thanks in probably the oldest extant eucharistic prayer for "the holy vine of David" (9.2) and later proclaiming "Hosanna to the God of David!" (10.6). What David was to Christ, Christ became for Christians: the archetype of a chosen, anointed son in God's kingdom.

His anointing as future king of Israel was far from a foregone conclusion. Like other leaders before him, such as Moses, David was an unlikely leader plucked from obscurity while working as a shepherd. He was delayed for his anointing by Samuel because he was at home keeping the sheep: "Jesse made seven of his sons pass before Samuel, and Samuel said to Jesse, 'The Lord has not chosen any of these.' Samuel said to Jesse, 'Are all your sons here?' And he said, 'There remains yet the youngest, but he is keeping the sheep'" (1 Sam 16:10–11). When David was brought in, "The Lord said, 'Rise and anoint him; for this is the one.' Then Samuel took the [ram's] horn of oil, and anointed him in the presence of his brothers. And the spirit of the Lord came mightily upon David from that day forward" (16:12–13).

The drama leading up to David's duel with Goliath also involved his leaving behind his flock of sheep in order to participate in the battle with the Philistines (17:19–30). Then he defended his audacious desire to fight Goliath by citing his past success in defending sheep from predators (17:34–36). Although these juxtapositions of shepherding and soldiering may seem odd to our ears—one is bucolic, the other disrupts such tranquility—it was not so strange in antiquity. In the early fourth century, for example, Eusebius praised the emperor Constantine as one who manifested on earth both the defensive shepherding and assertive soldiering of the Christ.[52] David's legacy as anointed shepherd-warrior was thus hatched with the victory over

Goliath. The "five smooth stones" he grabbed from the wadi and placed in the pouch of "his shepherd's bag" would become world-renowned. By next killing the dazed Goliath with Goliath's own sword, David assured his place in folklore. His continued triumphs are narrated in the ensuing battles with the Philistines, during which the Israelites shamed Saul with their war-song, "Saul has killed his thousands, and David his ten thousands" (18:7).

While it is true that the status of David as archetypal anointed one was established, at first, by his anointing from Samuel, military prowess, and royal ascendance, his importance was confirmed for later centuries especially through the book of Psalms. In antiquity, unlike today, all the psalms were thought to have been composed by David. Through them he recounts his anointing as God's son (Ps 2), as a royal bridegroom (Ps 45), and as one uniquely elected by God (Pss 2, 89, and 151).

For Christians and scholars of Christianity, Psalm 2 hardly needs introduction. It is among the most cited or echoed texts in the New Testament and early Christian literature. Along with Psalm 89, Christians saw in Psalm 2 the prefiguration of God's election of Jesus as the Messiah-King-Son in the line of David: the rulers of the earth conspire against the Lord's "Anointed/Messiah/Christ" (2:2), but the Lord declares this one both "king" (2:6) and "son," especially in the peak declaration of, "You are my son; today I have begotten you" (2:7). That line is frequently thought to be echoed in the baptismal voice over Jesus in the Synoptic Gospels, and it is quoted in full in the well-attested Lukan manuscript variant of the baptismal voice (Luke 3:22).[53] We have already discussed its probable use as a liturgical utterance in the initiatory rites of third-century Syria (*Didascalia* 9).[54] Yet because of the markedly pacific demeanor of Jesus of Nazareth, Christians and interpreters of Christianity have too often neglected the martial characteristics of the anointed son proclaimed by the psalm. The Lord inspired that one to "break [the enemies] with a rod of iron / and dash them in pieces like a potter's vessel," for the "wrath" and "fury" of the Lord are "quickly kindled" (Ps 2:9, 5, 11). Again we see that the ancient concatenation of shepherding, anointing, sonship, and militarism coalesced on the figure of David.

 Not even a wedding celebration could temper the force of the milita-
ristic imaginary that David conjured. Psalm 45 (LXX 44) is usually thought
of as the Bible's psalm for a royal wedding—and indeed it is. Addressed
ostensibly to David, it declares that God "has anointed you / with the oil
of gladness beyond your companions; / your robes are all fragrant with
myrrh and aloes and cassia" (45:7–8). Here the ritual of anointing—fit for
a coronation, an adoption, or a battle—also prepares David for a wedding
celebration. The bride is bedecked with gold and colorful robes and leads a
procession of virgins to the king: "With joy and gladness they are led along /
as they enter the palace of the king" (45:15). The imagery informs later in-
terpretations of marriage in real life and as a metaphor for salvation, as
later chapters will explore. But here we must note the beginning of the
psalm, which attests to the divine right of the king, so to speak, by acclaim-
ing his military prowess:

> Gird your sword on your thigh, O mighty one,
> in your glory and majesty.
> In your majesty ride on victoriously
> for the cause of truth and to defend the right. (45:3–4)

Noble ideals, to be sure—but the psalm continues, leaving no doubt of the
king's ferocity:

> let your right hand teach you dread deeds.
> Your arrows are sharp
> in the heart of the king's enemies;
> the peoples fall under you. (45:4–5)

Here too the ritual symbols connected to kingship, battle, and marriage
are united in the person of David.

 Some portion of David's psalms, such as 23, 42, or 45, probably com-
prised portions of early Christian initiation. Although this cannot be defi-
nitely proved for the specific rituals at Dura-Europos, Johannes Quasten
has argued that Psalm 23 was the foundational text for initiation in East and

West, and its lines do echo in this ritual site.[55] Here at the central painting over the font, it is baptism that "leadeth beside still waters" and "restoreth the soul." Beforehand the head is "anointed with oil"; afterwards the eucharistic "table is prepared." Yet other Psalms of David are also specifically relevant here. Many of them have headings that give a context or a musical directive, and two of these invoke the battle with Goliath and later mention oil or anointing: Psalm 144 (LXX 143) and Psalm 151.

Psalm 143 (LXX), introduced as a psalm by David "regarding Goliath" (πρὸς τὸν Γολιαδ), contains prayers for deliverance, victory, and prosperity.[56] This connection to Goliath was acknowledged by early Christian readers: in his letter to Marcellinus about the Psalms, Athanasius wrote, "Should a tyrannical foe rise up against the people and against you, as Goliath against David, do not tremble in fear. You too must have faith, like David, and say the things in Psalm 143."[57] The key line for our purposes is the beginning of the prayer for prosperity, which describes "sons like new plants that ripened in their youth" (LXX 143:12). "New plants" renders the Greek "neophytes" (νεόφυτα), a relatively rare word that is of obvious relevance here.[58] The psalm's reward for victory over Goliath is neophytes. Elsewhere Psalm 128 (LXX 127) describes sons as "new olive plants encircling a table," or literally "neophytes of oil" (νεόφυτα ἐλαιῶν, 127:3), which these anointed Christians would shortly become—sons of David, children of God, gathered around a eucharistic table.

Psalm 151 also recalls the epic battle and resonates even more strongly with the experience of Christian initiates. Despite not being present in the Masoretic Text of the Hebrew Bible, it was widely attested in antiquity, discovered in Hebrew among the Dead Sea Scrolls, and is still canonical today in eastern Christianity.[59] "This psalm is ascribed to David as his own composition," says its heading, "after he fought one-on-one with Goliath" (Ps 151:1).[60] In this translation from the LXX version (not the Hebrew from Qumran), David narrates how he came to face the giant:[61]

> I was small among my brothers
> And the youngest in my father's house.

I tended my father's sheep. (v. 1)

. . .

It was [the Lord] who sent his messenger
And took me from my father's sheep,
And anointed me with his holy oil [or anointing oil].
My brothers were handsome and tall,
But the Lord was not pleased to choose them.
I went out to meet the foreigner,
And he cursed me by his idols.
But I drew his own sword, beheaded him,
And removed disgrace from the sons of Israel. (vv. 4–7)

The psalm begins with David's youth as a shepherd and ends with his glory as a victor. It was also applied in antiquity to the Maccabees in their battle with foreigners, and in general it "can be explained perfectly within a re-shaped biblical tradition as a means of providing hope to the Jews involved in different wars with their neighbors."[62] Before the battle David recalls God's selection of him and the anointing with oil (ἔχρισεν με ἐν τῷ ἐλαίῳ τῆς χρίσεως).[63] The anointing seems here, in this midrashic paraphrase, really to be a preparation for battle, as if Samuel's anointing were specifically designed to prepare him for war. According to Athanasius, the psalm is also the archetype of individual election: "If, though you are insignificant, you yet are chosen for some position of authority among the brothers, you must not be puffed up as though you were superior to them, but rather glorify God who chose you, and chant Psalm 151, which is *David's own psalm.*"[64] Let me stress that point: though outside the number of the western canon, Athanasius considers this *the most Davidic of all the psalms.* Besides the connections in the baptistery to the sheep, the battle, and the anointing, the language of election is central: David was taken because God "was not pleased to choose" others (οὐκ εὐδόκησεν ἐν αὐτοῖς). The Greek construction is exactly the same as the divine voice at the baptism of Jesus in the Synoptic Gospels, which use the verb εὐδόκησα + ἐν.[65] Both psalms that comment on David's battle with Goliath, therefore, resound with specific language and imagery of Christian initiation.

Looking over at Goliath: Militaristic Visuality at Dura-Europos

The most Davidic of psalms—about David's anointing and election, his transition from shepherd to warrior—was used in antiquity to recast the role of God's chosen people vis-à-vis their neighbors threatening war. Just as Jews modified the heading of Psalm 151 to adapt its meaning to new situations, so did Christians in Dura-Europos suit Davidic narrative and motifs to their own context. They were becoming *spiritual* warriors of the noble shepherd, but at the same time, they stared across the Euphrates— or over the wall right behind their church—at a *real-life* Goliath in the form of the Sasanian army. Five smooth stones were not going to suffice.

Chapter 1 treated at some length the militaristic identity of Dura-Europos.[66] It noted that proposals about the origins of the Christian community at Dura depend in part on the four personal names found in the building's graffiti. Two of these—Paulus and Proclus—are Latin in origin and were "borne at Dura only by members of the garrison," known through military records discovered during the excavations.[67] In fact, it was a certain Proclus who dedicated the painting of David and Goliath: above the painting reads, "Jesus Christ (be) with you. Remember Proclus."[68] This is the only dedicated painting of those extant from the house-church. Its imagery of David's victory over Goliath would likely have resembled other militaristic art on display around town or in private dwellings.[69] About the artist it is sensible to ask, then, in the words of James Francis, "What if, as artists are wont to do, a painter did not look or think of a text at all but looked instead to other artists' depictions? . . . [T]he artists who produced the earliest Christian images operated within the ideas and practices of ancient visual artistry in general. Neither their subject, their inspiration, their patrons, any personal belief that they may have had, nor the existence of a Christian sacred text would have required them to depart from the artistic concepts and practice they knew."[70] At a minimum, we can conclude that, because a militaristic imagination was vibrant in this city, the figures in this scene were chosen to embody the imagined ideal characteristics of the community's members; and the figures were given explicit names by the artist precisely to distinguish them from other kinds of room decoration.

Recently, Stefanie Weisman has called attention to the militaristic un-
dertones of the paintings in the *synagogue* at Dura-Europos, a fact that
further bolsters the case for both the town's militaristic visuality and the
specific reception histories of biblical figures as warriors in such contexts.[71]
Weisman analyzes not only the explicit battle scene of Eben-Ezer depicted
in the synagogue, but also the militaristic features of *non*battle scenes, such
as Moses and the Well of Be'er, whose military-style tents "reinforce the
image of Moses as military commander," and the Valley of Dry Bones,
whose bones are not dry but in fact fleshy (figs. 2.5, 2.6, and 2.7).[72] The "Dry
Bones" example shows "the artists' desire to make the scene resemble a bat-
tlefield, a sight that would probably have been familiar to the inhabitants of
a military garrison on the Roman frontier. The severed heads, arms, and
legs strewn on the ground recall images of carnage."[73] After further

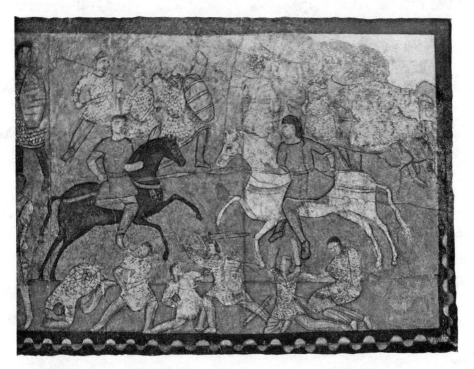

Fig. 2.5. Battle of Eben-Ezer. North wall, synagogue. Exhibition photograph.
(Yale University Art Gallery, Dura-Europos Collection)

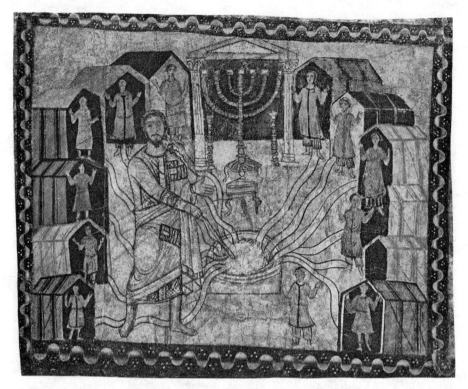

Fig. 2.6. Well of Be'er. West wall, synagogue. Exhibition photograph. (Yale University Art Gallery, Dura-Europos Collection)

arguments about the dress and weapons depicted in the paintings, she concludes that the designers of the synagogue's panels "chose to represent many biblical stories with themes of violence and destruction, and they played up the military aspect even in scenes that were not directly related to warfare."[74]

Taking a similar approach to the David and Goliath painting in the baptistery, Dieter Korol has examined the militaristic indicators visible in the best photograph of the highly damaged painting. He performed an exacting analysis of the image snapped sometime between January 20 and January 22, 1932, which preserves more detail than those done later (fig. 2.8). His recent articles demonstrate that the photos of the painting reveal more detail than scholars had previously thought.[75] The clothing and jewelry of

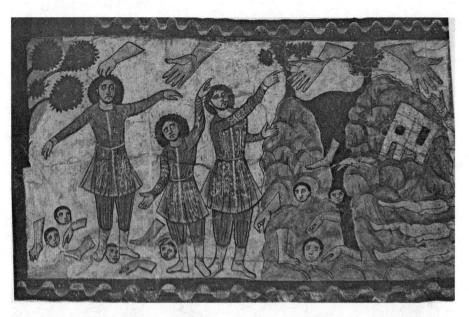

Fig. 2.7. Valley of Dry Bones. North wall, synagogue. Exhibition photograph. (Yale University Art Gallery, Dura-Europos Collection)

the two warriors help to situate them in their particular time and place. David's characteristics (tunic, armband, and sling) align him with the Romans, and the scene stands as a "typical product of the frontier between the Roman and Persian empires and thereby distinguishes [this painting] clearly from all other known examples of this iconography."[76] Moreover, he argues persuasively that the fallen Goliath in the painting displays features that identify him as a specific kind of enemy, a representative of the "current pagan enemy"—the Persians across the river.[77] Korol focuses especially on the fourfold concentric necklaces or neck armor of the Goliath figure, which resemble the same on coins of Parthian kings found at Dura-Europos.[78] He argues for decreased emphasis on the typological interpretations of Goliath evidenced from Christian exegesis and homiletics and renewed attention to artistic forms and details. In conclusion, "Goliath is signified at least as a particularly high-ranking Persian soldier, if not the Persian king himself. The figure of David, approximately centrally

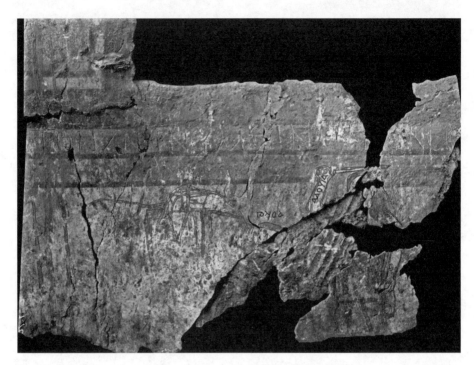

Fig. 2.8. David and Goliath. South wall, Christian building. Excavation photo-
graph. (Yale University Art Gallery, Dura-Europos Collection. Traced over and
originally published in D. Korol and J. Rieckesmann, "Neues zu den alt- und
neutestamentlichen Darstellungen im Baptisterium von Dura-Europos," in
D. Hellholm et al., eds., *Ablution, Initiation, and Baptism: Late Antiquity, Early
Judaism, Early Christianity* [Berlin: Walter de Gruyter, 2011], fig. 61.)

positioned and victorious, moreover might well have been viewed by a
Christian living in Dura as a sort of *Hoffnungsträger*—[a bearer of hope]—
considering the current threat caused by the superiority of the Persians."[79]

Korol provides an artistic comparandum of a slinger from the Roman
army featured on Trajan's column (fig. 2.9), and another exists on Aureli-
an's column. The depictions of David's sling in later examples, such as the
Davidic cycle of silver plates from Cyprus, show his sling to resemble that
of the Roman auxiliaries (fig. 2.10).[80] To Korol's excellent arguments we
might add that the Roman adoption of "slingers" in their eastern auxiliary

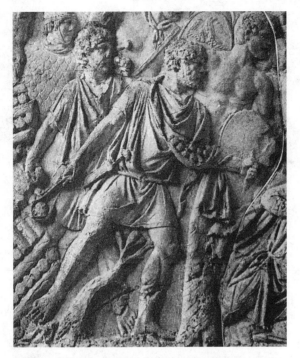

Fig. 2.9. Auxiliary slinger. Column of Trajan, 113 CE.
(Conrad Cichorius/Wikimedia Commons)

units was frequently "of Syrian origin," and though they are attested from
Republican times, they "were used most of all in the third century" of the
imperial era.[81] This unique depiction was thus suited specifically for the
Christian population at Dura that lived under constant threat of military
confrontation with the Persians.

Although Korol sets aside typological exegesis, his interpretation of
the David and Goliath battle—as a cipher for ethnic and religious violence—
can be bolstered by it. From a survey of patristic sources, Jean Daniélou
has argued that David's struggle against the seemingly insurmountable
Goliath was the oldest and most important theme of Davidic typology.[82] A
roughly contemporaneous example comes from Hippolytus's sermon about
David and Goliath. Throughout Hippolytus's exposition of the narrative,
he focuses on the arms and armor and allegorizes every possible piece of

Fig. 2.10. David and Goliath silver plate, 629–630 CE (detail).
(The Metropolitan Museum of Art, New York, 17.190.396. Gift
of J. Pierpont Morgan, 1917. www.metmuseum.org.)

each. Moreover, he usually removes the specific ethnic signifier "Philistines"
when discussing Goliath's side, preferring instead epithets such as "Gen-
tiles," "foreigners," or "godless and unbelieving Gentiles."[83] That is to say,
he contemporizes the enemy to include the idolatrous pagans of his pre-
sent day. This symbolization would look quite different later, when Emperor
Julian the Apostate would be called by Ephrem the "second Goliath" and
the "wolf" that threatens the herd.[84]

Korol's argument can also be supported by examinations of the ar-
tistic reception of David from later historical periods. In a study of David
as "musician and poet" in the history of art, Erich Zenger has found that
any purported connection between the biblical text and an artistic repre-
sentation is weaker than the connection between the artistic piece and the
cultural context of its viewers. We should not find it odd that the Chris-
tians at Dura imagined Goliath—consciously or not—as a Persian, when
we have other examples from later history that fashion Goliath in the mili-
tary dress of *their* contexts (e.g., medieval European chain mail).[85] After
examining five artistic programs about David from different centuries,

Zenger concludes: "The pictures are not supposed to be interpretations of any biblical texts. Rather, the biblical texts are used to constitute and evoke a religious, cultural, political or anthropological horizon for interpretation in which the viewers of the picture should situate themselves and their community and from which they should understand themselves."[86] What might seem anachronistic to a post-Enlightenment thinker is described better as "a subtle fusion of biblical and contemporary levels," which "lends the pictures a dynamic structure and demands from viewers a creative examination of the *sujet* [subject], even if only 'somehow' known, *and* of the associations, intentionally suggested by the pictures, that do not come from the Bible but from different historical periods."[87] Just as the processional visuality of the eastern and northern walls at Dura-Europos suggests an interpretation of the torch-bearing women as "self-reflective embodiments of the initiates" (in Wharton's words), so too does the militaristic visuality of the southern wall reflect their worldview. They are anointed spiritual warriors against the devil, just as they stand poised, in real life, for war with the Goliath across the river.

The principles of environmental psychology, when applied to Roman sources, further corroborate an interpretation of David and Goliath as symbolic of the imperial standoff over the Euphrates. Tacitus's depiction of the Roman Empire has it "cordoned by the sea of Ocean or lengthy rivers" (*Ann.* 1.9.5). Most modern summaries of the empire's geography explain the importance of the Rhine-Danube border to the north and the Euphrates to the east. David Braund delves further into the ancient sources to show how potent rivers were in the Roman imagination. "In the first place," he writes, "we must recognise that in antiquity, from Homer onwards, rivers are gods. . . . [They] have cults and priests, rivers receive sacrifices, and rivers procreate, speak and fight, not least, it should be noted, for their own lands."[88] Braund analyzes the obeisance due to rivers, their paternal power, and the propagation of their identities through ritual and iconography. To channel a river—or more boldly, to bridge it—was an ambition that required oracles, rituals, and sacrifices. *Pontifices* were required, in both literal ("bridge-builders") and metaphorical ("priests") senses of the term.[89]

The modern poet T. S. Eliot, whose sensibility was formed by North America's largest river, the Mississippi, begins "The Dry Salvages," one of his *Four Quartets,* with lines that could have been uttered by a Roman poet:

> I do not know much about gods; but I think that the river
> Is a strong brown god—sullen, untamed and intractable,
> Patient to some degree, at first recognised as a frontier;
> Useful, untrustworthy, as a conveyor of commerce;
> Then only a problem confronting the builder of bridges.
> The problem once solved, the brown god is almost forgotten
> By the dwellers in cities—ever, however, implacable,
> Keeping his seasons and rages, destroyer, reminder
> Of what men choose to forget.[90]

Later in life, Eliot expressed gratitude for the environmental psychology formed in his youth: "It is self-evident that St. Louis affected me more deeply than any other environment has ever done. I feel that there is something in having passed one's childhood beside the big river, which is incommunicable to those who have not. . . . [T]he Missouri and the Mississippi have made a deeper impression on me than any other part of the world."[91] Great rivers indeed form the imagination—their powers to bound, to bear, to rage and destroy. When Eliot's poetic predecessor Walt Whitman visited St. Louis, he said that all he did every night there was "haunt" the river and gaze by moonlight at its bridge, at that time the largest ever built.[92] Whitman was rapt in awe at what these *pontifices* had achieved.

Yet it has also become de rigueur—after the twentieth-century era of building bridges and large dams—for scholars to dismiss the symbolic power of rivers. "To the unthinking," quips Roman historian J. C. Mann condescendingly, "the Rhine or the Danube can appear as a 'natural frontier.' No such thing as a 'natural frontier' exists. Rivers in particular hardly ever function as effective boundaries between groups. Rather, Rome held long stretches of the Rhine and Danube as a bureaucratic choice."[93] The problem seems solved, and the brown god all but forgotten. Others have

come under Mann's influence, raising the question of whether such schol-
ars have tried recently to cross any rivers unaided by a bridge or engine-
powered boat. Large rivers such as the Mississippi, Rhine, Danube, and
Euphrates do, in fact, constitute formidable boundaries for those trying to
cross them—all the more so when under attack. Of course, there are some
instances when a united people has straddled both sides of a large river,
and some rivers do function primarily as conduits and not barriers; the
Egyptian Nile is an example. But, like the Mississippi, most cases are of-
ten the result of long wars fought across a frontier.

Regarding Roman environmental psychology, Braund has clearly
demonstrated that—as the classics-lover Eliot no doubt knew—Roman
sources consistently imagine rivers as powerful boundaries, and their evi-
dence cannot "be so easily brushed aside."[94] Caesar's *Gallic War* dwells
on the significance of the Rhine as a boundary—not even to mention his
subsequent, infamous crossing of the Rubicon.[95] The channels of the Oron-
tes and Euphrates in Syria were commemorated by "solemn and grandi-
ose" inscriptions.[96] Cicero and others "stressed the need to propitiate a
river" before crossing it and take auspices "to look into the future beyond
it."[97] With regard to the Euphrates specifically, the Roman general Lucul-
lus sacrificed a bull to the Euphrates after crossing it, since it had given him
great fear of delay and difficulty.[98] The general Pompey had been expressly
forbidden to cross the Euphrates by Phraates III, the Parthian king at that
time, and both acknowledged it was a boundary.[99]

Probably the most significant crossing of the Euphrates in Roman his-
tory was that of Marcus Licinius Crassus, a member of the First Triumvi-
rate and governor of Roman Syria in the mid-first century BCE. His
inauspicious crossing led to a disaster at Carrhae, the first major battle of
the Romans with their eastern nemesis.[100] Crassus's army ignored several
bad omens before crossing: difficulty removing a golden eagle standard
from the ground after the winter, loss of a standard into the river during a
violent wind, and a thick fog engulfing the soldiers during passage such that
they could not see across to the enemy country on the other side of the river.
So great was his troops' fear that Crassus promised they would return by
way of Armenia to avoid crossing the Euphrates again. The soldiers, "as if

predestined to ruin by some divinity, deteriorated in both mind and body."[101] Thus did Crassus lose the first contest between the Romans and the Persians—through a chain of events spawned by his lack of attention to the power, both physical and symbolic, of the Euphrates. His loss had repercussions back in Rome, setting Pompey and Caesar at odds with one another. In other words, Crassus's calamitous crossing of the Euphrates at the end of the Republic led to Caesar's portentous crossing of the Rubicon and the beginning of empire.

Evidence from Roman sources and environmental psychology thus suggests that in the Roman imagination, the Euphrates—like the mythical river Styx in the Greek underworld or the river Jordan in Israelite memorialization—effectively separated life from death.[102] In the concluding words of Braund: "From a Roman perspective, rivers were indeed natural boundaries in a sense that includes their religiosity, their natural power and their tendency to divide and to bound. When modern strategists leap to the criticism that rivers are inadequate (even non-functional) boundaries and dividers, they miss much of the point which lies embedded in the environmental psychology of the Roman world."[103] Coupled with that insight, Korol's argument in favor of a Persian-styled Goliath effectively refocuses our attention on both the militaristic reception of the biblical David and the militarized setting of Dura-Europos.

As a final note on this topic, the newly emphasized setting should cause us to have another look at some of the forgotten art of the house-church. The baptistery gets all the attention, but was any other artwork salvaged from the site? In fact, the main assembly hall (room 4) contained two figural graffiti on its south wall, which were analyzed in detail by Rostovtzeff and situated in the ranks of Parthian and Sasanian cavalry (figs. 2.11 and 2.12). They have been difficult to situate in the regnant interpretations of the building, and so hardly anyone has tried. On the left is a mounted archer in body armor, poised to release his arrow (a *cataphractarius* or cataphract). Similar graffiti were found in the Temple of the Palmyrene Gods and other buildings—public and private—in Dura-Europos.[104] On the right side, a heavily armored lancer charges atop a fully armored horse (probably a *clibinarius*). On his head sits "a conical helmet which consists

Fig. 2.11. Tracing of mounted archer. Assembly hall, Christian building. (Yale University Art Gallery, Dura-Europos Collection)

of metal plates. To the top of the helmet are fastened two floating ribbons, a kind of diadem similar to the diadems of the Sasanian kings."[105] A similar image was found in the Palace of the Dux Ripae, the building that gazed directly over the river at Persia.[106]

The graffiti are difficult to date, and as far as I can tell, neither Rostovtzeff nor Kraeling tried to do so. Since they were not on the most recent coat of plaster, Kraeling suggests they dated to the "private house" phase of the house-church.[107] It is thus possible that they are not related to the house-church in the era under consideration, and yet, their existence remains a curiosity. Were they part of a Christian's private house then? Or are we to presume that the house was not previously owned by a Christian? And if the graffiti were present and exposed during the Christian house-church phase, then why in the assembly hall of the house-church, where

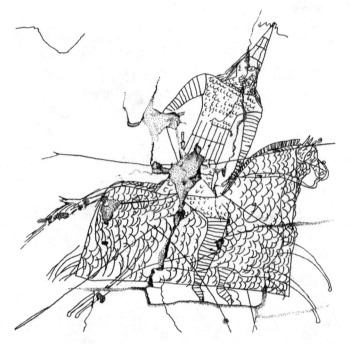

Fig. 2.12. Tracing of armored lancer. Assembly hall, Christian building. (Yale University Art Gallery, Dura-Europos Collection)

we conjecture the Eucharist was celebrated? Were these fearsome Persian riders imagined spirits with which to do battle? A kind of legion of demons that needed to be cast out? Or were they forms of the "holy rider" image so common to apotropaic amulets and jewelry? To be sure, the graffiti provoke more questions than responses. The Persian archers and riders across the river were memorialized out of fear, curiosity, admiration, or any combination of these. In general, we can say that they further establish the militaristic visuality of residents—and perhaps of Christians—in Dura-Europos.

Returning now to the baptistery: as a space of ritual initiation, it conjured liminality, the in-betweenness and transience of living on the edge. Pondering the militaristic imaginary of the city inevitably calls to mind the literal frontier on which Durene Christians lived. With a mighty army across the river, they lived on the border between death and life. On and

off for three hundred years, since Crassus's ill-starred crossing of the Euphrates, Rome had been at war with the Persians. Often they had trouble fending off the Persians' cataphracts. Yet Roman history offered occasional glimpses of hope. After Crassus's initial defeat, in fact, the Romans had successfully stopped an invasion by the Parthian crown prince, Pacorus I. How did they stop the mighty Persian cavalry and retain control of Syria? According to Cassius Dio, the winning tactics that repelled the Persians hinged on—that's right—*the slingers*.[108] These were no child-size "slingshots," but fearsome ballistics whirled and fired farther than the Persian archers could shoot.[109] In a decisive battle in the history of Roman-Persian conflict, it was the auxiliaries' slinging of stones that marked a turning point and led to the death of Persia's royal general.[110] Thus was David, the slinger and mightiest warrior available in the long memory of the Jewish and Christian traditions, imagined and claimed years later as a "bearer of hope" against a formidable foe whose defeat was not certain.[111] As a flock looks to their shepherd and an army looks to its hero for protection from enemies, so did the Durene Christians craft the memory of David as the anointed victor whom they hoped also to be.

"Sealed as a Soldier of the Heavenly King"

We have been attending as much as possible to the specific historical context of Christians in Dura, but in conclusion, we should remember that even outside of explicitly military towns, the social marks of the army provided suitable metaphors for Christian initiation, progress, and perfection. Exhortation was drawn from the imagery related to soldiers in general and also from specifically Davidic narratives. We have already seen how the *Didascalia* suggests the proclamation of Psalm 2:7 over initiates, and the rest of that psalm echoed with the sounds of war. Elsewhere, in his baptismal catecheses, Cyril of Jerusalem uses military enlistment as a symbol of commitment: "The Holy Spirit is about to imprint a seal on your souls. You are to be enlisted in the service of the Great King" (*Bapt. Cat. 3.3*).

The Syrian Tatian, a second-century author most famous for compiling the *Diatessaron*, used military training in a treatise "On Perfection"

as a means of explaining Christian progress and maturity. Starting from the teaching of Jesus, "Strive to enter the narrow door" (Luke 13:24), Tatian elaborates at length on the verb "to strive," whose root meaning is to struggle in competition or battle (*agōnizomai*). The one "who desires to be enlisted in the muster roll of warriors" must live "like a warrior," "learn military matters," and when the time comes, "throw himself manfully into the strife." If one wants "to be inscribed in the enrollments of life with the Warriors, the Prophets, the Apostles, we must learn in advance the military matters, the rules and laws of our Lord, and daily drill ourselves in them, and purify ourselves like a clean armor." Tatian's allegorical exhortation moves on from there to expound the battle with the devil and the "greatness of renown" in the afterlife that a mighty warrior will achieve.[112]

Such militaristic exhortation was also thought to fit the context of ritual initiation. In his oration on baptism, for example, Gregory of Nazianzus uses the model of David and Goliath to speak specifically to young candidates: "Are you young? Stand against your passions. Be numbered with the alliance in the army of God. Do valiantly against Goliath. Take your 'thousands' or your 'ten thousands' [quoting the victory song]. Thus enjoy your manhood, but do not allow your youth to be withered, being killed by the imperfection of your faith."[113] Here the military enlistment metaphor is directed against Goliath as the personification of the passions.[114] In the Syrian context, Aphrahat imagines the defeat of Goliath as the conquering of pride, while Ephrem finds in him a manifestation of the devil.[115] Ephrem even applies the imagery to anointing and baptism, in a crucial passage:[116]

> Samuel anointed David
> To be king among the people,
> But behold, the priest anoints you
> To be heirs in the kingdom.
> David, anointed with oil,
> Fought with his weapons
> And brought down the giant

> Who wanted to subjugate Israel.
> Behold, the oil of Christ!
> And with weapons hidden in water,
> He has sunk the pride of the evil one,
> Who wanted to subjugate the people.[117]

Ephrem illuminates the typology through linguistic and structural parallelism. David's anointing prefigured that of Christ and Christians; Goliath fought against the Israelites, but the devil fought against humanity. The oil of Samuel on David's forehead empowered him as warrior-king; the oil with which Christ was anointed empowered him to battle "the evil one." Both David and Christ's weapons were "hidden in water"—David chose his stones from the wadi; for Christ and Christians, the water itself is the weapon. Into the water Christ has sunk the pride of the devil. The devil wanted to subjugate the people, but Christ has brought the devil down to drown.[118] A tantalizing related text comes from Pseudo-Cyprian, commenting on the stone that slew Goliath: "David smote the forehead of Goliath and slew him; signifying that the devil and his servants are thereby thrown down—that part of the head, namely, being conquered which they have not had sealed" (*Adv. Jud.* 16). Cyprian is contemporaneous to Christians at Dura-Europos, of course, but writes from North Africa, far west in the empire. His use of military metaphors for initiation is attested (e.g., *Ep.* 73.22), but we cannot say for sure whether the specific connection between the forehead of Goliath and the forehead of anointing goes back authentically to him.

As discussed earlier, the prebaptismal anointings in ante-Nicene Syria seem to have included both a messianic anointing of the forehead and a full-body anointing. Dominic Serra has argued that the forehead ritual "brings to mind the anointing of David by Samuel, but the anointing of the whole body in preparation for the struggle with Satan better relates to David's victory over Goliath."[119] Serra is quite right, in a heuristic sense, but Davidic texts such as Psalm 143 and especially Psalm 151 inveigh against our ability to separate out the election-anointing from the battle-anointing. Our textual traditions from Syria corroborate both understandings. The *Acts of*

Thomas, for example, prays to Christ as "the one who wards off the enemy and drives him away from us, the one who competes in many contests on our behalf, and who makes us victorious in all; Our true and unconquered athlete, our holy and victorious general" (39; cf. 50). Meanwhile, an archaic Syriac prayer over oil imputes the struggle in the arena to the anointed Christians too: "[By the oil] he illumines us and chases away from us darkness and error, and in its Mystery, again, athletes in the contest overcome their enemies. To you be praise, Mystery of the oil, who were worthy to have participation with Christ, and with it the victorious are crowned in the contest."[120] Finally, in the late fourth century, the variegated baptismal catecheses of John Chrysostom bring many of the motifs about anointing, soldiers, and athletes into one place. Christians are anointed with the oil of gladness before the combat, but the devil has been bound.[121] "As if you were a combatant chosen for the spiritual arena, the priest anoints you on the forehead with the oil of the spirit and signs you."[122] The anointing provides arms and armor, such that the anointed is "a heavy-armed soldier," while the devil is merely an "archer" shooting darts.[123] The full-body anointing is protective: "after he anoints all your limbs with this ointment, you will be secure and able to hold the serpent in check."[124] Chrysostom fluidly mixes metaphors, moving from passages about recruitment and enlistment of soldiers to analogies about the Olympic games and other contests in a spiritual arena.[125] In a later chapter, we will see that he even combines these *martial* metaphors with, of all things, *marital* metaphors.

 As this book proceeds, the polysemic ritual of anointing will bear other meanings for other parts of the baptistery's artistic program. For this chapter, though, at what seems to be the site of the anointing of the head (and perhaps the whole body), the ritual does seem to conjure a militaristic visuality centered on the figure of David. At the nexus of Bible, art, and ritual we find the anointed warrior in whose mighty footsteps Christians— "anointed ones"—hoped to follow. As this chapter has shown, Syrian commentaries on initiatory rites corroborate this view: one wanted to be "sealed as a soldier of the heavenly king," in the words of Theodore of Mopsuestia. And if we were able to listen in on the ritual utterances themselves in Syria, we might expect to find liturgical language similar to what Theo-

dore describes. In fact, though we cannot reconstruct the exact words used at the third-century prebaptismal anointing with any certainty, the earliest extant Syriac ritual commentaries do offer probabilities. Sebastian Brock argues that the oldest of these manuscripts belongs to the same catechetical tradition as that of Theodore but exhibits "a more primitive structure of service" and is perhaps slightly earlier in date.[126] Consider how these manuscripts describe the first anointing:[127]

- "Oil is the invincible armor against the adversary."
- "Being signed . . . is the imprint of the heavenly king which is put on the spiritual soldier."
- "Being imprinted on the forehead: (since this is) the part on the body that is important, for he becomes fearsome to the demons."

When we combine these ritual descriptions with the tenuous military position of Roman Dura-Europos and the biblically based reception of David among Christians, the painting of David and Goliath in the baptistery no longer appears "surprising" or "unexpected," as in the assessments of previous scholars. For anointed soldiers, David's archetypal battle scene was entirely appropriate—even expected.

Lord and Shepherd of the Water

"A God on a Cloud": The Presence of Jesus in the Baptistery

The shepherd David became the anointed lord over Israel. Then in Christian tradition, the anointed son of David, Jesus, became the lordly shepherd. As we process with Isseos from the place of anointing around the room to the font, we encounter fragments of that progression.

Looking to the upper panel of the baptistery's artistic program, we imagine what might have been, had the city's rampart been built a little taller or better, thereby preserving more of these paintings. The top of the eastern and northern walls probably depicted a series of Jesus' mighty deeds, distinctive examples of how he used the power God granted to him. Only two of these scenes remain, at the western edge of the northern wall: Jesus and Peter walk on the water, with a boat of disciples looking on in disbelief; then Jesus heals a paralytic man, who walks away under his own power. Recall from the introduction that the second of these was recorded in Clark Hopkins's diary on the first day of excavation as "a god on a cloud." And indeed, divine power was on display here (though Jesus stands on the ground and not a cloud). Moreover, both miracles of empowerment occur at a body of water, and it is possible that Jesus' other mighty works related to water—stilling the storm, changing water to wine—filled out the upper panel lost to the centuries. For Isseos and other initiates, these images likely indicated the kind of power over nature and fate that they hoped would be enacted through these rituals.

The twin rituals of anointing and baptism marked the neophytes with the name of Christ. The Syrian emphasis on the "seal" (Greek *sphragis*)

or "mark" (Syriac *rushma*), explained in the previous chapter, thus prepared them for the focal point of the room's procession, which depicts a shepherd and sheep at the edge of a river or lake. This painting conjures textual memories of David as shepherd, Christ as the Good Shepherd, the parables of the lost sheep, and the foundational Psalm 23, which would become a central text of the ancient catechumenate in both East and West. Here in the context of Christian initiation, the psalmist's "lord and shepherd" becomes reinterpreted as Christ. It is baptism that "leads beside still waters" and "restores the soul." The neophyte's head is "anointed with oil"; the eucharistic "table is prepared." As the neophytes experienced the room, then, the blend of image and ritual would have called to mind many texts. How might they have looked up to the Lord and Shepherd of the water?

This chapter takes each of these three paintings in turn: the Walking on the Water, the Healing of the Paralytic, and the Shepherd and Sheep. Of the extant art from the house-church, these are the three works that depict Jesus either explicitly (as in the first two) or implicitly (as in the polyvalent image of the shepherd). They are rightly regarded as some of the earliest depictions of Jesus Christ, and they are probably the earliest securely dateable ones. Another reason I group them together is that, of all the images in the baptistery, these have been the easiest for scholars to interpret. In the mighty deeds panel, for example, the relationships of these two paintings to biblical narratives "hold still" in order for us to examine them. We don't have to argue about to whom these scenes refer, as scholars have done about the female figures in the baptistery. What is more, the scenes' occurrences at watery sites invite interpretation through a ritual-centered visuality. This chapter thus synthesizes previous scholars' findings about these three scenes and incorporates some new comparative material.

Following Jesus on the Water

The right side of what remains of the upper panel shows part of the earliest extant depiction of the Walking on the Water (plate 4 and fig. 3.1).[1] Two figures walk in the foreground, while the disciples look on from a large boat.

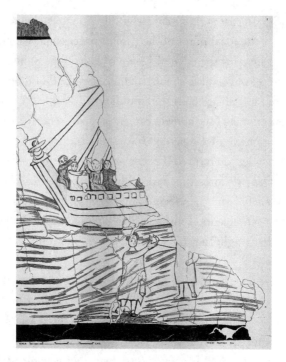

Fig. 3.1. Tracing of Walking on the water painting.
North wall, Christian building. (Yale University Art
Gallery, Dura-Europos Collection)

The four disciples that are preserved gawk wide-eyed at the marvel, rais-
ing their arms in amazement or prayer. In the versions of the biblical story
narrated by Mark and John, only Jesus walks on the water, a sign of his
unique power over nature.[2] He alone reigns over watery chaos, which
was a common mythological adversary in the ancient Near East.[3] But in
Matthew's version of this episode, Jesus' disciple Peter leaves the boat to
walk toward Jesus.[4] When Peter becomes frightened, he begins to sink and
cries out, "Lord, save me!" And Jesus saves him, of course. This episode
thus furnished the early church with a powerful image of Christian salva-
tion and discipleship.[5] Peter is the model of a bold yet floundering follower;
his frailty and fear necessitate his need for Christ and subsequent faith in
Christ's power to save. New Testament scholars use this as the example of

redaction criticism par excellence, a case in which Matthew's Gospel expands Mark's account of a nature miracle in order to showcase a tale of faith, discipleship, and salvation.

Before the Gospel of Matthew was written, Paul had already expressed a type of drowning baptism—of a disciple's sinking and rising up from the water—as a ritualized participation in Christ's death and resurrection: "we have been buried with him by baptism into death, so that, just as Christ was raised from the dead by the glory of the Father, so we too might walk in newness of life" (Rom 6:4). There is a key difference, however, between Paul's version of this metaphor and Matthew's: for Paul, the believer *descends with Christ* into a watery grave; whereas for the Gospel writers, Christ is the one who *does not* sink—and that is precisely the point. Paul's portrayal of baptism as death and resurrection with Christ has been influential throughout Christian history. In this baptistery, however, the only signified death is that of Goliath.

This disconnection should cause us to look again at the wall painting. Most modern viewers initially identify the figure on the left as Peter, drowning in his lack of faith and reaching up to Jesus for salvation. When I first saw it, I was reminded of a painting from my grandparents' church in rural Illinois that showed a partially immersed Peter being raised up from the waves by the firm-footed Jesus. This image of failed and redeemed discipleship preached a weekly sermon all by itself. But Carl Kraeling has persuasively argued, on the basis of a detailed study of the two figures, that the figure on the *left* is Jesus. According to Kraeling, "There can be not the slightest doubt under the circumstances that the artist meant the lower of the two figures" to represent Christ, and Peter is walking toward him from the bow of the boat on the right.[6] As in other early depictions of this scene, Peter stands between Jesus on one side and the boat on the other.[7] Dieter Korol reviews Kraeling's evidence in detail, adding more comparanda to the analysis. He concludes that there are a few reasons to doubt the identification, but those do not overwhelm the highly probable interpretation of the left figure as Christ.[8]

The wall painting thus does not depict "the 'sinking Peter' familiar from the religious art of the nineteenth century," upon which I gazed as a

child.[9] The figure on the left is painted lower on the picture plane so that he will appear to be in the foreground, not so that he will appear to be sinking in the water. Kraeling mused on this fact: "If the artist passed up the opportunity to show Peter almost drowning and with it the most graphic way of illustrating the importance of a strong faith, he must have meant his composition to make some other point. Was it to show how Christ's own powers over the elements are communicated by him to his disciples so that they too can successfully perform his wonders?"[10] As happened so often, Kraeling's intuition (and tentative suggestion) was right. The upshot of this is that we are looking at the scene *before* Peter's panic, fear, and drowning.[11] He is not yet frail or floundering. Peter imitates Christ's power, not his death.

Early Syrian interpretation of the story corroborates this construal of the art in its ritual context. Ephrem's commentary on the *Diatessaron,* which confirms that what we think of as Matthew's version of the story was part of the *Diatessaron* in Syria, emphasizes Peter's faith in the power granted by Christ: "When he went down to walk [upon the water] and he began to sink, [the Lord] did not reject him. He did not say to him, 'Without faith,' but 'Little faith.' Because the sea carried our Lord, the sea was revealing concerning the path that he was treading out for his apostles in the world. That [word] was fulfilled there: 'You will have dominion over the splendor of the sea and you will calm its waves' (Ps 89:10)."[12] Thus the power granted to Jesus through his anointing as Christ was passed on to those anointed as Christian disciples. Elsewhere Ephrem compares this power over water to oil's natural ability to avoid sinking in water: "Just like the Anointed, oil is empowered to run upon the waves. It also gave power to flame to walk on water, as his Lord gave Simon [power] to walk on the waves. Like the Anointed, oil rescues the sinking flame that flickers in the womb of water, like Simon in the sea of water. By a flame oil enlightens the house; by Simon the Anointed enlightened the inhabited earth."[13] Here at Dura-Europos, empowered by faith, the anointed and illuminated disciple is victorious over water and the chaos of nature.

The biblical episode occurs on a large lake, the "sea" of Galilee, around which most of Jesus' ministry took place. But in East Syria, lakes are scarce. As the previous chapter argued, people along the Euphrates were formed more by a riparian imagination. The bottom of this upper panel, with flowing lines of wavy water, in fact suggests a river more than a lake. It seems that a kind of river flowed figurally around the room, perhaps beginning from the opposite side's upper panel, which has traces of a "garden scene."[14] While one cannot say anything for certain about the absent upper panel of the southern wall, the best conjecture is that a scene of paradise (Eden) generated a river or rivers that flowed around the room underneath the series of mighty deeds. Other baptisteries and textual sources about baptism showed the theme of new creation, a restoration of paradise, and the rivers of paradise.[15]

The notion of walking on the water as a kind of river crossing was even propagated by one of our earliest Syrian sources of liturgical material, the *Odes of Solomon*. The *Odes* constitute a unified collection of psalm-like texts pseudonymously attributed to the biblical Solomon (as with the *Psalms of Solomon* in the Septuagint, with which the *Odes* were often linked in antiquity). They were composed in either Greek or Syriac and date to the second or third century CE. Most scholars, such as Michael Lattke—the world's leading expert on the *Odes*—locate their origin in Syria in the second century.[16] The texts are Christian in character, though they interlace motifs and themes that scholars would later separate out as indicative of Jewish or Gnostic influences. In fact, for texts produced and used during the precanonical and preconciliar era of Christianity (first to mid-fourth centuries), we should not be surprised to find a rich mixing of imagery and ideas that would later be unraveled by the shapers of orthodoxy and heresy.[17] As Lattke has shown, the *Odes* are bursting with mythic narrative and soteriological images—not unlike the canonical Psalms themselves—and they are thus a tantalizing source to include in the analysis of Dura at the nexus of Bible, art, and ritual.[18] It remains nonetheless challenging to know how frequently and in what ways to rely on them as evidence of Syrian Christianity during the second and third centuries.

The ode in question here is Ode 39, which implies knowledge of the walking on the water narrative but recasts it as a river crossing:

> Raging rivers, the power of the Lord,
> that turn head downward those who despise him
> and entangle their steps and destroy their fords
> and seize their bodies and ruin their souls,
> for they are more sudden than lightnings and faster.
> But those who cross them in faith will not be disturbed,
> and those who walk in them without blemish will not be perturbed.
> For the Lord is a sign on/in them [the rivers],
> and the sign is the way of those who cross in the name of the Lord.[19]
> Put on, therefore, the name of the Most High and know him;
> then you shall cross without danger
> while the rivers will be obedient to you.
> The Lord bridged them by his Word,
> and he [the Word] went and crossed them on foot.
> And his footprints remained on the waters and were not destroyed,
> but they were like wood that is truly fixed.
> And on this side and on that the waves rose up,
> but the footprints of our anointed Lord [Lord Messiah] stand firm
> and are not blotted out nor destroyed.
> And a way has been established for those who cross after him,
> and for those who follow the walk of his faith and revere his name.
> Hallelujah.[20]

Preserved in two Syriac manuscripts, this ode has often been interpreted as a kind of Christian reflection on the Israelites' crossing of the Red Sea—certainly a midrash relevant for baptism and employed from the beginnings of Christian tradition (1 Cor 10:1–5). But Lattke makes adamantly clear that "rivers" are the main metaphor here, even if crossing a body of water always contains "indirect reminders" of the exodus narrative.[21] In this Christian adaptation of an ancient motif, wherein gods and holy men enacted power over the water, the Christ's bridging and crossing of raging

rivers demonstrates not only his own might. The crucial feature of this ode is how the power is transferred to the followers behind this "pioneer of faith" (Heb 12:2), who both led "the way" and enabled "the way" for others. No finer example of exemplarist Christology—Christ as a model to be imitated—could be found than this: "his footprints remained on the waters and were not destroyed . . . / And a way has been established for those who cross after him, / and for those who follow the walk of his faith."

Lattke only tentatively embraces a proposed allusion to Jesus' walking on the water. But considering the Syrian emphasis on the empowerment of Peter in the reception of the narrative—as seen through the Dura painting and Ephrem's exegesis of the passage—I contend that the allusion is stronger than previously indicated. The ode emphasizes in the end "the walk of his faith," that is, the faith that Jesus himself had in the power of God, which laid the firm path for others "to cross in faith" after him.[22] In the Syrian interpretation of the Matthew/*Diatessaron* version of the episode, it was precisely Peter's faith that was signaled by his stepping on to the water. Here at Dura-Europos, with the formidable Euphrates dominating the landscape, the blessing of God to bridge mighty rivers would have been no mean power in which to hope.

The Power of Healing

The action of the upper panel continues from right to left, following the processional visuality of the room and the directionality of Semitic languages. The water flows out from the place on which Peter and Jesus walked, down the imagined (but unpainted) Jordan River valley, and comes to rest in a Judean pool called Bethesda.[23] It was here, in Jerusalem near "the Sheep (Gate)" or "the Sheep (Pool)" according to the Gospel of John, that Christ healed a man who had been ill for thirty-eight years (plate 5 and fig. 3.2).[24] His specific ailment is not stated, but he is classed among the "blind, lame, and crippled" (John 5:4). The story narrates the man's years of suffering and desire to be healed by the water. He laments, "I have no one to put me into the pool when the water is stirred up" (5:7), and some manuscripts clarify the belief that an angel periodically "stirred" the water

Fig. 3.2. Tracing of Healing of the paralytic painting. North wall, Christian building. (Yale University Art Gallery, Dura-Europos Collection)

and infused it with healing powers. The man ultimately is healed not by the water, but by Jesus, who tells him to lift up his pallet and walk away. The healing is thus read on the wall painting from right to left, along with the rest of the artistic program. The man is shown first ill on his pallet, receiving healing from Jesus standing behind (above, on the wall) the pallet, and then second hoisting his pallet on his back. Showing the "before" and "after" scenes of the narrative distinguish this example from the most common portrayals of this miracle, which often show the paralytic alone in a single scene.[25] In the Gospel of John, Jesus' closing command to the man is to "sin no more" (5:14), and he leaves, spreading the good news that Jesus made him well.

The healing of a paralytic is also recorded in the Synoptic Gospels, but John's version is the only one narrated with a connection to water.[26] Although the presence of the *Diatessaron* in Syria and the precanonical

date of the painting should eliminate any concern for picking the "right" version to connect with it, several ancient authors—Tertullian, Chrysostom, Ephrem—do privilege what we know as the Johannine version.[27] For some early Christian authors, the resonance with baptism primarily lies not in the mention of the pool, but rather in the closing command to refrain from sin. The presence of water in this story was actually a stumbling block to faith. Ephrem and Cyril of Jerusalem contrast faith in the healing power of the pool with faith in the power of Jesus;[28] therefore, while the composition at Dura-Europos likely was chosen for its image of water, as was that of the painting to its right, the power of water is overridden in both cases by the power of Jesus. Cyril's sermon on the paralytic expresses the point well: "Why fix your hope on a pool? You have him who walks upon the waters, who rebukes the winds, who holds sovereign sway over the ocean; who not only himself walked on the sea as on a firm pavement but vouchsafed the like power to Peter . . . There stood by the waters of the pool the ruler and maker of the waters."[29] The paralytic and Peter serve as models for the baptized: despite the power of the water, they should have faith in the power of Jesus, Lord of the water.

Jesus' power as a healer was, of course, among his most famous attributes. He even refers to himself twice as a "doctor" (Luke 4:23; Mark 2:17 and parallels). Yet despite more than twenty healing stories proclaimed in the canonical Gospels—not counting exorcisms—seasoned Bible readers can sometimes overlook this obvious fact: people sought Jesus primarily as a healer, secondarily as a teacher. Even his opponents did not question his powers of healing; they challenged from whence he derived them, but not the powers themselves. Lee Jefferson has further argued that Christians in late antiquity were not reticent about the reception of these healing narratives: both Christians and non-Christians "were united in differentiating divine healing from *superstitio*," a label that usually connoted religious deviance or suspiciousness of some sort.[30] The success of Jesus' healing ministry was a point of pride, and the patristic sources show "a keen interest in purveying a sense of Jesus not only as a healer but as the preeminent healer, hinting at a competition with [other] healing cults, specifically the cult of Asclepius."[31] Besides the frequent portrayals of Christ's healing in

late ancient art, an abundance of papyri also implored his aid. One of the Oxyrhynchus papyri, for example, was folded and tied as an amulet to be worn by an ill woman named Joannia. Its opening lines read: "Flee hateful spirit! Christ pursues you; the Son of God and the Holy Spirit have overtaken you. O God of the Sheep-Pool, deliver from all evil your handmaid Joannia."[32] At Dura-Europos, Jesus was this "God of the Sheep-Pool," a clear invocation of the healing at Bethesda.

In his *Christ the Miracle Worker in Early Christian Art*, Jefferson also notes the relative frequency of the healing of the paralytic in the art of sarcophagi and the catacombs: following Josef Wilpert's tabulation, he finds fifteen instances in the catacombs, compared with seven for healings of blind men and fewer for lepers and the woman with the flow of blood.[33] Although it is "not the most duplicated of all the scenes depicting Christ as a healer, it does portray a successful healing; the paralytic is walking proof of Christ's powers."[34] Other miracles can be presented more dramatically, according to Jefferson's analysis, but "the healing of the paralytic more deeply captures the end result of the healing."[35] I hasten to add, though, that Dura's version is on the more dramatic end of the spectrum, since it shows a two-stage process and includes Jesus' outstretched arm in the act of healing, while many examples from the sarcophagi and catacombs show only the healed man walking alone, carrying the mat to show the successful healing.

The region of Christianity in antiquity that most emphasized Christ as "Healer" and "Physician" was Syria. According to Susan Ashbrook Harvey, "imagery of healing and bodily health or wholeness is one of the most pervasive and enduring themes of Syrian Christianity, appearing throughout its regions and across its various doctrinal forms."[36] As early as Ignatius of Antioch, Christ is called the "one physician, both fleshly and spiritual, born and unborn."[37] Later the title "Physician" was, according to Robert Murray, "Ephrem's favorite title of all for Christ," being "a constant refrain" in his commentary on the *Diatessaron*.[38] Because the role and goal of a typical physician is to conquer death, Ephrem amplifies Christ's ultimate conquering of death by this attribution. Before that, the *Acts of Thomas* invoked Jesus as "Physician" or "Healer" about ten times,

and in truth the theme imbues almost all of the narrative.[39] Harvey notes that the many conversion episodes are "often a response to healing from severe illness or demon possession," and Thomas's ministry is especially to the suffering. "More than a narrative motif in which 'physical' signifies 'spiritual' healing, as if metaphorically, these works indicate that for emergent Syrian Christianity the human body was an essential component of the human person as a religious entity. 'Healing of soul' was not opposed to 'healing of body'; rather, these were understood to be mutually inclusive actions. . . . The redeemed body promised and imaged by the resurrected Christ was a body healed of its mortality—healed of any illness or suffering, and healed, too, of the necessity of procreation."[40] For the Thomas tradition, bodily integrity and wholeness were inextricable from promotion of ascetic lifestyles and voluntary celibacy. The cycle of illness-decay-death from which Jesus' power offered respite could be juxtaposed in antiquity with the cycle of sex-birth-death. Asceticism and celibacy offered one form of protection against that cycle and a form of spiritual liberation for female converts to Christianity, who besides Thomas were the main characters of this popular text.

In Syrian tradition Christ's title and function of healer is shared with his apostles and, later, the bishops. Christian leaders, as earlier in the canonical book of Acts, were portrayed as empowered by initiation and the laying on of hands to imitate Jesus. As Peter walked on the water made firm by Jesus' faith, so would the successors of the apostles imitate his healing power. Aphrahat emphasizes this theme in two ways: first, it is probable that anointing of the sick with "light-giving olive [oil]" was practiced by Christian leaders, as was also done in non-Christian settings (see chapter 2);[41] second, Aphrahat continues the biblical connection between healing the body and absolving sin, as with the healing of the paralytic. Bishops as early as the *Didascalia* practiced what Aphrahat called the "medicine of penance."[42] The proper response to reception of healing, both physical and spiritual, was to go forth and "sin no more."

Finally, texts and commentaries from Syria specifically about ritual sometimes allude to the narrative of the healing of the paralytic as a means of understanding baptism. Ode 6 of the *Odes of Solomon* imagines the water

of life as a raging river that "spread over the face of all the earth and in-
undated everything, and all the thirsty upon the earth drank. . . . Blessed,
therefore, are the ministers of that drink, those who have been entrusted
with his water. *They have revived the parched lips and raised up the will
that was paralyzed, and the souls that were near to expiring they held back
from death, and limbs that had fallen, they straightened and set upright.*
They gave strength to their coming and light to their eyes."[43] In this par-
able, which extends Jesus' "water of life" that "gushes forth" into a longer
metaphor of salvation, the healing of body and soul are united. Parched lips
are nourished and fallen limbs are strengthened, just as wills are freed from
paralysis and souls saved from death.

What Ode 6 leaves as merely allusive, later Syriac ritual texts make
explicit. Sebastian Brock's study of the various baptismal *epicleses* (invo-
cation prayers) in Syriac liturgy finds two fifth-century authors who refer
directly to the healing at Bethesda. A short liturgical order attributed to
Philoxenos of Mabbug prescribes this prayer: "Shine forth, O Lord, on this
water, and may thy Holy Spirit stir it in the power of its might, and do thou
be mingled, and let the all-worshipful Trinity, too, be mingled in it."[44] The
prayer for "stirring" in the water unmistakably refers to the biblical epi-
sode.[45] The writings of Jacob of Serugh corroborate this interpretation and
resound the themes of healing and new birth: "The Son of God descended
and stirred the baptismal water, so that it might give healing birth to all
kinds of beautiful creatures every day: a new creation has begun, having
come from our Lord." And later in the same homily, "That mighty one, who
was born of [the Father] in a divine way, will stir the fountain, so that the
whole world may be healed in it."[46]

The prominent themes of the two paintings preserved from the
mighty works cycle, therefore, were empowerment and healing—in both
body and soul. On the contrary, there is "meager support" for the notion
that "the purpose of the scene of the Healing of the Paralytic and the Walk-
ing on the Water was to point to forgiveness and faith as factors in the
proper understanding of baptism in eastern Christian baptismal lit-
erature."[47] Rather, they indicate the healing and saving power of Christ,
and, not to be forgotten, Christ's transfer of such powers to Christians. To

conclude, we return to the *Acts of Thomas*, which showcases Christ the Physician throughout. Yet here, in the tale's final conversion episode, Thomas also juxtaposes the healing Physician with the protective Shepherd during the rite of initiation:[48]

> Friend and ally, hope of the sick . . .
> Physician who accepts no pay . . .
> You prepared for them a way, and all those you liberated
> followed in your footsteps. Bringing them into your own
> flock, you mingled them with your sheep. . . .
> Gather them into your fold and include them in your number.
> Be their guide in a place of error,
> Be their physician in a place of illness . . .
> Be the physician of their bodies and souls.[49]

When Isseos turned from the Healing of the Paralytic toward the canopied font, on the wall behind it, he would have seen the shepherd, offering rest and water to weary sheep.

Joining the Flock

"The west wall of the Dura Baptistery, which the font set before it brought into particular prominence and made the natural focus of attention, the artist chose to embellish with the most familiar of all themes of early Christian art": a shepherd and his sheep.[50] This claim made by Kraeling ("the most familiar of all themes") remains difficult to challenge. Recently, Robin Jensen has emphasized the prevalence of the shepherd and sheep imagery in extant Christian art and artifacts: "The Shepherd's standard appearance—youthful and beardless, wearing a short tunic and boots, and carrying a sheep (lamb, ewe, or ram) over his shoulders—exists in almost every kind of medium from the most precious to the commonplace: frescoes, sculpture, glass, mosaic, gems, and pottery lamps and bowls. The figure appears more than 120 times in catacomb paintings alone, often in the center of the dome of a small private family burial chamber."[51] In

baptisteries later than Dura's, too, shepherds and flocks are widespread. We should note, though, that shepherds were very popular in non-Christian art as well. Classical Greek imagery featured the *criophorus,* based on Hermes the sheep-bearer, which is often indistinguishable in form from representations of Christ as a shepherd.[52] Likely the ambiguity of the image served well the needs of early Christian visual culture during the early centuries, just as other popular images (the dove, the anchor, the fish) could bear great meaning for in-group viewers and weaker or different meanings for out-group viewers.

The shepherd at Dura (plate 6 and fig. 3.3) carries a ram on his shoulders, and his flock walks before him to the right. The faded paint makes it difficult to discern whether all the sheep are rams and how many are there. In any case, there seems to have been no symbolic difference between rams, ewes, and lambs in the visual culture of early Christianity, and some of the biblical textual traditions are similarly unstable about which words from the sheep family are used at which times.[53] The number of sheep (fourteen to sixteen) also does not likely have symbolic significance, despite some textual traditions' assigning of meaning to numbers in general and flocks in particular.[54] The sheep leading the flock bend their heads down to graze, drink water, or both. While I agree with Kraeling that some grass is visible for grazing, I maintain the belief that the sheep at the right edge of the painting are shown drinking water. If so, an art-ritual transitive exchange occurs between the depicted water of the painting and the physical water of the font. The "refreshment" or "restoration" of the "soul," which Psalm 23 portrays as the result of the shepherd's care, offered a biblical backdrop for the ritualized encounter with the art. (Finally, in the lower left, below the feet of the shepherd, a painting of Adam and Eve appears as an inset. It is likely that this vignette was added secondarily to the painting, and it will be discussed in the book's conclusion.)[55]

One feature that does distinguish this instance of shepherd and sheep imagery from others in late antiquity is the relatively large number of sheep in the flock. Most other examples feature just the *criophorus* or a small number of sheep (e.g., two or four). The large number here thus draws attention somewhat away from the shepherd and toward the flock, which

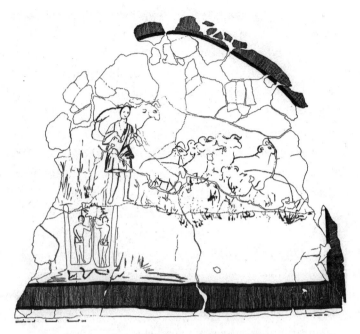

Fig. 3.3. Tracing of Shepherd and sheep painting. West wall, Christian building. (Yale University Art Gallery, Dura-Europos Collection)

occupies more than half of the horizontal field. In its ritual context, the focus on the flock emphasizes not only the individual marking and salvation of an initiate, but also the incorporation into a community of newly sealed sheep. Jensen has identified many other popular motifs of incorporation in early Christian art and ritual, such as enlisting in the military, being adopted into a large family, competing with an athletic team, and joining a school or catch of fish. "These analogies and metaphors allude not only to [the initiates'] incorporation into a new religious organization but also to the marks, responsibilities, and benefits of that membership."[56]

In what follows we explore the possible meanings of this painting within, first, the trajectory of biblical reception and, second, its ritual context. To what biblical passage did this shepherd and sheep allude? Kraeling was certain: "the Biblical basis is, of course, the equally familiar passage John 10.11–16, 'I am the good shepherd,' etc."[57] But what would warrant

such certainty? No other aspects of John's passage are present: there is no "gate" protecting a "sheepfold"; the shepherd is not "leading" the sheep; neither "thief" nor "wolf" threatens the flock; and the shepherd does not "lay down his life" for the sheep (John 10:1–18). The figurative language of John 10 was undoubtedly widespread, but so were many other pastoral motifs in the Bible.

The closest biblical analogy to the *criophorus*, for example, would be the parables of lost sheep (Matt 18:12–14; Luke 15:3–7). Luke's version is vivid: "Which one of you, having a hundred sheep and losing one of them, does not leave the ninety-nine in the wilderness and go after the one that is lost until he finds it? When he has found it, *he lays it on his shoulders* and rejoices" (Luke 15:4–5; italics added). Through contextualization, Luke shows that for him the parable of Jesus primarily symbolized God's concern for saving those who are lost. Matthew's version, while very similar, is situated in a different narrative context. It emphasizes preventing sheep from getting lost in the first place and thus encourages the nascent Christian community to protect those vulnerable to going astray.

In the Hebrew Bible, many of the major figures have tales of shepherding or use metaphors about it. Moses was tending the flock of his father-in-law Jethro when he encountered the burning bush (Exod 3:1). As discussed in chapter 2, David was a famous shepherd-warrior; another of his most famous moments—the prophet Nathan's judgment of his sins— occurred through a parable about flocks of sheep (2 Sam 12:1–15). The prophet Ezekiel spins out a long exhortation against the leadership of Israel through metaphors of shepherds failing their sheep (Ezek 34:1–31), which Clement of Alexandria picks up on and applies to Christ as the Good Shepherd.[58] The list of eligible biblical passages could go on and on. Yet one other remains to be considered for its connection to pastoral imagery in Christian ritual contexts: the foundational Psalm 23.

The magisterial scholar of patristics Johannes Quasten has offered persuasive arguments that Psalm 23 (which begins, "The Lord is my shepherd") had "a prominent place" in early Christian liturgy in both East and West, at least by the fourth century and possibly the third.[59] Many lines of this most popular psalm resonate with the ritual activity and symbolic

meanings of Christian initiation. The root metaphor of a sheep "sealed/marked" by a shepherd will be discussed more below, but almost every line of Psalm 23 (LXX 22) can be related to initiation. The "still waters" are literally "waters of refreshment" or "rest," and the same term for "refreshment/rest" was a common one for Christian salvation (v. 2).[60] The "restoring" of the soul was literally a "conversion" or "turning" of the soul, with the verb having been frequently used in the New Testament and early Christian literature for spiritual conversion (v. 3). To be "led on a path" or "way" was how archetypal salvation narratives were depicted, and Christians considered themselves taking the "name" of Christ at initiation (v. 3).[61] In times of uncertainty, the New Testament promises that the Holy Spirit will "comfort" or "encourage" believers, the same verb used for the "rod and staff" of the shepherd (v. 4). Even when the psalm's master metaphor shifts from shepherd and sheep to host and guest, it remains connected to the rituals of initiation. The "table" is "prepared" for a meal, and the head is "anointed with oil," as at baptism (v. 5).

Most aspects of this interpretation were indicated already by Origen in the third century.[62] Athanasius followed suit, connecting each line explicitly to ritual steps of initiation in his own commentary on the psalm.[63] Quasten shows how interpretation is nearly uniform across regions and centuries on these points, noting Eusebius of Caesarea, Cyril of Jerusalem, Ambrose of Milan, Augustine of Hippo, Hesychius of Jerusalem, Theodoret of Cyrus, Cyril of Alexandria, Cassiodorus (of Vivarium), Severus of Antioch, and more.[64] Inscriptions at baptisteries refer directly to the psalm too. The fifth-century Orthodox baptistery at Ravenna includes v. 2 of the Latin translation above a lost mosaic, and all of the inscriptions there were somehow related to parts of the initiation ritual.[65] The fourth-century baptistery at St. Peter's Basilica contained an inscription (recorded in pilgrimage diaries) that elaborated on the psalm: "Here in this place, innocent lambs, having been washed in the celestial stream, are signed by the right hand of the chief shepherd. Come here, you have been reborn in the waters, because the Holy Spirit calls you into unity, so that you may receive his gifts."[66] In sum, the motif of joining a flock led by Christ as shepherd was ubiquitous in early Christianity. It carried forward multiple

biblical texts, from Moses to David to Ezekiel to Christ, and it enabled Christian art and ritual to draw from existing types and also innovate liturgies of initiation. Still today the motif remains so central to Christianity that it can be easily overlooked: the Latin term for "shepherd," after all, is now the common word "pastor."

The Seal of the Shepherd

Having been popular in the Bible and early Christian visual culture, the image of a shepherd and his flock was also widespread in ritual. In chapter 2 I mentioned that the "seal" (*sphragis*) or "mark" (*rushma*) of initiation was based in part on the practice of sealing or branding property. In Quasten's words, "proprietors branded their animals with such a mark in order to make deceit and theft more difficult. . . . Attaching this sign of ownership to an animal was usually done in the form of a stamp with a branding iron. . . . This brand usually consisted in an abbreviated signature which was meant to represent in a kind of monogram, the name of the owner."[67] Still today, the seal of anointing is made in many churches. Though made now in the sign of the cross, it is more likely that ancient churches would have used the *chi-rho* (or "Christogram"), which was far more prevalent than the cross as a symbol of Christ during the first four centuries. It evoked the "name" of Christ, with which Christians were marked. (As a different indication of "marking," it is possible that some Christian communities added a kind of dye to the waters of baptism, although this practice is not well-attested.)[68] In any case, after initiation, neophytes were frequently compared to sheep entering a flock. In the western churches, Tertullian, Ambrose, Augustine, Prudentius, and others make explicit references in artistic or ritual contexts.[69]

In Syria and Palestine, the theme was even more emphasized. Consider the paradigmatic initiation rites narrated in the *Acts of Thomas* for King Gundaphorus. Thomas's opening prayer implores: "Now, at my earnest request, accept the king and his brother and *include them in your flock,* having cleansed them with your bath and anointed them with your oil from the error which encompasses them. *Guard them also from the wolves,*

supporting them in your meadows. Give them *drink from your ambrosial fountain,* which is never muddied and never gives out."[70] Later in the prayer, Thomas calls the Lord "truly our good shepherd," before King Gundaphorus replies, "Since our souls are ready and eager for God, give us the seal; for we have heard you say that *the God you herald recognizes his own sheep through the seal.*"[71] After this the oil is brought and the lamps are lit, "so that they might receive the seal." Most narratives of initiation later in the text are less explicit in their details, but the connection of the seal with the sheep remains: the figure Siphor asks "to receive the seal" from Thomas, so that he and his companions "may become worshipers of the one true God and might be numbered among his lambs and sheep."[72]

Cyril of Jerusalem also emphasizes the proprietary function of the seal in his catecheses, exhorting candidates in the first lecture: "Come forward for the mystical seal, that you may be recognizable by the Lord. Be numbered in the holy, spiritual flock of Christ, that you may be set apart on his right hand and inherit the life prepared for you."[73] Cyril here calls to mind a biblical text not yet brought into our discussion: Jesus' parable of the sheep and the goats, in which the final judgment of humanity is dramatized as a shepherd separating two species of animals to the right and left of the Son of Man (Matt 25:31–33). He later concludes the first catechesis with a quotation of Psalm 23, signifying that incorporation into the community as sheep under a shepherd will lead ultimately to the "spiritual table" of the Lord.[74] Many other texts from this period could be cited to show that these motifs were prominent in eastern liturgy, but the Syrian rites of Severus of Antioch will have to suffice. The baptismal formula prescribed that a person was "baptized that he may be a lamb in the flock of Christ, in the name of the Father and of the Son and of the living Holy Spirit unto eternal life."[75] The sheep or flock was referenced at least four more times in the ritual text: "The humble lambs who have come unto baptism," says the priest at anointing, "shall be anointed with oil." Thus from the *Acts of Thomas* down to the fifth century and beyond, the regional Syrian rites of initiation emphasized the shepherd, sheep, and flock at the seal of anointing and baptism. In the words of Ephrem's responsorial hymn on the anointing oil of initiation: "Christ with chrism, lo! He is sealing the newborn lambs in his flock!"[76]

For Ephrem too, the metaphor of shepherd and flock connoted the protection of boundaries, whether between Christians and those he considered heretics or—within the fold—between Christians and celibate Christians. Outside his fold, Ephrem rejected those "flocks" that had been "signed and named" according to Bardaisan or Mani, for example, which had been "signed with this ugly sign of thieves" like "stolen sheep" from the flock of Christ.[77] Inside the fold, Ephrem encouraged shepherd-bishops to care for the boundaries between celibate Christians—the "singles" and "children of the covenant"—and everyone else. The precise characteristics of these "singles" and "children of the covenant" in Syrian Christianity are not easy to discern, but Sidney Griffith summarizes well our best guess:

> From the evidence we have in hand it seems that, at the dawn of the fourth century at least, both the men and the women celibates were free to choose their own living arrangements within their local communities. One does not yet hear of withdrawn individuals or communities of singles in desert or mountain areas in the Syriac-speaking world. But St. Ephraem does offer evidence of some formal ecclesiastical organization about the [singles] of his day. He says that Bishop Abraham of Nisibis, for example, . . . governed his diocese as the chief [shepherd] of the [flock], with the help of what St. Ephraem called a [fold of herdsmen], of which group he was himself a member, on his own testimony.[78]

More will be said about these "singles" in this book's conclusion. For now, I merely note that they were set apart as a flock within the flock. Ephrem encouraged shepherd-bishops and clergy-herdsmen to care for their protection, in order better to preserve their chastity and witness of ascetic holiness.

The shepherd-as-defender motif calls to mind the connection to soldiering discussed in chapter 2. The memorialization of David as shepherd, warrior, and psalmist colors the Christian transmission of this imagery. The shepherd-warrior David implores God as shepherd-warrior on behalf of

"the anointed": "O save your people, and bless your heritage; / be their shepherd, and carry them forever" (Ps 28:9). Syrian authors continue the connection. Ephrem's hymns on the nativity address the infant Jesus in the presence of shepherds with reference to David's role as shepherd and defender. "You, then, the shepherds will acknowledge, for You reconciled wolves and lambs in the flock. . . . For the sake of a lamb, David, Your father, killed a lion. O Son of David, You have killed the hidden wolf that killed Adam, the innocent lamb who grazed and bleated in paradise."[79] The seal of the shepherd and the tattoo of the soldier were even juxtaposed as the two analogies for the baptismal sign by Theodore of Mopsuestia (see also chapter 2). In his baptismal catecheses, he wrote:

> The sign with which you are signed means that you have been stamped as a lamb of Christ and as a soldier of the heavenly King. Indeed, immediately when we possess a lamb we stamp it with a stamp which shows to which master it belongs, so that it may graze the same grass as that which the rest of the lambs of the owner graze, and be in the same fold as that in which they are. A soldier who has enlisted for military service, and been found worthy of this service of the State because of his stature and the structure of his body, is first stamped on his hand with a stamp which shows to which king he will henceforth offer his service.[80]

Thus the two main images of ritualized Christian incorporation offered to Theodore's Syrian catechumens—a sheep and a soldier—were both pictured in biblical guise on the walls of Dura's baptistery.

Shepherd-Warrior . . . and Shepherd-Bridegroom?

The paintings considered in this chapter each depict Jesus either explicitly or implicitly. The upper panel's images are "ideographic" and "optic," in the interpretation of Annabel Jane Wharton, so that they function primarily as representational art—visual signs for biblical narratives—and are

meant to be viewed more than embodied. By contrast, Wharton presents the lower panel—the procession to the font and the shepherd and flock—as "haptic," and its meaning is "embedded in the physicality of the action of which it was a part."[81] While Wharton's distinctions have been formative for my own thinking, the arguments of this chapter have shown that even the upper panel's narrative imagery found expression in the ritual texts of Syrian Christianity. At the nexus of Bible, art, and ritual, each of these three paintings evokes multiple significations for anointing, baptism, and the overall seal of initiation.

The previous section showed how rituals drew on biblical memory and social reality to unite imagery of shepherding and soldiering under the concepts of commitment to and incorporation in a community. As if that were not unusual enough for modern ears, other evidence can be brought to show the juxtaposition of shepherding also with marriage—and of the Good Shepherd as the Bridegroom. Eusebius, for example, interprets Psalm 23 as a prayer to "the one who came as both shepherd and bridegroom."[82] Theodoret follows suit, imagining the "shepherd and bridegroom" as the Lord of this psalm.[83] How to explain this juxtaposition? Both metaphors are well-attested, of course, for Christ in the New Testament (and God in the Hebrew scriptures before that). And both feature prominently in narratives of salvation: to the shepherd-and-flock texts discussed above we might add all the imagery of divine-human communion as a marriage covenant and heavenly afterlife as a wedding banquet. The biblical book of Revelation imagines the end-of-time Bridegroom as the Lamb himself (a title that author prefers instead of the Good Shepherd):

"Hallelujah!
For the Lord our God
 the Almighty reigns.
Let us rejoice and exult
 and give him glory,
for the marriage of the Lamb has come,
 and his bride [the New Jerusalem of the saints] has made herself
 ready." (Rev 19:6–7; cf. 21:9)

But the deeper connection is likely to be found in the realm of ritual imagination. The second part of Psalm 23—the extended host and guest metaphor—makes sense as a wedding banquet, in line with the Christian eschatological interpretation of the psalm. That is to say, the very prevalence of Psalm 23 during initiatory rites seems to have brought about the "shepherd and bridegroom" juxtaposition in patristic discussions of anointing and baptism. And going beyond that plausible scenario, the notion of spiritual marriage in a bridal chamber was—in its own right—among the most prominent motifs for Christian initiation during the third and fourth centuries. The boundary-drawing sheepfold and the boundary-protecting shepherd were complemented by the invitation-only wedding banquet and the bridegroom in charge of the guest list. Becoming initiated into a flock was akin to attendance at a wedding in what became mainstream texts, but others affiliated with Valentinus, Gnostics, or Manicheans were just as drawn to the boundary-making metaphors. For example, the *Epistula Apostolorum,* a second- or third-century work of uncertain provenance, offers one of the earliest allegorical interpretations of Jesus' Parable of the Wise and Foolish Virgins, in which five are admitted to a wedding and five left outside. Immediately after the interpretation, the author compares those shut out to those who will "remain outside of the kingdom and the fold of the shepherd and his sheep. But whoever remains outside the fold of the sheep will the wolves eat."[84] Before that, Clement of Alexandria wrote in his "excerpts" about an eastern Valentinian named Theodotus that the "seal" of animals marked them as property in the same way that the "faithful souls" of the "wise virgins" bear the "marks of Christ" and are "resting" inside the bridal chamber.[85] Finally, a chant from the Manichean Psalm-Book confirms the two motifs as symbols of initiation in an especially liturgical mode:

> We are men of the rest. Let no one give us toil.
> It is Jesus that we seek, the one whose model we have
> received. Let no one give us toil.
> Our binding is upon our loins, our testimony is in our hand.
> Let no one give us toil.

> We knocked at the door, the door opened to us; we went in
> with the bridegroom. Let no one give us toil.
> We were counted in the number of the virgins in whose torches
> oil was found. Let no one give us toil.
> We were counted in the number of the right hand; we ceased
> to be in the number of the left hand. Let no one give us toil.
> We were counted in the number of these sheep, we ceased to
> be in the number of the goats. Let no one give us toil.[86]

Being counted as a sheep of a flock of a Christian community meant also being counted as a wedding guest of the messianic banquet. In the next chapter, then, let us step back from the font to consider the procession of women on the eastern and northern walls, figures with whom (like the flock of sheep) Dura's initiates were also expected to identify. Who were these women, and where were they going?

The Procession of Women

SO FAR WE HAVE CONSIDERED individual paintings of male biblical figures—David, Jesus, Peter—whose distinct episodes were brought together for viewers during rituals of initiation. We now turn back to take in, as it were, the core of the baptistery's artistic program: a procession of women toward a large white structure (see plate 1). It occupies the lower, main register of the room's two uninterrupted walls. It was undoubtedly intended to be the dominant visual image, and it worked. You can't miss it. Therefore, the core meaning of what happened between these walls depends most emphatically on how we interpret—through Bible, art, and ritual—the visual vocabulary of this procession. The heart of the room is the heart of this book.

Yet the basic identification of the processing figures was in doubt from the beginning. In March 1932, Clark Hopkins's initial in situ proposal about the "three kings" going to Jesus' manger gave way to Henri Seyrig's proposal of the women going to Jesus' tomb. Hopkins and others onsite in Syria subsequently propagated Seyrig's theory, but a vocal minority back in the United States dissented once they had seen the paintings themselves. Why are the women carrying torches? Why are they dressed all in white? To what are they processing? How many were there originally, when the northern wall was intact? Were they meant to represent a biblical narrative at all, or were they rather portraying ritual action in the room? All of these questions are still alive. Forget the question of interpretation for a moment—the very *identification* of the main figures on the walls of the world's oldest church remains up for debate.

Scholars do agree, however, about the importance of these figures to both the room and our understanding of its initiation rites. Processional

art was among the most prominent forms of religious visualization in antiquity. And as I argued in chapter 1, the number and variety of ancient, processional cultic activities encouraged a ritual-centered, processional visuality on the part of viewers. Art historian Thomas Mathews highlights depictions of processions from Greek and Roman antiquity, including the early third-century "Aventine Mithraeum" in Rome and fourth-century processions to temples of Apollo and Diana in Carthage or Bacchus/ Dionysus in Spain.[1] At Dura-Europos, the "Purim panel" in the synagogue features a procession, and the Mithraeum's side walls show a hunt that moves toward the central tauroctony. Processions cover Christian sarcophagi and adorn Christian arcosolia in the catacombs.[2] The primary mode of such processions—"convergence," according to Mathews—would then hit its peak in the mosaics of fifth- and sixth-century Christianity, especially those of the two grand baptisteries of Ravenna.[3] Processional activity was, in short, "basic to all Christian liturgy."[4]

Granted, it is in a sense true that at Dura-Europos the font (and concomitantly the painting of the shepherd and flock over it) was the central focal point of the ritual and its space. But the proper study of processional art does not focus only on its target of convergence. The procession itself can communicate the kind of ritual events and comportments expected of participants. In contemporary church art, the Cathedral of Our Lady of the Angels (Los Angeles, California; consecrated in 2002) exemplifies this role of processional visuality. The cathedral's liturgical procession begins down a long hallway that runs parallel to the entire length of the nave, which demands for participants a liminal transition time between the profane exterior and sacred interior of the church. After turning to enter the nave, viewers are drawn forward toward the altar by twenty-five tapestries hung on the walls that depict 135 larger-than-life saints processing forward. Saints from the first to the twentieth century are realistically portrayed in solemn procession. Augustine, Clare, and other famous saints stand out, but soon viewers notice anonymous figures—twelve in all—interspersed among the holy. The procession thus evokes an embodied, self-reflective identification, as viewers realize that these "saints" are mirrors of themselves. Christians are invited not just to *look at* saints, but to *be* saints.

A less unusual version of processional visuality occurs in that most common of "stational liturgies," the devotion known as the "stations of the cross." In fact, the stations perfectly show the distinction between what Annabel Jane Wharton calls the *optic* and the *haptic* forms of viewing sacred art (from the Greek words for "to see" and "to touch or feel"). In many traditional Catholic churches, the nave's upper register features stained-glass windows or paintings that are engaged optically: they represent well-known "biblical salvational narratives"—each is a "visual sign for a text."[5] The lower register, which is at the actual height of standing viewers, shows a procession of the final events of Jesus' life and death, fourteen stations of the Via Dolorosa. For devotees of this intermittent, circumambulatory prayer, the meaning "is not located elsewhere, in a text, but rather embedded in the physicality of the action of which it was a part."[6] For many of the stations, such as Veronica's wiping the sweat from Jesus' face, *there was no biblical text*. The stations function haptically, inviting the touch of viewers' hands and requiring the movements of their feet. They draw viewers through a narrative world and forward to an altar that commemorates the very death with which the stations culminate. At that altar, then, the body of the viewed is touched.

Returning now to Dura-Europos: in a recent essay on the Julius Terentius frieze from the Temple of the Palmyrene Gods—the discovery of which started it all—Maura Heyn has shown that the temple's overall artistic program enables active participation of attendees in the votive sacrifices being made.[7] The directionality of the paintings aims toward the *naos*, or focal point of the structure, and most of them depict ritual activity. The location of the cult statue in the room vis-à-vis a given painting determined the formal poses depicted therein; the paintings themselves were votive.[8] What is more, attendees felt called to record their identification with the ritual activity depicted on the walls: "The graffiti scratched throughout the painted decoration were not disfiguring and did not detract from the desirability of location, because they were *also* votive. . . . The adornment of the walls does not conform to the conventional idea of what is aesthetically pleasing; it results from a system in which all types of mural markings could function as votive offerings."[9] Temple participation was a kind of

local pilgrimage through a liminal space. Like pilgrims of time immemorial, participants left their mark.

Over in the Christian baptistery, carved onto the procession of women, a single graffito was found. Scratched next to the head of the woman leading the procession was a woman's name: Hera ('Hρᾶς).[10] Ritual-centered, processional visuality suggests that this Hera, like those who carved their names in other temples at Dura-Europos, was literally inserting herself into the imagined ritual activity in which she took part. In Hera we seem to have found another real neophyte—a companion for Isseos. The question for us now is, when Hera processed with these women, *with whom did she think she was identifying?*

Procession to a Tomb?

The procession begins on the eastern wall, where all that remain are five pairs of feet (figs. 4.1 and 4.2). The figures that once stood above these feet

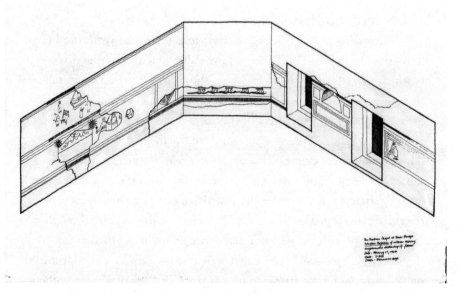

Fig. 4.1. Reconstruction of sequence of scenes. South, east, and north walls, Christian building. (Yale University Art Gallery, Dura-Europos Collection)

Fig. 4.2. Five pairs of feet, in situ. East wall, Christian building. (Yale University Art Gallery, Dura-Europos Collection)

then turned the corner and encountered the image of a paneled door painted near the corner, of which only the bottom remains (fig. 4.3). The door seems to be open. Immediately after the door, the wall was unfortunately not pre-served. The extant procession resumes with portions of three women ap-proaching a large white structure (fig. 4.4). There is no way to be absolutely certain whether the missing portion of wall had room for two more women (a total of five inside the door) or only one (a total of four inside the door), but measurements confirm the possibility of five.[11] Painted with detail and care, set against a rich red background, and much larger in size than the other human figures in the room, these processing women would have drawn the most attention from anyone crossing the threshold (plate 7). Though not fully life-size, their height "gave them almost heroic propor-tions" compared with the small representations of Christ and Peter in the upper register.[12] "The figures of the women are stiff, rigidly frontal and posed in hieratic calm and detachment," in Kraeling's words.[13] Each wears a "long-sleeved white *chiton* belted at the waist" with a long white veil.[14]

Fig. 4.3. Bottom of a door, in situ. North wall, Christian building. (Yale University Art Gallery, Dura-Europos Collection)

The torches in their extended right hands are plain to discern, and the bowls at waist level in their left hands "have rounded bases, wide mouths and broad flaring rims."[15]

The leader of the procession approaches a white structure with gabled top. The size is significant, at almost 1.5 meters wide and with a peak that reaches above the boundaries of the lower register planned by the artist. The upper part of the structure is decorated "with a vine design in light brown, the branching elements of which spread irregularly to the right and the left from a stock at the apex" of the structure.[16] Atop the two sides of the depthless structure shine multipointed starbursts, each of which shows "a central disc represented by three concentric circles" and yellow rays reaching out.[17] In short, the procession features a group of women, carrying torches and bowls, both outside and inside a door, and ultimately approaching a large white, gabled structure with fiery light.

The majority of viewers have regarded the scene as a representation of the myrrophores, the women going to the empty tomb of Jesus to anoint

Fig. 4.4. White structure. North wall, Christian building. Exhibition photograph. (Yale University Art Gallery, Dura-Europos Collection)

his corpse.[18] From this perspective, the torches guide their way in the dark morning hours or inside the door of the tomb, the vessel in the left hand carries the anointing unguents, and the white structure on the left is a sarcophagus. Kraeling labeled the paintings "The Resurrection Sequence." The prominence of the myrrophores in this ritual context would thus signify an interpretation of anointing and immersion baptism as an experience of death and resurrection.

Many scholars express certainty about this interpretation.[19] Others, however, have remained unsure because of significant problems with the artistic identification of the scene.[20] How many women were represented originally, and how does that number line up with associated narratives? (There would have been room for one or two more figures on the northern wall.) What might the door represent, and how did they get inside? Should there not be guards or angels, or any other typical iconographic patterns of

the empty tomb accounts? Why is the supposed sarcophagus so big—taller than the women? And if it *is* a sarcophagus, why does it still look closed if the tomb's door was already open? Isn't Christ risen and gone? Isn't that the point of a "resurrection sequence"?

Early interpreters almost immediately considered the problem of the number of women, since the Gospel accounts record different numbers of myrrophores, but none of them records five. Kraeling argues that the number must have come from a harmonization of all the named women present in the various parts of the passion narratives, regardless of whether all of them are listed as myrrophores.[21] Recently, L. Michael White has proposed that the prominence of the *Diatessaron* and the discovery of the Greek parchment at Dura prove the five-women harmonization.[22] Kraeling was, however, characteristically cautious about even his own proposal: "it is too much to expect that we should be able to recapture from the surviving versions of Tatian's work precisely what is required to explain fully either the five-fold number of the women in the Dura scenes or the exact reason for the concatenation of more than one scene in the series as the artist has constructed it."[23]

Even if one were able to rationalize the number of women—saying that the five outside the door are the same as the five inside the door, and that the number five is a conflation of multiple accounts—even then, defenders of the sarcophagus interpretation find themselves with a lot of explaining to do. There are no distinguishing features of the empty tomb account or its iconography: angel(s), guards, fearful women, or any indication that the corpse has risen from the dead. Kraeling ultimately admits that the supposed empty tomb scene is *"fundamentally so different from all later treatments of the subject and in [its] own period stand[s] so thoroughly alone, that there is no basis for comparison."*[24]

I would heartily agree and further emphasize that the largest problem for the empty tomb interpretation is the torches. With this interpretation of the procession, it is onerous to explain why the women would have them: the Synoptic Gospels recount multiple women, but they come at dawn; John and the *Diatessaron* narrate Mary Magdalene's visit in the dark, but she is alone and *not* coming to anoint the body.[25] Moreover, in terms of artistic comparanda, the Christian tradition is not lacking examples of the

resurrection sequence and the myrrophores. Examples from Syria and its environs occur in some of our earliest illuminated manuscripts, for instance, and multiple pilgrimage objects (such as amulets, ampullae, and censers).[26] But in the long history of Christian art, concerning one of the most widely portrayed scenes from the New Testament, I am not aware of *any* artistic comparanda of the myrrophores that show them carrying torches.

Why Did This View Take Hold?

The predominance of the empty tomb interpretation is due to two main factors. First, Kraeling defends it with vehemence and dismisses all other interpretations in his magisterial excavation report.[27] He had studied the available evidence with such breadth and care that it seems rash to go against him. What was proposed in Syria by Henri Seyrig and ratified by Kraeling in Connecticut then became propagated and anthologized in encyclopedias and textbooks. Who would have the audacity to disagree with a placard in the Yale University Art Gallery, one of the world's finest art museums? Yet Kraeling himself recorded the disputes among interpreters in 1933, when all the material was assembled for the first time at Yale. The "combined elements" of the whole sequence "caused doubts to arise," because the details did not cohere with any biblical accounts of the empty tomb narrative.[28] At that time, several scholars argued that the scene represents the Parable of the Wise and Foolish Virgins (Matt 25:1–13, a proposal discussed at length below).[29] If the original team of experts was sharply divided, and if the empty tomb interpretation does not relate to a particular biblical text or to any other Christian iconographic tradition, Kraeling's certitude is unwarranted.

A second, and more important reason for why the Seyrig-Kraeling interpretation predominated is that this interpretation corroborated a kind of "commonsense" expectation about what the dominant motif of a baptistery ought to have been. For most of Christian history, the Pauline interpretation of baptism as death and resurrection has been dominant. As Paul asked the congregation in Rome: "How can we who died to sin go on living in it? Do you not know that all of us who have been baptized into

Christ Jesus were baptized into his death? Therefore we have buried with him by baptism into death, so that, just as Christ was raised from the dead by the glory of the Father, so we too might walk in newness of life" (Rom 6:2–4).[30] Jesus himself imagines his own death as a kind of baptism, one that his disciples must also undergo as part of servant leadership. In a tête-à-tête with James and John, after Jesus predicts his own death and resurrection, he pointedly challenges them, "Are you able to drink the cup that I drink, or be baptized with the baptism that I am baptized with?" (Mark 10:38). Still today in the Roman Catholic, Greek Orthodox, and Protestant Revised Common lectionaries, the Pauline interpretation of baptism—what Gabriele Winkler has called "death mysticism"—remains central to the initiation mysteries.[31] Romans 6:3–11 is the epistle selection at the Easter Vigil liturgy, read immediately before the Gospel proclamation of the resurrection and the rites of Christian initiation. Thus historians living in this Christian cultural context will have been, to some extent, programmed to interpret a procession of women in a baptistery as a portrayal of the myrrophores. At a minimum, one would be inclined to find that interpretation agreeable.

The image of "dying with Christ" through the ritual of initiation has been widespread throughout Christian history, and ritualized participation with a dying and rising deity was not uncommon in Greek and Roman antiquity before that. As Adela Yarbro Collins has noted, "These qualities of reenactment of a foundational story and the identification of the participant with the protagonist of the story are strikingly reminiscent of what is known about initiation rituals of certain mystery religions, notably the Eleusinian mysteries and the Isis mysteries."[32] Clearly, the Pauline tradition tapped into a deep, immortal longing at the bedrock of "conversion" or "salvation" religions.

Despite the seemingly primal attraction to ritualized death, it remains true, as I argued in chapter 1, that Christian rites and motifs of initiation exhibited great variety during the first few centuries of the Christian era. Leading liturgical historians (Gabriele Winkler, Paul Bradshaw, Maxwell Johnson, Robin Jensen) have drawn out the regional diversity of early Christian ritual and shown that "death mysticism" was not emphasized or alto-

gether absent in many churches of the East.[33] And even for western churches, before the late fourth century there was not a uniform emphasis on initiation at Easter or on the Romans 6 interpretation of the ritual. Kilian McDonnell makes the point sharply: "What is a matter of surprise is that in the immediate post-biblical period, the second century, the Pauline paradigm of death and resurrection fell out of Christian consciousness so completely. . . . [It] seemingly had *fallen through a hole in the memory of the church.* To be specific, in the second century [it] is found neither in the *Didache,* nor in the *Epistle of Barnabas,* nor in the letters of Ignatius of Antioch, nor of Clement, nor in [*The Shepherd of*] *Hermas,* nor in Justin or the other apologists, nor in Irenaeus."[34] These authors, for the most part, cite Romans in their writings—just not *this* passage, even when discussing baptism. In fact, Origen of Alexandria was the "*only* Eastern theologian to refer to the text of Romans 6 in relationship to Christian baptism" before the mid-fourth century.[35] And for Origen, like Paul before him, death-resurrection was just one of many meanings connected to the rite.[36]

As to why death mysticism fell down a rabbit hole in the second and third centuries, only to be recovered in the late fourth century, historians can only conjecture. It is possible that the death memorial of the eucharistic celebration was sufficient to express ritual communion with Christ's death. Another compelling possibility is brought to mind, though, by the names of second-century authors cited above: Ignatius, Justin, Irenaeus. For second-century martyrs and those close to the developing culture of martyrdom, "dying with Christ" was not construed primarily in the realm of ritual and metaphor. The imitation of Christ through death—becoming "other Christs," in the words of Candida Moss—was a *literal* possibility during precisely those two centuries.[37] Alastair Campbell summarizes this idea: during the era of possible martyrdom, "those being baptized hardly needed to be taught *through* the liturgy of the cost of their commitment. They knew it all too well. What they needed was the assurance of the presence of the Spirit, giving them strength to cope."[38] Then after the fourth century, participation in Christ's death came to be increasingly ritualized through baptism, the Eucharist, and the bodily mortifications of the new ascetic movements.

"Torch and Veil"

If not a procession of ritualized death and resurrection, if our best sources say that such motifs were not as relevant in third-century Syria, then what did these processing women at Dura-Europos call to mind? Which women, veiled in white, *did* carry torches in antiquity? And where did they go?

To scholars of classical art, the iconography looks not like a funeral procession but like a wedding procession. White-veiled women are virgins, and torches signify a legitimate marriage ritual. Especially illuminating in this regard is the experience of Diane Apostolos-Cappadona, an expert on the portrayal of women in classical and Christian art. Not long ago, she had turned to this painting from the Dura-Europos baptistery in the course of doing research about Mary Magdalene in Christian art. This was the oldest extant image of her, right? Apostolos-Cappadona concluded, however, that the common identification of the women as myrrophores might be mistaken, and she needed to recast her research. She describes the "iconographic elements" that allow her to identify the female figures instead as virgins: "heroic androgynous bodies; flowing hair covered with a veil; loose, unrestrained, and predominately white garments; and a clear (glass?) container."[39] The oil in their containers keeps their torches burning all night, while also recalling the anointing of a bride that precedes a wedding.

Textual sources that corroborate the connection between torches and weddings in classical antiquity are numerous and widespread, and a few representative examples will suffice. In Euripides' classic *Medea*, the title character makes a farewell speech to her children, which has been considered the most influential speech of all Attic tragedy.[40] Her poignant address begins: "My children, my children, you have a city and a home, in which, leaving your poor mother behind, you will live henceforth, bereft of me. But I shall go to another land as an exile before I have the enjoyment of you and see you happy, before I have tended to your baths and wives and marriage-beds and held the wedding torches aloft [λαμπάδας τ' ἀνασχεθεῖν]."[41] Medea's character calls to mind the torch-lit procession as an essential signifier of a wedding celebration. The Greek novel *Daphnis and Chloe* also imagines torches that accompany bride and groom into the

bridal chamber, but these lovers find a happier ending than that of Medea's tragedy. The romance culminates in their marriage bed: "when night came, everyone conducted them into the bed-chamber, some playing the pipes, some playing the flute, others holding up great torches."[42] Even as a loanword in Latin, the Greek *lampas* ("torch") frequently refers to weddings, such that the Latin phrase *lampade prima* ("at the first torch") was sufficient shorthand to signify "at her first opportunity for marriage," that is, the attainment of mature womanhood.[43]

In her recent study of nuptial imagery in Athenian vase painting, Jennifer Udell has further argued that torches evoke two primary meanings: first, their plain sense indicates the appropriate nighttime setting for a wedding; second, they grant legitimacy to the wedding—and thereby to the couple as well:

> Although torches are practical, light-giving objects, which evoke nighttime in wedding scenes, they also denote a legitimate marriage. The connection between torches and legitimacy in marriage was evidently so strong that a wedding without them was considered invalid, and the children born from these unions were considered bastards (*nothoi*), shadowy beings (*skotioi*) to be concealed. . . . [I]t was understood that the nuptial procession culminated in the formation of a new *oikos,* the basic social unit in Greek society and an essential component in the economic strength and political influence of the *polis.* The aeteology of torches and the concept of legitimacy in marriage, therefore, evolved logically and perhaps anticlimactically from the pre-existing tradition of the nocturnal wedding.[44]

Elsewhere she argues that torches and only torches "are explicitly and repeatedly connected to legitimate marriages in the [Greek] poetic tradition. The same is true in the vase-painting."[45]

Udell's persuasive argument about torches and legitimacy holds up in ancient Christian usage as well. During Tertullian's invective treatise

against the Valentinians, he mocks their beliefs and rituals of spiritual marriage in a bridal chamber (about which more will be said below). In the course of that diatribe, he sarcastically praises Valentinian spiritual consummation, which occurs "instead of the torch and veil [*pro face et flammeo*]," the normal accouterments of nuptial ceremonies.[46] Tertullian's mockery continues, when after the consummation he supposes some "secret fire is then to burst forth, which, after devastating the whole existence of things, will itself also be reduced to nothing at last, after everything has been reduced to ashes. And so their fable too will be ended."[47] Thus in Greek and Roman—and in turn, Christian—notions of marriage, "torch and veil" were necessary and sufficient to signify a legitimate wedding.[48]

Torches were featured in other manner of ritual processions, especially those in honor of a god or culminating in initiations. In the most famous description of a "mystery" cult initiation (a category that by definition precludes certainty about its secret proceedings), Apuleius narrates the path of a devotee of Isis. Among the many rites, when this candidate finally approaches his meeting with the goddess, he carries in his right hand a "flaming torch," after which he celebrated his "birth into the mysteries."[49] The archetype of mysteries, those at Eleusis, may also have involved torch-lit processions, according to Udell. The liturgical drama—though difficult to reconstruct—is possibly pictured on vase paintings of Persephone's return, and textual sources corroborate a ritual movement from darkness and confusion to light and clarity.[50] "Eleusis celebrates with torches," wrote Clement of Alexandria, and his contemporary Plutarch compares the mystery's enlightenment to that of a convert to philosophy.[51]

In Ephesus the festival processions in honor of Artemis were led by sacred objects and torches, and according to one source, one of their goals was matchmaking and marriage for young men and women. *An Ephesian Tale,* a Greek novel by Xenophon of Ephesus, dramatizes the attraction of its two lovers through an opening scene during the procession. The hopeful suitor spies his beloved among the torch-lit procession of young women "dressed as if to receive a lover."[52] The reconstruction of the Ephesian ritual serves for Jaś Elsner as a key example of ritual-centered, processional visuality in the Greco-Roman world.[53] Finally, the third-century rhetori-

cian Menander elaborates on the ritual connection of fire and marriage by evoking how both point toward immortality. In his advice on giving different kinds of speeches, he cites in a specific "bedroom speech" the torch-lighting by the wedding attendants.[54] But in his instructions on how to praise marriage overall, he exalts the gift of immortality through children. The ideal orator's wedding toast "should proceed to tell how [Zeus] also made ready to create man, and fashioned to make him almost immortal, providing successive generations with the passage of time. Say that he is better to us than Prometheus, for Prometheus stole only fire and gave it to us, but marriage procures for us immortality."[55] From the archaic to the Roman period, in text and image, ancient Mediterranean culture thus manifested the motif of processional fire that accompanies a tale of marriage and immortality. We should not be surprised to find it, then, in the New Testament itself.

The Parable of the Wise and Foolish Virgins

In the Gospel of Matthew, the most influential narrative in early Christianity, Jesus spends his final discourse describing the end of time and the prospects for salvation in that day. In the process he tells this parable (Matt 25:1–12, translation mine):

> Ten virgins[a] took their torches[b] and went out to meet the bridegroom. Five of them were foolish, and five were wise. When the foolish took their torches, they took no oil with them; but the wise took vessels of oil with their torches.
>
> As the bridegroom was delayed, all of them became drowsy and slept. But at midnight there was a shout, "Look! Here is the bridegroom! Come out to meet him." Then all those virgins got up and prepared their torches. The foolish said to the wise, "Give us some of your oil, for our torches are extinguished." But the wise replied, "No, lest there not be enough for you and for us. You had better go to the dealers and buy some for yourselves."

And while they went to buy it, the bridegroom came, and those who were ready went with him into the wedding festivities. And the door was shut. Later the other virgins came also, saying, "Lord, Lord, open it for us." But he replied, "Amen, I tell you, I do not know you."[c]

> [a]The term παρθένοι (*parthenoi*) means virgins, unmarried women, which in the original context of this story may also be translated "bridesmaids," since none of these ten is a virgin bride. In later allegorization, however, the virgins become interpreted as "brides" awaiting Jesus as spiritual bridegroom.
> [b]See below on "torches" instead of "lamps."
> [c]Form criticism suggests that this parable should be truncated here. The following verse, "Therefore, stay awake, for no one knows the day or the hour" (Matt 25:13), is a free-floating maxim of Jesus' that has been applied to several different moments in the Gospels (e.g., just prior in Matt 24:36–44). Matthew in particular has a tendency to complete Jesus' parables with allegorical interpretations or one-line, didactic "moral of the story" conclusions.[56] But this one, reductive point could hardly have been Jesus' intended meaning, since "staying awake" was not the virtue that set the wise apart from the foolish (they "all" fell asleep while waiting).

In its original historical context, the parable was likely meant to both convict and exhort its audience in preparation for the eschaton. Jesus' message of apocalyptic sorting into two camps—the wheat and the chaff on the threshing floor, the good fish and bad fish in the dragnet, the sheep and the goats of the herd, the wise and foolish women at the wedding—rings throughout the Gospel of Matthew. This parable convinces listeners of the *certainty* of final judgment and the utter *uncertainty* about when that moment will occur. Yet for those with ears to hear, it also exhorts them

toward preparation, perseverance, and hope that the bridegroom's arrival, and the ensuing messianic banquet, will be worth the wait.

In the earliest interpretations, it seems likely that the parable was not fully allegorized. For instance, many early manuscripts end the first verse with "went out to meet the bridegroom *and the bride*."[57] This would be the realistic narrative for a wedding procession to the bridegroom's house, but when the parable's allegorical interpretations came to focus on the second coming of Jesus as the bridegroom, the verisimilitudinous bride was erased from the manuscript tradition. The virgin "bridesmaids" in the original parable become virgin "brides" in the allegorical interpretation. With this shift, the parable's eschatological interpretation became further allegorized. The oil came to symbolize "good works" or "compassion," which was thought to be required for entry to heaven, above and beyond the perseverance of faithfulness shown through the act of waiting. In this sense, the parable was aligned with Jesus' earlier teaching during the Sermon on the Mount: "Not everyone who says to me, 'Lord, Lord,' will enter the kingdom of heaven, but only the one who does the will of my Father in heaven" (Matt 7:21). God's will is for Jesus' followers to do acts of charity, which is above all other virtues and signified by oil, according to Augustine: "For oil swims above all liquids. Pour in water, and pour in oil upon it; the oil will swim above. Pour in oil, pour in water upon it; the oil will swim above. . . . Charity never fails."[58] Like the anointing oil of the Spirit that hovers over the water of baptism, the oil to fire torches was interpreted as the uppermost virtue.

As already mentioned, several scholars in the 1930s had this parable in mind when they studied the processing women from Dura-Europos. It would seem to be the leading candidate for a narrative that might have given rise to a painting of two groups of five women separated by a door. The veils would normally signify virginity—whether of bridesmaids or of virgin brides. And their torches and containers evoke the two items carried by the women in the parable: "torches" to give light and "oil" to keep their torches burning. The parable takes place in the dead of night, with the bridegroom arriving at "midnight" (Matt 25:6), unlike the empty tomb accounts, which occur early in the morning. The proposal goes all the way

back to 1933—only one year after the Dura-Europos discovery—and it was later supported by scholarly heavyweights in both art history (Joseph Pijoan, author of the multivolume *History of Art*) and early Christianity (Johannes Quasten, author of the multivolume *Patrology*).[59] Liturgical historian Dominic Serra concurs with the identification.[60] And Robin Jensen leans in that direction, although she notes that polysemic interpretations may be preferable and "the solution to the problem of identification may be unanswerable."[61]

The strongest evidence for this identification includes three items: the veils and the torches (both discussed above), and the number of women. Although the northern wall shows only three women, there is room for two more in the unpreserved portion, and Kraeling argues for this number. As mentioned, however, he tries to fit the five women into the empty tomb interpretation: the five women on the eastern wall are the same as those on the northern. They are depicted before and after entering the tomb.[62] He then proposes that the text to explain the number five is the *Diatessaron* or some other Gospel harmonization, even though no extant version of the *Diatessaron* attests five women at the tomb. Therefore, regarding Kraeling's reconstruction of the hypothetical text, art historian Annabel Jane Wharton has quipped, *"the image authors the text that explains it."*[63] By committing to his interpretation, Kraeling could not escape a circular argument.

Challenges to this identification include the following: First, doesn't the parable mention "lamps," not torches? Second, if that white structure is not a sarcophagus, what is it? Third, shouldn't the door be closed, as in the parable? The issues with the "sarcophagus" and the door will be addressed below, after more artistic comparanda are assessed, but the question of the lamps can be resolved now.

The term λαμπάς (*lampas*) in the parable is almost universally mistranslated as "lamp," which calls to mind an ancient oil lamp. But the common word for an oil lamp with a wick was λύχνος (*luchnos*), while λαμπάς almost always means "torch." The proper translation has been acknowledged by some major commentators but has yet to be incorporated into popular translations of this text.[64] Removed from any literary context, as in

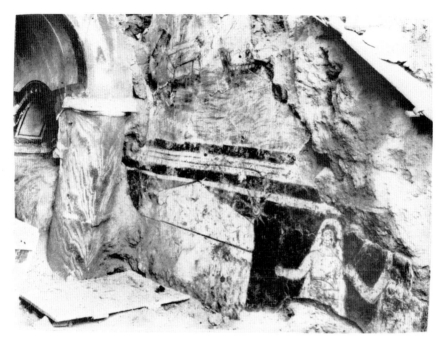

Plate 1. Procession of women approaching a white structure, Walking on the water, and Healing of the paralytic, in situ. North wall, Christian building. (Yale University Art Gallery, Dura-Europos Collection)

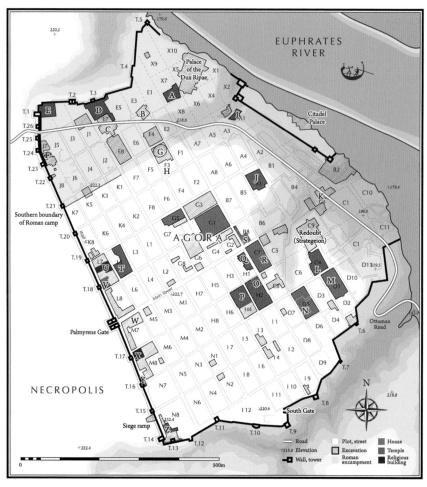

A	Temple of Jupiter Dolichenus	H	Baths	O	Temple of Atargatis	U	Synagogue
B	Baths	I	Military Temple	P	Temple of Artemis Nanaia	V	House of the Roman Scribes
C	Principia (Praetorium)	J	Temple of Zeus Theos	Q	Temple of the Gadde	W	Baths
D	Temple of Artemis Azzanathkona	K	Baths	R	House of the Frescoes	X	Christian Building
E	Temple of Palmyrene Gods (Bel)	L	Temple of Zeus Megistos	S	House of Nebuchelus	Y	Temple of Zeus Kyrios
F	Mithraeum	M	House of Lysias	T	Temple of Adonis	Z	Temple of Aphlad
G	Amphitheater	N	House of the Large Atrium				

Plate 2. Site plan of Dura-Europos. (Drawn by John McCoy, after Simon James, after MFSED; originally published in *Dura Europos: Crossroads of Antiquity*, ed. Lisa R. Brody and Gail L. Hoffman, exh. cat. [Chestnut Hill: McMullen Museum of Art, Boston College, 2011], 15)

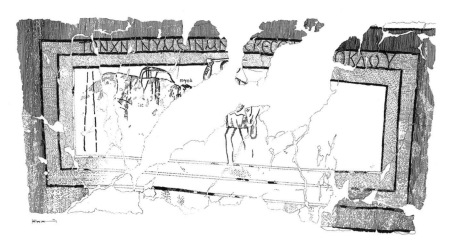

Plate 3. Tracing of David and Goliath painting. South wall, Christian building. (Yale University Art Gallery, Dura-Europos Collection)

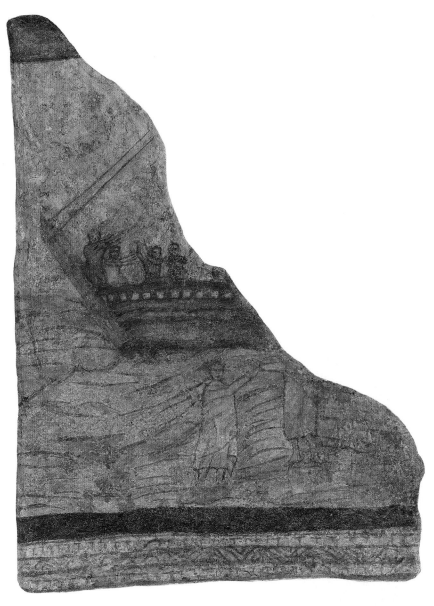

Plate 4. Walking on the water. North wall, Christian Building. Exhibition photograph. (Yale University Art Gallery, Dura-Europos Collection)

Plate 5. Healing of the paralytic. North wall, Christian building. Exhibition photograph. (Yale University Art Gallery, Dura-Europos Collection)

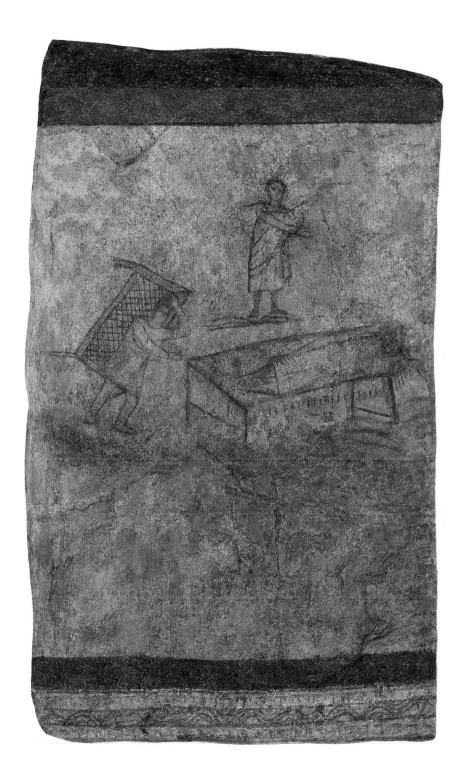

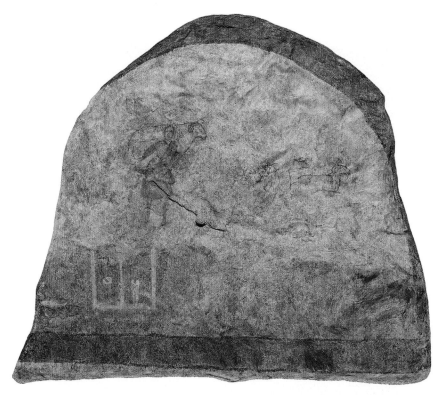

Plate 6. Shepherd and sheep. West wall, Christian building. Exhibition photograph. (Yale University Art Gallery, Dura-Europos Collection)

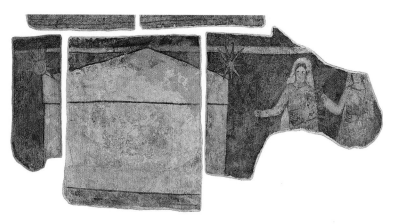

Plate 7. Procession of women. North wall, Christian building. Exhibition photograph. (Yale University Art Gallery, Dura-Europos Collection)

Plate 8. Illumination 4, "Concerning the 10 Virgins," Codex Purpureus Rossanensis. (Rossano, Archivio Arcivescovile. Wikimedia Commons.)

Plate 9. Woman at a well, in situ. South wall, Christian building. (Yale University Art Gallery, Dura-Europos Collection)

Greek dictionaries, the word generally means torch, that is, a stick wrapped with an oil-soaked cloth. In the *Acts of Thomas*, during a scene of initiation discussed in chapter 2, the blazing light of a torch (λαμπάς) is contrasted with the smaller flame of a lamp (λύχνος).[65] When one adds to this evidence the relevance of torches for wedding processions specifically, as shown above, it is difficult to understand why the mistranslation persists.

Perhaps a kind of semantic interference has come from the Gospel of Luke, which says: "May you be dressed for action [literally, 'have your loins girt'] and have your lamps [λύχνοι] lit. Be like those who are waiting for their master to return from the wedding festivities, so that they may open the door for him as soon as he comes and knocks. Blessed are those slaves whom the master finds alert when he comes" (Luke 12:35–37). The resonances with the Parable of the Wise and Foolish Virgins are easy to see at first glance, but closer examination reveals key differences. Luke's call to alertness concerns slaves, indoors, awaiting a master's return from a completed wedding. The imagined situation provides, in fact, a helpful *contrast* to Matthew's parable, which imagines an earlier stage of a wedding night. Perhaps, then, contemporary cultural memory is the real reason for the persistence of the mistranslation. When the King James Version says "lamps," and the great African-American spiritual intones, "Keep your lamps . . . trimmed and burning!," then any attempt to clarify the translation faces an uphill climb.

Wedding and Marriage Imagery in Early Christianity

This parable was not alone in imagining marriage as a motif for spiritual commitment and salvation. Metaphors of a wedding—bride, bridegroom, bridal chamber, wedding feast, bridesmaids, and even "best man"—were widespread in early Christianity, and scholars have begun to interpret the baptistery at Dura-Europos with that imagery in mind.[66] Diverse texts in the New Testament describe the relationship between Christ and the Christian as a spiritual marriage. Joining the Christian community was akin to attending the grandest wedding party imaginable, and Jesus was the anointed bridegroom.[67] While the bridegroom was present, there was to

be no fasting, and if the party ran out of wine, the new wine would be better.[68] The banquet was to be as big as possible, with all manner of guests invited.[69] The groom would be marrying as many brides as possible too—so many that he needed two "best men" to help him handle the attention. Both John the Baptist and Paul discuss the honor in brief "best-man speeches."[70] And finally, as we learned already, it was crucial not to fall asleep while waiting for the wedding party to begin: those who want to celebrate marriage with Christ must be vigilant and wise.[71]

Texts from early Christian Syria were especially fond of the marriage metaphor.[72] Christ as bridegroom can be paired with either the church or an individual Christian as bride. The first episode in the *Acts of Thomas,* for example, narrates the apostle Thomas's singing of a wedding hymn, which invites a princess to leave behind her betrothed to seek spiritual marriage with Christ. Here, as throughout the Syrian literature, the motif of illumination accompanies that of marriage: "The young woman is light's daughter . . . her bridal chamber is full of light. . . . [She and her attendants] will be with him forever in joy eternal, and in that wedding feast where great ones are assembled. . . . They will glorify the Father of the worlds, whose exultant light they have received."[73] The subsequent preparations are reminiscent of Jesus' parable of the wedding banquet, in which the king throws his doors wide open to everyone.[74] Before the wedding, the guests anoint their bodies and enjoy music and festivities. But later, Thomas, with the aid of an apparition of Jesus, intervenes and prevents the consummation of "this marriage which passes away" and convinces the bride to be "bound in another marriage" (a spiritual one in which she is "yoked with the true man," Jesus).[75] Near the end of the adventure, Thomas again disrupts a marriage—this time one already begun. He persuades a certain Mygdonia to exchange her earthly marriage for a spiritual one with Jesus. In these words, she expresses her choice to her former husband: "You have seen that marriage [with her husband], which passed away and remains here on earth, but this marriage [with Christ] abides forever. That fellowship was one of corruption, but this of life eternal. Those attendants are short-lived men and women, but these now remain to the end . . . That bridal chamber is taken down, but this remains

forever . . . You are a bridegroom who passes away and is destroyed, but Jesus is a true bridegroom, abiding immortal forever."[76] Each aspect of Mygdonia's tangible, customary marriage finds a superior spiritual, eternal counterpart in a mystical marriage with Christ.

The *Gospel of Philip*, a text discovered at Nag Hammadi and probably of Syrian provenance, is also famous for its imagery of the "bridal chamber" (νυμφών) and the "unpolluted" (spiritual) marriage that occurs there.[77] The bridal chamber occurs so often (in about 20 percent of the extant text) that some scholars have thought it describes a ritual previously unknown: "The Lord did all things by means of a mystery: baptism, chrism, eucharist, ransom, bridal chamber."[78] Was the author here listing a set of Syrian sacraments? That is difficult to discern. What is certain is that the bridal event was seen to reverse the primordial separation of Eve from Adam:[79]

> If the woman had not separated from the man, she and the man would not die. That being's separation became the origin of death. Because of this the Anointed (Christ) came to rectify the separation that had existed from the beginning and again unite the two, and to give life to those who had died as a result of the separation and unite them. Now, a woman is united to her husband in the bridal chamber, and those who have been united in the bridal chamber will no longer be separated. Thus Eve became separate from Adam because it was not in the bridal chamber that she united with him.[80]

Anointing is a necessary condition of the baptism and the marriage so that "whoever has been anointed has everything: resurrection, light, cross, holy spirit; the father has given it to that person in the bridal chamber."[81] The arrival of Christ as bridegroom is celebrated in his birth and baptism (two events celebrated in the East by the feast of the Epiphany before the separate nativity celebration took root in the fourth century).[82] The text thus emphasizes both "birth" and "marriage" mysticism and explicitly rejects the Pauline interpretation of initiation as death with Christ:

"Just as Jesus perfected the water of baptism, so too he poured out death. For this reason we go down into the water, but not into death, so that we are not poured out into the spirit of the world."[83] The baptismal font is not a grave but rather a bridal chamber that survives the water: it is an "ark [of] salvation when the watery flood rages."[84]

Elsewhere in Syrian literature, Aphrahat expounds on the themes of virginity and marriage in relation to Adam and Eve, and he makes explicit use of the Parable of the Wise and Foolish Virgins several times.[85] During a teaching about how the Virgin Mary overturned the curse of Eve, he writes of the glorious eschatological kingdom:

> All the pure virgins who are betrothed to Christ shall light their torches and with the Bridegroom shall they go into the marriage chamber. All those that are betrothed to Christ are far removed from the curse of the Law, and are redeemed from the condemnation of the daughters of Eve; for they are not wedded to men so as to receive the curses and come into the pains. They take no thought of death, because they do not deliver children to him. . . . And instead of the groans of the daughters of Eve, they utter the songs of the Bridegroom.[86]

Adam and Eve's mistakes were embodied in sex, marriage, and labor pains, so the triumph of the Virgin Mary inaugurates an era of celibacy and spiritual marriage. These virgin brides are thus embodied by both Mary and the five virgins from Jesus' parable.

As in the *Acts of Thomas,* virgins are here instructed to reject the advances of men in favor of betrothal to Christ; Aphrahat uses the Parable of the Wise and Foolish Virgins as a means of exhortation toward voluntary celibacy.[87] These instructions were meant not only for virginal women: as Sebastian Brock and others point out, the Greek and Syriac words for "virgin" often were applied to Christian men.[88] Apostolos-Cappadona argues that in classical antiquity, "the category of virgin/virginity was neither sex specific nor a permanent 'state-of-being-in-the-world.' It was a transitional stage in that the virgin was neither male nor female but rather

an intermediary between the human and the sacred."[89] Some eastern Christian communities may have held that actual celibacy was a requirement of men and women for baptism, though this is difficult to prove.[90] Nonetheless, for Aphrahat and other Syrian authors, the "no male and female" vision of Paul for the idealized Christian community was in some sense realized.[91] Both men and women—or should we say, neither men nor women—were initiated as celibate brides of Christ.[92]

Initiation as Spiritual Marriage

The marriage metaphor was not consigned to the fringes of the early Christian tapestry—apocryphal tales and buried codices—but lay at the very center of what became the established traditions of initiation. In his baptismal catecheses, Cyril of Jerusalem implores the candidates to prepare their souls for spiritual marriage: "For worldly marriages and contracts are not always made with judgment, and the bridegroom is quickly swayed wherever there is wealth or beauty. But here there is concern not for beauty of body, but for the blameless conscience of soul."[93] Cyril teaches in a lecture what the *Acts of Thomas* emplots in an adventure tale. The first baptismal instruction of John Chrysostom also prepares for the "days of spiritual marriage": "Come," he says in the first instruction, "let me talk to you as I would speak to a bride about to be led into the holy bridal chamber."[94] Chrysostom expands the metaphor into a full-blown allegory, interpreting the "beauty" (virtue) or "ugliness" (vice) of the bride, the amount of the "dowry" (obedience), and that she might never have seen the bridegroom until the "wedding night" (baptismal initiation at night).[95] Lest anyone misunderstand his allegory and "fall into a crass and carnal interpretation" of the marriage metaphor, he makes clear its main point: "When the blessed Paul, that loftiest of souls, said: 'I have betrothed you to one spouse, that I might present you a chaste virgin to Christ,' he merely meant that he espoused to Christ as chaste virgins those souls which had made progress toward piety."[96]

Cyril and Chrysostom each weave together the strands of the image into a midnight wedding procession. The opening section of

Cyril's *Procatechesis,* addressed to the "candidates for illumination" (φωτιζόμενοι)—and the *very first text* of these ancient catecheses— describes how they "have carried the torches of a wedding procession" and the "door" has been "left open" for them to enter the wedding.[97] The "door left open" for a torch-lit wedding procession undoubtedly manifests the influence of the Parable of the Wise and Foolish Virgins on the ritual imagination in fourth-century Jerusalem. In fourth-century Antioch, John Chrysostom's final baptismal instruction expands on the image: "I have come as the last to tell you that after two days the Bridegroom is coming. Arise, kindle your torches, and by their shining light receive the King of heaven. Arise and keep watch. For not during the day but in the middle of the night the Bridegroom comes to you. This is the custom for the wedding procession [νυμφαγωγία]—to give over the brides to their bridegrooms in the depth of nightfall."[98]

Kraeling's assertion that the Parable of the Wise and Foolish Virgins was unimportant in baptismal literature is thus incorrect. It is a master motif for several Christian authors in Syria and Palestine, and its application extends beyond virginal women.[99] The event of baptism in early eastern Christianity meant anointing, illumination, and marriage of both male and female virgin brides. Reading Matthew's parable along with the painting suggests that in the darkness of midnight, the oil of anointing leads to the illumination of baptismal marriage.

An especially rich example comes from Gregory of Nazianzus, who concludes his oration *On Holy Baptism* (delivered to candidates in Constantinople at Epiphany of 381 CE) with his elaboration of the same parable:

> The place where you will soon stand, in front of the bema, after your baptism, is a pattern of the glory hereafter. The psalmody with which you will be received is a prelude to the hymnody hereafter. The torches that you kindle are a sacrament of the procession of light hereafter, with which our beaming and virginal souls will greet the bridegroom—beaming with the torches of faith, neither sleeping due to laziness, lest the antici-

pated one escape our notice when he arrives unexpectedly, nor unnourished and unoiled and lacking good works, lest we be thrown out of the bridal chamber.[100]

The ideas are similar to those of Chrysostom, but Gregory offers us more insight into the relationship between text and ritual. The bema is the pattern of the bridal chamber, and a virginal soul is required for entry. The torches of the procession are brilliant with faith, but bodily comportment is not to be ignored: the brides must have good works and proper bodies (nourished and well-oiled) for the wedding night. Gregory uses the oil of the parable as a dual allegorical signifier: the virgins need the oil of perseverance in good works but also the oil of adornment for baptismal marriage.[101] We unfortunately do not know whether the wise and foolish virgins were artistically depicted in any churches of fourth-century Jerusalem, Antioch, or Constantinople, but the texts of these catecheses and sermons do call to mind the paintings from Dura-Europos: anointed women in a torch-lit procession to the bridal chamber of baptism.

Lingering Questions About Spiritual Marriage

The evidence for the motif of spiritual marriage in early Syrian initiation is strong, but a few questions linger, and not all can be answered. *First,* what did all these texts really mean by "virgins"? Was celibacy required for all initiates? The great scholar of Syriac Arthur Vööbus argued in the affirmative in the middle of the past century. According to him, celibacy was required for admission to baptism in the early Syrian churches, and positive statements about married life in primary sources could be explained through source criticism—the older strata being more restrictive, the later being more permissive of marriage.[102] Recent scholars disagree, however, arguing that the "sons/daughters of the covenant" in Syriac texts designate an elite group of celibates or "solitaries" within the overall Christian community.[103] The reason why Aphrahat, for instance, speaks so frequently and highly of virginity, therefore, was that he himself was probably one of these ascetic virtuosos. Nevertheless, he speaks positively of married life in parts

of his *Demonstrations*.[104] Sidney Griffith summarizes the current view of celibacy in early Syria: the sons/daughters of the covenant "designated a group of celibate people belonging to a certain station in life in the community that in the early period of the history of the church in the Syriac-speaking world they assumed by covenant, or solemn pledge, at baptism. Such persons took their stand with an anticipatory view to the Resurrection," a state in which Jesus himself taught that people "would neither marry nor be given in marriage" (Matt 22:30).[105] The elite celibates thus served in the community "as a type for the expectations of all the baptized."[106]

With characteristic brilliance, Elizabeth Clark zooms out from this debate about Syrian asceticism to assess its relationship to spiritual "marriage" in early Christianity overall. Voluntary asceticism qua celibacy did not fit into established cultural mores, the common sense of ancient Mediterranean cultures. A consecrated virgin in a temple "made sense," but a celibate living day-to-day in nonsacred space was not comprehensible without a metaphor to help people grasp its meaning. Thus, "by styling a commitment to virginity or to celibacy as 'marriage,' [the metaphor of marriage to Christ] reinserted Christian ascetics within a familiar domestic economy. Although a young virgin's rejection of earthly nuptials might shock the aristocratic society of the late Roman Empire, she could nonetheless be imagined as *someone's* wife."[107] Moreover, the metaphors of "celibate bridegroom" and "virgin brides" worked well to embrace both the "normal" married lives of most Christians and the celibate lives of an elite group. These crucial metaphors "held together 'marriage' and 'celibacy' in a creative tension that reflected the Church's need to affirm the worth of each."[108] While some Christians no doubt remained voluntarily celibate in a spiritual marriage to Christ, we should not forget how many sources champion the marriage motif for *all* initiated Christians. From Jesus' parables to Pauline exhortations to the baptismal catecheses of Cyril and Chrysostom, all chaste Christians—virgin celibates, the chaste married, and widows—"could be subsumed in the category of 'pure virgin,'" as defined by Paul (2 Cor 11:2).[109]

A *second* question relates to the first: where did the "bridal chamber" sit on the literal-to-metaphorical spectrum? Was some kind of marriage rit-

ually enacted, or was it primarily a concept? To begin, I find no evidence that an actual sexual union was consummated in the bridal chamber of Christian initiation, nor even a "sacred marriage" (*hieros gamos*), which was a well-recognized mythical or ritual union between god and goddess or divine and human being in diverse ancient Mediterranean cultures.[110] To conjecture so would be like assuming that the frequent military motifs in texts of Christian initiation necessitated actual armor or military tattoos having been applied to the initiates.

Nonetheless, the motif of marriage was ritually enacted to some degree, especially insofar as the preparatory rituals imitated the rituals of mundane marriages. As already discussed, the anointing, the bathing, and the torch-lit procession all call to mind marriage, as does the overall linkage with new birth.[111] Chapter 2 highlighted the connection between anointing and the bridal chamber in Syrian texts such as the *Acts of Thomas* or the *Gospel of Philip,* which states: "Whoever has been anointed has everything: resurrection, light, cross, holy spirit. The father has given it to that person in the bridal chamber."[112] Like a common bridal chamber, that of initiation produces "births" and "children." Beyond that, the well-known Christian "kiss" was sometimes interpreted in connection with marriage, as by the fifth-century Syrian Narsai.[113] And a golden wedding (or engagement) ring was found in the excavation of the house-church itself![114] That being said, the rituals of anointing, bathing, and firelight are all polysemic in their ritual contexts. The kissing ritual was likely more expressive of fictive kinship relations in general and not marriage in particular, which was commonly expressed in antiquity by hand-holding. As for the wedding ring inscribed with *HOMONOIA* ("concord, harmony, agreement"), it probably demonstrates nothing beyond the mere fact of a married person having sometime been present in that building. If it was indeed connected to the rituals of the baptistery, that would certainly have actualized the motif of marriage in a more sacramental mode than currently assumed. Those called "betrothed to Christ," in Paul's words, might have marked that betrothal with a ring—but again, the evidence is too sparse to make the case.

On the question of "mystical marriage" in a "bridal chamber," then, Elaine Pagels strikes the right tone. In an essay on this theme in the *Gospel*

of Philip, she argues that not all Christians in Syria, not even all Valentinian Christians, were encratites (celibate, extreme ascetics).[115] Since some were but most were not, the author of the *Gospel of Philip* avoids pronouncing on the worthiness of either celibate spiritual marriage or common sexual marriage. This text rejects the dichotomous question outright and immerses the reader instead in the ambiguous relationship between language and reality, between the sensible world and the world of ideas. Fleshly marriage or spiritual marriage is a false dichotomy, in Pagels's reading of the text, which counsels: "Do not fear the flesh or love it. If you fear it, it will dominate you; if you love it, it will swallow you up and strangle you."[116] "Imagined marriage" between an initiate and a heavenly counterpart serves as a check on desires, just as actual marriage could provide an outlet (and thus bridle) for desires.[117]

In the end, while it is unquestionable that the "bridal chamber" is the dominant symbol of the *Gospel of Philip,* its concept of the "imaged bridal chamber"—a ritualized imagining of a heavenly covenantal partner and a hoped-for heavenly wedding party—ultimately suggests that early Syriac understanding of spiritual marriage was not different in kind from that championed by Jesus, Paul, Cyril, or Chrysostom. Christians employed multiple images that mirrored heavenly realities, and they moved from image to image toward an understanding of truth. In the words of the *Gospel of Philip:* "Truth did not come to the world nakedly; rather, it came in prototypes and images. The world will not accept it by any other form."[118] Christian initiation was a bridal chamber primarily through attention to preparation in purity for controlling desire, anointing as adornment, torch-bearing as perseverance in commitment to a covenant, and ultimately, a celebratory meal with the new kin. It looked toward a restoration of paradise, in which Christ and his many brides would reunite with the primordial couple, Adam and Eve.[119]

A *third* and final question: how might our historical neophyte, the male Isseos, have imagined himself as a female bride during these rituals?[120] If pondering the Parable of the Wise and Foolish Virgins, he might have been taught an allegorical interpretation: Tertullian, for instance, reports that Gnostic and Valentinian interpretation assigned five intellectual

virtues to the wise virgins and five bodily senses, which can be deceived, to the foolish virgins.[121] The *Epistula Apostolorum* reframed this tradition in an anti-Gnostic polemic.[122] At a more basic level, though, virginity and its attendant properties were not sex-specific in classical antiquity. Elizabeth Clark has gathered voluminous patristic citations which presume that "males as well as females can be 'married' to Christ. . . . That the image could be so indiscriminately manipulated suggests that, despite the progressive asceticization of Christianity, patristic authors, even ascetic enthusiasts such as Jerome, did not wish to foreclose marriage to the Heavenly Bridegroom to those who were not women, not perpetual virgins, and not sinless. Here a near-universal message of redemption, construed as 'marriage,' appears to trump the elitism of ascetic Christianity."[123] Recall that the opening pages of the catecheses of both Cyril and Chrysostom have no problem describing new initiates—male and female—as virgin brides. Chrysostom, for his part, pairs the motif of spiritual marriage immediately with the militaristic imaginary: "To call what takes place today a marriage would be no blunder; not only could we call it a marriage but even a marvelous and most unusual kind of military enlistment."[124] To assure his listeners that no contradiction exists between the juxtaposed metaphors, he cites Paul's hortatory usage of both and rounds out the exordium with a metaphor easily open to both genders: to join "the flock" of Christ.[125] Chrysostom exhorts through marriage, the military, and shepherding—three resonances of "sealing" with oil, and three paintings in the Dura-Europos baptistery.

Returning to the material source that preserved the identity of Isseos can help us to understand how he might have imagined himself as a bride of Christ. When I introduced him in chapter 1, I noted that his name was painted on a clay jar, along with the word "neophyte" twice. But why would this word be painted on a jar at all, for anyone? And why would the jar have been found elsewhere in the city, outside of the church's environs? If we consider ancient rituals of marriage to have been functioning analogues for Christian initiation, a plausible explanation emerges. The clay jar that Isseos took home was a kind of *loutrophoros,* a personalized vessel that contained the ritual liquid (or liquids) for his initiation. In Hellenistic

culture, the *loutrophoros* was the name for both a person who fetched water for the marriage bath and the urn itself. Many of these vessels have been preserved from antiquity; they are often exquisitely painted with scenes of weddings (and, in some cases, of funerals) for the people to whom they belonged. The motif of marriage offers a realistic reason why the jar would exist, be labeled for a neophyte, and be found elsewhere in the city. We cannot know whether it contained water for pouring over Isseos at his baptism—recall that the font was big enough for a person to stand or kneel in, but not big enough for full adult immersion—or whether it held oil for anointing (or both). Isseos might well have carried it himself in the procession toward the font, just as the wise women on the wall each carried a vessel in their left hands.

As we ponder the textual, ritual, and artistic means by which men imagined themselves as brides, we might also consider how a woman, such as Hera at Dura-Europos, would have imagined herself as a fearsome soldier of Christ. Did she not feel called to identify with the sword-wielding David, on the room's opposite wall, just as Isseos bore a torch and vessel with the processing virgins? Chrysostom, again, speaks plainly to this question: the "new soldiers of Christ" comprise "both men and women, for the army of Christ knows no distinction of sex."[126] Whether men or women, brides or soldiers—the Bible, the art of Dura-Europos, and Syrian ritual provided the imaginative resources for both.

Artistic Comparanda: The Riting on the Walls?

The details may vary, but the evidence for a general motif of spiritual marriage, accompanied by the oil of anointing and of illumination, is abundant in early Syrian sources. Why then did Kraeling and others argue against the interpretation of this painting as either a wedding procession or Jesus' specific parable? It is clear that Kraeling and others had not mined the sources for ritual initiation, some of which were not well-known at the time. He argued that "early Christian baptismal literature of the eastern Church assigns no special importance" to the Parable of the Wise and Foolish Virgins.[127] Sebastian Brock, however, called the parable very popular in Syrian

Christianity, and several texts have already been shown to use the parable to draw connections between Christian initiation and spiritual marriage.[128]

Perhaps more importantly, other scholars have not considered possible artistic comparanda for the procession of the wise and foolish virgins, to which we now turn.[129] The iconography of the procession of women at Dura-Europos may be fruitfully compared with painted comparanda, and especially two examples of Syrian provenance. First to consider are the wall paintings in the medieval monastery of Mar Musa al-Habashi (St. Moses the Ethiopian), located about 80 kilometers northeast of Damascus. The eleventh- and twelfth-century frescoes comprise "the only full program of medieval church decoration to have survived in greater Syria."[130] The chapel's artistic program contains a large portrayal of the Last Judgment, which covers the western wall. Each of five horizontal registers depicts the saved saints on the left and the damned sinners on the right. On the eastern wall is a triumphal arch representing the Annunciation, which occurs at a well (as it often does in the East; see chapter 5). The semidome over the apse shows Christ enthroned and flanked by John the Baptist and the Virgin Mary: baptism and virginity are thus juxtaposed in the building's focal point. Below this scene, the wall behind the bema features the Virgin and Child surrounded by a gallery of eastern saints.

The relevance of this artistic program becomes clear when we see that to enter the sanctuary of the saints, one must pass through the door of the iconostasis, as in most eastern Christian architecture. The frescoes of this iconostasis represent a procession of wise and foolish virgins: the five wise are on the left of the door to the sanctuary, and the five foolish are on its right (fig. 4.5). Only a few of the figures have been preserved; the wise virgins are clearly carrying torches as they approach the door to the bema, where the wedding feast–cum–Eucharist is celebrated. Since the iconography of the wise and foolish virgins appears little in the West before the twelfth century, Erica Dodd suggests that this motif survived in ancient Syria and Palestine to be passed to Europe during the Crusades.[131] The eastern traditions continue the iconographic program, and the long-standing bond between Syrian and Armenian types is evidenced in the latter's manuscripts too.[132]

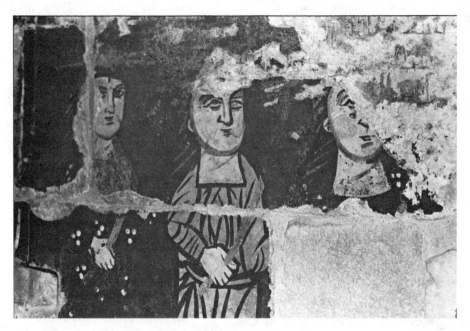

Fig. 4.5. Iconostasis. North half, west face (detail). Mar Musa al-Habashi. (Erica Cruikshank Dodd)

The western tradition does have a couple of extant examples, however, from funerary art. Before the excavations of Dura-Europos or Mar Musa al-Habashi, Josef Wilpert had identified two catacomb paintings as representations of the parable. One of these shows five women with lit torches held upright and five with torches (apparently extinguished) held downwards.[133] The two groups approach Christ, who stands in front of an archway, from different sides. The second and more fascinating example shows five foolish virgins processing with torches and four wise virgins already seated inside at the wedding feast.[134] In between them stands not a door, but a figure in prayer. To account for only four wise virgins, Wilpert suggests that the deceased person buried in the room should be regarded "as one of the wise virgins; she was to have completed the number, and thus [Christ] had designated a seat at the meal for her."[135] He argues further that the deceased is represented in between the five and the four as an *orant*, perhaps to symbolize her liminal status between death and resurrection.

(As a side note, if it is ever decided that only four women were present inside the door on the north wall of the Dura-Europos baptistery, this example would then provide a possible comparandum for interpreting a seemingly incomplete artistic program. The picture is incomplete because the ritual in the space—whether a funeral or an initiation—completes it. These two examples would be analogous to the ritual completion of an artistic program at the Byzantine Church of the Multiplication at Tabgha in Galilee. The floor mosaic under the altar shows only four loaves of bread, despite the narrative tradition of five loaves. But when the ritual is celebrated, the fifth loaf—the Eucharist—is there, on the altar.) In any case, though the parable does seem to have been more popular in the East, a group of five or ten torch-bearing women processing toward an artistic focal point was not unknown in ancient Christian art from the West.

Illuminating the Procession

For the most compelling comparandum to the procession at Dura-Europos, we return to Syria—or at least, a codex likely of Syrian provenance: the fourth illumination of Codex Purpureus Rossanensis (also called the "Rossano Gospels"; plate 8).[136] This manuscript (designated by Nestle-Aland as 042 or Σ and hereafter called "Codex Rossanensis") contains the entire Gospel of Matthew and almost the whole Gospel of Mark. It is dated between the fourth and seventh centuries, with most estimates proposing the later portion of that timeframe. Its provenance is almost certainly Asia Minor, Palestine, or Syria; paleographer Guglielmo Cavallo argues that Syria is the only likely possibility.[137] Codex Rossanensis thus provides a chronological middle point on the trajectory of Syrian iconography that runs from Dura-Europos to Mar Musa al-Habashi.

The identification of the illumination is not in question, since the page is titled "Concerning the 10 Virgins." The scene moves from left to right, with the five foolish virgins approaching the door from the left and the five wise already inside on the right. Christ is gesturing from inside toward the door.[138] The distinction between the two groups of women is starkly portrayed by their garments: those of the foolish are multicolored, while those

of the wise are white with golden trim. The torches of the foolish contain mere embers, while those of the wise are blazing. Upon closer inspection, one can see that the flasks of oil are transparent, showing empty containers on the left and partially full ones on the right. That is to say, though the text requires the flasks of the foolish to be full—they have just returned from purchasing more oil—the verbal interpretive tradition has found its way into the visual. The allegorical interpretation of the parable as a scene of eschatological judgment—in which the oil represents good works, which the excluded do not have—has influenced the artistic depiction of the parable.[139]

The space outside the door is not illustrated, but the inside offers a few details. The night sky corresponds to the timing of the parable, which takes place at midnight (Matt 25:6), and other features elaborate its meaning. Four streams of water flow from a rocky spring and converge into one river below the feet of the wise virgins. Above the rock are green lines that appear to be vines, and where the river terminates at the door, a small tree sprouts. The tops of trees are visible against the night sky, above the heads of the women. These features suggest a scene of paradise, in line with the prevalent early Christian interpretation of the parable as a portrayal of the Last Judgment and admission to eternal life.

The illumination bears several iconographic similarities with the artistic program at Dura-Europos. The pattern of five women, a door, and five more women is the best construal of the extant portion of the procession at Dura-Europos.[140] The comportment of the female figures is virtually identical in both examples: the women inside the door wear loose, white garments, and each carries a blazing torch and container partially filled with oil.[141] The star-studded night sky of the manuscript is also present in the Dura-Europos baptistery, having been painted there on the ceilings of both the canopy over the font and also the entire room (fig. 4.6).[142] The flowing river from the rock undergirds the vision of paradise in the manuscript illumination, even as the memory of "water from the rock" supported baptismal ideas for early Christian authors.[143] The water calls to mind the four branches of the river of Eden (Gen 2:10–14), a popular motif in Christian iconography, which is found or alluded to at multiple sites of early Chris-

Fig. 4.6. Ceiling of the canopy over the font, in situ.
Christian building. (Yale University Art Gallery,
Dura-Europos Collection)

tian initiation.[144] As with the "river of the water of life" in the vision of the
New Jerusalem (Rev 21:6; 22:1–2, 17), this fourfold river evokes the new cre-
ation and the restoration of paradise. The Dura-Europos baptistery is full
of water imagery, of course, and the restoration of paradise is suggested by
the inset painting of Adam and Eve just over the font.[145] The mostly miss-
ing upper register of the south wall of the baptistery bears part of what
seemed to be a garden scene, and the pilasters supporting the rear of the
canopy have "an overall grape and leaf design," as if they support vines
growing up from the font.[146] The front of the canopy is "decorated in imi-
tation of a fruit garland," depicting grapes, ears of grain, and pomegran-
ates.[147] Taken together, all of these iconographic similarities between the
illuminated manuscript and the artistic program of the baptistery should

invite serious consideration during any attempt to interpret the procession of women.

Why then is Codex Rossanensis not normally discussed in connection with the Dura-Europos baptistery? Simply stated, the main problem with interpreting the procession of women as the Parable of the Wise and Foolish Virgins has always been the large white structure to which the women are processing. That is to say, the proverbial elephant in the room might be a sarcophagus. In the early debates about the painting, both André Grabar and Carl Kraeling dismissed the parable interpretation primarily out of indubitable conviction that the white structure depicted in the baptistery is a sarcophagus.[148] Yet it is either the same size as or larger than the women and gives no perspectival indication that it is closer to the viewer than the women are. The pointed roof of the structure is normal for a building or tent. Kraeling's interpretation would require us to call this an awkward profile view of a sarcophagus, with no indication of depth. This is not even to discuss that the "sarcophagus" appears closed, and there are no other indications of the events normally depicted at the empty tomb. Despite these difficulties, Kraeling insists it "must under all circumstances be a sarcophagus" and "can not be the house of the bridegroom."[149]

In fact, the initial field reports called the structure not a sarcophagus but "a white building," which is another valid way of seeing it.[150] Early interpreters who connected the painting to the parable imagined it as the house of the bridegroom, but a better proposal might be a tent or bridal chamber—an internal structure where the wedding is consummated.[151] The Greek text of the parable does not specify what kind of place the wedding is in, calling it just "the wedding."[152] Nevertheless, several eastern authors, such as Aphrahat and Ephrem, use the word "bridal chamber" when they discuss the parable.[153] In terms of the artistic tradition, a gabled structure of similar appearance, being no taller than the women (as also at Dura), is pictured in Byzantine illuminations of the Parable of the Wise and Foolish Virgins.[154] In addition, portrayals of tents from the second and third centuries show basic gabled roofs, such as those on Trajan's column in Rome or the twelve tents depicted in the scene of Moses at the well (Be'er) in the synagogue at Dura-Europos (see fig. 2.6).[155] As for the bridal chamber's

presence inside a door, Robert Murray's explanation of the Syrian notion of the temporary facility is instructive: "the *gnônâ* [bridal chamber] seems to have been *a sort of enclosed tent set up in the house of the bridal pair.*"[156]

Since the connection of a bridal chamber (as metaphor or ritual) to Christian initiation in Syrian Christianity has been so well-documented, we can then amplify the connection of wedding parable, bridal chamber ritual, and baptismal font by reference to the practice of veiling the baptismal font. The *Testamentum Domini* and the *Apostolic Constitutions,* liturgical "church orders" likely of Syrian provenance, both prescribe a veiling of the sanctuary area.[157] In his fourth-century *Letter to the Armenians,* Macarius of Jerusalem prescribes a veiled sanctuary that includes both a font and table for the Eucharist.[158] The *Testamentum Domini* prescribes a veil specifically for the site of baptism (literally, the "house for the place of baptism").[159] If one thus imagines the canopied font at Dura-Europos to have been surrounded by one such "veil of pure linen," then its resemblance to the painting of the white structure would not be difficult to see.

The second reason for Kraeling's rejection of the parable interpretation is that the door in the painting should be shut if it was to have symbolized the parable (see fig. 4.3).[160] If the goal of the artist were to represent only the exclusionary function of the parable, I would agree. But if the artist were intending the processional painting to have a *haptic* and invitatory function—to physically draw forward those present in the room toward the font—then leaving the door open would make more sense. Recall the opening section of Cyril of Jerusalem's *Procatechesis,* which described how the candidates carried the "torches of a wedding procession" (νυμφαγωγίας λαμπάδες) and the "door" had been "left open" for them (ἀνετὴν ἀφήκαμεν τὴν θύραν) to enter the "wedding feast" of their initiation.[161] Remember too that the frescoes at Mar Musa al-Habashi surround the bema's entrance, which can be both open and closed depending on the liturgical moment, a scene one also would imagine when hearing Gregory of Nazianzus's evocation of the Parable of the Wise and Foolish Virgins in his baptismal homily.[162] Whether the door is open or closed therefore does not determine the image's correspondence to a text (or not), but rather it shapes the experience of the viewer as one of either invitation (as in Dura-Europos

and Mar Musa al-Habashi) or discrimination and exclusion (as in Codex Rossanensis).

Text-Image Relationships in Codex Rossanensis

The texts presented underneath the illumination in Codex Rossanensis corroborate the divisive function of the door that the picture there suggests. On the right side, David condemns the foolish virgins: "They were put to shame, for God brought them to naught" (LXX Ps 52:6c).[163] Hosea curses them: "Woe to them, for they turned away from me! Wretches! For they acted irreverently toward me" (LXX Hos 7:13ab). The left side offers versions of two verses from Psalm 45 (LXX 44), a text to accompany a royal wedding. The text on the far left describes a procession of virgins at a wedding: "behind her, virgins shall be led away to the king" (LXX Ps 44:15a). The pronoun refers to the king's daughter from the previous verse in the psalm, which is partially presented in the next column of the manuscript: "all the glory of the king's daughter [is] within" (LXX Ps 44:14a). In its original context, that verse was intended to capture the glorious external ornamentation of the princess while she waits in hiding before the wedding. Her glory is manifest in her clothing, while she is "within" her private chamber before the ceremony. In the context of Codex Rossanensis, however, it is likely that the words "glory within" (δόξα ἔσωθεν) do not describe a bride in her chamber. They evoke both the glory of admission into the wedding feast of eternal life and also the glorious inner self required to gain that admission.

That is to say, the texts do much more than praise or condemn the virgins. They conjure an intertextual web of meaning, whose intricacies can be partially understood by consulting patristic commentaries.[164] For example, in Augustine's interpretation of the parable, the wise virgins had torches that burned with "internal oil, assurance of good conscience, interior glory, and innermost charity."[165] The "interior glory" ascribed to the virgins in the parable may have influenced the reception and transmission of the psalm verse, which in turn influenced the artistic depiction of the foolish virgins at the door with empty flasks. John Chrysostom's commentary on the psalm

takes a similar tack, arguing that the golden garment of the bride should be seen as symbolic of her soul: the "glory within" is the mind, soul, and virtue of the virgin bride.[166] The golden trim of the white garments in Codex Rossanensis perhaps portrays such an interpretation of the psalm. Chrysostom further explains that the psalmist added this phrase to protect against future misinterpretations, lest "any of the more materialistic listeners form an idea [about the bride's garment] at the level of the senses."[167]

Chrysostom sees the wedding imagery of the psalm as an opportunity to play off the marriage metaphors of the New Testament and extend a lengthy string of typological interpretations.[168] The superscription of the psalm as "a song for the beloved" (LXX 44:1) means it was "composed with Christ in mind"; another superscription, "for those to be changed," refers to the "great change" that Christ worked in Christians, transforming them by grace.[169] The "grace" of the psalm (LXX 44:3) calls to mind the incarnation, the "grace which became flesh" at Jesus' baptism (when he was called "beloved").[170] Chrysostom explicitly connects the bride's garment with the ritual of baptism: "It was the king who wove this garment, and she wore it through her baptism."[171] Similar to Codex Rossanensis, he compares the virgins of the psalm with the wise virgins of the parable, who will "go to meet the bridegroom carrying bright and glowing torches and welcome him."[172]

Other connections to Christian initiation—and the imagery of the Dura-Europos baptistery specifically—resound in Chrysostom's exposition of the psalm. The psalm speaks of a "mighty one" as having been "anointed" with the "oil of gladness" (LXX Ps 44:8), just as happens during Christian initiation. Chrysostom connects this with the anointing of Christ by the Spirit at his baptism, which is the type of subsequent Christian baptism. Then, in order to explain why the same figure in the psalm can be both militaristic ("strap your sword to your thigh," LXX Ps 44:4) and peaceful ("fair" and "beautiful" with anointing unguents, LXX Ps 44:4, 8–9), Chrysostom refers to Moses and David as types of Christ. David, an anointed one, was gentle and meek with Saul, but also "the gentle David laid Goliath low, put the army to flight, and carried the day."[173] Elsewhere, in his baptismal catecheses, Chrysostom uses the bride of Psalm 45 as a prototype

of the Christian "bride" at initiation, and he oscillates without hesitation between imagining an initiate as both the *bride* and the *soldier* from this very psalm.[174] Finally, in later traditions, the call of LXX Ps 44:11 for the daughter to "incline your ear" was explicitly connected to the Annunciation (see chapter 5), so that Mary's bent head in the artistic tradition was imagined as a manifestation of the virgin bride in the psalm.[175] Following the trail of Psalm 45 (LXX 44) thus leads us, in the end, back to the baptistery's art and ritual. Chrysostom's interpretations invoke the ideas of incarnation, baptism, anointing, David and Goliath, marriage, and the wise virgins. New artistic comparanda lead to different textual comparanda, and the combinations can generate new interpretations of some very old paintings.

'Til Death Do Us Part?

Earlier in this chapter I wondered who would have the audacity to question a placard in one of the world's greatest art museums. You now know that through the course of writing this book, I have done just that. Am I prepared then to conclude that the painting of the procession of women is a representation of the text of the Parable of the Wise and Foolish Virgins? Through my previous articles and personal communications, I have engaged with the curators of the Dura-Europos Collection at Yale University on precisely this question. As recently as 2010, the painting was identified officially by the gallery as "Women at the Tomb," representational art of a particular text. The curators were subsequently persuaded, though, that such certainty was not warranted, and now, instead of reidentifying the painting with a particular text, the official placard remains open to multiple interpretations. The painting is simply titled "Procession of Women."

The placard goes on to explain the two main options for interpreting the painting, and though I find much more evidence for the wedding-marriage interpretation than the empty tomb interpretation, the gallery's polysemic presentation appropriately honors the lack of consensus among scholars. Moreover, the ideas of marriage, death, and birth are not as easily separated in the premodern worldview as they are for modern western

sensibilities. In almost all instances, marriages were precisely for the sake of giving birth, the wedding night was a consummating beginning of the process toward new birth, and pregnancy was for women fraught with the prospect of death for both mother and child. The polysemic stance of postmodernity—seeing marriage, death, and birth in one image—would not have been foreign to the late ancient viewer.

To wit, John Chrysostom's commentaries and catecheses combine characters, metaphors, and images that modernist thinkers might find difficult to unravel. For example, at one moment during his commentary on Psalm 45 (LXX 44), other parts of which were considered above, Chrysostom has seemingly backed himself into a corner by a typological interpretation: he interprets one of the female figures in the psalm as both the daughter and bride of Christ—an incestuous royal union. To escape this conclusion, he says: "How is his bride his daughter? How is his daughter his bride? . . . He gave birth to her again through baptism, you see, and he also betrothed her to himself."[176] The ritual polysemy of Christian initiation as a birth and a wedding undergirds his textual interpretation of the psalm.

Chrysostom also combines the wedding metaphor with imagery of death: understanding "anointing" as referring to a burial is another acceptable interpretation of the ritual act. In his baptismal catecheses, Chrysostom ruminates on the paradox of Christ as the bridegroom who "lays down his life for his bride," and only because he dies can the marriage exist.[177] Drawing on the "great mystery" of the Pauline author of Ephesians, who links marriage, death, and baptism, Chrysostom proposes that the wedding "gift" brought by the bridegroom before the marriage is his own death, "the ineffable bounty of his love."[178] Similarly, in the opening of Cyril of Jerusalem's baptismal catecheses, the master metaphor is a wedding procession, but the specter of the bridegroom's suffering seems to have haunted the festivities. Cyril teaches the candidates, "Keep unextinguished in your hands the torches of faith you have just kindled, so that here, on all-holy Golgotha, the man who opened paradise to the thief on account of his faith may allow you to sing the bridal melody."[179] When the wedding metaphor of Christian initiation combines with the Pauline "death mysticism" of

baptism, the resulting image is mysterious, macabre, even monstrous.[180] Bridal entry becomes funeral procession, and wedding march becomes funeral dirge. After the fourth century, and especially in the western tradition, the birth and marriage imagery of baptism would give way to such death mysticism from the Pauline tradition. But one can see the change beginning already in the catecheses of Cyril and Chrysostom. Thus the marriage motif dominates, but does not completely subordinate, the notions of death and rebirth.

From Married Virgins to the Virgin Mary

There is yet a third interpretation of the painting. Though I do not find it persuasive, it nevertheless captures a partial truth—and offers a fitting segue between this chapter and the next. Some scholars attuned to noncanonical sources, those crucial repositories of narratives for early Christian art, have seen in the procession of torch-bearing virgins a procession of consecrated virgins to a temple.[181] The practice of maintaining virginal purity in the temple of a god was widespread in the ancient Mediterranean world (e.g., the Vestal Virgins in Rome). The real-life practice was imagined also as a vision of the afterlife, whereby early Christian texts, such as the *Pistis Sophia,* portrayed processions of seven virgins escorting a righteous soul to the heavenly temple.[182] The fact that virgins processing to consecrated life resembled in form virgins processing to a wedding—with veil and torch—should not surprise us. Most likely, the ritualizing of consecrated virginity along the lines of marital customs embodied the motif that virgins were dedicating their virginity, as in a marriage, to a god.

The *Protevangelium of James* employs this tradition in the narration of Mary's childhood. Her parents, Joachim and Anna, offered her to the temple in service of God: "When the child was three years old, Joachim said, "'Let us call *the undefiled daughters* of the Hebrews, and *let each one take a torch,* and let these be burning, in order that the child may not turn back and her heart be enticed away from the Temple of the Lord.'"[183] Later, when the "pure virgins of the tribe of David" are summoned to weave the veil for the temple, the officials find "seven such virgins."[184] As mentioned

above, Aphrahat and Ephrem drew on the virginity of Mary as an inspiration for Christians in Syria to overturn the model of Eve and Adam. In a similar way, the *Gospel of Philip* offers some of the earliest Mariology, setting Mary's virginity and the incarnation of Jesus at the core of its message of salvation, the rectification of the estranged Adam and Eve, the restoration of paradise.[185]

As an artistic comparandum for virgins processing to a temple, David Cartlidge and Keith Elliott have seen the procession of consecrated virgins before Mary, as narrated by the *Protevangelium,* in a painting from El-Bagawat, Egypt (Kharga Oasis). Fifth- or sixth-century frescoes in the "Exodus chapel" of the Christian necropolis there show a procession of seven veiled, torch-bearing women approaching a tetraprostyle (four frontal-columned) temple. They are labeled "virgins" (*parthenoi*), and St. Thecla, whose life was a paradigm of consecrated virginity, is pictured above. Cartlidge and Elliott suggest that both the Dura-Europos and the El-Bagawat processions may be the virgins going to the Jerusalem temple with the Virgin Mary.[186] However, in his treatment of the materials related to the cult of Thecla in Egypt, Stephen Davis has argued persuasively from the funerary context that the painting represents a heavenly procession of virgins: "In this context, the seven virgins approaching the temple probably are meant to represent the celestial choir of virgins, who lead the deceased up toward the heavenly Jerusalem."[187] Thus neither the painting from El-Bagawat nor the traditions of consecrated virginity are the best comparative materials for the procession at Dura-Europos, which does not show seven women or approach a temple structure.

Yet as I said, this line of inquiry carries forward a partial truth. Just as virginity, marriage, birth, and death were not easily separable phenomena in antiquity, so also the Christian notions of virginal purity, spiritual marriage, union in the bridal chamber, and new birth were not easily separable from each other, nor from the archetypal incarnation of Christ in the Virgin Mary. The descent and embodiment of the Holy Spirit in Mary's virginal womb produced the result of a marital union—a new birth—even though no typical marriage occurred. In the words of one fifth-century writer, the anointed one came forward like the sun "from the virginal womb

in the splendor of eternal life," he "shone the true light to minds, and he has stepped forth from the Virgin just like the bridegroom from the bridal chamber."[188] In other words, like a font at initiation, the incarnation of God's Spirit thus condensed the motifs of marriage and birth, making Mary's womb both a bridal chamber and a temple of God's illuminating presence.

This chapter began by imagining the Dura-Europos baptistery as a tomb. More fitting than that is the motif of the bridal chamber. But with one more painting left to examine, can this font also have been a womb?

A Woman at a Well

OF THE MANY MEANINGS and metaphors attached to the rites of initiation, a central one remains to be examined: how did Christians in Dura-Europos imagine the descent, reception, or incarnation of the Holy Spirit?

In his study "Baptismal Patterns in Early Syria," liturgical historian Bryan Spinks records a hunch about how Syrian Christians understood the connection between the ritual of anointing and the descent of the Holy Spirit at initiation.[1] What text or narrative would they have had in mind to lend meaning to the ritual? Previous scholars have usually looked to the baptismal accounts of Jesus himself, and indeed there is evidence to support a notion of Christ's baptismal "initiation" as the exemplar for Christians' initiations.[2] Spinks notes, however, that the distinctive *pre*baptismal anointing in Syria does not correspond to the accounts of Jesus' baptism: "In the Synoptic accounts of the baptism of Jesus, for all their differences, the descent of the Spirit, or messianic declaration, comes *after* the baptism in water. A better paradigm might be *theological,* namely, *the incarnation of Jesus and then his baptism,* where the messianic Spirit hovers at conception to bring forth new birth. The themes of the invocations on the oil combine new birth and fertility, as well as cleansing and remission of sins."[3] Drawing on his vast knowledge of Syriac ritual texts, Spinks conjectures that the analogy Christ's incarnation : baptism :: Christians' anointing : baptism would better connect biblical narrative to ritual logic. Gregory the Great also connects the incarnation to anointing when interpreting the "oil of gladness" from Psalm 45: "To be conceived by the Holy Spirit of the flesh of the Virgin was itself to be anointed by the Holy Spirit."[4] Christ's

incarnation was his anointing, and Christian anointing enacted, in turn, an incarnation and new birth in the Spirit.

We now follow Isseos toward the door exiting the baptistery, looking again at the southern wall, where he was anointed. I argue that Spinks's hunch can find support from the final extant painting in the Dura-Europos baptistery: the figure of a woman at a well on the western part of this wall. Despite the nearly unanimous opinion that the painting portrays the Samaritan Woman from the Gospel of John—known colloquially as "*the* woman at *the* well"—I contend that the painting ought *at least* to be interpreted as polysemic and ought *probably* to be interpreted as a portrayal of a different, even more famous "woman at a well": the Virgin Mary at the Annunciation and incarnation of Jesus. Like the procession of women, this figure models the ritual activity of the initiates: through a divine encounter at a well of water, she receives the illumination and incarnation of the Holy Spirit.

Challenging the Consensus: Which Woman Is It?

On the southern wall, near the baptismal font, one sees a woman bent over a well (plate 9 and fig. 5.1). She is holding the rope of her water vessel and looking out at the viewer, or perhaps over her shoulder. She is alone. There was space to paint another person behind her, as plate 9 shows, but that space is empty.[5] The image has usually been regarded as depicting the Samaritan Woman at the Well—according to Kraeling, "interpreters have had no doubts"—and almost no one has doubted it since. Indeed, there are connections with baptismal ritual to warrant that identification.[6] The pretext for the episode in the Gospel of John is that Jesus was under suspicion of "making and baptizing more disciples than John [the Baptist]" (John 4:1), and so he left Judea and headed back to Galilee, passing through Samaria.[7] The baptismal allusions continue at the well of Jacob, where he engages the woman in a dialogue about "living water" (ὕδωρ ζῶν), a phrase that carries a double entendre. She thinks he is speaking about water that is moving and thus fresh—our metaphor is "running" water; theirs was "living" water—instead of stagnant water, but he explains that he can

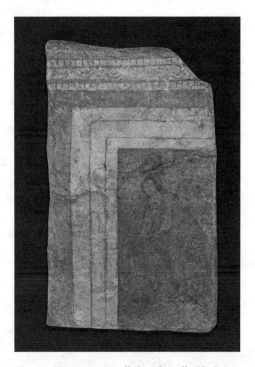

Fig. 5.1. Woman at a well. South wall, Christian
building. Exhibition photograph. (Yale Uni-
versity Art Gallery, Dura-Europos Collection)

give what becomes "a spring of water gushing up to eternal life" (4:14).
This continues Jesus' teaching that "water and spirit" are necessary for
eternal life (3:5).

Other early Christian texts resonate with this text-image relationship.
The promotion of "living" or "running" water as the best water for Chris-
tian baptism is exemplified in the *Didache* (ὕδωρ ζῶν, 7.1–2), likely of
Syrian provenance. The common interpretation of the Samaritan woman
as a sinner in need of repentance also implies the connection of baptism
with repentance in early Christianity (e.g., Mark 1:4–5). Some early Chris-
tian authors, such as Tertullian and Ephrem, connect the Samaritan
Woman directly to baptism,[8] and the narrative may even have had a litur-
gical *Sitz im Leben* during the ancient catechumenate, at least as attested in

the fourth-century West.[9] Finally, one other baptistery from late antiquity, San Giovanni in Fonte (Naples), includes the Samaritan Woman with Jesus as part of its artistic program.[10] Seeing the painting at Dura-Europos as the Samaritan Woman has often encouraged, therefore, an interpretation of the baptismal ritual primarily as repentance and cleansing of sin through living water.

We should recall, though, that women visit wells all over the biblical landscape. Betrothal at a well is a type-scene in the Hebrew Bible: Rebecca and Isaac, Rachel and Jacob, Zipporah and Moses. Each meeting involves courtship and marriage, and the Gospel of John adapts this motif or "bends the genre," subverting the expectation of its audience.[11] What's more, the absence of Jesus from this painting distinguishes it from all the other well-known representations of John 4, as we will see below. In other examples, the Samaritan woman stands in a posture of dialogue with Jesus, who sits on or stands near the well. Below we analyze other features that are formally incongruous with the Samaritan Woman. For some of these reasons, Kraeling himself hesitated in his identification and entertained the possibility that the biblical account of *Rebecca* at the well (Gen 24) had inspired the image in question, on the basis of Ephrem's many allusions to Rebecca and Laban and also the geographical proximity of Dura-Europos to the legendary site of that event (in Harran, Roman Carrhae, northern Mesopotamia).[12] Ultimately, though, the evidence for Rebecca is weak, and Kraeling opted for the accepted identification of the painting, thereby solidifying the consensus about John 4. Until now, I know of only one other scholar who has dissented from it.

The Annunciation at the Well: Textual Traditions

Dominic Serra has suggested, in a very brief treatment, that a noncanonical tradition captured in the *Protevangelium of James* might better explain the image.[13] He proposes that the more prominent "woman at the well" in Syrian Christianity was the Virgin Mary, and my own research expands into a full argument what he first noted in a short paragraph.[14] According to the *Protevangelium,* Mary was no mean peasant, but the beloved

daughter of the wealthy Joachim and Anne. They consecrated her to the temple, and she was chosen as one of the "pure virgins of the tribe of David" called forth to work on weaving the veil for the temple of the Lord.[15] Through a casting of lots, she received the "scarlet" and the "pure purple" threads to spin as her service. But one day, during a break from her work, "she *took the pitcher and went forth to draw water,* and behold, a voice said: 'Hail, you are highly favored, the Lord is with you, blessed are you among women.' *And she looked around on the right and on the left to see from where this voice could have come.* Then trembling she went [to her house?] and put down the pitcher and took the purple and sat down on her chair [throne?] and drew out (the thread)."[16] In this narrative tradition, the initial greeting of the angel occurs not inside, but outside; not in Mary's home or the temple, but at a nearby water source—either a well or a spring. Next, after she was back at home spinning, "an angel of the Lord stood *before her*" and this time she *saw* it. Only then did the angel continue with the speech so familiar from the canonical account of the Annunciation (Luke 1:26–38).

It is important to note straightaway that the *Protevangelium of James,* also called the "Nativity of Mary," the "Revelation of James," or the "Book of James" in late antiquity, was no fringe text. It was likely composed from oral traditions in the mid-second century and was widely disseminated, especially in the East. Manuscripts of it exist in every relevant language from late antiquity through the medieval period: Greek, Syriac, Coptic, Armenian, Latin, Ethiopic, Georgian, Arabic, and Old Church Slavonic.[17] As Stephen Shoemaker has shown, texts such as this one, surviving in "almost innumerable copies" and transmitting "among the most influential extrabiblical traditions of the Christian faith," are not properly thought of as "rejected scriptures" or failed Gospels.[18] On the contrary, "some are better understood as an accepted part of ecclesiastical Tradition," especially "the Marian apocrypha of early Christianity."[19] Shoemaker notes that "even an arch-conservative such as Epiphanius cites apocryphal material as an authoritative part of Christian Tradition," recounting information about Mary's parents drawn from the *Protevangelium.*[20] As the narration of the oldest extant hagiographic tales about the young Mary, the *Protevangelium* was inevitably popular, and this popularity was then augmented by the

rising attraction of asceticism and consecrated virginity during the third and fourth centuries. That is to say, the text's predominant motif is the virginal purity of Mary.

Moreover, George Zevros has argued that the oldest manuscript of the *Protevangelium of James* (from the Bodmer papyri) reveals an even earlier layer of the narrative.[21] Zevros removes the secondary "corrective" hand from the papyrus and aims not to assimilate the first hand's version to later versions in the manuscript tradition. What he concludes is that this ancient, perhaps early second-century, narrative did not include a "second Annunciation" at Mary's house at all. Rather, she heard the voice while drawing water and then returned to *the temple*, from whence she had come. Indeed, according to Tacitus, there was an "ever-flowing spring of water" there; this may or may not be the same as that which later came to be called the "Fountain of the Virgin," because of "an opinion that she frequently came hither to drink."[22] Zevros shows that the references to Mary's "house" are "foremost among the secondary passages which assist in harmonizing the interpolated canonical material" from Luke with this other ancient tradition.[23] He argues that each instance of Mary going to her house impedes the normal flow of the narrative, which is otherwise focused on her life as a consecrated virgin in the temple. If Mary returned to the temple after the Annunciation, that would also help to explain why her seat is called by the elevated term "throne" (θρόνος).[24] Zevros's assessment deserves serious consideration, based as it is on papyrological evidence, a logical analysis of the narrative's redactions, and the theological connection to the temple. Indeed, at this chapter's end, artistic evidence will be offered that may support his theory.

Other textual traditions corroborate the importance of what we call the "Annunciation at the Well" or the "Annunciation at the Spring." The so-called "Gospel of Pseudo-Matthew," which was also called "The Nativity of the Blessed Mary and the Infancy of the Savior," is later than the *Protevangelium of James* and flourished mostly in the West. However, it too had a great influence on the history of Christian art and piety. Its recounting of the two annunciations specifies in the first one the "fountain/ spring" and eliminates the previous tradition of the angel's initial invisi-

bility: "And on the second day, while Mary was at the fountain to fill her pitcher, the angel of the Lord appeared to her, saying: Blessed are you, Mary; for in your womb you have prepared a habitation for the Lord."[25] It also connects the notion of illumination to the incarnation as the angel continues: "For, lo, the light from heaven shall come and dwell in you, and by means of you will shine over the whole world."[26] The following day finds Mary back at home spinning and receiving the second visit from the angel.

In other eastern traditions of the life of the Virgin, the Annunciation at the Well is emphasized and even interpreted. The various versions of the "Armenian Gospel of the Infancy" narrate the Annunciation at a water source, one of many connections in textual and artistic traditions between Syria and Armenia.[27] Ephrem seems to presume an Annunciation at a well during his *Hymns on Nativity:* "Come all you mouths, pour out and become *a type of water and wells of voices;* let the Spirit of truth come! Let Her sing praise in all of us to the Father who redeemed us by His Child. Most blessed of all is His birth!"[28] Finally, the great Byzantine theologian Maximus the Confessor, whose *Life of the Virgin* has recently been translated by Stephen Shoemaker from the surviving manuscripts in Old Georgian, waxes eloquent about the fittingness of the place of Annunciation: "the archangel Gabriel was sent by God . . . and he announced to the Virgin Mary the glorious and wonderful Annunciation, ineffable and incomprehensible, the foundation and beginning of all good things. And when, how, and where did the Annunciation take place? The virgin was fasting and standing in prayer near a fountain, because she conceived the fountain of life."[29]

Let us now return to ponder the figure at Dura-Europos. At the first Annunciation scene in the *Protevangelium,* Mary's certainty of her solitude is characterized by her looking all around in wonderment for whence the voice could have come (πόθεν αὕτη εἴη ἡ φωνή). There is no indication that the voice came from an angel; indeed, the voice of God—or the *bat kol* of Hebrew tradition—is more likely.[30] Therefore, one cogent explanation of the vacant space behind the woman in the Dura-Europos image is that it represents (or rather, does *not* represent) the bodiless voice of the apocryphal Annunciation.[31] In the story, as in the art, the Annunciation's speaker

was invisible. From behind Mary, on the wall as in the narrative, the absence speaks.

Ancient Annunciations: Artistic Comparanda

With a thriving devotion to Mary already developed in the first Christian centuries, it is not surprising that she began to be portrayed artistically. Indeed, in some locales, she came to be depicted more prominently and frequently than Christ himself. But can most modern viewers—even frequent museum-goers—call to mind an image of the Annunciation to Mary at a spring, fountain, or well?

Viewers of art in the modern West can be forgiven for not imagining the Annunciation at a well. Most of us have in mind some Renaissance masterpiece, such as Botticelli's in the Uffizi museum (1489). Or consider an example exhibited closer to my own home: when I take my students to the medieval Cloisters Collection of the Metropolitan Museum of Art, we behold the exquisite indoor, domestic Annunciation scene of Robert Campin (fig. 5.2, ca. 1427–32). Though innovative in its time, it yet retains formal features of late Byzantine and medieval iconography: Mary is seated and reading (presumably the prophecies about her recorded in scripture); the lines of incarnation subtly penetrate the glass of the window on the left side of the painting and approach her womb; the angel Gabriel is visible in human form, and she will encounter him face-to-face. But a closer look at the scene, with a different artistic trajectory in mind, shows that Campin has also retained a feature from the ancient tradition of the well. Like a vestigial organ, past which the Annunciation's artistic form has evolved, this object sits nonetheless at the *center* of the scene. There on the table—forgotten but not gone—rests Mary's old pitcher of water, repurposed as a vase for a flower.

The artistic traditions of the Annunciation that led from antiquity to the Renaissance cannot be perfectly charted, but we can collect a morphology of types from our extant sources that helps to demonstrate the options available in late antiquity and the Byzantine era. At its basic level, the iconography can consist of merely a woman and a winged angel standing together, as on some Byzantine censers; in a context of a cycle of scenes,

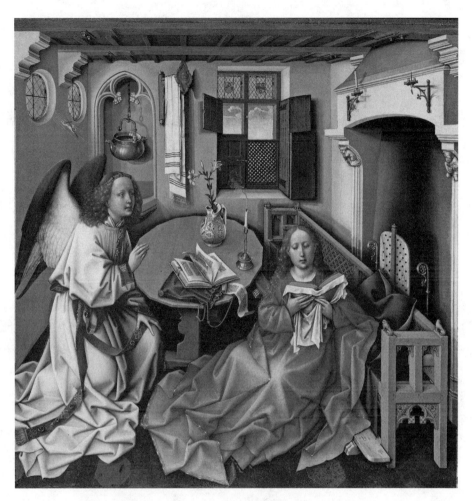

Fig. 5.2. Middle panel of the Annunciation Triptych (Merode Altarpiece), Robert Campin and assistant, ca. 1427–32. (The Metropolitan Museum of Art, New York, 56.70b. The Cloisters Collection, 1956. www.metmuseum.org.)

that is enough to signify the Annunciation. Most types fill out details of various narrative traditions, and the most important of these follow below, according to my own classification system.[32]

Before that, however, two anomalous Annunciation types from the Roman catacombs must be briefly summarized. In one of the oldest parts

of the catacomb of Priscilla, in the upper-right corner of an arcosolium, an image of a mother holding her infant was painted.[33] A male figure next to her extends his arm, pointing either at her or upwards. Modern viewers have typically seen a particular photograph of the restored painting that appears to show a veiled mother and the male figure pointing up at a star. This would be Mary holding Jesus, with a figure, either an angel or a prophet (such as Balaam, Num 24:15–17), indicating the prophesied star of the incarnation and nativity. However, scholars have recently interrogated these identifications. Geri Palbry has noted that the oldest drawing of the scene, done by Antonio Bosio, contains "no star above the head of the woman and the figure standing in front of them is clearly pointing at them and not up into the sky."[34] Prominent catacomb explorer Josef Wilpert, in fact, has been accused of "touching up" the painting in the early twentieth century, and contemporary Italian archaeologist Fabrizio Bisconti "uncovered evidence of changes in the painting," including a different type of paint used for part of the male figure and the star.[35] Recent scholars have argued, then, that this fresco may be "a poignant funerary portrait of a dead mother and child."[36]

A second Annunciation type, evidenced elsewhere in the catacomb of Priscilla and also in that of Peter and Marcellinus, features a seated woman being addressed in speech by a standing man. Regarding the better preserved example from the catacomb of Priscilla, Bosio's drawing shows a togate, senatorial Roman man with his arm extended in speech to a "seated woman veiled and looking downcast."[37] If correctly identified, this would probably be the oldest scene of the Annunciation proper, but Bosio did not identify it as such. In recent decades, many historians have agreed with Bosio, since the scene lacked features to distinguish it from other scenes of formal address.[38] In a recent survey of the materials, art historian Elżbieta Jastrzębowska has argued that such a scene is "insufficiently specific," lacking any of the indicators from Marian tradition—a water source, a water vessel, spinning instruments—that signify an Annunciation dialogue.[39] In any case, even if these two catacomb paintings were intended as Annunciation scenes, these types did not become commonplace in the artistic traditions of the Annunciation, to which we now turn.

A Morphology of Annunciations

1. Aside from the disputed examples from the catacombs, the most ancient extant type seems to be the Annunciation *At the Spring*. In this type, Mary stoops down with a pitcher in order to draw water from a spring or water-fall that flows out from a rock. She usually looks backward, over her shoulder, at Gabriel who approaches from behind. Probably the oldest example is preserved on the sarcophagus of Adelphia (fourth century, Syracuse), which is distinctive among the group in its portrayal of a bearded divinity—presumably that of the water source—emerging from the top of the rock.[40] Anthropomorphic divinities of rivers and water sources were not uncommon in ancient or early Christian art (e.g., the Jordan River can be depicted in human form), but in this group the other extant examples show only the water or perhaps a tree sprouting nearby.[41] The paradigmatic example of the group is probably that from an ivory book cover (fifth century, Milan), which shows Mary adorned in a dress and necklace (fig. 5.3).[42] Another fifth-century example occurs on the "Werden casket" (Victoria and Albert Museum, London).[43] Examples from the East include a terracotta pilgrim token (ca. sixth century, Monza) from Palestine, about which more will be said below, and the Egyptian "Mary Silk" textile (Abegg-Stiftung, Riggisberg, Switzerland), which is unique in not showing a water source next to Mary's pitcher.[44] Instead, the scene abuts a nativity scene with a brick manger and a donkey.[45] Finally, an Armenian manuscript illumination varies the theme by showing a kind of water spigot or pipe, under which Mary holds her pitcher.[46]

2. The *Spinning, Looking Back* type bears some formal similarity to the At the Spring type, in that Mary is otherwise occupied with a domestic task when Gabriel surprises her from behind. But here she is indoors and spinning—the second Annunciation scene from noncanonical sources. The most well-known example comes from a metal pilgrimage flask (sixth century, Monza), in which Mary looks back from her work to see Gabriel, who points up to the greeting, "Hail!" (see more below) (fig. 5.4).[47] Another pilgrimage flask from Bobbio, Italy, places the basket of thread in between Mary and the angel, similar to a scene on a well-preserved ivory pyxis (sixth

Fig. 5.3. At the Spring type of Annunciation (upper left) on ivory diptych (detail of two Marian scenes). Milan Cathedral treasury. (Carlo Romussi [public domain])

century, Cleveland), in which a seated Mary looks back over the basket at Gabriel.[48] Finally, at least four censers from Palestine or Syria display this type in their cycle of scenes about the life of Christ.[49]

3. The oldest extant mosaic of the Annunciation, at Santa Maria Maggiore (fifth century, Rome), shows the *Spinning, Seated, Face-to-Face* type. Here, like a Roman matron, Mary sits and spins thread that comes up from a basket next to her (fig. 5.5).[50] Another contemporaneous or possibly earlier example can be seen on the left side of the "Pignatta" sarcophagus (fifth century, Quadrarco di Braccioforte, Ravenna).[51] In this seated Annunciation type, Mary is sitting on a low stool (not a high-backed chair), and Gabriel stands facing her, whereas the mosaic example shows Gabriel flying in from above. A gold medallion found in Egypt, probably produced in Constantinople in the sixth century, resembles the Pignatta sarcophagus example in form, as does another medallion from Adana, a sixth-century ivory now housed in Moscow, and at least one Byzantine censer.[52] A pilgrimage ampulla, or oil flask (Israel Museum), deemphasizes the spinning activity and thus serves as a segue to the next Annunciation type.[53]

Fig. 5.4. Spinning, Looking Back type of Annunciation on metal pilgrimage flask (detail). Monza. (From André Grabar, *Les Ampoules de Terre Sainte* [Paris: C. Klincksieck, 1958], pl. VI. © Klincksieck, Paris 1957)

Fig. 5.5. Spinning, Seated, Face-to-Face type of Annunciation. Mosaic (detail), Santa Maria Maggiore, Rome. (Wikimedia Commons)

4. Several examples of the Annunciation show an *Ambiguous Rope-to-Vessel* type, which seems to have evolved from the spinning types (thread-to-basket) but also bears resemblance to some well types below (rope-to-well). A clear example of this is an amuletic silver armband from sixth- or seventh-century Egypt, which shows in a *locus sanctus* (holy site) cycle a vessel between Gabriel and Mary and a squiggly line coming up from it (fig. 5.6, photograph of Annunciation and rollout of entire armband).[54] A Syrian pilgrim token shares the form, though it is too small and worn to know for sure.[55] An octagonal marriage ring (sixth to seventh century, Constantinople) from the Walters Art Museum also shows Mary leaning over toward an ambiguous vessel, while Gabriel points up at a cross or star above (fig. 5.7).[56] This type is sometimes difficult to distinguish from scenes of

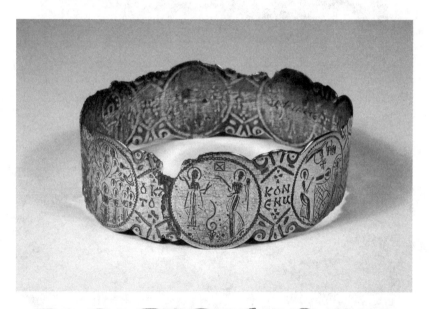

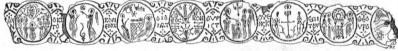

Fig. 5.6. Amuletic silver armband (photo and panoramic drawing) with *locus sanctus* scenes and Ambiguous Rope-to-Vessel type of Annunciation. (Museum of Art and Archaeology, University of Missouri)

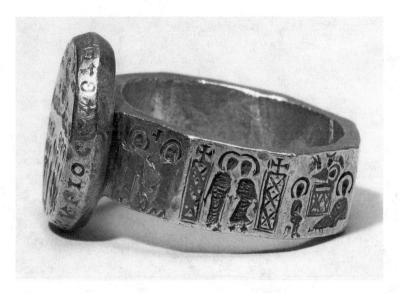

Fig. 5.7. Marriage ring with *locus sanctus* scenes, sixth to seventh century. The Ambiguous Rope-to-Vessel type of Annunciation appears closest to the bezel. (The Walters Art Museum, Baltimore, 45.15)

Jesus' baptism in the *locus sanctus* cycle on pilgrimage items; on the right stands an angel, on the left stands a figure bent over touching a central item (baptizing a small head or touching a vessel), and above is a symbol (dove, star, or cross).

What is crucial to note about this ambiguous type is that later in the iconographic tradition, the rope coming out of a central vessel will evolve to become the stem of a flower coming out of a vase. Recall Mary's water pitcher–cum–flower vase in the center of Robert Campin's famous Annunciation. In fact, there are hundreds if not thousands of examples of this feature; in anthologies of Annunciation scenes, a vase of flowers or a small tree is found more often than not next to Mary or in between Mary and Gabriel.[57] Often, it is only a small vase of flowers in between them, but many examples show a long lily plant growing up from a vase on the floor, which clearly has been adapted in form from the Ambiguous Rope-to-Vessel type (e.g., Simone Martini's altarpiece, 1333, Uffizi; fig. 5.8).[58]

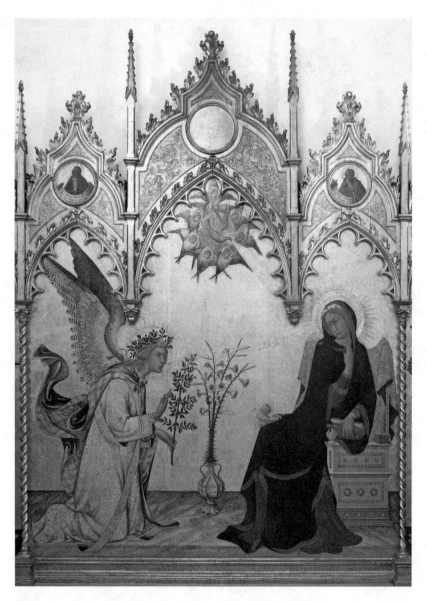

Fig. 5.8. Annunciation altarpiece. The Ambiguous Rope-to-Vessel type of An-
nunciation has evolved to show a lily growing from a vase. Simone Martini and
Lippo Memmi. Uffizi Museum. (Wikimedia Commons)

5. Some examples show Mary not in the act of domestic work—whether drawing water or spinning—but sitting or standing *With Spinning Tools,* especially the distaff. An accessible example of this type can be seen in a meticulously preserved reliquary of the true cross from the early ninth century (fig. 5.9). Mary's basket sits in the center between her and Gabriel, though no thread extends to her distaff.[59] Syriac illuminated manuscripts from the sixth to seventh century also feature this type.[60] The sixth-century ivory throne of Maximian offers an example of Mary seated and holding her distaff in her left hand, with her basket of thread on

Fig. 5.9. Underside of the lid of the Fieschi Morgan Staurotheke, early ninth century. The upper left quadrant shows the With Spinning Tools type of Annunciation. (The Metropolitan Museum of Art, New York, 17.190.715. ab. Gift of J. Pierpont Morgan, 1917. www.metmuseum .org.)

the floor between her and the angel.[61] The same type is shown on the sixth-century ivory book covers of the Etchmiadzine Gospels and the St. Lupicin Gospels.[62]

6. Other examples present Mary neither at work nor holding her tools, but instead display a *Vestigial Vessel*—either a water pitcher or a thread basket—nearby. The ivories of the Grado Chair (sixth to seventh century), for example, show Mary standing with nothing in her hands, but in the bottom corner of the scene rests her basket with distaff sticking out of it.[63] A seventh-century wall painting in Santa Maria Antiqua in Rome is only partially preserved, but the vestigial basket sits similarly on the floor by her feet.[64] The eighth- to ninth-century silk from the Sancta Sanctorum in the Vatican shows Mary's basket next to her on a side table, while one type of Byzantine censer depicts some kind of vessel in between a standing Mary and Gabriel.[65] A variation on this type shows not a vestigial vessel but a vestigial spring of water: a carved wooden door from Egypt presents Mary holding a book, but in the background, behind Gabriel, flows a spring of water, recalling the early tradition.[66]

Most interesting for our purposes, though, is the Syriac church of Mar Musa al-Habashi, whose triumphal arch is surrounded by an Annunciation scene (introduced in chapter 4; fig. 5.17 below). Though the wall is only partially preserved, its type shows Mary looking back at Gabriel, with her left hand outstretched in surprise. Because of damage to the painting, it is not clear whether she holds anything in her right hand, but according to Erica Cruikshank Dodd, who published the paintings, "a water jug in the corner indicates that the scene takes place beside a well. The jug is decorated with blue and white vine scrolls."[67] It is important to remember that here, more than eight hundred years after the paintings at Dura-Europos, is the *next* preserved program of church paintings in Syria. And this church included *both* a procession of torch-bearing virgins *and* an Annunciation scene with lines of incarnation and a vestigial water pitcher.

7. Finally, we turn to Annunciation scenes at a well. Several examples of illuminated manuscripts from Syria and Armenia show the Annunciation *At the Well, Face-to-Face*. One form of this type shows an outdoor water well stationed between Gabriel and Mary, though Mary stands par-

tially inside a doorway, or just in front of a covered throne (examples at the British Museum and Vatican Library).[68] Possibly the oldest version of the indoor-outdoor hybrid is a sixth-century ivory pyxis, which seems to show Mary seated under an arcade but Gabriel flying toward her over a well.[69] Some types are fully outdoors, such as a beautiful example from Midyat in Tur Abdin (fig. 5.10; southeast Turkey/northeast Syria, 1226).[70] It comes much later than Dura-Europos, of course, but is proximate geographically. In terms of church paintings, an alleged Annunciation at the well from Pera Chorio, Cyprus (1160–80) is badly damaged, but those who have seen it

Fig. 5.10. Annunciation of the At the Well, Face-to-Face type. Syriac manuscript from Midyat, Syro-Orthodox Diocese, folio 14v. (Originally published in Jules Leroy, *Les manuscrits syriaques à peintures conservés dans les bibliothèques d'Europe et d'Orient.* 2 vols. [Paris: Paul Geuthner, 1964], 2:105, fig. 1. Courtesy Éditions Guethner.)

firsthand describe it as this type.[71] A perfectly preserved version exists at the fourteenth-century church in Decani, Serbia, with a pitcher dangling its rope as Mary looks above the well toward a flying Gabriel.[72]

Some Armenian manuscripts resemble the versions in Syriac illuminations, but others offer their own spin on the At the Well, Face-to-Face type.[73] The Armenian style tends to place a pitcher not in Mary's hand, but below the well, and in some instances, water is flowing out from the well into the pitcher. Mary is usually holding her spinning tools in one hand, showing surprise with the other, while the well pours forth on its own into a pitcher, thus offering a hybrid of the types that emphasize drawing water and spinning thread. Thomas Mathews argues that this well is "more than a narrative detail" and that "both well and vessel are common metaphors of the Blessed Virgin in the hymns of the Armenian church, which refer to her as the 'fountain of living water' and the 'golden pitcher.' "[74] The stunning illumination of the Annunciation in the Gladzor (Glajor) Gospels exemplifies this tradition (fig. 5.11).[75] Here we also see that the Ambiguous Rope-to-Vessel type in the center has evolved in this regional tradition to become a tree sprouting directly behind the central water well (cf. other examples from Venice and Jerusalem).[76] In the fourteenth century, the painters of Glajor began showing not one but two streams of water flowing from the well into a basin or the pitcher itself, "a perfectly gratuitous detail" in the words of Mathews, and thus quite inviting of an allegorical interpretation.[77] An example from New Julfa, an Armenian enclave in Iran, shows the two streams flowing and Mary holding her pitcher in her left hand.[78] Never having accepted the Christological formula of Chalcedon (451), the Armenian tradition continued to use metaphors of "mixing" to describe how Christ had both divine and human natures. The two-spigoted well pouring into one receptacle (Mary's womb) was thus an apt pictorial icon for Armenian Christology.

8. Last, we turn to the type that most formally resembles Mary's portrayal at Dura-Europos, if indeed it is Mary depicted there. The *At the Well, Looking Back* type is well-attested, but not very early in the extant materials. One possible example from late antiquity is a censer with a unique Annunciation type, in which Mary's body is crouched down and looking

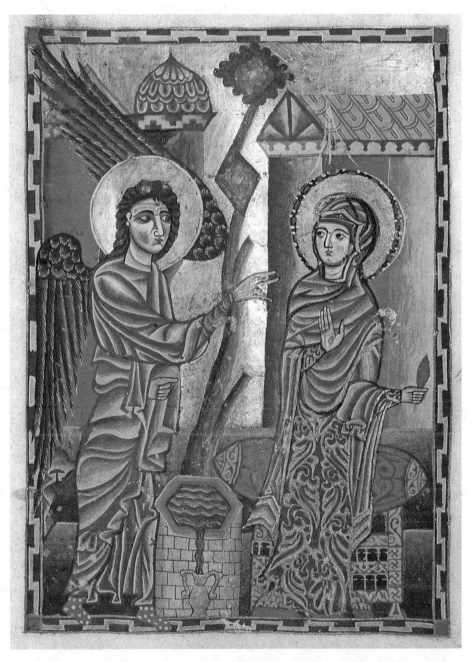

Fig. 5.11. At the Well, Face-to-Face type of Annunciation. Gladzor (Glajor) Gospels. University of California–Los Angeles. (Creative Commons)

back from her work (as in several examples of the At the Spring type), but here she holds a rope-to-vessel. Housed in Tbilisi, Georgia, a clear photograph of this scene exists in Ilse Richter-Siebels's 1990 dissertation, but it is nonetheless difficult to discern whether it was intended as a spinning or drawing water type (fig. 5.12).[79] The tree growing near the vessel suggests the outdoors (drawing water), but there may also be part of a chair showing behind Mary, which would suggest the indoors (spinning). After this ambiguous example, the At the Well, Looking Back type is not evidenced until the eleventh century and later.

Though coming centuries later than the art of Dura-Europos, illuminated manuscript pages of the Annunciation from Byzantine manuscripts bear arresting formal resemblance to it. Several examples show a solitary

Fig. 5.12. At the Well, Looking Back type of Annunciation. Byzantine censer. Tbilisi, Georgia. (Originally published in Ilse Richter-Siebels, "Die palästinensischen Weihrauchgefäße mit Reliefszenen aus dem Leben Christi" [Ph.D. diss., Frei Universität Berlin, 1990], labeled "Tiflis 1," Fig. 95)

Mary at a well, paused in her work and looking back or up at an approaching Gabriel (fig. 5.13, eleventh century).[80] Some examples, such as the brilliantly preserved illumination in James of Kokkinobaphos's *Homilies on the Virgin*, are shocking in their formal similarity (fig. 5.14, twelfth century). It was this image, in fact, that first sparked my interest in revisiting the identification of the painting from Dura. Versions preserved in both the Vatican Library and the Bibliothèque Nationale in Paris show Mary grasping her rope, which goes down into the well.[81] This iconographic Annunciation type developed from a tradition of illuminated manuscripts of the life of Mary.

The most familiar version of this type is probably that from the well-touristed San Marco in Venice. The western vault of the northern transept contains twelfth-century mosaics of the life of the Virgin, and the Annunciation type matches those from illuminated manuscripts of the era (fig. 5.15).[82] Perhaps the grandest extant version of this scene is a mosaic from the inner narthex of the Late Byzantine monastery at Chora in Istanbul.[83] As with the previous examples that feature a flying Gabriel, Mary looks over her shoulder at the angel approaching from above, here coming from a different panel of the artistic program. This female figure can be contrasted with the portrayal of the Samaritan Woman in the same church, who is looking toward Jesus in a posture of dialogue, just as in other iconography of that scene (see

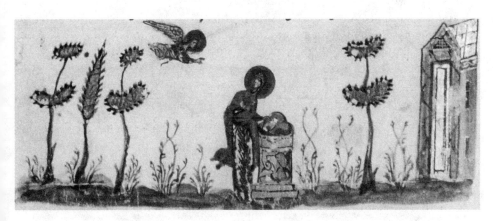

Fig. 5.13. At the Well, Looking Back type of Annunciation. Illuminated Gospel book, ms. grec 74 (detail). (Bibliothèque nationale de France)

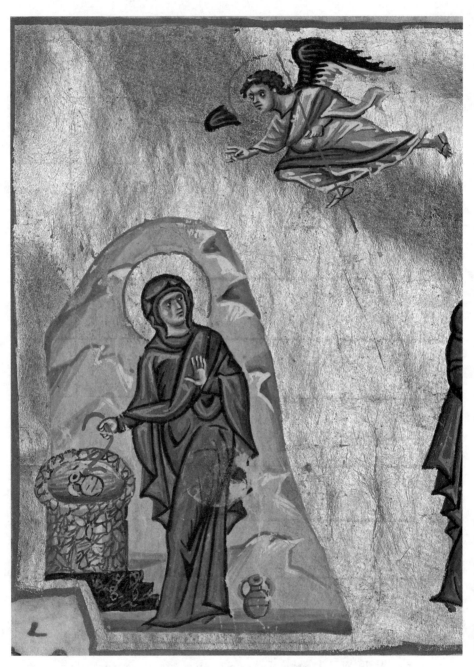

Fig. 5.14. At the Well, Looking Back type of Annunciation. James of Kokkinoba-phos, *Homilies on the Virgin,* ms. grec 1208 (detail). (Bibliothèque nationale de France)

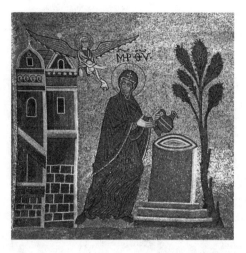

Fig. 5.15. At the Well, Looking Back type of
Annunciation. Museo di San Marco, Venice.
(Wikimedia Commons)

below for examples). Finally, the Armenian tradition varies slightly, show-
ing Mary standing at a two-spigoted water source, looking back at a stand-
ing Gabriel, with her water pitcher up on her shoulder.[84]

Looking Again at Dura's Woman at a Well

With this tour of the morphological variety for the Annunciation fresh in
mind, we return to the most ancient woman at a well. Most viewers of the
scene at Dura-Europos see only the features discussed so far: a woman, a
rope, and a well. However, a close reading of the archaeological report, cou-
pled with the photo in situ (see plate 9), reveals other details. Upon in-
spection, one can see that the supposed absence behind the female figure
is not totally silent—it speaks a couple of lines. That is to say, the painting
at Dura-Europos shows two lines touching the woman's back, lines that
grow wider with distance from her body. The lines are difficult (but not
impossible) to see in the photos of the wall in situ; but more importantly,
they are included in one of the drawings in the archaeological report—the

Fig. 5.16. Tracing of Woman at a well. Christian building. (Yale University Art Gallery, Dura-Europos Collection)

"new tracing" done in the field specifically "*to show additional details*" (fig. 5.16).[85] The lines are not depicted, however, in the drawing most commonly reproduced.[86] In Kraeling's text they are described simply as "unexplained."[87] But with the new interpretation of the female figure, in connection with later iconography, the lines invite a rather evident meaning. They represent a motion toward the woman's body, as if something were approaching her or entering her—an incarnation.

As we have already seen, the iconography of the Annunciation from the Byzantine era in the East frequently portrayed lines coming from heaven, often with a dove included as well.[88] These lines of incarnation are shown on the next available church art from Syria—at Mar Musa al-Habashi (fig. 5.17)—and in illuminated Syriac manuscripts from that era.[89] Virtu-

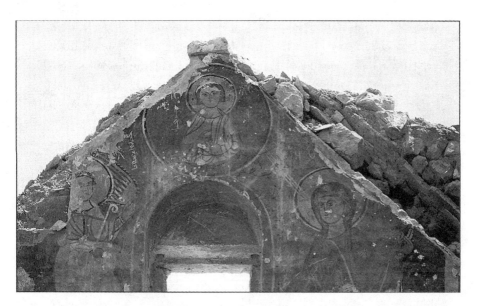

Fig. 5.17. Christ Emmanuel and the Annunciation. The chapel, east pediment over the triumphal arch. Mar Musa al-Habashi. (Erica Cruikshank Dodd)

ally all Armenian illuminated manuscripts portray the lines of incarnation as well.[90] Dodd has concluded that the preponderance of examples of these lines in Syria and Cyprus (and I would add Armenia) "reinforce the suggestion that the motif was rooted in the east" and traveled west after the Crusades.[91] On the whole, "before the eleventh century, painting in the churches of the Syriac communities in Moslem lands drew upon a different tradition from that associated with Constantinople."[92]

Reimagining the scene from Dura-Europos as a depiction of Annunciation might also help to explain another rarely mentioned aspect of the woman's figure. On her torso she has a five-pointed star (see fig. 5.16), which Kraeling calls "unusual" and "unexplained."[93] He does not offer a compelling guess about the star's symbolism, regardless of whether the painting represents Rebecca or the Samaritan woman (the two options he considers).[94] However, with our new interpretation of the scene, this star may signify the spark of incarnation in the body of the Virgin. Indeed, many modern icons of the Virgin Mary still show a star on her torso; or consider

Martini's Annunciation (see fig. 5.8), which has a small starburst below her right shoulder, near where the lines of incarnation meet her body. In eastern Christianity generally speaking, the metaphors of baptism, incarnation, nativity, and illumination were often woven together (see more below).[95]

In conclusion, let us consider the iconography of Rebecca at the well (very rare), Rachel at the well (very rare), and the Samaritan woman at the well (relatively frequent). If my argument aims to refute, or at least unsettle, the consensus view about this painting from Dura-Europos, it is essential to mention the available artistic evidence for how these other female figures were depicted. The scene of Rebecca at the well, though not shown often, does appear in the earliest well-preserved illuminated manuscript—and that from Syria. The "Vienna Genesis" (early sixth century) illuminates the story by showing Rebecca giving a drink to Isaac's servant Eliezer at a wellhead, with camels in the foreground and a female personification of the water source in the background.[96] A very early presentation of Rachel meeting Jacob at a well occurs on the lower panel of the right side of the Brescia Casket, a late fourth-century box with carved ivory scenes.[97] Rachel with her flock meets Jacob at a well with a rope-and-pulley system, and the scene of Jacob wrestling with the angel is off to the right. As with Rebecca's well, here contextual clues make plain the narrative to which the art refers. Neither scene resembles the woman at the well from Dura-Europos.

Of the extant examples of the Samaritan Woman, not one that I have seen looks like the image from Dura-Europos. First, all of them feature a conversation between the two figures: Jesus engages the woman in a posture of dialogue. Second, the well is often a "rope-and-pulley" type, as is shown in ancient examples from the Roman catacombs and the baptistery at San Giovanni in Fonte, in Naples (fig. 5.18).[98] Or, to take a more proximate example, the Syriac Rabbula Gospels (586 CE) shows alongside its canon tables both an Annunciation scene (in a standing spinning or rope-to-vessel type, Mary separated across the page from Gabriel) *and* the Samaritan Woman scene, where she stands next to a well, holding the rope-and-pulley system, speaking across the well to Jesus.[99] The same type of well and posture, without much variation, is found on many other sixth-century items: the cover of the St. Lupicin Gospels,[100] ivory pyxides,[101] a gold

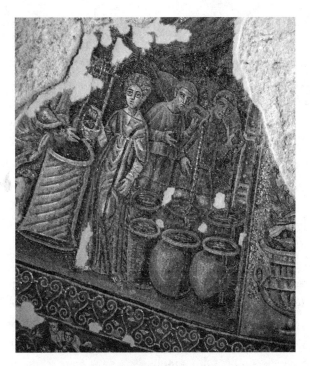

Fig. 5.18. Samaritan Woman at the well. Baptistery of
Santa Restituta, San Giovanni in Fonte, Naples. (Photo:
Robin M. Jensen)

medallion,[102] an ivory plaque from Egypt,[103] the mosaics at San Apollinare
Nuovo (Ravenna),[104] and the chair of Maximian (also in Ravenna, though
here the woman has her back to the well).[105] It is true that some examples
feature a simple wellhead without pulley system, but all examples show the
woman in a posture of dialogue with Jesus.[106] Simply stated, the only artistic
examples of a woman at a well with distance between her and the other
figure—either flying in from behind or above—are those of the Annunciation.

Pilgrimage and Ritual

Several of the artistic examples above—ampullae, terracotta tokens, and
censers—were able to spread iconography across the Mediterranean world

through the hands of pilgrims. The practice of pilgrimage was so popular that in the late fourth century, Gregory of Nyssa penned a letter with singular purpose: to persuade Christians that pilgrimage to the newly fashionable "Holy Land" was unnecessary—and even *unholy:* "We knew that [Christ] was made human through the Virgin—before we saw Bethlehem; we believed in his resurrection from the dead—before we saw his memorial-rock; we confessed the truth of his ascension into heaven—without having seen the Mount of Olives. We benefited only this much from our traveling there, that we came to know by comparison that our own places are far holier than those abroad. . . . For the changing of one's place does not bring about any greater nearness to God."[107] Not many Christians were persuaded.

Indeed, judging by the extant evidence of the period from the refounding of Jerusalem by Constantine to the Muslim conquest, pilgrimage to the Holy Land was a popular enterprise. E. D. Hunt has argued that pilgrimage properly so-called actually existed before Constantine, as evidenced by Christian travelers in the second and third centuries who attested some knowledge of sacred topography—a "tradition of the location of key moments in the scriptural record, albeit only occasionally and dimly documented."[108] Then, following on the heels of Constantine's mother Helena's alleged discovery of the "true cross," a sense of Christian holiness radiated outward from Golgotha and permeated Judea and Galilee. Soon, ascetics from all over were emigrating to set up hermitages and monasteries in this holiest of lands.

Growing flocks of pilgrims were not far behind. The most famous of these are known by their travel diaries passed down through history: the "Bordeaux pilgrim," the "Piacenza pilgrim," "Peter the Deacon," and the preeminent one, "Egeria," who offers detailed accounts of Holy Week in Jerusalem.[109] Most do not give reasons for their journeys, but they were likely drawn by the allure of religious blessing (*eulogia*) from both holy places and holy people. In the words of Gary Vikan, "For the early Byzantine pilgrim, the word *eulogia* (Latin, *benedictio*) held special meaning, referring to the blessing received by contact with a holy person, holy place, or holy object, sometimes realized through the reenactment of the event that

had initially sanctified the *locus sanctus*."[110] Pilgrims used all their senses and "sometimes sought blessing through mimesis—action imitative of the sacred heroes and events along his or her route."[111] A favorite example records the tradition of throwing stones at the tomb of Goliath.[112]

Pilgrims returned from their journeys with more than memories. They brought back iconography and especially reverence for the cross, which was featured prominently in the ritual encounter orchestrated by the Church of the Holy Sepulchre.[113] Considering how uncommon cruciform imagery was before the fourth century, it seems probable that the popularity of the cross was the greatest legacy of Helena and the inauguration of religious tourism to Jerusalem. Some of the wealthier pilgrims brought back censers that were adorned with a *locus sanctus* cycle of at least four and as many as twelve scenes; the extant examples have been helpfully cataloged by Ilse Richter-Siebels (see fig. 5.12).[114] The Annunciation is featured on almost all of them, and it occurs in a variety of types that originated in Palestine and Syria.

Other common image-bearing souvenirs included oil lamps, ampullae, and terracotta tokens, called "seals" or "stamps" (*sphragis*). The latter group was similar in concept to the modern souvenir coin from many American tourist sites that can be stamped with an image by a machine. The most well-known group of "image-bearing pilgrim blessings" from the Holy Land contains flasks and tokens housed at Monza and Bobbio in Italy.[115] More than forty of the metal flasks with *loca sancta* are known, and some are in very fine condition. They often feature veneration of the cross and tomb, but some of them show a fuller cycle of holy sites.

A pewter flask housed in the treasury of the Cathedral of Saint John the Baptist (Monza), for example, includes scenes of the annunciation, visitation, nativity, baptism, crucifixion, women at the tomb, and ascension (see fig. 5.4).[116] The Virgin Mary features in the top three scenes—in Byzantine art, she is the *orant* at the ascension—and also the central nativity, demonstrating her crucial role in the pilgrimage drama. The Annunciation iconography at the upper left shows the most common Spinning, Looking Back type, and here Gabriel points up at the word "Hail!" (XEPE for Χαῖρε). Other instances of the *locus sanctus* cycle show the Annunciation as the

Ambiguous Rope-to-Vessel type, with Mary and Gabriel facing one an-
other. A sixth- or seventh-century marriage ring shows Mary either spin-
ning from her basket or holding a rope to a well, while Gabriel points above
at a star or dove (see fig. 5.7). And a sixth- or seventh-century amuletic arm-
band from Egypt shows a transitional Annunciation type, in which the
rope-to-vessel is close to losing its rope and becoming a Vestigial Vessel type
(see fig. 5.6). In all these cases, Vikan argues that the appeal of "mimetic
identification" explains their popularity, and in the case of the armbands,
they "delve explicitly into the world of magic by including images and
phrases otherwise familiar from late antique gem amulets and from magi-
cal bronze pendants."[117]

 Because of the heartiness of lead and pewter, the metal ampullae were
able to stand the test of time much better than the stamped terracotta to-
kens; however, the more fragile tokens were far cheaper and easier to pro-
duce, and these were almost certainly the souvenir choice for most pilgrims,
as seems to have been the case at popular pilgrimage sites of saints. More
than 250 tokens are extant, for example, from the *locus sanctus* of Simeon
Stylites in Syria.[118] And about 100 more of these stamped tokens exist that
feature a biblical or Holy Land scene; those at Bobbio and Monza feature
scenes from none other than the *Protevangelium of James*.[119]

 The meeting of Mary and Elizabeth, the mother of John the Baptist,
is well-known from canonical Luke and included on many *locus sanctus* cy-
cles: the neighborhood of Ein Kerem, west of Jerusalem, remains a pilgrim
destination devoted to John the Baptist and his family. But a token from
the Bobbio collection includes a scene different from the typical "Visita-
tion" (Luke 1:39–56).[120] After the birth of John the Baptist and Jesus, when
Herod seeks to kill all the children two years old and younger (Matt 2:16),
the *Protevangelium* records a tale not found in the canonical witness: "But
Elizabeth, when she heard that John was sought for, took him and went up
into the hill-country. And she looked around to see where she could hide
him, and there was no hiding place. And Elizabeth groaned aloud and said:
'O mountain of God, receive me, a mother, with my child.' For Elizabeth
could not go up further for fear. And immediately the mountain was rent
asunder and received her. And that mountain made a light to gleam for her;

for an angel of the Lord was with them and protected them."[121] Whether made at Ein Kerem or elsewhere, this token clearly commemorates that event, its legend promising a "Blessing of the Lord, from the refuge of Saint Elizabeth." Mother and child are entering into the mountainside on the right, a soldier pursues them with sword drawn, and an angel looks down from above. The token promised safety for travelers in general, and women who were pregnant or rearing infants perhaps chose these tokens specifically.

The second token preserved (this one at Monza) shows one of the earliest images of the At the Spring type of Annunciation (fig. 5.19).[122] Probably acquired by a pilgrim to either Nazareth or Diocaesarea (Sepphoris)—and beautifully preserved—it shows Mary bent, drawing water in her pitcher from a spring near a tree and looking back over her shoulder at Gabriel flying down from above. The angelic greeting "Hail, full of grace" is printed below his figure (XEPE KEXAPITOMHNI for χαῖρε κεχαριτωμένη), and the blessing encircles the token: "Blessing of the Mother of God, from the rock Boudiam(o?)."[123] This token is thus among the most locative of pilgrimage objects from the Holy Land: it names a specific place commemorated as Mary's well or spring in probably the sixth century. Unfortunately, all attempts to line up "Boudiam" or "Boudiamo" with a place name in Greek, Hebrew, or Syriac have been in vain.[124] Again, the notion of amulets relating to pregnancy comes to mind, and it is probable that a token such as this functioned as a prayerful hope for successful conception and delivery. In any case, it shows that the Annunciation at a water source was among the earliest iconographic traditions, reinforced by the production of image-bearing tokens for pilgrims to Galilee.

Corroboration of pilgrimage to a well or spring in connection to the Annunciation comes also from the textual tradition. One of the earliest extant pilgrimage narratives was written by a man (often called Antoninus) from Piacenza (Italy), who visited Palestine about 570. Amid his many fantastic details, he records the following about the visit to Sepphoris, which had by then become associated with Mary's parents, Joachim and Anne: "We came to the borders of Galilee, to the city called Diocaesarea [Sepphoris] in which we adored (as recounted to us) *the pail and basket of blessed Mary. In that place also was the chair where she was sitting when the angel*

Fig. 5.19. Pilgrimage token showing At the
Spring type of Annunciation. Monza. (From
André Grabar, *Les Ampoules de Terre Sainte*
[Paris: C. Klincksieck, 1958], pl. XXXI. ©
Klincksieck, Paris 1957)

came to her."[125] From this short description, I argue that all three aspects
of Annunciation traditions were implied by the site: the outdoor trip to the
wellspring ("pail," *amula*), the weaving back inside ("basket," *canistellum*),
and the sitting indoors during the appearance of Gabriel. Whichever tra-
dition a pilgrim had known upon arrival, there was something to see or
touch—it was a full-service, living museum.

The Piacenza pilgrim also records his participation in the timeless
tradition of pilgrim graffiti, for which he seems to feel ashamed: "Three
miles farther we arrived in Cana, where our Lord was at the wedding, and
we reclined upon his very couch, upon which I, unworthy that I am, wrote
the names of my parents."[126] Indeed, this pilgrim used all of his senses,
touching and tasting more items in the Holy Land than anyone else
did. Blake Leyerle argues that he was motivated by the hope of receiving
blessings and healing from the many items handled and ingested along his

route: "From his account, the Holy Land emerges as a kind of vast phar-
macopia of discrete portable objects. . . . We perceive the extent to which
the holiness of the Holy Land had pooled into distinct locales, as well as
how the land itself had become charged with religious powers."[127] The
rocks of Mount Carmel were said to prevent miscarriage, for example, just
as how one imagines a woman's visit to the Annunciation sites would call
to mind similar hopes for healthy pregnancy and childbirth.[128]

But wasn't the Piacenza pilgrim's homage to the Annunciation hap-
pening in the wrong city? Current pilgrimage to "Mary's Well" finds its way
to *Nazareth,* of course, where the ancient wellspring is maintained by
St. Gabriel's Orthodox Church. A nineteenth-century pilgrim remarked,
"if there be a spot throughout the Holy Land which was more particularly
honoured by the presence of Mary, we may consider this to be the place."[129]
The medieval pilgrim Peter the Deacon was probably drawing on Egeria's
fourth-century text when he wrote that "an altar" was placed in "the cave"
where Mary lived, "from which she drew water," while he also records
"the spring from which Holy Mary used to take water" that was "outside the
village."[130] In between Peter the Deacon and Egeria, there came a Gallic
pilgrim, Arculf, who notes the water source in about the year 670: in his
narrative he describes two churches, one built to commemorate the spring
and another over the house to which Gabriel came and addressed Mary.[131]
Water from the spring is drawn up into the church in vessels by means of
a pulley system, as from a well. Here too, then, the double tradition of the
Protevangelium of James—the well type and the indoor type of Annuncia-
tion—is confirmed by pilgrimage accounts. What is more, the two cities
were promoting their Annunciation sites at the same time: pilgrims to
Sepphoris were still noting a "well of Mary" or "well of roses" there in the
twelfth and thirteenth centuries.[132]

In the end, one can draw connections between the ritual experience
of pilgrimage and that of initiation itself. Despite obvious differences, both
pilgrimage and initiation involve a "liminal" process, in the words of Vic-
tor Turner, during which participants cross a "threshold" (Latin *limen*) in
search of healing or renewal, temporarily lose the markers of identity from
their previous contexts, have their statuses homogenized with other

participants in *"communitas,"* and ultimately return with a new *"axis mundi"* for their faith.[133] Cynthia Hahn concurs and explains the affinity between notions of "sealing" participants in both pilgrimage and ritual: "The pilgrim is stamped or filled with his experience in a way parallel to the blessing that completes the ritual of baptism, the sealing unto the Lord."[134] Christians received a *sphragis* at their initiations, one that marked them as members of a flock and impressed upon them the image of their redeemer. So too did pilgrims become marked or stamped by their experience, and the blessings conferred thereby were carried home in ampullae, tokens, and other *eulogiae* from the Holy Land. A Christian neophyte was sealed as a soldier, as a sheep, as a bride, and over time, as a pilgrim.

Of Wells and Wombs

In the beginning of this chapter I cited the various meetings of women at wells in the Hebrew Bible. When Jacob, Isaac, and Moses go to wells, they each find more than water—they find wives, mothers for their sons. The fourth evangelist plays with this tradition in the narration of Jesus' meeting of the Samaritan woman (John 4). In his article about "genre bending" in the Gospel of John, Harold Attridge argues that the episode "evokes a type scene, rich with sexual innuendo, of a patriarch encountering his future bride," but "Jesus, who appears initially in the formal position of the suitor, quickly becomes the one to be courted and sought."[135] When Jesus meets a woman at a well, marriage is indeed a topic of discussion, but erotic desire is nowhere to be found. "A story begins in eros and ends in mission," when the woman becomes an evangelist on behalf of the Messiah.[136]

The motif of spiritual marriage from the previous chapter thus continues into this engagement with a woman at a well. The third-century author Origen connects the woman-well-marriage traditions also to the ritual of baptism. In his *Homilies on Genesis,* he writes: "Do you think it always happens by chance that the patriarchs go to wells and obtain their marriages at waters? . . . You see that everywhere the mysteries are in agreement. You see the patterns of the New and Old Testament to be har-

monious. There one comes to the wells and the waters that brides may be found; and the Church is united to Christ in the bath of water."[137] The heirs of the biblical traditions knew that whenever a man and a woman met at a water source, a "bride may be found."

With the strength and longevity of these well traditions, one cannot overlook the resonances in the tradition of Mary at the water source. Unlike the Samaritan woman, her sex life has not (yet) been interrogated; she is a "pure virgin" of the tribe of David according to sources canonical and noncanonical. And yet the wellspring is the place of the first announcement about her pregnancy. Beyond that motif of pregnancy *at* a wellspring, Syrian texts describe Mary's fruitfulness—her productive labor—also *as* a wellspring. In the words of Ephrem, "She is a pure spring which has never been mingled with the flow of marital union, for she received into her womb that River of Life which had flowed down in abundance on creation, whereby all the dead have come to life."[138] Elsewhere, an anonymous Syriac hymn about Mary exalts her above the "water from the rock" struck by Moses: "Much more than this rock has the virgin, by giving birth, poured forth Living Waters—a Fountain from which the thirsty land of humanity has slaked its thirst; a draft which has flowed from the Father at which all creation rejoices."[139] In a verse homily that rhapsodizes on Mary's many symbols, Ephrem alludes again to the "living water" of the Gospel of John: "*She is the fountain,* whence flowed living water for the thirsty."[140]

Jacob of Serugh continues the theme in the next century, styling Mary in his homilies as the "new well." She is "the new well from which gushed forth living water, and without being hewn out, she generated rushing streams to the thirsty world."[141] In this allusion to the dialogue with the Samaritan woman at Jacob's well, the author calls to mind several biblical narratives and recapitulates them through the incarnation of Jesus in Mary's womb. The theme of Mary as "new well" was thus "made use of very extensively in the Syrian Church especially surrounding the feast of nativity."[142] In the later artistic traditions, one can envision the aforementioned Annunciation types from Armenia, in which Mary and the angel stand on two sides of a well. Armenian ritual texts celebrate her as a "fountain of living water" and a "golden pitcher."[143]

Ritualized Pregnancy and New Birth

In the classic exposition of early Syrian Christian theology, *Symbols of Church and Kingdom,* Robert Murray identifies two main aspects of the church emphasized by Syriac authors: the church as bride and as mother.[144] The events that correspond to those concepts are, of course, wedding/ marriage and pregnancy/birth. In the previous chapter I explored the motifs of wedding and marriage in early Syrian ritual and theology, and I argued for the probability that these formed a dominant symbol in the artistic and ritual program at Dura-Europos. It remains to be seen how pregnancy and birth—even incarnation—might also have been imagined and ritualized in Dura-Europos.

As specialists in Syrian Christianity have long demonstrated, "the Johannine language of rebirth, focused on the image of the womb, is a central and constantly recurring theme within the Syrian baptismal tradition. . . . Womb imagery and the language of regeneration are by no means lacking in the baptismal theology and liturgies of other churches, but they do not occupy the same central position that they enjoy in the Syrian tradition."[145] In texts such as the *Odes of Solomon* and the writings of Aphrahat, Ephrem, and Philoxenos of Mabbug, the feminine Spirit (the noun is feminine in Semitic languages) corresponds to a maternal womb in the rites of initiation. Even the death of Christ is brought under the aegis of birth imagery, when "Sheol" is imagined as "giving birth" to him in the resurrection.[146]

Ritual texts enhance this "birth mysticism" and express it through both anointing with oil and immersion in water. As we have seen in the *Acts of Thomas* (see chapter 2), the anointing can invoke the Spirit as "mother" over the initiate.[147] Simon Jones has used Ephrem's seventh hymn "on virginity" to draw out the motif. The oil of anointing is "the dear friend of the Holy Spirit" that has been "sealed" on those in baptism and "is in travail with them in its womb . . . to replace the image of the former Adam," for "baptism is a second womb."[148] These themes appear frequently in Ephrem's writings and also feature in later liturgical scripts. Sebastian Brock's editing of the *ordines* from the Antiochene tradition shows a focus

on the "spiritual womb" in initiation, drawing a special contrast between the "womb of the water" and the "womb of Eve."[149] Theodore of Mopsuestia even refers to postbaptismal garments as "swaddling" clothes, using language characteristic of physical birth, and some baptismal fonts—though not yet discovered in Syria—"appear to have been designed to represent a woman's vulva."[150] In general, new birth imagery was widespread in ancient Christian initiation, and specifically, the Syrian prebaptismal anointing could "confer upon the candidate the necessary characteristics and properties so that, on his entering the waters of new birth, the womb might become impregnated."[151]

The missing typological link here is the womb of Mary, which was understood to have overturned the corruption of Adam and Eve. Brock has demonstrated a strong resonance between Syriac ritual texts and the Annunciation to Mary in the Syriac Bible, since the verb *aggen* ("overshadow" or "tabernacle") describes both the action of the Holy Spirit on Mary's womb (Luke 1:35) and the Holy Spirit in Syriac liturgical rites of initiation and the Eucharist.[152] It became a "technical term denoting divine intervention" and "a special type of salvific activity."[153] For our purposes, it is also suggestive to note the verb's etymological connection to *gnōnā*, the Aramaic/Syriac word for "bridal chamber" (something "covered over" or "shaded over," as with a chuppah).[154] Ephrem further demonstrates a link between the womb of Mary and the ritual of baptism, offering this Marian speech-in-character: "The Son of the Most High came and dwelt in me, and I became his mother. As I gave birth to him—his second birth, so too he gave birth to me a second time. He put on his mother's robe—his body; I put on his glory."[155] The incarnation thus doubled as Mary's baptism.

As I argued above, the lines behind the female figure in the Dura-Europos baptistery can be explained by such in-dwelling incarnation of the Spirit; in addition, Syriac texts about Mary help to interpret the star painted on that figure's chest. Fire or light often manifests the Holy Spirit, and in the Syriac traditions of the Annunciation and incarnation, such imagery sparkles. Ephrem summarizes a general Syrian view: "fire is the symbol of the Spirit, it is a type of the Holy Spirit who is mixed in the baptismal water so that it may be for absolution."[156] In his hymns he specifically

connects these themes to the Annunciation. The examples are striking to many modern readers, since they are so different from the western traditions: "Fire and Spirit are in the womb of her who bore you, see Fire and Spirit are in the river in which you were baptized," Ephrem sings to Jesus, and so too, "Fire and Spirit are in our baptismal font," he says to Christians.[157] Mary would be justifiably concerned when the "fiery" angel delivers the announcement, and a later Syriac dialogue poem imagines her response: "You greatly disturb me now, for if, as you say, He is all flame, how will my womb not be harmed at the Fire residing there?"[158] For Ephrem, the combination of fieriness and wateriness shows forth the paradox: "It is a source of great amazement . . . how a Flame dwelt in a moist womb which did not get burnt up."[159]

Beyond the dialogue with the angel, Ephrem also, in his final hymn for the feast of the Epiphany, constructs a dialogue between Mary and the Magi, during which they mutually discover that Mary's angel and the Magi's star are manifestations of the same being.[160] The *angelic voice* and the *star* are two forms of the same epiphany, that the newly conceived baby is the anointed Son of God. Here in Dura-Europos, the unseen angel of the Annunciation may thus be represented in the painting by the manifest star of incarnation. The same spark of light illumines the night sky, the baptismal river Jordan, and the womb of Mary. The opening images of the hymn "Blessed Is the Creator of Light" describe how "*the Light settled in Mary,* it polished her mind, made bright her thought and pure her understanding, causing her virginity to shine. The river in which he was baptized conceived him again symbolically; the moist *womb of the water* conceived him in purity . . . In the pure *womb of the river you should recognize the daughter of man, who conceived having known no man.*"[161] Uniting many of the aforementioned motifs into one hymn, Ephrem connects the light of incarnation with the waters of the baptismal river and the incarnational womb.

Premodern Polysemy

Analysis of early Christian art has often focused on finding the right text— what text does a painting, carving, or symbol represent?[162] If correctly iden-

tified as a representation of the Annunciation, the painting at Dura-Europos would be the earliest securely dateable example of that scene. The idea is exciting and enticing—and might turn New Haven into something of a Marian pilgrimage site! Yet one must remember that an angel-less icon of the Annunciation would actually be unique. In all other examples, Gabriel is pictured somewhere, occupying that empty space in the example from Dura-Europos. The proposal that Gabriel might have featured in the upper panel, flying in from above, as in later examples of the type, remains an argument from silence. The fact also remains that the Samaritan Woman features prominently in the early Christian imagination of baptism, though much more in the West than in Syria.[163] Most importantly, I would contend that the *Protevangelium of James* cannot provide the key to unlocking the image of Dura-Europos's woman at a well any more than the Gospel of John does. Against the method of Kraeling and many other interpreters of the baptistery, I usually hesitate to accept proposals of one-to-one correspondences between images and texts, as if the paintings were allegorical treasures that the right biblical text could unlock.[164] This woman at this well may be polysemic, inviting the neophyte in the ritual space to imagine multiple, intertwining texts: the betrothal of Rebecca, the Samaritan Woman, the Annunciation to Mary. It opens up the viewer to the ideas of purity, spiritual marriage, incarnation, and new birth. The veil of image, text, and ritual is spun with multiple threads, and it captures a surplus of meanings.

The ritual context of the paintings in the baptistery further encourages polysemic interpretations in most instances. Anthropologist Victor Turner describes two of the chief properties of dominant ritual symbols to be "condensation," by which "many things and actions are represented in a single formation," and "a unification of disparate significata," which are "interconnected by virtue of their common possession of analogous qualities or by association in fact or thought."[165] The procession of women and, to a lesser degree, the woman at a well are dominant, polysemic symbols in this ritual space. Annabel Jane Wharton has argued along similar lines (as discussed in chapter 1), concluding that some of the paintings in the baptistery may not have functioned as one-to-one correspondences to texts.

Ritual-centered viewing and processional visuality can de-center the priority of texts in interpretation.

In his book *Image and Text in Graeco-Roman Antiquity*, Michael Squire agrees with the polysemic school of thought and defines a chief problem with modern western analysis of ancient art:

> the critical problem . . . stems from the reductive definition of the image as simply a mode of communication after the manner of words. It is a definition that descends from the theology of Reformed Christianity, with its emphasis on the invisibility of faith and its faith in invisibility. The Lutheran apologia for the image viewed pictures as legitimate only in so far as they could symbolize some external verbal meaning and could be collapsed into an expression of language. Not only is the image deemed subservient to text, it is also treated *as* text—as visual means to an avisual end.[166]

Images do not merely "illustrate" texts, nor do texts simply "caption" images, but Squire identifies a "transitive exchange . . . a two-way interaction," through which "each medium enlarged the other's field of reference."[167] We have already seen this above in the Gospel illumination of the Parable of the Wise and Foolish Virgins: the late ancient homiletic traditions about the text, coupled with prophetic intertexts, became painted into the art. In ritual-centered viewing, we add the third component of embodied, processional, sacred visuality to Squire's transitive exchange. Meaning is generated at the nexus of text, art, and ritual.

Squire places the blame for our common privileging of text over image—and both of these over ritual—squarely at the feet of the Reformation, which itself was dependent on the printing press and the concomitant logocentric revolution. He aphorizes, "One simply could not be a Protestant in the Graeco-Roman world."[168] Then if modernist epistemology is a problem to be overcome, is postmodernist epistemology the solution? Does postmodernity's rejection of absolutes, grand meta-narratives, and

the myth of detached observers—coupled with its emphasis on context, contingency, and surplus of meaning—better account for ancient phenomena? Most art historians would say so. In terms of hermeneutics, ancients were closer to postmodernity than modernity, the period that increasingly seems like the historical anomaly.

Context, contingency, and surplus of meaning—even rhetorical "play" in theological interpretation—are not postmodern fads.[169] In the fourth century Ephrem himself was a master spinner of polysemic ritual texts. Consider again the motif of a woman at a well and see how Ephrem connects the biblical betrothal scenes to baptism: "At the well Rebecca received in her ears and hands the jewels. The Spouse of Christ has put on precious things that are from the water: on her hand the living Body, and in her ears the promises."[170] Elsewhere, he interprets the Samaritan woman as a virgin, which allows him to connect her with Mary, the archetypal Virgin. Addressing the Samaritan woman directly, he sings: "O, to you, woman in whom I see a wonder as great as Mary! For she from within her womb in Bethlehem brought forth His body as a child, but you by your mouth made him manifest as an adult in Shechem, the town of His father's household. Blessed are you, woman, who brought forth by your mouth light for those in darkness."[171] In this ritual text, the spark of incarnation and the light of evangelization are condensed into one. He continues: "Mary, the thirsty land in Nazareth, conceived our Lord by her ear. You, too, O woman thirsting for water, conceived the Son by your hearing. Blessed are your ears that drank the source that gave drink to the world. Mary planted him in the manger, but you [planted him] in the ears of His hearers."[172] Rebecca is a baptized-married bride of Christ, and the Samaritan woman is a pregnant virgin like Mary, all of them incarnating the Word. If Ephrem the Syrian were to have seen this woman at a well in Dura-Europos, then, might he have seen all of these women at once?

With a woman at a well, as with most of the extant paintings from Dura-Europos, polysemy makes sense. But in order to destabilize the established positions about David and Goliath, the procession of women, and the woman at the well, my arguments have needed to show forcefully the

cogency of other options. In this particular case, my role has been to spin out the threads of Mary's side of the story—a viable and possibly preferable interpretation of this woman at this well.

Incarnation as Salvation

In my overall interpretation of the artistic and ritual program of the Dura-Europos baptistery, these Christians emphasized salvation as victory, empowerment, healing, refreshment, marriage, illumination, and incarnation more than participation in a ritualized death. In early eastern Christianity, and especially before a cruciform spirituality began to radiate out from Jerusalem's pilgrimage center, salvation was more likely to be conceived of through "birth mysticism" than "death mysticism." This is not to undermine the power of the passion and resurrection accounts, but rather to rebalance the perspective of modern western viewers looking back after centuries of cross-centered Christianity. Stephen Shoemaker aptly summarizes the historian's viewpoint:

> It is through God's joining Godself to the Creation and to the human race that both are again made whole and restored to God. . . . Human nature is healed by the Immortal One's condescension to unite with the human race in the Incarnation, allowing the recreation, the recapitulation, as Irenaeus calls it, of humankind. . . . Far more important—and constant—in Eastern Christian soteriology is the notion of ultimate unification with God that is made possible through the act of Incarnation, rather than any compensation due to the devil or, in the case of Anselm [centuries later], the satisfaction of a debt that God must collect through the suffering and sacrifice of the Crucifixion.[173]

This emphasis on incarnation and nativity—exalted forms of pregnancy and birth—can lead back to one of the earliest extant examples of the Annunciation: the famous fifth-century ivory book cover from the

Milan Cathedral treasury (see fig. 5.3). The upper-left panel shows that paradigmatic example of the At the Spring type of Annunciation. But what does the upper-right panel show? Gertrud Schiller's magisterial *Iconography of Christian Art* calls it an "unidentified scene."[174] In my view, this scene is a condensation of Marian symbols and traditions that evokes virginity, spiritual marriage, and incarnation. This second stage of the Annunciation complements and elaborates on the first Annunciation scene at the spring. The hermeneutical key is the star above, to which the angel points; as in the scene of the Magi at the center left, the star signifies the spark of miraculous pregnancy in the virgin.[175] But instead of placing this second Annunciation in Mary's house, as does the longer redaction of the *Protevangelium of James,* this scene places her in front of the temple, as in the reconstructed prior version, in order to call to mind her virginity.[176]

Both aspects of the Marian paradox—virgin bride and mother—were crucial to the developing traditions about Mary, and this small ivory vignette captures the mystery. The veil of the temple, which Mary had been called as a virgin to weave, suggests her consecrated virginity to the viewer. And yet, the veil is pulled back somewhat. As in paintings from centuries later, the illumination of incarnation wends its way into seemingly closed rooms. The temple becomes for Mary a kind of mystical bridal chamber, where her vow of virginity is both consummated and productive of new life. The *Gospel of Philip* alludes to Mary as a "bridal chamber," as would later liturgical prayers in the Syriac tradition.[177] One of those sings: "Blessed and glorious is the Mother of God, the pure Virgin who received the Most High, the glorious *tabernacle* of the divinity, the radiant place of the Shekhina of the Maker of all, the *pure temple* of the Word God, the *bridal chamber* [*beth gnōnā*] of the heavenly Bridegroom."[178] Here, Mary's womb is imagined as tabernacle, temple, and bridal chamber in one. Through the incarnation as a mother and her own baptism as a bride, it is not surprising that Ephrem channels Mary's paradox through her voice: "Should I call you 'Son,' or should I call you 'brother,' or should it be 'betrothed,' or 'Lord'? You yourself give your own mother second birth from the baptismal water."[179]

The *Gospel of Philip* also viewed the incarnation in Mary as the mystical key for the "bridal chamber" uniting heaven and earth: "How fitting

it is to speak of a mystery! The parent of the entirety joined with the virgin
who came down, and fire illuminated him. On that day he revealed the great
bridal bedroom; it was for this purpose that his body came into being. On
that day he came forth from the bridal bedroom as from what is born of a
bridegroom and a bride."[180] The "fire" of illumination incarnated in the
Virgin, and her womb became a "bridal bedroom," from which Jesus
emerged as if born from a normal union. The same text compares the bridal
chamber twice to the "Holy of Holies" of the temple, and thus the allegory
of the temple's open veil—at the crucifixion—can be interpreted via the nar-
rative of the incarnation. The veil was "torn from top to bottom" to show
that "the upper realm was opened for us in the lower realm, so that we might
enter into the hidden realm of truth."[181] Through the incarnation, the up-
per/inner realm was opened to others: the "holy of holies was uncovered.
And the bedroom invites us in."[182] In the canonical witness, after all, it is
not only Mary who receives God's "spirit" as in a "temple," but all Chris-
tians (1 Cor 3:16). Returning then to the significations of this "unidentified"
Marian scene: the star of incarnation flickers over the gabled roof of a
templelike bridal chamber, outside of which stands a virgin who herself
became a temple and bridal chamber. The open veil "invites in" subsequent
initiates to a spiritual marriage and new birth—a marriage and an incarna-
tion. Viewed through the lens of these ancient, if unfamiliar, symbols, new
meanings have also emerged for the fiery bursts over the white structure
on Dura-Europos's wall, the stars painted in its font's mythic canopy, and
the spark on Mary's breast.

 In the end, these ideas are not really so foreign to modern Christians:
Christ as the light that illuminates all believers, Christ as the incarnation
continually reborn in the hearts and wombs of the faithful. Despite centu-
ries of emphasis on salvation through the cross, Christian tradition has
always maintained an abiding affinity for salvation as illumination and in-
carnation. The feast of the nativity remains the most popular Christian
holiday in many locales. And it is not only *Christ's* incarnation that is
celebrated. Even today, in contexts not thought of as "mystical" or "eastern"
in spirituality, Christians proclaim and pray for the illumination and incar-
nation of God into their very own selves—not in some obscure tome, but in

the heart of a beloved English Christmas carol. The singers of Phillips Brooks's "O Little Town of Bethlehem" acclaim the "shining" of "the everlasting Light." Despite the "silence" of nativity, in which "no ear may hear his coming," "the dark night wakes, the glory breaks," and "the dear Christ enters in." The ancient theme of incarnation as salvation resounds in the final stanza:

> O holy child of Bethlehem,
> Descend to us we pray;
> Cast out our sin, and enter in:
> Be born in us today.

It would have been a fitting hymn in Dura-Europos. Under a starry roof, at the darkness of midnight, hearing a voice in the silence—thus proceeded an initiation and spark of incarnation. "Be born in us today," the neophytes could have said, gazing on the illuminated Mary, mother of their church.

Conclusion: Paradise Restored

What Remains

We have now completed our procession around the baptistery and seen the main fragments of the world's oldest church: David and Goliath; the mighty deeds of Jesus, with Peter on the water and the paralytic alongside it; the procession of women toward the font; the shepherd and flock behind it; and finally, a woman at a well. In each case, sources from early Christian Syria have shed light on probable meanings at the nexus of Bible, art, and ritual.

With our new perspectives on each painting, classic Syrian sources take on new relevance and sound almost tailored for use at Dura-Europos. Consider the following lines from Ephrem's *Hymns on Virginity,* which can serve as a final confirmation that Dura's walls expressed well early Syrian understandings of initiation and salvation. The hymns on oil and anointing resonate especially clearly in this baptistery.[1] "Mary brought forth the Luminary of the seven holy brightnesses that illuminate for us all creation," meaning the light of the incarnation outshines the sun, moon, and five known planets in antiquity. The spark of illumination on Mary's breast shines like the stars on the ceiling and the fiery flames over the bridal chamber. The walking on the water is evoked too: "Just like the Anointed, oil is empowered to run upon the waves. It also gave power to the flame to walk on water, as his Lord gave Simon [power] to walk on the waves. Like the Anointed, oil rescues the sinking flame that flickers in the womb of water, like Simon in the sea of water. By a flame oil enlightens the house; by Simon the Anointed enlightened the inhabited earth." Simon Peter hovers like oil on water, and even when he sinks, the water becomes not a grave,

but a womb. The oil of the anointed also "enriches the lamps of the virgins espoused to Him. . . . Since the time of the Bridegroom is not revealed to us, you virgins have become our Watchers, so that your lamps might gladden, and your hosannas might glorify." Ephrem compares processing virgins to genderless angels (Watchers), who keep their flames burning in expectation for the coming of Christ and shout "Hosanna!" upon his arrival. Ephrem never set foot in the house-church at Dura-Europos, but his hymns would have felt right at home.

Though grateful that we have at least this one set of painted church walls from before Constantine, we still leave with questions about what else was pictured there. Did the upper panels show a full cycle of Jesus' miracles? Did they all involve water? Was Jesus' own baptism depicted? How were the five women outside the painted door portrayed? Queries about ritual remain too: For what was the second story of the building used?[2] Why were there supports for poles near the canopy? What occurred in the building's other rooms? Why were their walls mostly unadorned? We wait in hope that someday some of these questions might be answered.

Until then, there remain two small painted bits to discuss in this conclusion, both of which call to mind the scene of a garden, the Greek word for which is *paradeisos,* or "paradise." On the upper panel of the southern wall, above the woman at a well, Hopkins's field report described "part of a garden, perhaps Paradise [the biblical Garden of Eden], adorned with a mass of green trees and bushes."[3] Unfortunately, the final fate of this fragment is unknown. It never arrived at Yale with the rest of the frescoes, nor did it surface in Damascus. The excavation records do not report its deterioration or loss. A lone excavation photograph preserves its faded sketches of plant life. And yet Hopkins's field description of the color and shapes suggests that the plants were not ancillary to the design, but rather its main focus.

We ought not to be surprised by a depiction of paradise in a site of initiation. Indeed, Robin Jensen's broad summary of baptismal imagery in early Christianity highlights new creation and the restoration of Eden among the main motifs of initiatory texts, art, and ritual.[4] This notion is further corroborated by the final image to interpret from this baptistery: a small, inset painting of Adam and Eve in the Garden of Eden. Through

this tiny signal of new creation, several other themes of the baptistery—and this book—can be recapitulated.

Paradise Restored

In the lower left corner of the painting behind the font was a small inset depicting Adam and Eve (see plate 6 and fig. 3.3; fig. C.1). The iconography is unmistakable: two figures flank a tree and reach up to its boughs to pick fruits, covering their shameful parts while a snake slithers below their feet. The "simultaneous composition" shows sequential narrative events of "cause (the picking of the fruit) and effect (use of aprons made of leaves)" in the same moment.[5] The scene is set apart from the rest of the field by two larger tree trunks (or pillars), so it appears like an inset in a modern pictorial production, with a kind of box around it.

Fig. C.1. Tracing of Adam and Eve. West wall, Christian building. (Yale University Art Gallery, Dura-Europos Collection)

The painting suffered from poor artisanship, even before the sands of time wore it down. The artist seems to have first begun to paint the serpent on the left side, but then stopped and painted it centrally without eliminating the first attempt. He or she even permitted some of the paint from above the central tree to drip down over the face of the figure on the left (Adam).[6] In addition, the background color of the whole field continues under the inset painting, contrary to the normal practice elsewhere in the room. And the upper-right portion of the painting seems to run out of space, encountering the right leg of the shepherd. For all these reasons, Kraeling argued that "the sketch is a supplement to the decorative program," a kind of afterthought, update, or commentary on what preceded it.[7] "Hence there is implied in the addition an element of criticism of the program as originally conceived."[8]

But what is the criticism? Kraeling correctly noted the lack of emphasis on the doctrine of sacrificial atonement through the cross in the extant remains of the baptistery; the "religious faith that they reflect can be described without reference to the central teachings of Paul."[9] Among those central teachings is the notion of "death through Adam, life through Christ," most explicitly elaborated in Romans 5–7. Just as Adam brought sin into the world through primordial disobedience rooted in pride, so Christ saved the world from sin through an act of obedience rooted in humility. The inset would then have brought the artistic program into some conformity with this vision of sin and salvation.

> In other words, the addition serves to introduce into the program precisely the elements needed to make it conform to the theology and the interpretation of the sacrament of baptism current in the churches of the Mediterranean world. Seen in the light of the addition, the Good Shepherd in the scene to which the representation of Adam and Eve has been added should be understood as the one who gives his life for the sheep vicariously, and the scene of the Women at the Tomb should be thought to suggest the death and resurrection of the believer in baptism with Christ.[10]

Thus the interpretation of the Adam and Eve painting would exercise significant explanatory power on the two most dominant motifs in the room: it makes the shepherd and flock a rendering of John's Good Shepherd who dies; likewise it makes the procession of women a summoning to ritualized participation in death. The Pauline "death mysticism" of Romans 6 seems here to have been resurrected.

Yet another way of reading this image exists, one that honors the stunning lack of emphasis on Romans 6 before the fourth century and is much more in line with theological emphases in the region of Syria. Christian initiation symbolizes a return to paradise—a microcosmic restoration of paradise—not in the western (and mostly later) sense of a drowning of inherited sin, but in the sense of reuniting alienated entities. The theory of atonement at work here may not be sacrifice in place of sin, but reconciliation and restoration in place of alienation and exile.

Primordial Coupling

In early Syrian Christianity, the narrative of Adam and Eve was not primarily received as a tale of "original sin." Lucinda Dirven has argued most eloquently along these lines. While giving great respect (as also do I) to Kraeling's research, she finds the theory of a later, corrective inset painting not very probable. But even if it was done later, "it is equally possible to suppose that it was an addition meant to highlight the program's original meaning"—a "marginal footnote," not a corrective.[11] Dirven assesses the Syrian traditions about Adam and Eve in the century on either side of Dura's baptistery in order to show that a Pauline interpretation was not very likely. On the contrary, incorporating Adam and Eve might have corresponded more to anti-Marcionite polemics.

The influential second-century thinker Marcion preached that the creator God of the Jewish Bible was not the same as the God of Jesus Christ. In much of Syria and Mesopotamia, followers of Marcion "formed the majority of Christians in large areas."[12] Marcion had taken his inspiration from a radical interpretation of Paul's antithesis between law and grace, and to this he added selections from the Gospel of Luke to form his own small

canon of scripture—possibly the earliest gesture toward canon-making by a self-identifying Christian. One substantive response to Marcion, whose views were exceedingly popular from the second to the fourth century, was the creation of the *Diatessaron*. A fragment of this Gospel harmonization (the only Greek version yet discovered) was, of course, found at Dura-Europos; it was by its very nature anti-Marcionite, since it incorporated the witness of four Gospels. In addition, "the anti-Marcionite character of Christianity in Dura is confirmed by the scenes from the Jewish scriptures in the decoration of the baptistery. The scene of Adam and Eve, in particular, touches upon the core of Marcion's teachings. It is, after all, man's fall that led Marcion to believe in an imperfect Creator God in addition to the unknown good God."[13] What is more, the inscription "One God in heaven" was found very frequently in Syria and was almost certainly a polemic against Marcionite dualism (and other Mesopotamian forms of cosmic dualism). In fact, this same text—εἷς θεὸς ἐν ὁ⟨υ⟩ρανῷ—was among the graffiti in the Dura-Europos house-church, having been found by Hopkins on the doorjamb between the courtyard and the baptistery.[14]

Dirven further uses the distinctive Syrian motif of the "robe of glory" to situate the meaning of the primordial couple in this ritual context: "The concept of the robe of glory, or robe of light, derives from Jewish thinking and was taken as a reference to the potential divine nature of man at creation. . . . The aim of the incarnation, according to Ephrem and other Syriac writers, is to re-clothe mankind in their robes of glory."[15] The putting on of the primordial, immortal robe occurs through baptismal initiation, "a re-entry into Paradise, not just the Paradise of the beginning of time, but also an eschatological Paradise, of which the Church is the terrestrial anticipation."[16] Thus Adam and Eve here do not call to mind sin and death so much as incarnation and immortal paradise. Our reconfiguring of this painting thus resembles the shift from seeing the Samaritan Woman (sin and repentance) to seeing the Annunciation (incarnation and divine humanity).

Ritual return to paradise also cannot be isolated from Syrian sources that imagine Christian salvation as a reunification of two distinct beings through the symbol of marriage. As mentioned in chapter 4, early Christian

salvation was frequently symbolized by marriage in new creation; many Syrian sources emphasize salvation-as-reunification, which reconciles sin-as-alienation. According to the *Gospel of Thomas,* Jesus said, "When you make two into one you will become 'sons of man' [i.e., bring about the King-dom of God], and when you say, 'O mountain, go elsewhere!' it will go elsewhere."[17] He further says that "to enter the kingdom," his followers must "make the male and the female be one and the same."[18] Both the *Gospel of Thomas* and the *Gospel of Philip* rely on the commonly believed myth of the primal androgyne, the notion that the first human was not di-vided into two sexes.[19] The Jewish story of origins is creation by separa-tion: light from darkness, saltwater from freshwater, land from sea, and male from female. "That is why the tale of Creation begins with the letter *bet,*" states one Jewish interpreter, playing on the second letter of the Hebrew alphabet; because "here begin the twos, and so the whole creation tale is told in terms of pairs."[20] The myth of primal androgyny was found every-where from Plato to early rabbinic sources. Even the Apostle Paul implies his belief in salvific "new creation" as a reunification of opposites, when he famously describes initiation thus: "As many of you as were baptized into Christ have clothed yourselves with Christ. There is no longer Jew or Greek, there is no longer slave or free, there is no longer male and female; for all of you are one in Christ Jesus" (Gal 3:27–28). Paul's use of "and" with "male and female" breaks the pattern of the phrases and shows he is quot-ing the creation account (Gen 1:27). A "new creation" or restored paradise would thus recapitulate the world before the primal divisions.

These ideas depend on corporeal sexuality, through which the uniting of two sexes really does produce a new creation. The sexless incar-nation opened the way, though, for a restoration of paradisiacal innocence, shamelessness, and (presumably) sexual continence. According to some early Christian theologians, such as Gregory of Nyssa, in the kingdom of God "humanity will be changed from being earthly and corruptible (and necessarily gendered) into impassible and eternal. Since there will no longer be need for generation, the eternal world will be beyond sexual difference."[21] Susan Ashbrook Harvey views the Syrian take on sexual renunciation in light of its overarching emphasis on healing and bodily wholeness, dis-

cussed in chapter 3: "The redeemed body promised and imaged by the resurrected Christ was a body healed of mortality—healed of any illness or suffering, and healed, too, of the necessity of procreation."[22]

Quite unexpectedly, then, these altered perspectives on Adam and Eve imply connections to other parts of the artistic program: the wedding procession, the shepherd and flock, and the woman at a well. First, the donning of a robe of glory to enter the door to paradise calls to mind Jesus' parable of the wedding banquet, in which only the properly robed can enter the heavenly feast (Matt 22:1–10). The shepherd and flock also take on new meaning, as he becomes not the self-sacrificial shepherd of John, but the pastoral, paradisiacal shepherd of the Psalms. Ephrem's *Hymns on Paradise* expresses well this vision of a saved sheep grazing just outside the gates of paradise—even though "he remains outside, he may pasture there through grace"[23]—waiting to be let back in at the end of time:

> Have pity on me, O Lord of Paradise,
> and if it is not possible for me to enter your Paradise,
> grant that I may graze outside, by its enclosure;
> within, let there be spread the table for the diligent,
> but may the fruits within its enclosure drop outside like the crumbs
> for sinners,
> so that, through your grace, they may live![24]

In the Syrian tradition, Adam and Eve were expelled from paradise, to be sure, but Lucas Van Rompay has demonstrated the distinctive tradition affirming their subsequent proximity to the garden. This "neighborhood of Paradise represents the transition between paradisiac and earthly life"—a liminal space that was hymned as sheep pasturing just outside the gate and ritualized in Christian initiation.[25] Finally, Syrian typological interpretations of Adam and Eve connect ritually to baptismal rebirth and narratively to the incarnation in the Virgin Mary. Simon Jones describes Ephrem's birth imagery at initiation as follows: "Once in the womb, the candidate is able to put on the lost robe of glory, at one time worn by Adam and Eve in the garden, deposited in the Jordan by the Second Adam at his baptism by

John, and thereby be invested with the status which Adam and Eve enjoyed before the Fall."[26] In Ephrem's own words, directed to Christ, "Our body became your garment, your Spirit became our robe."[27] His *Hymns on Paradise* further incorporate Mary into the drama of salvation.[28] Adam's "garment" had been "covered with stains" and was expelled from the garden, but "through Mary, Adam had another robe," which adorned "the thief" on the cross—as the first representative of humanity to enter paradise clothed in Christ.[29] Therefore, the dominant imagery surrounding Adam and Eve in Syrian theology includes birth, restoration, clothing, anointing, and reunification.

Considering these theological and ritual emphases on virginal marriage and spiritual birth, what can be said about the actual marital status of the initiates at Dura? Were they all celibates themselves, married only to Christ and born in him? Or was virginal marriage a spiritual notion kept separate from ascetical practice, like how birth or military victory were ritualized and spiritualized but not literally enacted?

In his work on Syrian asceticism, Sidney Griffith charts a possible middle way. While it is true that Syrian asceticism was often more severe and idiosyncratic than that of other regions, he does not argue that all or even most Christian initiates were voluntary celibates. Rather, the distinctive Syrian "solitaries" or "singles" in existence by at least the fourth century (and probably by the third) were a celibate subgroup within regular Christian communities "whose way of life is parallel to that of the biblical widows and virgins and with whom the men and women 'singles' will be bracketed in later canonical legislation."[30] The painting of processing virgins on the walls of the baptistery coheres, then, with the ritual convergence of both regular initiation and the elevation of specific individuals to the rank of "solitaries."[31] Ephrem's *Hymns on Epiphany* portray as much: "Here they are, coming to be baptized and to become Virgins and Holy Ones. They step down, are baptized, and they put on the Solitary One. For whoever is baptized and puts on the Solitary One, the Lord of the many, has come to fill for him the place of the many, and Christ becomes for him the greatest treasure."[32] By Griffith's reckoning, these solitaries are uniquely joined with Christ—the celibate bridegroom—and yet are neither simply elite in social

status nor a separate church. The solitaries are "living icons" of what all the baptized are called to be.[33] Also called "sons" (or "children") of the "covenant" (or "resurrection"), they anticipated the general resurrection and restoration at the end of time. Jesus' own teachings said that the resurrected body would be "like the angels" and "neither marry nor be given in marriage" (Matt 22:30 and parallels). Early Syrian texts, especially in the tradition of Thomas, emphasize the gift of solitariness: "There are many standing at the door, but it is the solitaries who will enter the bridal chamber," says Jesus in the *Gospel of Thomas*.[34]

It is not surprising, finally, that Aphrahat's treatment of the "solitaries" and "children of the resurrection" invokes related scenes from Dura's baptistery. His sixth *Demonstration,* "On the Solitaries," invokes the "Blessed Mary" who overturned the curse of Adam and Eve, alongside repeated references to almost every marriage motif from the Gospels. Those to be initiated shall say, "I will make me ready oil, that I may enter in with the wise virgins and may not be kept outside the door with the foolish virgins."[35] Sebastian Brock identifies the Parable of the Wise and Foolish Virgins as "first and foremost" among the Syrian "conceptual models" promoting virginal ideals and a restoration of paradise.[36] Thus, like saints processing along the nave of a cathedral, drawing regular participants forward toward holiness, the manifestations of commitment in a marriage covenant were embodied in the baptistery's virginal procession and its ritual actors. The solitaries "came to anticipate symbolically, almost in an iconic fashion, the situation of paradise restored."[37]

Looking Back, with the *Odes of Solomon*

Throughout this book I have invited readers to imagine early Christian initiation at the nexus of Bible, art, and ritual. Marshaling the proximate resources available for the study of third-century Syrian Christians, we have tried to follow the processional footsteps of initiates such as Isseos and Hera. To do so, we have relied on the core resources of ritual texts and artistic comparanda. But I sometimes suggested other texts that might plausibly have been on their minds: popular Psalms of David and various

episodes from early Christian narrative sources. Since so much of this work
has involved historical imagination as the means for reconstructing plau-
sible meanings, I have intentionally tried not to have any one narrative,
source, or image bear too much weight. Rather, I wanted to richly describe
the circumstances—landscapes, buildings, stories, figures, gestures, pasts,
and presents—in which Dura's neophytes encountered Christianity and
made it their own. On their night of initiation, what did they use to think
with, to see and feel with, to pray with?

In chapter 3 I introduced one of our earliest Syrian sources of litur-
gically resonant material, the *Odes of Solomon*. These odes are replete with
biblically imitative language, and their evident role in prayer—with lan-
guage frequently suggestive of *communal* prayer—offers us one final op-
portunity for imagining initiation at Dura-Europos.[38] Since their discovery
in the early twentieth century, scholars have debated whether the *Odes* were
a kind of early Christian hymnal, with answers ranging from "obviously
yes" to "absolutely not."[39] The mediating stance of Mark Pierce makes
sense, though: the text cannot be used to reconstruct precise liturgical prac-
tice in nascent Syrian Christianity, but the "common baptismal context"
of the themes of the *Odes*—"the descent of the dove, being begotten and
born of the Spirit, new creation, the putting on of the new man, anointing,
water, and rest—may delicately support the conjecture that the overall char-
acter of this hymnbook is indeed baptismal."[40] While I too would stop
short of calling the *Odes of Solomon* "the first Christian hymnal," at least
some second- or third-century Christians—and almost certainly in Syria—
used these texts to pray with. Let us then use them to think with, to look
back on the entire procession of Bible, art, and ritual.

The *Odes* overall sing of love and salvation, of paradise and planting,
of illumination and cleansing, of sun and water—but some of the particu-
lars are even more resonant with the ritual space at Dura. Odes 35 and
36, for instance, are first-person thanksgivings for salvation that have even
been defended as "baptismal hymns."[41] While that is difficult to prove, one
can see why it was proposed. Salvation is imagined as "rain of the Lord"
that "overshadowed," "guarded," and "became salvation." A rebirth through
water occurred as a member of "the Lord's group," and "like a child by its

mother I was carried and [the group] gave me for milk the dew of the Lord." The recipient of this grace came to be "called the shining one, the son of God," and the Most High "anointed me from his perfection." The initiatory themes of water, anointing, rebirth, and divine sonship in imitation of David and Christ are all present.

Regarding the miracles of Jesus, I already cited Odes 6 and 39 in chapter 3. In one, the "great and wide river" of "ever-living water" raised up "the will that was paralyzed" and the "limbs that had fallen." The other showed how "raging rivers" like the Euphrates become "obedient" to those who "put on the name of the Most High." The "footprints of the Anointed" establish a way across, fording a merciless river for "those who cross in the name of the Lord." Thus both of the mighty deeds that are preserved on the upper panel of the baptistery feature in the *Odes,* a fact made more noteworthy because of the relative paucity of explicit references to Jesus' actions in these texts.

The "living spring of the Lord" is hymned in Ode 30, a text that calls to mind both the refreshment of a watered flock (as in Psalm 23) and Jesus' teachings about his own gift of salvation as "living water" that "gushes up to eternal life" (John 4:14):

> Draw water for yourselves from the living spring of the Lord,
> because it has been opened for you.
> And come, all you thirsty, and take the drink
> and rest beside the spring of the Lord,
> because it is beautiful and pure
> and gives rest to the soul. . . .
> Blessed are those who drank from it and found rest by it.
> Hallelujah.[42]

The salience of Psalm 23 for early Christian initiation, not least the imagery of watering, sealing, and incorporation into a flock in Syrian sources, was described in chapter 3. And while the text may invoke the dialogue between Jesus and the Samaritan woman about "living water," chapter 5 notes well the multiplicity of water-drawing women in biblical and

early Christian texts. Mary was also often presented as drawing water from a spring or a well at her moment of God's calling. The middle verses of this ode might be reconceived in connection with such salvific incarnational ideas:

> [The water] issues from the lips of the Lord,
> and from the heart of the Lord [is] its name.
> And it came unbounded and unseen,
> and until it was placed in their midst they did not know it.[43]

At Mary's wellspring, the "living water" came "unseen" from the "lips of the Lord" in speech, and she was given "its name." What was conceived in her was not known at first, though this ode presents the living water similarly to how Wisdom/Sophia was depicted in sapiential texts on which the *Odes* drew: "I came forth from the mouth of the Most High," says Wisdom (Sir 24:3).[44] The combination of sapiential ideas and metaphors of ritual initiation remains polyvalent, to be sure, but again the primary motifs are at home in the visual vocabulary of Dura's extant paintings.

Bridal and marital imagery also abounds, though it is often obscure or redirected toward other metaphors. Ode 38, for instance, narrates an otherworldly vision that includes a deceptive bride and bridegroom, who invite the many to a wedding feast, only to get them drunk, nauseated, and "foolish." But the narrator was not led astray by all this seduction: "But *I* became wise, since I did not fall into the hands of the deceivers, and I was glad for myself because Truth had gone with me."[45] The notion of a "wise" wedding guest occurs also in the incomplete Ode 3, a meditation on the unity of lover and beloved as the archetype of unity of salvation with God. That ode concludes with the exhortation, "Be wise, and understand, and be vigilant."[46] Returning to Ode 39, the rest of it then depicts the narrator's having been planted in the garden of paradise. This rendition of the theme of wedding feast as heavenly salvation builds on biblical precursors, such as Jesus' parables about weddings in general. But is it possible that the parable of the wise and foolish wedding guests was specifically in mind? Here, the "foolish" were *made* foolish by entering the wedding, but the

wrong wedding—one hosted by Error and a couple of deceivers. The "wise" narrator, on the other hand, avoids the decoy altogether and follows truth to the garden of paradise, where he or she was "firmly fixed and revived and redeemed . . . because he planted me. For he set the root and watered, fixed, and blessed it, and its fruits are forever. It went deep, grew upward, and spread out, and became full and large."[47] Just as in the illumination of the Parable of the Wise and Foolish Virgins in Codex Rossanensis, the inside of the heavenly "wedding" is portrayed not as a realistic earthly feast, but rather as a restored paradise, with flowing water and trees of life.

Related themes echo most clearly in Ode 42. Here, the saving Christ compares his "yoke on those who acknowledge me" to "the arm of the bridegroom on the bride," the "yoke of my love."[48] The saving bridegroom compares that love to a bridal chamber (*gnōnā*): "like the bridal tent, pitched in the house of the bridal pair, so my love is over those who believe in me."[49] The parables of the wedding feast and the ten virgins are recalled at the end of the ode, when those outside the bridal bedroom, those who had died without salvation, cry out for pity and ask to be let in through the doors.[50] Consider Dura's artistic rendering of a wedding procession in light of this prayerful text. Christ describes love and salvation as a bridal tent—a kind of chuppah—that is *inside* the doors of the house of the bridal pair, just as Dura's white structure is inside the doors of the wedding procession. From outside the doors, others beg to be let in. Unlike Matthew's Parable of the Wise and Foolish Virgins, the Christ of this ode "heard their voice and took their faith to heart."[51]

Among the most unique of all the collection is Ode 19, which includes a kind of nativity hymn and early example of veneration for the Virgin Mary. Susan Ashbrook Harvey calls it "arguably the earliest non-biblical testimony to Mary as virgin mother, and with devotional titles that would characterize western Mariology of a significantly later period."[52] The ode opens with an extended metaphor of nursing on divine milk: "the Father" is a lactating figure, the "Spirit of holiness" is the "one who milked him," and "the Son is the cup" of milk offered to the speaker of the text.[53] Then the text narrates how the mixture of milk from the Father was given to the world:

The womb of the Virgin caught [it],
and she conceived and gave birth.
And the Virgin became a mother in great compassion
and she was in labor and bore a son.
And she felt no pains because it did not happen without purpose.
And she did not require a midwife because he [God] delivered her.[54]

In this ode, the incarnation is not a seed, a spark, or a word, but rather a drop of milk. Han J. W. Drijvers shows how the text reflects first on the prologue of the Gospel of John—the preexistence narrative of the Son, the Spirit, and the Father's bosom—but then elaborates the Annunciation story of the Gospel of Luke (and other noncanonical narratives).[55] This sequence follows the order of the *Diatessaron,* which places John's prologue before the Lukan nativity narratives.[56] Drijvers argues that the text also bears a date and location proximate to Dura's Christian community: "Its theological ideas contain a working out of second-century conceptions directed through text and structure of the Diatessaron, and therefore a date in the first half of the third century or later is most likely. . . . [It] is a doctrine of recapitulation, how to regain paradise lost" and "a link between Ephrem's works and theology and his theological and literary antecedents."[57] Finally, the identification of Mary's conception as a prototype of each Christian initiate's reception of the Spirit, conception of Christ, and new birth in the womb—put forward in the previous chapter—is also on display in this ode. Its very opening line tells how the narrative of conception was not only a story of the past, but also one of the odist's own ritually constructed present: "A cup of milk *was offered to me, and I drank it* in the sweetness of the Lord's kindness."[58]

Finally, the *Odes* invoke the restoration of paradise, of salvation as new creation. Figurative language like that of the aforementioned Ode 38 comes to its fullest expression in Ode 11, where the notion of salvation as being planted in paradise is elaborated.[59] After the Holy Spirit enters the speaker, that spiritual "circumcision" begins to "grow," "flower," and "bear fruit" in the speaker, who is then "firmly founded upon the rock of truth, where [the Most High] set me."[60] As with the four rivers in the primordial Gar-

den of Eden, this paradise features abundant water to nourish the planted figure:

> And the speaking water drew near to my lips
> from the spring of the Lord who is without envy.
> And I drank from the living water that dies not, and became drunk,
> but my drunkenness was not without knowledge.
>
> . . .
>
> And I worshipped the Lord because of his glory
> and said, Blessed, Lord, are they who are planted in thy earth,
> and those who have a place in thy paradise
> and grow in the growth of thy trees
> and have passed from darkness to light.
>
> . . .
>
> For generous is the area in thy paradise
> and there is nothing in it that lies fallow,
> but everything is filled with fruits.
> Glory to thee, God,
> everlasting paradisiacal delight.
> Hallelujah.[61]

The plant drinks of the "speaking water" with its "lips." On one hand, this could be a simple metaphor for flowing water that makes a gentle sound, as the verb for "speak" here is onomatopoetic in Greek and used elsewhere for streams of water.[62] (English does the same with "babbling brook.") The very metaphor of "living" water, after all, signifies flowing water in its normal usage (John 4; *Didache* 7), just as the English "running" water does the same. But the mysterious "speaking" water also features in the writings of Ignatius of Antioch: when describing his willingness to die as a martyr in Rome, he writes, "There is no burning love in me for material things; instead there is in me living water that is also speaking, saying to me from within: 'Come to the Father.'"[63] Though Ignatius's context of imminent martyrdom is far different from that of the *Odes,* both texts rely on living and speaking water as what enables salvation after death. Water is neither

a site nor a means of death, but a primordial and ultimate symbol of God's care and nourishment in the paradise hereafter.

Each chapter of this book is thus captured by some aspect of the *Odes of Solomon*. Through richly metaphorical and polyvalent poems, the *Odes* transmit the traditions of a "baptismally oriented, albeit somewhat peripheral community of Syrian Christianity of perhaps the late second or early third century who share in the common parlance of early Christian typology, raising the same to a new height in these hymns."[64] In other words, a community like the house-church at Dura-Europos.

A Door Left Open

I conclude this book with reflections on these odes not to argue that they themselves were sung by Isseos and Hera at Dura-Europos, but rather to recapitulate the plentiful gallery of motifs available to early Christian initiates in Syria and its environs. And while I hope to have persuaded readers of at least some of my own particular arguments in this book, I also know that attempts at robust historical imagination will necessarily fail here and there. The general progress of the argument has been inductive more than deductive, cumulative and associative more than classificatory and analytical. My guiding approach has over and over been to ask, "What if . . . ?" and "What does this other comparison allow us to see?"

Now that we have completed the procession around the baptistery and walked out of its door, I hope to have allowed us to see that in third-century Syria, at the world's oldest extant church building, the dominant symbols of Christian initiation did not primarily signify individual sin buried through ritualized death and resurrection. Rather, the traditions of anointing and baptism as illumination, preparation for battle, healing, empowerment, marriage, and birth were carried through history, in part, between these four walls. Such motifs are well-attested by texts from multiple genres, proximate artistic comparanda, and plausibly reimagined rituals in early Christian Syria.

Yet little of what we say about Dura-Europos can ever be said without doubt. Preserved under duress, rediscovered by chance, and restored

with great toil, the remains grant us only a keyhole's view into a cityscape as full as it is foreign. Regarding this unique church building, then, we would be wise to keep our oil of interpretation burning—and to leave the door open. The attempts to find the right texts and images, the hermeneutical keys that unlock the meaning of this church and baptistery, will continue to enhance our understanding. But it would be foolish, once inside, to use those same keys to lock the door behind us.

Abbreviations

Ancient sources not listed here have been abbreviated according to The SBL Handbook of Style *(ed. Patrick H. Alexander et al.; Peabody, MA: Hendrickson, 1999).*

ABull	*The Art Bulletin*
Acts Thom.	*Acts of Thomas*
ANF	*Ante-Nicene Fathers*
ANRW	*Aufstieg und Niedergang der römischen Welt*
BASOR	*Bulletin of the American Schools of Oriental Research*
CSCO	Corpus scriptorum christianorum orientalium
EL	*Ephemerides liturgicae*
Gos. Phil.	*Gospel of Philip*
Gos. Thom.	*Gospel of Thomas*
ICA	Index of Christian Art
JBL	*Journal of Biblical Literature*
JQR	*Jewish Quarterly Review*
LXX	Septuagint
NPNF[1]	*Nicene and Post-Nicene Fathers,* Series 1
NPNF[2]	*Nicene and Post-Nicene Fathers,* Series 2
NTApoc	*New Testament Apocrypha,* 2 vols. (Hennecke-Schneemelcher)
Odes Sol.	*Odes of Solomon*
PG	Patrologia graeca
PL	Patrologia latina
SL	*Studia liturgica*
SP	*Studia patristica*
SC	Sources chrétiennes
VC	*Vigiliae christianae*
VCSup	Vigiliae christianae Supplements

Notes

Introduction

1. Clark Hopkins, "Excavation Daybook," January 18, 1932. His overall narrative of the discoveries can be found in Hopkins, *Discovery*. Kraeling, *Christian Building*, 228. The most recent summary of the excavation is Brody, "Yale University and Dura-Europos."
2. Letter of Clark Hopkins to Michael Rostovtzeff, January 22, 1932. Kraeling, *Christian Building*, 230.
3. Letter of Clark Hopkins to Michael Rostovtzeff, January 22, 1932. Kraeling, *Christian Building*, 229.
4. Clark Hopkins, "Excavation Daybook," January 20, 1932. Kraeling, *Christian Building*, 229.
5. Clark Hopkins, "Excavation Daybook," February 2, 1932. Kraeling, *Christian Building*, 229.
6. Letter of Clark Hopkins to Michael Rostovtzeff, March 15, 1932. Kraeling, *Christian Building*, 230.

Chapter 1. Dura-Europos and the World's Oldest Church

1. He made this comparison most fully in public lectures in London and Paris during the summer of 1937, revised versions of which became Rostovtzeff, *Dura-Europos and Its Art*. Cf. Dyson, *Ancient Marbles to American Shores*, 195–99, which describes Rostovtzeff's "lifelong fascination" with Pompeii.
2. The clearest ancient evidence about the city's names comes from Isidore of Charax, a geographer of the first century BCE/first century CE who described it in *Parthian Stations* as "the city of Dura Nicanoris, founded by the Macedonians, also called by the Greeks Europus" (Schoff, *Parthian Stations*, 5). The city's two names, as combined in modern scholarship, are explained well by Leriche, Coqueugniot, and de Pontbriand, "New Research." They argue that "Europos" is the better choice for a primary name, since an official inscription was discovered in 1999 that dates to the Roman era (230 CE) and refers to τῶν εὐρωπαιῶν ἡ βουλή ("the city council of the Europeans").
3. See now Kosmin, "Foundation and Early Life of Dura-Europos."
4. Leriche, Coqueugniot, and de Pontbriand, "New Research," 23.
5. Leriche, Coqueugniot, and de Pontbriand, "New Research," 26.

6. On the expansion of Roman control along the middle Euphrates, see Edwell, *Between Rome and Persia*. On Roman-era Syria in general, see Butcher, *Roman Syria and the Near East*.

7. An initial and solid onomastic analysis was Welles, "Population of Roman Dura." Recent studies include Millar, *Roman Near East*, 452–72; Edwell, *Between Rome and Persia*, 93–148; and Kaizer, "Religion and Language in Dura-Europos."

8. To imagine this in modern terms, one might think of the Yale University Art Gallery in New Haven, Connecticut, as the northwest corner of the city wall. The northern wadi runs along Park Street to Broadway, the western wall runs down Chapel Street to State Street, the southern wadi runs east along State Street, and the cliff above the Euphrates is approximated by Trumbull Street. For amusing reflections on how various scholars have imagined the size and significance of Dura-Europos, see Olin, "Émigré Scholars of Dura-Europos."

9. See now the excellent analysis in Gascou, "Diversity of Languages."

10. P.Dura 47 (third century), which is also discussed in Gascou, "Diversity of Languages," 75.

11. Methodological comments on the archaeological study of ethnicity can be found in Jones, *Archaeology of Ethnicity*. For the study of ethnicity at Dura-Europos specifically, see now Hoffman, "Theory and Methodology."

12. See Welles, "Gods of Dura-Europos."

13. Edwell, *Between Rome and Persia*, 117.

14. Kennedy, "Cohors XX Palmyrenorum," 90.

15. Dirven, "Strangers and Sojourners," 212–13.

16. See Millar, *Roman Near East*, 468–69.

17. See Brody and Hoffman, eds., *Crossroads of Antiquity*, 345 pl. 38.

18. Edwell, *Between Rome and Persia*, 135–43.

19. Dirven, "Strangers and Sojourners," 211.

20. For interpretation of the "mysteries" of Mithraism, see Beck, *Religion of the Mithras Cult*.

21. Rostovtzeff, Brown, and Welles, eds., *Preliminary Report on the Seventh and Eighth Seasons*. The assessment of Franz Cumont was eventually published as "The Dura Mithraeum," in *Mithraic Studies* 1:151–214. Cf. Edwell, *Between Rome and Persia*, 125.

22. Edwell, *Between Rome and Persia*, 128–35; *pace* Rostovtzeff, Bellinger, Brown, and Welles, eds., *Preliminary Report on the Ninth Season of Work*, 69–96.

23. Libanius, *Orations* 24.38, and Ammianus Marcellinus, *Res gestae* 23.5.3. The story is imaginatively told in Lieu, "Rome on the Euphrates," 33–35.

24. Edwell, *Between Rome and Persia*, 153.

25. Edwell, *Between Rome and Persia,* 135–46.

26. James, "Dark Secrets," 297. Cf. Gelin, "Histoire et urbanisme d'une ville."

27. James, "Dark Secrets," 297.

28. The date is based on a coin of the year 256 found in the possession of one of the soldiers deceased in a tunnel under tower 19 (Lieu, "Rome on the Euphrates," 59).

29. James, "Dark Secrets," 303. See diagrams of the siege on pp. 315–17 of the same article.

30. James, "Dark Secrets," 304.

31. Breasted, *Oriental Forerunners,* 53.

32. Breasted, *Oriental Forerunners,* 53. Italics in original.

33. Breasted, *Oriental Forerunners,* 56. This is usually called the "Sacrifice of Conon/Konon."

34. Breasted, *Oriental Forerunners,* 58.

35. Cumont, *Fouilles.* The work of Cumont is currently being prepared for republication by the Belgian Historical Institute and the Academia Belgica in Rome.

36. Cumont, *Fouilles,* ix–x. Quoted also in Hopkins, *Discovery,* 23.

37. Hopkins, *Discovery,* 25.

38. A distinctive viewpoint on the excavations can be seen through the letters and photographs of Susan Hopkins compiled in *My Dura-Europos.*

39. Hopkins, *Discovery, passim.*

40. On the compital altars in general, see Hano, "A l'origine du culte impérial."

41. This book will not deal extensively with the synagogue, except insofar as it directly affects particular interpretations of the Christian building that I offer. The final archaeological report is Kraeling, *Final Report VIII, Part I. The Synagogue.* Its art and architecture have continued to be interpreted in the study of early Judaism.

42. Fine, *Art and Judaism,* 53.

43. That field has been demarcated, surveyed, and analyzed with aplomb by Steven Fine in many publications, including *Sacred Realm, This Holy Place,* and other books and articles. Also of great interest is the work of Levine, *Ancient Synagogues Revealed, From Dura to Sepphoris,* and other books and articles.

44. Goodenough, *Jewish Symbols,* 9:4. Cited also in Fine, *Art and Judaism,* 174.

45. White, *Social Origins,* 2:124.

46. White, *Social Origins,* 2:124.

47. E.g., Thaddeus (Addai), the legendary founder of Christianity at Edessa, for whom the very ancient *Liturgy of Addai and Mari* and *Doctrine of Addai* are named.

48. Lucian of Samosata, *On the Passing of Peregrinus,* is in part a satire of a Christian martyr.

49. Kraeling, *Christian Building,* 102–10, addresses this question and argues for a predominantly gentile community that was "swelled by members of [the] garrison" (109).

50. Rajak, "Dura-Europos Synagogue," 150–51.

51. Rajak, "Dura-Europos Synagogue," 151, 148.

52. Fine, *Art and Judaism,* 174–85; and Teicher, "Ancient Eucharistic Prayers in Hebrew." But Teicher's proposal that the Dura-Europos Hebrew parchment (P.CtYBR inv. DPg 25 = P.Dura 11) was a version of a Christian eucharistic prayer is not necessary to account for its similarity to *Didache* 10. The connections between the Jewish grace after meals (Birkhat Ha-Mazon) and the prayer preserved in *Didache* 10 had, in fact, been analyzed previously in the same journal: Finkelstein, "Birkhat Ha-Mazon."

53. The best attempt to systematize and interpret the Valentinian school of thought and tradition of ritual practice is Thomassen, *Spiritual Seed.*

54. The sojourn of Valentinus and Valentinianism at Rome is summarized and analyzed in Lampe, *From Paul to Valentinus,* 292–318. Textual traditions affiliated with Valentinus are treated in Layton, ed., *Rediscovery of Gnosticism.*

55. Irenaeus, *Adversus Haereses;* Tertullian, *Adversus Valentinianos.*

56. E.g., Irenaeus, *Haer.* 1.13–21, about the Marcosians (in the Valentinian school of thought).

57. Ambrose, *Ep.* 40.16, described in a letter to Theodosius as *fanum* (to compare it pejoratively to a pagan "temple"), and *Ep.* 41.1, described in a letter to his sister as *conventiculum* (a neutral term, "building" or "meeting place").

58. *Pace* Nigel Pollard, who argues that the soldiers carried on lives less integrated with the civilian population ("Roman Army as 'Total Institution'"). Population estimates are challenging. Simon James argues for a garrison size of three thousand to five thousand in *Final Report VII. The Arms and Armour,* 19.

59. Welles, "Population of Roman Dura," 271, 258; cf. Rostovtzeff, *Dura-Europos and Its Art,* 30–31.

60. Kraeling, *Christian Building,* 3. Another aspect of this argument is the report that Christianity was brought to Gundeshapur, the new Sasanian capital of Shapur I, by Roman soldiers taken as prisoners of war. See Labourt, *Christianisme dans l'Empire Perse,* 19–20.

61. Lassus, "Maison des chrétiens," 138–39. Support for the western origin of Christians at Dura is offered by Kilpatrick, "Dura-Europos." Kilpatrick argues that the Jewish community had come from Persia, while the Christian community had come from the west.

62. Dirven, "Paradise Lost, Paradise Regained," 49.

63. Kraeling, *Christian Building*, 90.

64. Kraeling, *Christian Building*, 96 no. 18: τὸν Χ(ριστὸ)ν Ἰ(ησοῦ)ν ὑμεῖν. Μν[ή]-σκεσθε [. . . Πρ]όκλου, "Jesus Christ (be) with you. Remember Proclus"; see White, *Social Origins*, 132. Others have interpreted the dative ὑμῖν as part of an oath or swearing formula, as in "(I implore) you, by Christ Jesus, remember Proclus." Cf. Perler, "Inschriften des Baptisteriums."

65. Baur, Rostovtzeff, and Bellinger, eds., *Preliminary Report of Fourth Season of Work*, 215–21.

66. See Kraeling, *Christian Building*, 145.

67. Bradshaw, Johnson, and Phillips, *Apostolic Tradition*. Bradshaw also edited the journal *Studia Liturgica* for eighteen years.

68. Bradshaw, *Search*, x.

69. Bradshaw, *Search*, ch. 7. A similar method is followed, at least within each century, in the sourcebook Johnson, *Worship in the Early Church*.

70. Johnson, *Images of Baptism*.

71. On these, see chapters 2, 4, and 5.

72. Whitaker, *Documents of the Baptismal Liturgy*.

73. Everett Ferguson's mammoth book *Baptism in the Early Church*—more than nine hundred pages—covers every author, text, artifact, and glimpse into the ritual of baptism in the first five centuries. It is a true magnum opus, and I have profited greatly from it in my own research. Its strength as a compendium, however, is what prevents it from advancing scholarship on many particulars. Dura-Europos is covered in fewer than three pages, and the descriptions do not depart substantially from those in Kraeling's report. Several other stellar treatments of the theology and ritual of baptism have been offered, but not one of them addresses the evidence from Dura-Europos. Spinks, *Early and Medieval Rituals*, takes an even longer view, as part of a two-volume history of baptism to the modern era. Day, *Baptismal Liturgy of Jerusalem*, deals with the baptismal catecheses of Cyril and Chrysostom. Finn has provided a useful sourcebook of texts with introductions, *Early Christian Baptism and the Catechumenate*, but again, the topic of Dura-Europos is not addressed. For theological analysis of the early evidence about baptism, see McDonnell, *Baptism of Jesus in the Jordan*. In short, all of these excellent works attend to the textual traditions from early Christianity, but they do not propose connections between text, image, and ritual at Dura-Europos.

74. Jensen, *Understanding*, and Jensen, *Baptismal Imagery*. Cf. Jensen, "Early Christian Images and Exegesis."

75. Jensen, *Understanding*, 123.

76. Jensen, *Living Water.*

77. Jensen, *Baptismal Imagery,* 2.

78. Jensen, *Baptismal Imagery,* 3.

79. Information in this paragraph is gleaned mostly from Albright, "Carl Herman Kraeling."

80. The *Diatessaron* of Tatian, the most famous "harmonization" of what became the four canonical Gospels, has long been associated with Syria. A Greek parchment fragment of it or another Gospel harmonization—the only extant Greek fragment of a Gospel harmony—was discovered at Dura-Europos. P. CtYBR inv. DPg 24 (=P.Dura 10=NT uncial 0212) was initially published in Kraeling, *Greek Fragment.* Updates included in Welles, Fink, and Gilliam, *Final Report V, Part I: The Parchments and Papyri,* no. 10, pp. 73–74. The identification of the papyrus with Tatian's *Diatessaron* has been questioned by Parker, Taylor, and Goodacre, "Dura-Europos Gospel Harmony." The arguments therein have been rebutted by Joosten, "Dura Parchment and the Diatessaron," such that most scholars still accept the identification. Resolution of the dispute does not affect the argument of this book.

81. Kraeling, *Synagogue* and *Christian Building.*

82. Kraeling, *Christian Building,* 102–14.

83. Bauer, *Rechtgläubigkeit und Ketzerei,* was not translated into English until much later: *Orthodoxy and Heresy,* 1971.

84. Kraeling, *Christian Building,* 119–21.

85. Albright, "Carl Herman Kraeling," 7.

86. The *Gospel of Philip* was not widely known until the early 1960s, when publications by Hans-Martin Schenke and Robert McL. Wilson provided wide access to the text.

87. White, *Social Origins,* 2:123–34; Snyder, *Ante Pacem,* 128–34; Brody and Hoffman, eds., *Crossroads of Antiquity;* Chi and Heath, eds., *Edge of Empires.*

88. Korol, "Neues zu den alt- und neutestamentlichen Darstellungen im Baptisterium"; Dirven, "Paradise Lost, Paradise Regained."

89. Jensen, *Living Water,* 182–84; Jensen, *Baptismal Imagery, passim;* Ferguson, *Baptism,* 440–43.

90. Serra, "Baptistery."

91. Pagoulatos, *Tracing the Bridegroom.*

92. His use of Methodius relies in part on Pallas, *Synagoge,* 1:91–93.

93. Pagoulatos, *Tracing the Bridegroom,* 30

94. Reviewed by Cecily J. Hilsdale in *Speculum.*

95. For overviews of early Syriac Christianity, see Murray, *Symbols;* Brock, *Introduction;* and Harvey, "Syria and Mesopotamia."

96. Brown, "In Gibbon's Shade."

97. Kraeling, *Christian Building,* 89–97.

98. The "biblical" art of the Dura synagogue is also engaged with liturgy, midrash, and folklore—none of which employs only one-to-one correspondences with the Bible.

99. This observation is borrowed from Elsner, "Cultural Resistance," 278.

100. This is the subtitle of Jensen, *Baptismal Imagery.*

101. Jensen, *Understanding,* 4.

102. Jensen, "Early Christian Images and Exegesis," 69.

103. Jensen, "Early Christian Images and Exegesis," 69. Italics added.

104. Jensen, "Early Christian Images and Exegesis," 77. One might compare the work of Steven Fine on Jewish materials, e.g., "Liturgy and the Art of the Dura Europos Synagogue," in Fine, *Art and Judaism,* 174–85.

105. Jensen, "Early Christian Images and Exegesis," 77. Cf. Jensen, *Substance of Things Seen,* 49.

106. See his collected essays in Nelson, *Later Byzantine Painting;* and related essays in Nelson, ed., *Visuality.*

107. Elsner, *Roman Eyes,* 48. Cf. Fine, *Art and Judaism,* 174–207, on ritual-centered readings of Jewish art from late antiquity.

108. Elsner, *Roman Eyes,* 25.

109. Elsner, *Roman Eyes,* 25.

110. Elsner, *Roman Eyes,* 45, and cf. pp. 11–13 and 42–45; and Ando, *Matter of the Gods,* ch. 2, "Idols and Their Critics."

111. Elsner, *Roman Eyes,* 48.

112. Elsner, *Roman Eyes,* 48. He further argues that "ultimately, in a sacred context, naturalistic images ceased to be necessary, since the kinds of viewing they enticed [viewing that promoted desire and sexual impulses] were at odds with the suppression of such viewing ideally encouraged and policed by ritual" (26).

113. Elsner, *Roman Eyes,* xvii.

114. Elsner, *Roman Eyes,* xvii.

115. Nelson, *Visuality,* 2.

116. Francis, "Visual and Verbal Representation," 299–300.

117. Francis, "Visual and Verbal Representation," 301.

118. Elsner, *Art and the Roman Viewer,* 18–22; Nelson, "Empathetic Vision"; Francis, "Visual and Verbal Representation," 302.

119. Nelson, "Empathetic Vision," 496.

120. Mathews, *Clash of the Gods*, 150.

121. Mathews, *Clash of the Gods*, 151.

122. MacCormack, *Art and Ceremony*. Mathews rejects this connection as part of an overblown "emperor mystique," which he argues has bewitched interpreters of Christian art (Mathews, *Clash of the Gods*, 157–67 and *passim*).

123. Mathews, *Clash of the Gods*, 151–52.

124. See Baldovin, *Urban Character of Christian Worship*.

125. For the Aventine Mithraeum, see Mathews, *Clash of the Gods*, 158; and Vermaseren and Van Essen, "Aventine Mithraeum."

126. For the Dionysiac procession, see Brody and Hoffman, eds., *Crossroads of Antiquity*, pls. 69–72.

127. MacCormack, *Art and Ceremony*, 10.

128. Wharton, *Refiguring*, 51–63. Cf. her ritual visuality in "Ritual and Reconstructed Meaning."

129. Wharton, *Refiguring*, 54, 60. Italics in original. For an explanation of her distinction between optic (visual) and haptic (bodily), which is slightly different from the original art-historical usage of these terms, see pp. 68–69 and literature cited there.

130. Grégoire, "Baptistères de Cuicul et de Doura," 593. He connects this illumination to other inscriptions referring to the "illuminated" in early Christianity.

131. Du Mesnil du Buisson, "Inscriptions." This item is no. 42 on p. 18. The other inscription that seems Christian by subject matter is no. 123 on p. 36: Φιλητὸς πρ(εσβύτερος), or "Philetos the presbyter." What is most amazing is that the abbreviation ΠΡ for "presbyter" is written to resemble a crucifix. Plates V and VI show many staurograms and chi-rho markings.

132. The word νεόφυτος (neophyte = "newly planted") is already attested as a term for the baptized in 1 Tim 3:6. The variant spelling in this inscription is a common iotacism. Another fragment of the jar contains part of the correct spelling, written vertically: [ν]εόφυτο[ς]. Despite some scholarly descriptions of new members of the cult of Mithras as neophytes, I have not encountered an ancient source that uses that term in the context of Mithraism.

133. See Winkler, "Original Meaning."

134. The counterclockwise processional interpretation of the artistic program is also employed by Wharton, *Refiguring*; White, *Social Origins*; and Serra, "Baptistery." This method is preferable to the clockwise interpretation of Hopkins, *Discovery*, 106–17.

135. Peppard, "Illuminating the Dura-Europos Baptistery."

Chapter 2. Anointed like David

1. Millar, *Roman Near East,* 471.

2. Kraeling, *Christian Building,* 125.

3. Bardaisan, *The Book of the Laws of Countries,* in Drijvers, ed., *Book of the Laws of Countries.* Noted also by Kraeling, *Christian Building,* 126.

4. Kraeling, *Christian Building,* 21.

5. Winkler, "Original Meaning."

6. Terian, *Macarius of Jerusalem.* The text quoted here is from the oldest and most reliable version of the letter, preserved in the *Fragment in Anania of Shirak* 284.5–24, pp. 81–87.

7. During excavation, it was noted that the door locked from the inside. Kraeling, *Christian Building,* 23.

8. Kraeling, *Christian Building,* 11.

9. I thank Glenn Gunhouse and the Yale University Art Gallery for providing the screen capture that simulates the view of one entering the baptistery.

10. Kraeling, *Christian Building,* 190, endorses this interpretation.

11. Kraeling, *Christian Building,* 24. Cf. p. 28.

12. See essays in Dudley and Russell, eds., *Oil of Gladness.*

13. Its ubiquity is well-established, but the rituals and meanings are difficult to sort out, especially in the ante-Nicene period. See "Varieties of Anointing," in Bradshaw, *Reconstructing Early Christian Worship,* 85–97.

14. See Johnson, *Rites,* 43–52. One Coptic manuscript of the *Didache* does refer to anointing with μύρον, but it is not clear to which ritual this refers.

15. The manuscript tradition of the *Acts of Thomas* is challenging to sort out. I am persuaded by the hypothesis of an original Syriac, which has not come down to us, followed by a Greek translation, and then later expansions in Syriac, which *are* extant. Thus the Greek version, though derivative, often bears witness to an earlier version of the text than the extant Syriac versions, which have been expanded at many points. In the case of the initiation of King Gundaphorus, the Greek version is more important. See Attridge, "Original Language"; and Myers, "Initiation by Anointing."

16. All translations of the Greek version are from Attridge, *Acts of Thomas,* here slightly modified from 34–36. The youth carries a λαμπάς ("torch"), while the initiates each carry a λύχνος ("lamp"). Another excellent edition of multiple recensions with detailed commentary is Klijn, *Acts of Thomas,* 70–84, for this episode. For further interpretation of the prayers, see Myers, *Spirit Epicleses.*

17. Clement of Alexandria, *Paed.* 1.28; Ephrem, *Hymns on Epiphany* 8.22.

18. Myers, "Initiation by Anointing," 157.

19. Turibius of Astorga, PL 54:713–14. Latin: *non baptizare per aquam . . . sed per oleum solum.* Cited also by Myers, "Initiation by Anointing," 157.

20. *Didasc.* 16. Translation from Whitaker, *Documents of the Baptismal Liturgy,* 14–15, slightly modified.

21. Madigan and Osiek, eds., *Ordained Women,* 25–105.

22. Johnson, *Rites,* 54–55.

23. Johnson *Rites,* 58.

24. What follows is a summary of Winkler, "Original Meaning." Cf. Johnson, *Rites,* 58–63.

25. Unless otherwise noted, translations of the Hebrew Bible or New Testament are from the NRSV, and translations of the LXX are my own. In the Roman Catholic, Greek Orthodox, and Protestant Revised Common lectionaries, the Pauline interpretation of baptism remains central to the initiation mysteries. Rom 6:3–11 is the epistle selection at the Easter Vigil liturgy, read immediately before the Gospel proclamation of the Resurrection and the rites of Christian initiation.

26. Johnson, *Rites,* 72.

27. Johnson, *Rites,* 73. Cf. McDonnell, *Baptism of Jesus in the Jordan,* 203.

28. McDonnell, *Baptism of Jesus in the Jordan,* 183.

29. Jeanes, "Baptism Portrayed as Martyrdom"; and Campbell, "Dying with Christ," 292–93. Cited also in Johnson, *Rites,* 139–40.

30. Spinks, "Baptismal Patterns," 45–52.

31. Spinks, *Early and Medieval Rituals,* 23. Italics added.

32. See Jones, "Womb of the Spirit."

33. The feast of the Epiphany, the celebration of Jesus' baptism, is actually second only to Easter in antiquity. Though the extent of its celebration is uncertain, it predated the feast of the nativity (or "Christmas"). Clement of Alexandria knew of the celebration of Epiphany, although neither of the dates he records as the ones proposed for the feast day line up with the date he records for Jesus' birth. He notes that the followers of Basilides mark the feast with an all-night vigil of readings (*Strom.* 1.21.145). For a compilation and historical analysis of the evidence for Epiphany and nativity in early Christianity, see Usener, *Religionsgeschichtliche Untersuchungen.*

34. Terian, *Macarius of Jerusalem.* The text quoted here is from the oldest and most reliable version of the letter, preserved in the *Fragment in Anania of Shirak* 284.5–24, pp. 81–87.

35. Cf. Brock, "Anointing in the Syriac Tradition," in Dudley and Russell, eds., *Oil of Gladness,* 93.

36. *Gos. Phil.* 74.13–18. Translation by Layton, *Gnostic Scriptures,* 346, modified in consultation with the Coptic text: Layton, ed., *Nag Hammadi Codex II,* 2–7, 190.

37. *Gos. Phil.* 74.18–22. Layton translation modified.

38. Brock, "Anointing in the Syriac Tradition," 95. Cf. Brock, "Archaic Syriac Prayer," esp. p. 9.

39. Cyril of Jerusalem, *Procat.* 1.3 (PG 33:332–40). Many examples are found in Ysebaert, *Greek Baptismal Terminology,* 158–78. Cf. the connection of Incarnation, baptism, and illumination in Ephrem, *Hymni de Ecclesia* 36, in Brock, "St. Ephrem on Christ as Light." Moreover, the "light from light" image was so indispensable as a symbol of the idea of undiminished giving that it can rightly be thought of as the foundational image of Nicene Christology (see Jaroslav Pelikan's little gem of a book, *The Light of the World*).

40. A historical analysis of this image is found in Lampe, *Seal of the Spirit.*

41. Quasten, "Painting of the Good Shepherd," 6; cf. Quasten, "Bild des Guten Hirten." Much more will be said about this later.

42. Brock, "Anointing in the Syriac Tradition," 94.

43. For Chrysostom's military motifs, see later in this chapter.

44. Mignana, *Theodore of Mopsuestia,* 46. Translation slightly modified and italics added. On baptism as military tattoo, see Augustine, *De baptismo contra Donatistas* 1.4.5 and *Ep.* 185.43. Cf. Daniélou, *Bible and the Liturgy,* 58–59, for other examples of the solider motif in Christian initiation.

45. For a helpful survey of David's legacy in textual and artistic sources, see Zenger, "David as Musician and Poet."

46. Kraeling, *Christian Building,* 188; Weitzmann and Kessler, *Frescoes,* 84.

47. See the examples in Weitzmann and Kessler, *Frescoes,* 84–88; and Dale, "Power of the Anointed." There are other artistic comparanda from later centuries, e.g., p. 2 of *The Bamberg Psalm Commentary of Peter Lombard,* but they do not greatly aid interpretation of the Dura-Europos example in my opinion (see Zenger, "David as Musician and Poet," 288–93, for discussion of the Bamberg manuscript).

48. Clédat, "Monastère et la nécropole de Baouit," 13–29, and cf. pls. XV–XIX.

49. Kraeling reads it as Γολιόδ (*Christian Building,* 97), and LXX Ps 143 and Ps 151 have Γολιαδ. The final letter does not look like the other examples of delta in David's name, and so the spelling might rather be Γολιθα.

50. Weitzmann and Kessler, *Frescoes,* 84.

51. E.g., in his baptismal catecheses, Cyril of Jerusalem quotes this psalm in the David-Christ typology (*Bapt. Cat.* 7.2; 12.23; translation from NRSV).

52. See Drake, *In Praise of Constantine,* section 2.3.

53. On the Lukan variant in the manuscript tradition, see the excellent analysis in Ehrman, *Orthodox Corruption*, 62–67. On the Lukan variant in early liturgical traditions, see McDonnell, *Baptism of Jesus*, 85–100.

54. Johnson thinks it was "possibly recited" (*Rites*, 54).

55. Quasten, "Painting of the Good Shepherd"; cf. Quasten, "Bild des Guten Hirten." The affinities of Ps 45 with the motifs of initiation will be discussed in chapter 4.

56. On this psalm heading in Syriac manuscripts, see van Rooy, "Message of a Number of Psalms." The Greek could also be translated as "against Goliath."

57. Athanasius, *Letter to Marcellinus* 25, in Gregg, ed. and trans., *Athanasius*, 122.

58. Besides the two uses in the Psalms, it also appears in the planting allegories of Isa 5:7 and Job 14:9. This psalm also asks for deliverance from "mighty waters" and for an abundance of "sheep" in the prosperity prayer.

59. Ps 151 is in Codex Sinaiticus (which labels the Psalms as having 151 in number) and Codex Alexandrinus (which calls Ps 151 supernumerary). It was found in the Dead Sea Scrolls (11QPsa 28.3–12). In late antiquity, it was considered "David's own" by Athanasius (*Letter to Marcellinus* 25) and remains today in the Eastern Orthodox canon. The Syriac version of Ps 151 seems to derive from the LXX and not from a Hebrew lineage: Strugnell, "Notes on the Text."

60. The Hebrew version discovered at Qumran does not contain this heading but instead seems to discuss the battle with Goliath in the subsequent psalm. Cf. discussion in Sanders, *Psalms Scroll*. On the other versions, see also Wigtil, "Sequence of the Translations"; and van Rooy, "Psalm 151."

61. LXX version, translation adapted from NRSV.

62. Fernández-Marcos, "David the Adolescent," 216. Cf. Ps-Philo, *L.A.B.* 59–61.

63. The Hebrew version found at Qumran is similar but adds the idea of covenant: "God did not choose them, but sent to fetch me from behind the flock and anointed me with holy oil, and made me leader of his people and ruler over the sons of his covenant." Translation from García Martínez and Tigchelaar, eds., *Dead Sea Scrolls Study Edition*, 2:1179.

64. Athanasius, *Letter to Marcellinus* 25 ("own"=ἴδιον). Translation my own; italics added.

65. Matt 3:17 // Mark 1:11// Luke 3:22. I say this knowing full well the importance of the variant in some manuscripts of Luke 3:22, which reproduces the full verse of Ps 2:7 and seems to have been used in baptismal liturgy, according to *Didascalia* 9. For analysis of this construction, see the excursus on the baptismal voice in Peppard, *Son of God*, 106–12.

66. I should also note a minority position, held by Nigel Pollard, which maintains that the Roman military was a "total institution," functioning as a society unto

itself and insulated from the rest of the world. Pollard, *Soldiers, Cities, and Civilians,* and Pollard, "Roman Army as 'Total Institution.'" Pollard challenges the views of Millar, *Roman Near East,* 130–33, and Alston, *Soldier and Society,* who reiterates his view in reviewing Pollard's book in *American Historical Review.*

67. Kraeling, *Christian Building,* 90.

68. Kraeling, *Christian Building,* 96 no. 18: τὸν Χ(ριστὸ)ν Ἰ(ησοῦ)ν ὑμεῖν. Μν[ή]-σκεσθε [. . . Πρ]όκλου, "Jesus Christ (be) with you. Remember Proclus"; see White, *Social Origins,* 132.

69. Cf. graffiti of soldiers in Langner, *Antike Graffitizeichnungen,* nos. 1298, 1302, 1303.

70. Francis, "Biblical not Scriptural," 6–7.

71. Weisman, "Militarism."

72. Weisman, "Militarism," 19–22.

73. Weisman, "Militarism," 21.

74. Weisman, "Militarism," 31.

75. Korol, "David- und Goliath-Darstellungen"; and Korol, "Neues zu den alt- und neutestamentlichen Darstellungen im Baptisterium."

76. Korol, "Neues zu den alt- und neutestamentlichen Darstellungen im Baptisterium," 1648.

77. My translation of Korol, "Neues zu den alt- und neutestamentlichen Darstellungen im Baptisterium," 1648.

78. An example from Dura-Europos is the silver tetradrachm of Orodes II, 41–40 BCE, Dura-Europos Collection, inv. 1938.6000.45. Yale University Art Gallery, New Haven, CT.

79. My translation of Korol, "Neues zu den alt- und neutestamentlichen Darstellungen im Baptisterium," 1648–49.

80. Wander, "Cyprus Plates."

81. There are no specific cohorts of slingers attested, but they seem to have been drawn either from the Balearic islands in the West or Syria in the East. "Syrian slingers and stone-throwers" were used by Vespasian in his war with the Jews (Josephus, *B.J.* 3.7.18=3.211). Quotation about their increased use in the third century from LeBohec, *Imperial Roman Army,* 124.

82. Jean Daniélou, "David," *Reallexicon für Antike und Christentum,* 3:598–99.

83. The homily is preserved only in Georgian, but a Latin translation is offered in Garitte, ed., *Traités d'Hippolyte,* (see sections 5–7).

84. Ephrem, *Nisibine Hymns* 18.6; and *Hymns Against Julian* 1.1–2 and 2.1. Cf. Nitsche, *David gegen Goliath,* 163–64.

85. Zenger, "David as Musician and Poet," 290.

86. Zenger, "David as Musician and Poet," 298.

87. Zenger, "David as Musician and Poet," 298.

88. Braund, "River Frontiers," 44.

89. Braund, "River Frontiers," 45.

90. Eliot, *Complete Poems and Plays,* "The Dry Salvages," I.1–9.

91. Eliot, "Letter to Marquis Childs," 6. Cf. Miller, *Thomas Stearns Eliot,* 27.

92. Miller, *Thomas Stearns Eliot,* 11.

93. Mann, "Frontiers of the Principate," 513.

94. Braund, "River Frontiers," 44.

95. Caesar, *Bell. gall.,* 4.16 and *passim;* Suetonius, *Div. Jul.* 32.

96. *Supplementum Epigraphicum Graecum* 35 (1985): 1483; and *Inscriptions grecques et latines de la Syrie* I 65. Cited by Braund, "River Frontiers," 45.

97. Braund, "River Frontiers," 46.

98. Plutarch, *Luc.* 24.

99. Cassius Dio, *Roman History* 37.6.

100. Cassius Dio, *Roman History* 40.18.

101. Cassius Dio, *Roman History* 40.19.

102. For recent work on the Jordan in this vein, see Hutton, *Transjordanian Palimpsest;* and Havrelock, *River Jordan.*

103. Braund, "River Frontiers," 47.

104. Cf. Langner, *Antike Graffitizeichnungen,* nos. 1317–1325.

105. Baur, Rostovtzeff, and Bellinger, eds., *Preliminary Report of Fourth Season of Work,* 216.

106. Room 28. Cf. Langner, *Antike Graffitizeichnungen,* no. 1326.

107. Kraeling, *Christian Building,* 16.

108. Cassius Dio, *Roman History* 49.20.

109. Cassius Dio, *Roman History* 49.26.

110. Centuries later the silver Cyprus plates of David's life, of which the centerpiece featured David as slinger, were commissioned by the emperor Heraclius after his defeat of the Persians in 628–629.

111. "Hoffnungsträger" from Korol, "Neues zu den alt- und neutestamentlichen Darstellungen im Baptisterium."

112. Harris, "Tatian," esp. 30–31.

113. Gregory of Nazianzus, *Or.* 40.17, *In sanctum baptisma* (PG 36:380). Translation in *NPNF*², 7:365. For some of the references in this paragraph, I am indebted to the excellent analysis of the reception history of the David and Goliath story in Nitsche, *David gegen Goliath,* 149–200.

114. Athanasius, for his part, connects the story to baptism while preaching on the healing of the man born blind (John 9): he introduces his sermon with a

meditation on David's vocation, anointing, and victory. Athanasius, *In cae-cum a nativitate* 3 (PG 28:1005).

115. Aphrahat, *Dem.* 5.24; Ephrem, e.g., *Commentary on the Diatessaron* 4.11–12, in McCarthy, ed. and trans., *Saint Ephrem's Commentary*, 89–90.

116. Ephrem, *Hymni in Festum Epiphaniae* 5.10–11; Lamy, ed., *Sancti Ephraem Syri*, 54.10–11. Cited also by Kraeling, *Christian Building*, 189.

117. The "people" could also be translated as the "gentiles," which may be in parallel with "Israel" of the previous stanza.

118. Elsewhere Ephrem locates Christ's victory over Goliath on the cross. Ephrem, *Hymni de crucifixione* 8.4, cited by Kraeling, *Christian Building*, 189.

119. Serra, "Baptistery," 75.

120. Brock, "Archaic Syriac Prayer," 7.

121. John Chrysostom, *Baptismal Instructions* 3.8–9, in Harkins, trans., *St. John Chrysostom*, 58.

122. John Chrysostom, *Baptismal Instructions* 2.22, in Harkins, trans., *St. John Chrysostom*, 51.

123. John Chrysostom, *Baptismal Instructions* 3.11, in Harkins, trans., *St. John Chrysostom*, 59–60.

124. John Chrysostom, *Baptismal Instructions* 11.27, in Harkins, trans., *St. John Chrysostom*, 169.

125. John Chrysostom, *Baptismal Instructions* 12.30–35, in Harkins, trans., *St. John Chrysostom*, 182–83. Cf. John Chrysostom, *In act. apost.* 24–25.

126. Brock, "Some Early Syriac Baptismal Commentaries," 20–22.

127. Brock, "Some Early Syriac Baptismal Commentaries," 37.

Chapter 3. Lord and Shepherd of the Water

1. In addition to this example, one of the mosaics at San Giovanni in Fonte (Naples) is usually called the Walking on the Water, but in fact only part of the boat and the sea are present in the extant portion. There is no one walking on the water in what remains of the mosaic. The scene is featured on several late ancient sarcophagi: Dinkler, "Ersten Petrusdarstellungen."

2. This is mentioned as a proof of Jesus' power to be implored in *Acts Thom.* 47 and 66; Cyril of Jerusalem, *Bapt. Cat.* 4.9.

3. On the ancient Near Eastern motif of watery chaos and its adaptation in biblical traditions, see Batto, *Slaying the Dragon*, esp. 174–85.

4. Matt 14:22–36 // Mark 6:45–52 // John 6:15–21. Only in Matthew's version does the story have the second scene involving Peter.

5. Tertullian, *De bapt.* 12, deals with this text in order to address the question of whether Peter's dip in the sea was sufficient to count as his baptism (*Petrus satis mersus?*), since the baptism of the apostles is not narrated in the Gospels. He then quips, "to make guesses about the apostles' salvation is rash . . . if the apostles lacked that, I don't know whose faith is secure!"

6. Kraeling, *Christian Building,* 63. Contra Dinkler, "Ersten Petrusdarstellungen," 13.

7. Dinkler, "Ersten Petrusdarstellungen," e.g., 15.

8. Korol, "Neues zu den alt- und neutestamentlichen Darstellungen im Baptisterium."

9. Kraeling, *Christian Building,* 63.

10. Kraeling, *Christian Building,* 64.

11. It seems unlikely that Peter is represented *after* he has sunk and been pulled out of the water. His position between the boat and Jesus implies that he is walking out from the boat, not back to it. I should note, though, that according to Cyril of Jerusalem, after Jesus restored his faith, Peter walked upon the waters as before, and they returned to the boat together (*Bapt. Cat.* 5.7).

12. Ephrem, *Commentary on the Diatessaron* 12.7–8, in McCarthy, ed. and trans., *Saint Ephrem's Commentary,* 193–94.

13. Ephrem, *Hymns on Virginity* 5.4. Translated from McVey, *Ephrem the Syrian,* 282–83.

14. Kraeling, *Christian Building,* 65–66.

15. Jensen, *Baptismal Imagery,* ch. 5.

16. Lattke, *Odes,* 6–12.

17. Lattke, *Odes,* 12–13.

18. Lattke, *Odes,* 14.

19. These two lines of text (Lord=sign=way) are difficult to interpret, especially since the referent of "them" is not obvious.

20. Lattke, *Odes,* 539.

21. Lattke, *Odes,* 541–42.

22. On the subjective genitive interpretation, see Lattke, *Odes,* 556.

23. Kraeling does not defend the interpretation that the lines at the bottom of the scene represent water (*Christian Building,* 58). The manuscripts of John (5:2) differ on the name of the place: Bethesda, Bethsaida, Bedsaida, Bethzatha, and Belzetha.

24. John 5:2–15. Translation adapted from NRSV. The unexpected reference to sheep thus offers an intertextual connection with David the shepherd (southern wall) and the painting of shepherding above the font. On the interpretation of his verse, see Brown, *Gospel According to John I–XII,* 206. The clause

needs a noun supplied to make sense of the Greek, e.g., the "sheep gate," as in Neh 3:1.

25. See Knipp, *"Christus Medicus,"* 140–85, and recently Jefferson, *Christ the Miracle Worker,* ch. 4. At least one example in the Pio Cristiano does show the before-and-after type of this scene.

26. The Synoptic pericope is Matt 9:1–8 // Mark 2:1–12 // Luke 5:17–26.

27. Tertullian (*De Baptismo* 6) uses the version at the pool of Bethesda (he calls it Bethsaida), and Chrysostom also connects the Johannine version to baptism (*In paralyticum* 3, PG 51:53). The *Diatessaron* included what we consider the Johannine version separately from that of the Synoptic version, and the Johannine is treated at more length by Ephrem. McCarthy, ed. and trans., *Saint Ephrem's Commentary,* 205–08.

28. Ephrem, *Commentary on the Diatessaron,* 13.1 (according to McCarthy, ed. and trans.); Cyril of Jerusalem, *In paralyticum* (PG 33:1131–54).

29. Cyril of Jerusalem, *In paralyticum* 8–9, in McCauley, ed. and trans., *Works of Saint Cyril of Jerusalem,* 2:214.

30. Jefferson, "Superstition," 17.

31. Jefferson, "Superstition," 18. Cf. comparison of Asclepius and Jesus in Origen, *Contra Celsum* 3.24, Justin *Apol.* 1.22, Tertullian, *Ad. Nat.* 2.14.42. Cited also in Jefferson, "Superstition," 18 n. 22.

32. *P.Oxy.* VIII 1151, translated in Meyer and Smith, eds., *Ancient Christian Magic,* 40.

33. Jefferson, *Christ the Miracle Worker,* 91.

34. Jefferson, *Christ the Miracle Worker,* 92.

35. Jefferson, *Christ the Miracle Worker,* 93.

36. Harvey, "Syria and Mesopotamia," 356.

37. Ignatius of Antioch, *Eph.* 7.2; εἷς ἰατρός ἐστιν, σαρκικός τε καὶ πνευματικός, γεννητὸς καὶ ἀγέννητος.

38. Murray, *Symbols,* 200.

39. Murray, *Symbols,* 200, and *Acts Thom.* 10, 37, 42, 65, 95, 143, 155, 156, etc.

40. Harvey, "Syria and Mesopotamia," 358.

41. Jas 5:14; Aphrahat, *Dem* 23.9, cited also in Murray, *Symbols,* 200.

42. Aphrahat, *Dem* 7.317–320, cited also in Murray, *Symbols,* 202.

43. Lattke, *Odes,* 74. Italics added.

44. Brock, "Epiklesis," 193.

45. Brock, "Epiklesis," 210.

46. Jacob of Serugh, homily on the healing of the paralytic, cited and translated in Brock, "Epiklesis," 210.

47. Kraeling, *Christian Building,* 184.

48. Cf. Ephrem, *Commentary*, 4.14. Translated in McCarthy, ed. and trans., *Saint Ephrem's Commentary:* "He was not ill, because he was a healer. He did not go astray, because he was a shepherd" (91).

49. *Acts Thom.* 156. Translated by Attridge, *Acts of Thomas*, 115–16.

50. Kraeling, *Christian Building*, 50.

51. Jensen, *Baptismal Imagery*, 79.

52. See Schumacher, *Hirt und "Guter Hirt";* and Jensen, *Baptismal Imagery*, 75–82.

53. Kraeling, *Christian Building*, 53–55.

54. Cf. *Gospel of Truth* 31.28–32.17.

55. Kraeling, *Christian Building*, 55–57.

56. Jensen, *Baptismal Imagery*, 53–90, quotation from p. 54.

57. Kraeling, *Christian Building*, 50.

58. Clement of Alexandria, *Paed.* 1.9.

59. This paragraph draws heavily on Quasten, "Painting of the Good Shepherd"; cf. Quasten, "Bild des Guten Hirten," for an earlier treatment of similar material.

60. Here I interpret the LXX Ps 22, which was likely close to what most early Christians had available.

61. E.g., Mark 10:52 and *passim* in Acts, where Christianity was initially called "the way." Before that, John the Baptist had prepared "the way" of the Lord.

62. Origen, *Hom. in Cant. Cant.* 1, cited in Quasten, "Painting of the Good Shepherd," 9.

63. Athanasius, *Exp. in Psalmum* 22 (PG 27:140). Cited also in Quasten, "Painting of the Good Shepherd," 10.

64. See Quasten, "Painting of the Good Shepherd," 9–15, for detailed citations.

65. *In loco pascuae ibi me conlocavit | super aquam refectionis educavit me.* Cf. Wharton, "Ritual and Reconstructed Meaning," esp. 365.

66. Quoted in Jensen, *Baptismal Imagery*, 78.

67. Quasten, "Painting of the Good Shepherd," 6.

68. E.g., *Gos. Phil.* 37 and 47, in which God and the Son of Man are described as a "dyer" who "dips/baptizes" Christians in colors, yet they paradoxically come out "white." Cf. later the Qur'an 2.138 on *sibghat* (dye/dip/baptism), where an exegetical note by Yusuf Ali proposed that Arab Christians used to add dye to baptismal water; Ali, *Qur'an*, 56 n. 137).

69. See summary in Jensen, *Baptismal Imagery*, 76–77.

70. *Acts Thom.* 25. Italics added. Translated by Attridge, *Acts of Thomas*, 34. On the protective nature of the seal, see John Chrysostom, *Baptismal Instruc-*

tions 10.16, and Ephrem, *Hymns on Epiphany* 3.24 (cited also in Quasten, "Painting of the Good Shepherd," 7).

71. *Acts Thom.* 26. Italics added. Translated by Attridge, *Acts of Thomas*, 34.

72. *Acts Thom.* 131. Translated by Attridge, *Acts of Thomas*, 100.

73. Cyril of Jerusalem, *Cat.* 1.2, in McCauley, ed. and trans., *Works of Saint Cyril of Jerusalem*, 1:92.

74. Cyril of Jerusalem, *Cat.* 1.6, in McCauley, ed. and trans., *Works of Saint Cyril of Jerusalem*, 1:95.

75. Quasten, "Painting of the Good Shepherd," 15, for translations and references.

76. Ephrem, *Hymns on Epiphany* 3. This is the antiphonal response (chorus) sung in between each verse. See *NPNF*² 13:269.

77. Ephrem, hymn "Against the Heretics," translated in Quasten, "Painting of the Good Shepherd," 7.

78. Griffith, "Asceticism," 237. Cf. Ephrem, *Carm. Nisib.* 17.9.

79. Ephrem, *Hymns on Nativity* 7.8. Translated by McVey, *Ephrem the Syrian*, 116–17.

80. Mignana, *Theodore of Mopsuestia*, 46. Cf. Daniélou, *Bible and the Liturgy*, 58–59, for other examples of the solider motif in Christian initiation.

81. Wharton, *Refiguring*, 54.

82. Eusebius, *Comm. in Psalmos* 22.5 (PG 23:220). Cited also in Quasten, "Painting of the Good Shepherd," 10.

83. Theodoret of Cyrus, *Interpretatio Psalmi* 22.5 (PG 80:1025). Cited also in Quasten, "Painting of the Good Shepherd," 11.

84. *Ep. Apos.* 43–44. Translated from *NTApoc* 1:275.

85. Clement of Alexandria, *Exc.* 86. Cf. Tertullian, *An.* 18.

86. "A Psalm of the Vagabonds" from "Coptic Manichaean Psalm-Book, Part II," 170.16–171.24, translated in BeDuhn, "Manichaean Asceticism," 123. On the switch from left hand to right hand, cf. the interpretation of the lost sheep parable in *Gospel of Truth* 31.28–32.17.

Chapter 4. The Procession of Women

1. Mathews, *Clash of the Gods*, 151–60. For the Aventine Mithraeum, see Vermaseren and Van Essen, "Aventine Mithraeum."

2. Examples in Mathews, *Clash of the Gods*, 160.

3. Mathews, *Clash of the Gods*, 153–66.

4. Mathews, *Clash of the Gods*, 167. Cf. chapter 1 on processional visuality and, in early Christianity, Baldovin, *Urban Character*.

5. Wharton, *Refiguring*, 54, 68–69.

6. Wharton, *Refiguring*, 54.

7. Heyn, "Terentius Frieze."

8. Heyn, "Terentius Frieze," 228.

9. Heyn, "Terentius Frieze," 228.

10. Kraeling himself discovered the graffito in 1963 but decided "there is no reason to suppose that it has any connection with the fresco which it defaces" (*Christian Building*, 95).

11. Kraeling, *Christian Building*, 83–85, with reports of concurring opinions by Clark Hopkins, Joseph Pijoan, and Gabriel Millet.

12. Kraeling, *Christian Building*, 78.

13. Kraeling, *Christian Building*, 78.

14. Kraeling, *Christian Building*, 78.

15. Kraeling, *Christian Building*, 79.

16. Kraeling, *Christian Building*, 77.

17. Kraeling, *Christian Building*, 78.

18. The biblical accounts are found in Matt 28:1–8 // Mark 16:1–8 // Luke 24:1–12 // John 20:1–13, with several differences of detail. Before Kraeling's report, the main defenders of this interpretation were Seston, "L'Église et le baptistère," and Grabar, "Fresque des saintes femmes." Seston, however, does not defend a one-to-one correspondence with a Gospel narrative, but rather a presentation of an initiatory liturgical procession similar to that described by Egeria. After Kraeling's report, the empty tomb interpretation became settled, for the most part, and reproduced in surveys such as Perkins, *Art of Dura-Europos;* Hopkins, *Discovery;* White, *Social Origins;* Jensen, *Understanding;* Snyder, *Ante Pacem;* and Ferguson, *Baptism.*

19. Besides Kraeling, the other leading voice who seemed assured of the empty tomb identification was Grabar, "Fresque des saintes femmes."

20. Scholars who support multiple possible interpretations of the processing women include Jensen, *Living Water*, 277; Jensen, *Baptismal Imagery*, 201; Wharton, *Refiguring*, 53–54; Mathews, *Clash of the Gods,* 153; and Pagoulatos, *Tracing the Bridegroom*, 44–50.

21. Kraeling, *Christian Building*, 86.

22. White, *Scripting Jesus*, 396–97. White uses the Greek "Gospel harmony" fragment from the excavation (P.CtYBR inv. DPg 24 [=P.Dura 10=NT uncial 0212]) as a means of corroborating that interpretation of the painting. However, there is not one extant version of the *Diatessaron* or another Gospel harmony that has five women at the tomb. White reconstructs them as part of his argument, but the parchment itself has only one proper name, and that during a prior scene. Most interpreters further believe that the opening sentence

of the fragment refers to "the wives of those who had followed him," which would imply an undetermined number of female disciples present during the Passion narrative.

23. Kraeling, *Christian Building*, 86.

24. Kraeling, *Christian Building*, 213. Italics added.

25. In John the body had been anointed already by Joseph of Arimathea and Nicodemus (John 19:38–42). On the problems of lining up the Gospel accounts with the painting, see Kraeling, *Christian Building*, 85–87.

26. The earliest representations of that scene include illuminations from two Syriac manuscripts, usually dated to the sixth century (*Syr.* 33 fol. 9v., Bibliothèque Nationale de France, Paris, and the "Rabbula Gospels," fol. 13r, Medicean-Laurentian Library, Florence), both of which show two women at the tomb carrying vessels but not torches. These illuminations are compared with similar amulets and ampullae in Ernst, *Martha from the Margins*, ch. 6, "Picturing the Myrrophore." See chapter 5 for bibliography about sources for early Byzantine pilgrimage art.

27. Kraeling, *Christian Building*, 80–88.

28. Kraeling, *Christian Building*, 81.

29. Kraeling, *Christian Building*, 81, cites Otto Casel, Gabriel Millet, and Joseph Pijoan as defenders of this interpretation, but he does not say who proposed it first. Kraeling insists that the white structure must be a sarcophagus, but his certitude is not warranted, as I explain below.

30. The disputed Pauline letter to the Colossians repeats the image (2:11–12).

31. Winkler, "Original Meaning."

32. Yarbro Collins, "Origin of Christian Baptism," 55.

33. Winkler, "Original Meaning"; Bradshaw, *Search;* Johnson, *Images of Baptism;* Johnson, *Rites.*

34. McDonnell, *Baptism of Jesus in the Jordan*, 183. Italics added.

35. Johnson, *Rites*, 72.

36. Johnson, *Rites*, 73. Paul included birth (Phlm 10) and adoption (Gal 4:5; Rom 8:15) in his repertoire of metaphors.

37. Moss, *Other Christs.*

38. Campbell, "Dying with Christ," 293. Cited also in Johnson, *Rites*, 139.

39. Apostolos-Cappadona, "On the Visual and the Vision," 132.

40. Reeve, "Medea 1021–1080."

41. Eur., *Medea* 1021–27, from Kovacs, ed. and trans., *Cyclops; Alcestis; Medea*, 391.

42. Longus, *Daphnis and Chloe* 4.40. Translated in Reardon, *Collected Ancient Greek Novels*, 348.

43. E.g., Statius, *Silvae* 4.8.59.

44. Udell, "Times of Day," 141–42, 144–45. Cf. Furley, *Studies in the Use of Fire,* 186–88, whose argument centered on the transfer of fire from hearth to hearth, a view that Udell finds insufficient to explain the material evidence.

45. Udell, "Torches," 6.

46. Tertullian, *Adv. Val.* 32. Like *lampas,* the word *fax* ("torch") can stand metonymically for "wedding/marriage" (*Oxford Latin Dictionary* 682).

47. Tertullian, *Adv. Val.* 32. Translated in *ANF* 3:518.

48. Hersch, *Roman Wedding,* explains the metonymic function of torches also for Roman-era weddings, *passim,* e.g., 165.

49. Apuleius, *Metam.* 11.24. Cf. Elsner, *Roman Eyes,* 297.

50. Udell, "Times of Day," 207–15.

51. Clement of Alexandria, *Protr.* 2.12; Plutarch, *Mor.* 81e. Cited also in Udell, "Times of Day," 215–17.

52. Xenophon of Ephesus, *An Ephesian Tale* 1.2; cf. Reardon, *Collected Ancient Greek Novels,* 129. Cited also in Elsner, *Roman Eyes,* 233.

53. Elsner, *Roman Eyes,* 228–35. On the mysteries of Artemis and processional visuality there, see now Rogers, *Mysteries of Artemis,* e.g., 216–17.

54. Menander Rhetor, *Peri Epideiktikōn,* in von Spengel, *Rhetores graeci,* 3:404, lines 15–32 (cf. 409, line 10).

55. Menander Rhetor, *Peri Epideiktikōn,* in von Spengel, *Rhetores graeci,* 3:400–401. My own translation from 401.16–22.

56. A perfect example is the appending of Matt 20:16 to the parable of the workers in the vineyard. That phrase about eschatological *reversal* misinterprets the preceding parable, which is about an eschatological *leveling* of reward. In addition, Matthew uses that free-floating maxim immediately earlier to conclude a *different* teaching (Matt 19:30).

57. E.g., Greek codices D, Θ, *f*, and some Latin and Syriac manuscripts.

58. Augustine, *Sermon* 93.4 (PL 38:575; Sermon 43 in *NPNF* 6:402).

59. The list included Otto Casel, in a note appended to Kollwitz, "Bezeihungen zur christlichen Archäologie," 311; Millet, "Parabole des vierges," a posthumous publication written in 1934–35; Pijoan, "Parable of the Virgins"; Dinkler, "Ersten Petrusdarstellungen," 12; and Quasten, "Painting of the Good Shepherd," 1. Pagoulatos, *Tracing the Bridegroom,* does not support the proposal (p. 47), despite its connections with his overall theory of the "Christ the Bridegroom" service. Korol, "Neues zu den alt- und neutestamentlichen Darstellungen im Baptisterium," 1649–63, inveighs against and sometimes ridicules any attempt to make certain identifications of the painting, and he is keen to disregard any use of later texts in the service of interpretation.

60. Serra, "Baptistery."

61. Jensen, *Baptismal Imagery,* 129, prefers this identification, but on p. 201 she admits that the problem may be "unanswerable."

62. Kraeling, *Christian Building,* 85–87.

63. Wharton, *Refiguring,* 54. Italics added.

64. On the translation of λαμπάς (*lampas*) as "torch" instead of "lamp," see Davies and Allison, *Gospel According to Saint Matthew,* 3:395–96, and texts cited there, especially Jeremias, "ΛΑΜΠΑΔΕΣ Mt 25.1, 3f., 7f." For further evidence and analysis of the text in light of wedding rituals in Hellenistic and Jewish antiquity, see Zimmermann, "Hochzeitsritual."

65. *Acts Thom.* 26–27.

66. In addition to the modest argument of Serra, "Baptistery," there is a substantial treatment in Pagoulatos, *Tracing the Bridegroom.* Pagoulatos covers some of the same primary material as this chapter does, especially the *Acts of Thomas* and the *Gospel of Philip,* but he does not engage Aphrahat, Ephrem, the baptismal catecheses of Cyril and John Chrysostom, or artistic comparanda. He limits his textual corpus to the *Acts of Thomas,* the *Gospel of Philip,* and the *Symposium* of Methodius because of the likely second- and third-century dates of these works. His use of Methodius relies in part on Pallas, *Synagoge,* 1:91–93. Although our primary material overlaps somewhat, the thesis of Pagoulatos's book is much different from that of my chapter. He argues that the Dura-Europos baptistery "hosted an initiation bridal service" that united the participants with the image of Christ in anticipation of the second coming; as such, it was "the earliest known Iconophile service" (30). He connects the proposed third-century ritual to the still-celebrated "Christ the Bridegroom" service of the Orthodox Holy Week, which is not extant in the manuscript tradition before the eleventh century.

67. Matt 22:1–14; Rev 19:7–9. The God of Israel was imagined as a bridegroom in the Hebrew Bible (e.g., Isa 54:1–6; Jer 2:2; Ezek 16:8), as was the Israelite King (e.g., Ps 45 [LXX 44]).

68. Matt 9:15; Mark 2:19; Luke 5:34; John 2:10.

69. Matt 22:10.

70. John 3:29; 2 Cor 11:2.

71. Matt 25:1–13.

72. A helpful survey, especially of Aphrahat and Ephrem, can be found in Murray, *Symbols,* 131–58.

73. *Acts Thom.* 6–7. Translated by Attridge, *Acts of Thomas,* 20–21. See discussion in Murray, *Symbols,* 133–35.

74. Matt 22:1–14; *Acts Thom.* 4.

75. *Acts Thom.* 14. Translations in this paragraph adapted from *NTApoc* 2:322–411.

76. *Acts Thom.* 124.

77. The Coptic text uses Greek nouns for the wedding imagery, also including παστός, "bridal bed" or "bridal chamber." For a survey of options for interpreting the imagery, see Pagoulatos, *Tracing the Bridegroom,* 40–44; Pagels, "Mystery of Marriage"; and DeConick, "True Mysteries," esp. 245–58.

78. *Gos. Phil.* 67.27. Translations in this paragraph adapted from Layton, *Gnostic Scriptures,* 325–53, in consultation with the Coptic text, in Layton, ed., *Nag Hammadi Codex II,2–7,* 1:140–215.

79. *Gos. Phil.* 68.22–25; 70.9–22.

80. *Gos. Phil.* 70.9–22.

81. *Gos. Phil.* 74.18–21.

82. *Gos. Phil.* 70–71. Though the geographical extent of the celebration of Epiphany is uncertain, it predated the feast of the nativity (or "Christmas"). For evidence and analysis, see Usener, *Religionsgeschichtliche Untersuchungen.*

83. *Gos. Phil.* 77.7–11.

84. *Gos. Phil.* 84.34.

85. It is the opening image of Aphrahat, *Dem.* 6.1, *NPNF*² 13:362.

86. Aphrahat, *Dem.* 6.6, *NPNF*² 13:367–68.

87. Aphrahat, *Dem.* 6.7, *NPNF*² 13:368.

88. Brock, "Early Syrian Asceticism," 6; Brock and Harvey, *Holy Women of the Syrian Orient,* 8–9.

89. Apostolos-Cappadona, "I understand the mystery," 1731.

90. See below for more discussion of this lingering question. Cf. Vööbus, *Celibacy.* Ferguson, *Baptism,* 493–94, summarizes the subsequent refinements in the debate about eastern celibacy.

91. Gal 3:28.

92. Gal 3:28 is quoted immediately preceding the passage quoted above from Aphrahat, *Dem.* 6.6. On how this image relates to ascetic ideals, see below, and Clark, "Celibate Bridegroom."

93. Cyril of Jerusalem, *Bapt. Cat.* 3.1. From McCauley, ed. and trans., *Works of Saint Cyril of Jerusalem,* 1:108. Cf. *Bapt. Cat.* 3.2, 3.16.

94. John Chrysostom, *Baptismal Instructions* 1.3. Translation adapted from Harkins, trans., *St. John Chrysostom,* 23. Greek text found in Kaczynski, *Taufkatechesen,* 2:292–94.

95. Chrysostom, *Baptismal Instructions* 1.4–16.

96. Chrysostom, *Baptismal Instructions* 1.4, quoting 2 Cor 11:2.

97. Cyril of Jerusalem, *Procat.* 1.3–4 (PG 33:332–40).

98. Chrysostom, *Baptismal Instructions* 11.1. This is the beginning of the final instruction according to one of the manuscripts (Papadopoulos-Kerameus). Greek text from Piédagnel, ed., *Trois catéchèses baptismales,* 212.

99. Chrysostom even gets choked up when he recalls the day of his own baptismal marriage, as he contrasts the virginal purity of that day with his current sinful state. He admits jealousy toward the bridal procession before him, comparing himself to women that grieve and lament when they see "others as brides being married and given to wealthy bridegrooms, enjoying great honor, and being led away with a retinue and procession." Chrysostom, *Baptismal Instructions* 11.23. Greek text in Piédagnel, ed., *Trois catéchèses baptismales,* 230.

100. Gregory of Nazianzus, *Or.* 40.46, *In sanctum baptisma* (Epiphany, 381 CE), PG 36:425. My translation. Cf. Gregory of Nazianzus, *Or.* 5.30–31, which alludes to the parable as well.

101. The connection of oil with good works is also made by *Midrash Rabbah* on Num 7:19, cited already by Donfried, "Allegory of the Ten Virgins," 427. For Matthew's part, he connects "light" with good works in other parts of his Gospel (5:14–16; 13:43). As seen above, Chrysostom discusses baptismal anointing as perfume adorning a bride (*Baptismal Instructions* 11.27).

102. Vööbus, *Celibacy,* 35–57.

103. See Ferguson, *Baptism,* 493–94, and texts cited there.

104. Positive statements at, e.g., Aphrahat, *Dem.* 18.8, 18.12.

105. Griffith, "Asceticism," 238.

106. Griffith, "Asceticism," 238.

107. Clark, "Celibate Bridegroom," 2.

108. Clark, "Celibate Bridegroom," 9.

109. Clark, "Celibate Bridegroom," 16.

110. See the comprehensive collection of materials in Nissinen and Uro, *Sacred Marriages.*

111. A tantalizingly incomplete Greek inscription from second-century Rome (Via Latina, Capitoline Museum) mentions "illuminating torches in the [ba]ths of the bridal chambers" and is likely related to Christianity, but the imperfect preservation of the artifact precludes any solid reconstruction of its ritual context. It does seem related, however, to another from the Via Latina, which also mentions the "bridal chamber" and contains Valentinian language. See Lampe, *From Paul to Valentinus,* 298–313. A Christian-Manichean psalm-book that seems to have originated in Syria records a chant that sounds appropriate for a ritualized spiritual marriage: an excerpt reads, "We are men of the Rest. Let no one give us toil. It is Jesus that we seek, the one

whose model we have received. Let no one give us toil. Our binding is upon our loins, our testimony is in our hand. Let no one give us toil. We knocked at the door, the door opened to us; we went in with the bridegroom. Let no one give us toil. We were counted in the number of the virgins in whose torches oil was found. Let no one give us toil." Translation adapted from BeDuhn, "Manichean Asceticism," 122–24.

112. *Gos. Phil.* 74.18–21.

113. Narsai, *Homily* 221, quoted in Penn, *Kissing Christians,* 73. Hans-Martin Schenke found the *Gospel of Philip*'s references to the kiss (59:1–5; 63:34) to be proof of a marriage-type ritual in the bridal chamber, but Penn's arguments are more persuasive.

114. The ring is Dura-Europos collection, inv. 1933.606. Yale University Art Gallery, New Haven, CT.

115. Pagels, "Mystery of Marriage."

116. Pagels, "Mystery of Marriage," 449, interpreting *Gos. Phil.* 66.4–7.

117. *Gos. Phil.* 65.1–26; cf. 1 Cor 7:8–9.

118. *Gos. Phil.* 67.9–11.

119. Murray, *Symbols,* 254–57, and primary sources cited there.

120. I note that Mithraic rituals also seem to have featured torch-bearing "male brides," a *nymphos* or *nymphus* (seemingly a neologism to designate the paradoxical "male bride"). This was one of the grades in the Mithraic mysteries.

121. Tertullian, *An.* 18 in *ANF* 3:198.

122. *Ep. Apos.* 43. Cf. Staats, "Törichten Jungfrauen."

123. Clark, "Celibate Bridegroom," 17–18.

124. Chrysostom, *Baptismal Instructions* 1.1.

125. Chrysostom, *Baptismal Instructions* 1.2.

126. Chrysostom, *Baptismal Instructions* 1.40.

127. Kraeling, *Christian Building,* 190.

128. Brock, "Early Syrian Asceticism," 6.

129. Before the discovery of Dura-Europos, the reception history and artistic evidence were summarized in Heyne, *Gleichnis von den klugen und törichten Jungfrauen,* 62–112.

130. Dodd, *Frescoes,* xvii.

131. Dodd, *Frescoes,* 70. Millet, "Parabole des vierges," argues that the painting of a procession of seven women at the monastery of el-Bagawat in Egypt is also a representation of this parable, but others offer different interpretations. E.g., Cartlidge and Elliott, *Art and the Christian Apocrypha,* 36, give tentative support to the theory of Schiller, *Ikonographie,* vol. 3, fig. 1, who

suggests a procession of temple virgins; Stern, "Peintures du mausolée,"105–6, argues for a procession before the tomb of St. Thecla. The best treatment of the procession in relation to Thecla is Davis, *Cult of St. Thecla,* 159–72.

132. E.g., Walters Museum (Baltimore), Armenian ms. W. 539, fol. 106v (1262 CE).

133. Wilpert, *Gottgeweihten Jungfrauen,* 65–76, pl. II 1.

134. Wilpert, *Gottgeweihten Jungfrauen,* pl. II 5.

135. My translation from Wilpert, *Gottgeweihten Jungfrauen,* 69: "die Verstorbene [buried in the room] als eine von den klugen Jungfrauen; sie sollte die Zahl vervollständigen, und darum hat er für sie einen Platz bei dem Mahle bestimmt."

136. I am grateful to Alan Cadwallader for first drawing this to my attention several years ago. The facsimile edition is *Codex purpureus Rossanensis.* The commentary is *Codex purpureus Rossanensis: Commentarium.*

137. Cavallo, "Purple Codex of Rossano," 27–32.

138. On the different gestures of blessing or condemnation in Syrian iconography, see Dodd, *Frescoes,* 180–85.

139. Loerke, "Rossano Gospels," 129, writes that the virgins on the left "have just returned from replenishing their flasks," but they appear clearly to be empty, to contrast with those on the right. Cf. Grabar, *Christian Iconography,* which correctly calls the illumination "removed from the simple translation of the sacred account into iconographic language: here again liturgy intrudes between gospel text and the miniature" (90).

140. E.g., Kraeling, *Christian Building,* 85–87; White, *Scripting Jesus,* 396.

141. Kraeling, *Christian Building,* 79, describes the detail of the brown oil visible through the transparent container.

142. Kraeling, *Christian Building,* 44.

143. Exod 17:1–7; Num 20:7–11; Pss 78:20; 105:41; 114:8; Isa 48:21. The event was interpreted typologically with respect to baptism by Paul in 1 Cor 10:4, and many others followed. It was also artistically juxtaposed with baptismal scenes.

144. See Jensen, *Baptismal Imagery,* ch. 5, which highlights motifs of paradise. Paulinus of Nola, *Ep.* 32.10, describes the rock and four streams in the vault of the decoration of the basilica of Felix.

145. See conclusion below. Cf. Dirven, "Paradise Lost, Paradise Regained."

146. Kraeling, *Christian Building,* 44.

147. Kraeling, *Christian Building,* 45.

148. Grabar, "Fresque des saintes femmes," 10; Kraeling, *Christian Building,* 81.

149. Kraeling, *Christian Building,* 81.

150. Letter of Clark Hopkins to Michael Rostovtzeff, April 18, 1932, cited in Kraeling, *Christian Building,* 231.

151. See Millet, "Parabole des vierges." The chuppah or marriage canopy is attested already in Ps 19:6 and Joel 2:16. A "bridal chamber" (νυμφών) has strong manuscript attestation in Matthew's other parable of a wedding (Matt 22:10). Cf. the above quotation from *Acts Thom.* 124.

152. The Greek is τοὺς γάμους (Matt 25:10), but the plural is normal (e.g., Diogenes Laertius, *Lives* 3.2), like the English "nuptials" or "festivities."

153. See above for Aphrahat, *Dem.* 6.1. For other references, I am indebted to Davies and Allison, *Gospel According to Saint Matthew,* 3:399–400. Ephrem, *Serm.* 2.4. Cf. *Gos. Thom.* 75; Gregory of Nyssa, *De inst. christ.* 83.12; Simeon of Mesopotamia, *Hom.* 4.6.

154. E.g., ms. grec 74, folio 49, Bibliothèque nationale, Paris.

155. Synagogue WB1, "Well of the Wilderness," is based on both Num 21:16–20 and rabbinic legends about Miriam's well. Cf. Berger, "Temples/Tabernacles," 131–32. Images of scenes from Trajan's column are widely available.

156. Murray, *Symbols,* 132 n. 3. Italics added.

157. Metzger, ed., *Constitutions Apostoliques,* 8.11.11, 3:176. Cited also by Pagoulatos, *Tracing the Bridegroom,* 97 n. 283.

158. Macarius of Jerusalem, *Letter to the Armenians* 228.3–10. For translation and commentary, see Terian, *Macarius of Jerusalem.*

159. Sperry-White, ed., *Testamentum Domini,* I.19, 46–47. Cited also by Pagoulatos, *Tracing the Bridegroom,* 97 n. 283.

160. Kraeling, *Christian Building,* 81.

161. Cyril of Jerusalem, *Procat.* 1 and 3–4 (PG 33:332–40).

162. Gregory of Nazianzus, *Or.* 40.46, *In sanctum baptisma* (Epiphany, 381 CE), PG 36:425.

163. The manuscript adapts the verse to be about women: in LXX=αὐτούς, in codex=αὐτάς. The *Commentarium* on the manuscript misses this feature (Loerke, "Rossano Gospels," 156).

164. In addition to Chrysostom and Augustine, Methodius, *Symposium* 7, and the *Epistula Apostolorum* 42–44 are also relevant for understanding how this text was interpreted in the third century. The latter connects the entrance to the wedding of Matt 25 with entrance into the sheepfold of John 10, as mentioned above in chapter 3.

165. Augustine, *Sermon* 43 (PL 38:577). Latin: *de oleo interno, de conscientiae securitate, de interiore gloria, de intima caritate.* Cf. Methodius, *Symposium,* 7.2, and *Epist. Apost.* 43.

166. John Chrysostom, *Expositiones in Psalmos* (PG 55:182–203). Translations are from Hill, *St. John Chrysostom,* 1:257–84.

167. Trans. Hill, *St. John Chrysostom,* 1:279.

168. This is one of the longest psalm commentaries in the entire collection.

169. Trans. Hill, *St. John Chrysostom,* 1:257.

170. Trans. Hill, *St. John Chrysostom,* 1:261–62. Cf. Methodius, *Symposium,* 9.2.

171. Translation adapted from Hill, *St. John Chrysostom,* 1:279. This sentence is followed by a quotation of Gal 3:27, "As many of you as were baptized into Christ have put on Christ."

172. Trans. Hill, *St. John Chrysostom,* 1:283, modified.

173. Trans. Hill, *St. John Chrysostom,* 1:269.

174. Chrysostom, *Baptismal Instructions* 11.7–10; 1.6–8.

175. See Schiller, *Ikonographie,* trans. Seligman, 1:41–42, although admittedly the connection is not made explicitly until the eleventh century and onwards (i.e., depictions of David holding this psalm quotation over the Annunciation scene).

176. Trans. Hill, *St. John Chrysostom,* 1:279–80.

177. Chrysostom, *Baptismal Instructions* 11.4.

178. Eph 5:32; Chrysostom, *Baptismal Instructions* 1.16–17. Eph 5:25–27 states: "Husbands, love your wives, just as Christ loved the church and gave himself up for her, in order to make her holy by cleansing her with the washing of water by the word, so as to present the church to himself in splendor." Cited similarly by Cyril of Jerusalem, *Bapt. Cat.* 3.2; Chrysostom, *Baptismal Instructions* 11.9; cf. Chrysostom, *Exp. in Ps. 5* (PG 55:63).

179. Cyril of Jerusalem, *Bapt. Cat.* 1.1.

180. I use the word "monstrous" to foreground the bizarre early Christian image of a bleeding bridegroom, in which wedding and funeral are one. The image became normal through repetition, but its combination must have been initially jarring.

181. Cartlidge and Elliott, *Art and the Christian Apocrypha,* 34–37, and literature cited there.

182. The "seven virgins" lead souls toward the ultimate "Virgin of Light" (*Pistis Sophia* 3.112; 4.128).

183. *Prot. Jas.* 7.2; *NTApoc* 1:429. Italics added.

184. *Prot. Jas.* 10.1; *NTApoc* 1:430.

185. See chapter 5 below.

186. Cartlidge and Elliott, *Art and the Christian Apocrypha,* 36.

187. Davis, *Cult of St. Thecla,* 166.

188. Arnobius the Younger, *Commentary on Psalms* 19:4–5. Translation from Blaising and Lardin, eds., *Psalms 1–50*, 151.

Chapter 5. A Woman at a Well

1. Spinks, "Baptismal Patterns."
2. See full treatment in McDonnell, *Baptism of Jesus in the Jordan.*
3. Spinks, "Baptismal Patterns," 50. Cf. Spinks, *Early and Medieval Rituals,* 23. Some italics added.
4. Gregory the Great, *Ep.* 67, *NPNF*² 13:83–84.
5. With Kraeling, *Christian Building,* 69, but contra Perkins, *Art of Dura-Europos,* who claims that "she is alone, the small space available forbidding the addition of the figure of Christ as commonly seen in Roman catacombs" (54).
6. Kraeling, *Christian Building,* 68. The identification is supported by virtually everyone who mentions the painting, e.g., Ferguson, *Baptism,* 442; Rutgers, "Dura-Europos," 217; Jensen, *Understanding,* 87; Jensen, *Living Water,* 277; and Jensen, *Baptismal Imagery,* 195.
7. John 4:1.
8. E.g., Irenaeus, *Adv. Haer.* 3.17.2; Tertullian, *De Bapt.* 9; Jerome, *Ep.* 69.6. Ephrem, *Hymni in Festum Epiphaniae* 7.20–21 and *Hymni de Virginitate* 22.3, but see below about polysemy in Ephrem's interpretation.
9. See Maertens, "History and Function"; and Bonneau, *Sunday Lectionary,* 96–100.
10. See Jensen, *Living Water,* 193–94, 277–78; Jensen, *Baptismal Imagery,* 193–96; and Maier, *Baptistère de Naples,* 80–87.
11. On the story's resonance with Jacob's well, see Neyrey, "Jacob Traditions"; and Attridge, "Genre Bending," 9–13.
12. Kraeling, *Christian Building,* 69. Cf. Ephrem, *Carmina Nisibena* 31–34. Origen, *Hom. in Gen.* 10.3 also connects the stories of Rebecca and the Samaritan Woman. One of Henry Pearson's early drawings of the house-church even labels it "Rebecca at the Well."
13. Serra, "Baptistery," 77–78.
14. Part of my argument was published in Peppard, "Illuminating the Dura-Europos Baptistery."
15. *Prot. Jas.* 10.1. English version found in *NTApoc* 1:430.
16. *Prot. Jas.* 11.1; italics added. Greek text from de Strycker, *Forme la plus ancienne du Protévangile de Jacques,* 114. "Pitcher"=κάλπις. See below on skepticism about Mary's return to her house in the oldest stratum of the textual tradition.

17. See the summary of manuscripts in *NTApoc* 1:421–23.

18. Shoemaker, "Between Scripture and Tradition," 492, 494.

19. Shoemaker, "Between Scripture and Tradition," 492.

20. Shoemaker, "Between Scripture and Tradition," 499.

21. Zevros, "Early Non-Canonical Annunciation."

22. Tacitus, *Hist.* 5.12. I have not been able to trace the "Fountain of the Virgin" label back very far, having learned of it through modern pilgrimage sources (e.g., Mark Twain, *The Innocents Abroad,* and Russell, *Palestine, or the Holy Land,* 151, from which my quotation is drawn).

23. Zevros, "Early Non-Canonical Annunciation," 674.

24. Zevros, "Early Non-Canonical Annunciation," 677–79.

25. *Gospel of Pseudo-Matthew* 9. Translated from *ANF* 8:373.

26. *Gospel of Pseudo-Matthew* 9. Translated from *ANF* 8:373.

27. See Terian, *Armenian Gospel of the Infancy,* 150–70.

28. Ephrem, *Hymns on Nativity* 22.41; italics added. Translated from McVey, *Ephrem the Syrian,* 186.

29. Maximus the Confessor, *Life of the Virgin* 19; Shoemaker, *Life of the Virgin,* 50. Shoemaker does not argue definitively for authenticity but gives several reasons why Maximus's authorship should be seriously considered.

30. Zevros, "Early Non-Canonical Annunciation," 682–86. The *bat kol* ("daughter of a voice") is interpreted as the voice of God or God's spirit in rabbinic literature. Some have interpreted the voice at Jesus' baptism in this tradition.

31. It is also possible that the angel was painted in the (unpreserved) upper register of the wall, above and to the side of the female figure, just as in Vat. gr. 1162 (Vatican), in mss. grec 74 and 1208 (Paris), and at the Chora church, Kariye Djami (see below).

32. An attempt to do this for Marian art overall was Wellen, *Theotokos,* but it does not offer much detail on Annunciation scenes (pp. 37–44).

33. Photographs of this painting are widely available. Select bibliography includes Wilpert, *Cyklus christologischer Gemälde,* 3, 19–20, pls. 1, 2, 4; Février, "Peintures de la catacombe."

34. Palbry, "Origins," 44.

35. Palbry, "Origins," 47. Cf. Bisconti, "Madonna di Priscilla."

36. Palbry, "Origins," 48.

37. Palbry, "Origins," 50. Cf. Bosio, *Roma Sottorranea,* 541.

38. See discussion in Palbry, "Origins," 50.

39. Jastrzębowska, "New Testament Angels," 154.

40. In this section, citations are drawn as frequently as possible from the most common print sources, the best databases, or open-access museum

catalogs with images. Cf. photo in Schiller, *Ikonographie,* trans. Seligman, 1: no. 57.

41. On personifications of the Jordan, see Jensen, *Living Water,* 117–23.

42. Schiller, *Ikonographie,* trans. Seligman, 1: no. 53.

43. Victoria and Albert Museum, London, no. 149-1866.

44. Clear photograph in Stauffer, *Textiles,* 12. Cf. Kötzsche, "Marienseide."

45. Stauffer, *Textiles,* 12.

46. Many Armenian examples have the two-spigoted spring (see below), but single spouts exist too, e.g., tenth-/eleventh-century Gospel ms. 7739, 1v, from Erevan, Matenadaran (formerly Sanassarian no. 8), in Index of Armenian Art M7739G.

47. Photos and analyses in Grabar, *Ampoules.* Cf. Vikan, *Early Byzantine Pilgrimage Art,* 36–40; and van Dijk, "Angelic Salutation."

48. Cf. Bobbio 18 in Grabar, *Ampoules;* Cleveland Museum of Art, Pyxis 14 (accession 1951.114), pictured in Volbach, *Elfenbeinarbeiten,* no. 184.

49. Cataloged by Richter-Siebels, "Palästinensischen Weihrauchgefäße," as Dresden (no. 19), Erewan 1 (no. 20), Florenz 1 (no. 27), and Luzern (no. 51).

50. Schiller, *Ikonographie,* trans. Seligman, 1: no. 52.

51. Lawrence, *Sarcophagi of Ravenna,* 18, 26.

52. Beckwith, *Early Christian and Byzantine Art,* no. 43; Schiller, *Ikonographie,* trans. Seligman, 1: no. 56; Volbach, *Elfenbeinarbeiten,* no. 130; Richter-Siebels, "Palästinensischen Weihrauchgefäße," Bagdad (no. 4).

53. Flask in Rahmani, *Museums of Israel,* 199 and pl. 4.

54. Vikan, *Early Byzantine Pilgrimage Art,* 67; cf. Vikan, "Two Byzantine Amuletic Armbands," 49. I note that Mary seems to be holding something, and if this is a distaff, the rope would be less ambiguous in meaning.

55. Pilgrim token in Evans and Ratliff, eds., *Byzantium and Islam,* 91, no. 58A.

56. Vikan, *Early Byzantine Pilgrimage Art,* 67.

57. See the medieval and Renaissance examples in the anthology *Annunciation.*

58. *Annunciation,* 40–41.

59. Underside of lid, "Reliquary of the True Cross (Staurotheke)," New York, Metropolitan Museum of Art, 17.190.715ab.

60. E.g., Paris, Bibliothèque nationale, ms syr. 33, 4r, in Leroy, *Manuscrits syriaques,* 2:35.

61. Volbach, *Elfenbeinarbeiten,* no. 140.

62. Erevan, Matenadran ms 2374, in Durand et al., eds., *Armenia sacra,* 105; and Paris, Bibliothèque nationale, ms lat. 9384, in *Armenia Sacra,* 107. It is possible (but difficult to discern) that an eighth-century Coptic textile fragment in

Budapest shows tools in Mary's hand (Budapest Museum of Applied Arts, 82.158.1).

63. Evans and Ratliff, *Byzantium and Islam,* 47, no. 24H.

64. Beckwith, *Early Christian and Byzantine Art,* no. 131.

65. "Sancta Sanctorum" silk (Vatican Museum 61231), in Evans and Ratliff, *Byzantium and Islam,* 152, no. 101; censer type 6aC in Richter-Siebels, "Palästinensischen Weihrauchgefäße," nos. 31 and 74.

66. The al-Mu'allaqa Doors (thirteenth to fourteenth century, British Museum). See Hunt, "Al-Mu'allaqa Doors."

67. Dodd, *Frescoes,* 35, and accompanying plates (9a, 9b, 10, and 14).

68. British Museum add. 7170, 15r; Vatican Library Syr. 559, 8v. Both in Leroy, *Manuscrits syriaques,* 2:73. A similar but damaged scene occurs in a sixth-century ivory pyxis (Hermitage Museum, St. Petersburg), which seems to show Mary seated but Gabriel flying toward her over a well (Volbach, *Elfenbeinarbeiten,* 116, no. 188, fig. 1).

69. Hermitage Museum, St. Petersburg, pictured in Volbach, *Elfenbeinarbeiten,* 116, no. 188, fig. 1.

70. Midyat, Syro-Orthodox Diocese, folio 14v. Leroy, *Manuscrits syriaques* 1:321 and 2:105.

71. Dodd, *Frescoes,* 36–39.

72. Photo: ICA 000122528.

73. Resembling the Syriac is a fourteenth-century Gospel illumination in the Congregazione Armena, Venice, Armenian ms 1917, 153r (ICA 000141285).

74. Mathews and Sanjian, *Armenian Gospel Iconography,* 136.

75. Mathews and Sanjian, *Armenian Gospel Iconography,* pl. 43.

76. Mathews and Sanjian, *Armenian Gospel Iconography,* figs. 305a and 305b.

77. Mathews, "Annunciation at the Well," 343.

78. New Julfa, All-Savior ms 47, 1v; Mathews, "Annunciation at the Well," 355, fig. 7.

79. Richter-Siebels, "Palästinensischen Weihrauchgefäße," labeled "Tiflis 1," 2:48, fig. 95.

80. Illuminated Gospel book, ms. grec 74 (Bibliothèque nationale, Paris), in Omant, *Evangiles avec peintures,* 93. Cf. Gospel Book of John Alexander (fourteenth century, London, British Library Add. 39627).

81. James of Kokkinobaphos, *Homilies on the Virgin,* in Vat. gr. 1162 (Vatican Library), folio 117v; and Paris, Bibliothèque nationale, ms. grec 1208.

82. Demus, *Mosaics of San Marco,* color pl. 41 (ICA 88114).

83. On the Annunciation in the Byzantine Kariye Camii / Kariye Djami (Monastery of the Chora) in Istanbul, see Lafontaigne-Dosogne, "Iconography."

84. Fourteenth-century Armenian Gospels ms 6305 (Erevan, Matenadaran).

85. Kraeling, *Christian Building*, 68 (fig. 7), with description on p. 67. Italics added.

86. Kraeling, *Christian Building*, pl. XL, 2.

87. Kraeling, *Christian Building*, 69.

88. Dodd, *Frescoes*, pl. V. See many examples in Schiller, *Ikonographie*, trans. Seligman, vol. 1, figs. 64–129.

89. London, British Museum Add. 7170, 15r; Vatican Bibl. apost. Syr. 559, 8v; Deir es-Za'faran Gospels, 22. See Leroy, *Manuscrits syriaques*, 2:73 and 2:127.

90. Mathews, *Armenian Gospel Iconography*, pl. 43 and figs. 305a–e.

91. Dodd, *Frescoes*, 33.

92. Dodd, *Frescoes*, 36.

93. Kraeling, *Christian Building*, 69.

94. Kraeling, *Christian Building*, 186–88.

95. Many examples of initiation as illumination are found in Ysebaert, *Greek Baptismal Terminology*, 158–78. Cf. the connection of Incarnation, baptism, and illumination in Ephrem, *Hymni de Ecclesia* 36, in Brock, "St. Ephrem on Christ as Light in Mary." In Gregory of Nazianzus, *Or. 40, In sanctum baptisma* (Epiphany, 381 CE), "baptism" is interchangeable with φωτισμός, "illumination" or "enlightenment," to the extent that Rufinus's Latin translation of this oration usually renders φωτισμός as *baptismus*.

96. "Vienna Genesis," Vienna, Österreichische Nationalbibliothek, Cod. theol. gr. 31, folio 7.

97. Tkacz, *Key to the Brescia Casket*, 36–40.

98. Featured on the book cover of Jensen, *Baptismal Imagery*, and also (with discussion) in Jensen, *Living Water*, 278.

99. Florence Laur. Plut. I, 56, 4r and 6r, in Leroy, *Manuscrits syriaques*, 2:23.

100. Paris, Bibliothèque nationale, ms. lat 9384.

101. Paris, Louvre, OA 5524 A; Paris, Museé de Cluny, Cl 444.

102. Schiller, *Ikonographie*, trans. Seligman, 1:426.

103. Cambridge, Fitzwilliam Museum M.10-1904 (ICA 77533).

104. Schiller, *Ikonographie*, trans. Seligman, 1:432.

105. Schiller, *Ikonographie*, trans. Seligman, 1:453.

106. E.g., cubiculum 19 and cubiculum 54 of the Catacomb of Peter and Marcellinus (ICA 53616 and 156009, respectively) or a much later bronze relief from the Column of Bernward (Hildesheim Cathedral; Schiller, *Ikonographie*, trans. Seligman, 1:454). Illuminated manuscripts show both types of wells.

107. Gregory of Nyssa, *Ep.* 2.15–16. Translation adapted from Silvas, *Gregory of Nyssa*, 121.

108. Hunt, "Were There Christian Pilgrims?," 39.

109. Wilkinson, *Jerusalem Pilgrims;* and Wilkinson, *Egeria's Travels.*

110. Vikan, *Early Byzantine Pilgrimage Art,* 13.

111. Vikan, *Early Byzantine Pilgrimage Art,* 27.

112. *Antonini Placentini Itinerarium* (hereafter *It. Plac.*) 31. Geyer, ed., *Itinera Hierosolymitana,* 157–218.

113. *It. Plac.* 20 and Egeria, *Itin.* 36–37.

114. Richter-Siebels, "Palästinensischen Weihrauchgefäße."

115. Photos and analyses in Grabar, *Ampoules.* Cf. Vikan, *Early Byzantine Pilgrimage Art,* 36–40; and van Dijk, "Angelic Salutation."

116. Grabar, *Ampoules,* 18–20 and pls. 4–6.

117. Vikan, *Early Byzantine Pilgrimage Art,* 66.

118. Vikan, *Early Byzantine Pilgrimage Art,* 31–33.

119. Vikan, "Pilgrims in Magi's Clothing," 104, and Vikan, "Art, Medicine, and Magic."

120. Grabar, *Ampoules,* 44 and pl. 56.

121. *Protev.* 22.3. Translation adapted from *NTApoc* 1:436.

122. Grabar, *Ampoules,* 31 and pl. 31.

123. The Greek reads ΕΥΛΟΓΙΑ ΤΗϹ ΘΕΟΤΟΚΟΥ ΤΗϹ ΠΕΤΡΑϹ ΒΟΥΔΙΑΜ(Ο?).

124. The closest I've come is the Aramaic/Syriac for "conception" is *batnā.*

125. *It. Plac.* 4. Italics added. Latin: *amula et canistellum sanctae Mariae.*

126. *It. Plac.* 4.

127. Leyerle, "Landscape as Cartography," 133–34, 137.

128. *It. Plac.* 3.

129. Russell, *Palestine, or the Holy Land,* 237.

130. Wilkinson, *Egeria's Travels,* 96.

131. Arculf, according to Adamnanus 2.24, in Geyer, *Itinera Hierosolymitana,* 274.

132. See the summary in Ward, "Sepphoris in Sacred Geography," 396–98.

133. Victor Turner prefers to call pilgrimage "liminoid": Turner and Turner, *Image and Pilgrimage,* 1–40, 253–54.

134. Hahn, "Loca Sancta Souvenirs," 90.

135. Attridge, "Genre Bending," 9, 13.

136. Attridge, "Genre Bending," 13.

137. Origen, *Homilies on Genesis* 10.5, in Heine, ed. and trans., *Homilies on Genesis and Exodus,* 166–67.

138. Brock, *Bride of Light,* 80.

139. Brock, *Bride of Light,* 111 (ms. British Library Add. 14520).

140. Brock, *Bride of Light,* 160. Italics added.

141. Jacob of Serugh, *On the Perpetual Virginity of Mary,* translation from Puthuparampil, *Mariological Thought,* 140.

142. Puthuparampil, *Mariological Thought,* 137.

143. Mathews, *Armenian Gospel Iconography,* 136.

144. Murray, *Symbols,* 131–58.

145. Jones, "Wombs of the Spirit," 112–13.

146. Ephrem, *Sermo de Domino nostro,* cited in Jones, "Wombs of the Spirit," 107.

147. Myers, *Spirit Epicleses.*

148. Ephrem, *Hymns on Virginity* 7.5, 7.7. Cited in Jones, "Womb and the Spirit," 176–77.

149. Brock, "Epiklesis," 209–210.

150. Theodore of Mopsuestia, *Baptismal Homilies* 4.1; Jensen, *Baptismal Imagery,* 165.

151. Jones, "Womb and the Spirit," 190.

152. Brock, "Passover, Annunciation and Epiclesis."

153. Brock, "Passover, Annunciation and Epiclesis," 3, 5.

154. Brock, "Passover, Annunciation and Epiclesis," 4.

155. Ephrem, *Hymns on the Nativity* 16.11. Quoted also in Jones, "Womb and the Spirit," 186.

156. Ephrem, *Hymns on Faith* 40.10. Quoted in Brock, "Fire from Heaven," 234.

157. Ephrem, *Hymns on Faith* 10.17. Quoted in Brock, "Fire from Heaven," 238.

158. A fourth- or fifth-century dialogue poem, "Mary and the Angel," translated in stanza 40 of Brock, "Mary and the Angel," 128. Quoted in Brock, "Fire from Heaven," 239. Cf. *Gos. Phil.* 58.10–13, where Jesus prays, "O you who have joined the perfect light with the Holy Spirit, join the angels with us too, as images."

159. Ephrem, *Homily on the Nativity* 2.1, translated in Brock, *Harp of the Spirit,* 63. Quoted in Brock, "Fire from Heaven." 239.

160. Ephrem, *Hymni in Festum Epiphaniae* 15, esp. 15.40–49.

161. Ephrem, *Hymni de Ecclesia* 36.2–4. Italics added. Trans. Brock, "St. Ephrem on Christ as Light," 138.

162. A discussion of methodological shifts over the past generation can be found in Francis, "Visual and Verbal"; and Francis, "Biblical not Scriptural."

163. Serra, "Baptistery," 77.

164. See chapter 1 above.

165. Turner, *Forest of Symbols,* 27–28.

166. Squire, *Image and Text,* 88.

167. Squire, *Image and Text,* 297.

168. Squire, *Image and Text,* 89.

169. Rhetorical "play" is most associated with the deconstructive hermeneutics of Jacques Derrida, but it is discussed as an ancient method in Squire, *Image and Text,* 190.

170. Ephrem, *Hymni in Festum Epiphaniae* 7.4. Translation in *NPNF*² 13:275. Kraeling deals with some of these texts from Ephrem but draws different conclusions about how they might influence interpretation of the baptistery.

171. Ephrem, *Hymns on Virginity* 23.4. Translation from McVey, *Ephrem the Syrian,* 362. For a summary of Ephrem's innovative argument for the Samaritan woman's chastity, see also p. 354.

172. Ephrem, *Hymns on Virginity* 23.5. Translation from McVey, *Ephrem the Syrian,* 362.

173. Shoemaker, *Life of the Virgin,* 27–28. Cf. the many sources of Orthodox history and theology cited there, e.g., Turner, *Patristic Doctrine of Redemption.*

174. Schiller, *Ikonographie,* 1:no. 53.

175. The star was also a sign of Incarnation above Gabriel in the "Mary Silk" (fourth to fifth century, Abegg-Stiftung), see above under type 1.

176. See above on Zevros, "Early Non-Canonical Annunciation."

177. Brock, "Passover, Annunciation and Epiclesis," 6. Serra, "Baptistery," 78, also notes this concept: "the womb of the Virgin, the first wedding chamber of heaven and earth."

178. Brock, "Passover, Annunciation and Epiclesis," 6. Italics added. Cf. "the bridal chamber of [Mary's] womb" in Homilies 1.1, 2.7, 5.3, etc., of Proclus of Constantinople, in Constas, *Proclus of Constantinople.*

179. Ephrem, *Hymns on the Nativity* 16.9. Cited also in Brock, "Passover, Annunciation and Epiclesis," 6.

180. *Gos. Phil.* 71.3–10. Translation from Layton, *Gnostic Scriptures,* 325–53, in consultation with the Coptic text, in Layton, ed., *Nag Hammadi Codex II,2–7,* 1:140–215.

181. *Gos. Phil.* 85.10–12.

182. *Gos. Phil.* 85.19–20.

Conclusion

1. The quotations in this paragraph are from Ephrem, *Hymns on Virginity* 5. Trans. McVey, *Ephrem the Syrian,* 282–84.

2. Andrew McGowan has recently suggested it was a waiting room for initiates, while those of the opposite sex were baptized below; *Ancient Christian Worship,* 165.

3. Hopkins, Report of February 10, 1932, in Kraeling, *Christian Building,* 233.

4. Jensen, *Baptismal Imagery,* ch. 5, "Baptism as the Beginning of New Creation."

5. Kraeling, *Christian Building,* 55.

6. Eve seems to be the figure on the right, since there is a slightly larger breast area on that figure.

7. Kraeling, *Christian Building,* 56.

8. Kraeling, *Christian Building,* 56.

9. Kraeling, *Christian Building,* 201. Cf. Seston, "L'Église et le baptistère," 177: "la mystique paulinienne semble lui être étrangère."

10. Kraeling, *Christian Building,* 202.

11. Dirven, "Paradise Lost, Paradise Regained," 48. The footnote metaphor she owes to Wharton, *Refiguring,* 51 n. 128.

12. Dirven, "Paradise Lost, Paradise Regained," 52; cf. Drijvers, "Early Forms of Antiochene Christology."

13. Dirven, "Paradise Lost, Paradise Regained," 53. She further notes that the question of theodicy, the foundational challenge to monotheism, was literally the first topic of dialogue in Bardaisan's *Book of the Laws of Countries.*

14. Kraeling, *Christian Building,* 95 no. 15.

15. Dirven, "Paradise Lost, Paradise Regained," 54, and literature cited there.

16. Dirven, "Paradise Lost, Paradise Regained," 54.

17. *Gos. Thom.* 106, cf. 48. Translations from Layton, *Gnostic Scriptures,* 325–53, in consultation with the Coptic text, in Layton, ed., *Nag Hammadi Codex II,2–7,* 1:140–215.

18. *Gos. Thom.* 23.

19. For the seminal study, see Meeks, "Image of the Androgyne."

20. Green, "Judaism," 16.

21. Jensen, *Baptismal Imagery,* 181–82, citing Gregory of Nyssa, *Hom. op.* 22.4–5. On early Christian treatment of sexual difference in Adamic soteriology, see Dunning, *Specters of Paul.*

22. Harvey, "Syria and Mesopotamia," 358.

23. Ephrem, *Hymns on Paradise,* 10.14. Translated in Van Rompay, "Memories of Paradise," 565.

24. Ephrem, *Hymns on Paradise* 5.15. Translated in Van Rompay, "Memories of Paradise," 565. The "diligent" likely refers to the parable of the talents/pounds (Luke 19:11–27) and "crumbs" to Matt 15:27 and parallels. Cf. Brock, *Hymns on Paradise,* 107.

25. Van Rompay, "Memories of Paradise," 567.

26. Jones, "Womb and the Spirit," 192–93.

27. Ephrem, *Hymns on Nativity* 22.39. Cited also in Jones, "Womb and the Spirit," 193.

28. On Eve and Mary in early Syrian thought, see Murray, "Mary the Second Eve."

29. Ephrem, *Hymns on Paradise* 4.5, referring to the good thief crucified next to Jesus (Luke 23:39–43). Trans. Brock, *Hymns on Paradise,* 99.

30. Griffith, "Asceticism," 222. Harvey, "Syria and Mesopotamia," 358, locates their origin "by the third century."

31. See Griffith, "Asceticism," 226.

32. Beck, *Heiligen Ephraem,* 173.

33. Griffith, "Asceticism," 234.

34. *Gos. Thom.* 75; cf. 49.

35. Aphrahat, *Dem.* 6.7, but see the whole Demonstration.

36. Brock, *Hymns on Paradise,* 27–33.

37. Griffith, "Asceticism," 227.

38. Communal prayer is implied by frequent use of the imperative plural. See Charlesworth, ed. and trans., *Odes,* 20 and 114. Cited also in Pierce, "Themes in the Odes," 39.

39. The "yes" is Bernard, *Odes,* and the "no" is Charlesworth, *Odes.*

40. Pierce, "Themes in the Odes," 53.

41. Unless otherwise noted, translations in this section are from Lattke, *Odes,* here at 478 and 492. The view of these as "baptismal hymns" comes from Bernard, *Odes,* 121.

42. *Odes Sol.* 30.1–3, 7.

43. *Odes Sol.* 30.5–6.

44. Cited also in Lattke, *Odes,* 420.

45. *Odes Sol.* 38.15. Italics added.

46. *Odes Sol.* 3.11.

47. *Odes Sol.* 38.16–18.

48. *Odes Sol.* 42.7–8.

49. *Odes Sol.* 42.9.

50. *Odes Sol.* 42.15–20.

51. *Odes Sol.* 42.19.

52. Harvey, "Syria and Mesopotamia," 355.

53. *Odes Sol.* 19.1–5. A much longer and more famous reflection on divine lactation is found in Clement of Alexandria, *Paed.* 1.6; cf. Irenaeus, *Haer.* 4.38.

54. In addition to Lattke, *Odes,* I have used the translation in Drijvers, "19th Ode." It is not clear to me that the "virgin" of Ode 33 ought also to be connected

with the Virgin Mary, since a connection with Wisdom seems more likely. Cf. Lattke, *Odes,* 449.

55. Drijvers, "19th Ode," 345.

56. Drijvers, "19th Ode," 351.

57. Drijvers, "19th Ode," 355.

58. *Odes Sol.* 19.1. Italics added.

59. *Odes Sol.* 20.7–10 shares a similar vision of salvation.

60. *Odes Sol.* 11.1.

61. *Odes* 11.6–8a, 17–19, 23–24.

62. This is an ode for which a Greek version is extant. For contemporaneous usage with respect to a river, See Achilles Tatius, *Leucippe and Clitophon* 2.14.8: τοῦ ὕδατος λαλοῦντος.

63. Ign. *Rom.* 7.2: ὕδωρ δὲ ζῶν καὶ λαλοῦν ἐν ἐμοί.

64. Pierce, "Themes in the Odes," 40.

Bibliography

Note: For ancient sources, I have tried to use the editions and translations most widely available in the United States: the Hebrew Bible, Septuagint, and New Testament from Deutsche Bibelgesellschaft (Stuttgart), the Loeb Classical Library (Harvard University Press), Patrologia graeca, Patrologia latina, Corpus Scriptorum, Sources chrétiennes, *Thesaurus linguae graecae* (electronic), and Library of Latin Texts (electronic).

Albright, William F. "Carl Herman Kraeling: In Memoriam." *BASOR* 198 (1970): 4–7.

Ali, Abdullah Yusuf. *The Qur'an: Text, Translation, and Commentary*. Lahore: Sh. Muhammad Ashraf, 1938.

Alston, Richard. Review of Nigel Pollard, *Soldiers, Cities, and Civilians in Roman Syria*. *American Historical Review* 106 (2001): 1849–50.

———. *Soldier and Society in Roman Egypt: A Social History*. London: Routledge, 1995.

Ando, Clifford. *The Matter of the Gods: Religion and the Roman Empire*. Transformation of the Classical Heritage 44. Berkeley: University of California Press, 2008.

Annunciation. London: Phaidon, 2000.

Apostolos-Cappadona, Diane. "I understand the mystery, and I recognize the sacrament: On the Iconology of Ablution, Baptism, and Initiation." Pages 1721–41 in *Ablution, Baptism, and Initiation in the Greco-Roman, Jewish, and Early Christian World*. Edited by David Hellholm, Tor Vegge, Lars Hartman, and Øyvind Nordervall. Berlin: Walter de Gruyter, 2011.

———. "On the Visual and the Vision: The Magdalene in Early Christian and Byzantine Art and Culture." Pages 123–52 in *Miriam, the Magdalen, and the Mother*. Edited by Deirdre Good. Bloomington: Indiana University Press, 2005.

Attridge, Harold W. *The Acts of Thomas*. Edited by Julian V. Hills. Early Christian Apocrypha 3. Salem, OR: Polebridge, 2010.

———. "Genre Bending in the Fourth Gospel." *JBL* 121 (2002): 3–21.

———. "The Original Language of the Acts of Thomas." Pages 241–50 in *Of Scribes and Scrolls*. Edited by Harold Attridge, John J. Collins, and Thomas Tobin. Lanham, MD: University Press of America, 1989.

Baldovin, John F. *The Urban Character of Christian Worship: The Origins, Development, and Meaning of Stational Liturgy.* Orientalia Christiana Analecta 228. Rome: Pontificum Institutum Studiorum Orientalium, 1987.

Batto, Bernard F. *Slaying the Dragon: Mythmaking in the Biblical Tradition.* Louisville, KY: Westminster John Knox, 1992.

Bauer, Walter. *Orthodoxy and Heresy in Earliest Christianity.* Edited by Robert A. Kraft and Gerhard Krodel. Philadelphia: Fortress, 1971. Translated by a team from the Philadelphia Seminar on Christian Origins. Translation of *Rechtgläubigkeit und Ketzerei im ältesten Christentum.* Tübingen: Mohr, 1934.

Baur, Paul Victor Christopher, Michael I. Rostovtzeff, and Alfred R. Bellinger, eds. *The Excavations at Dura-Europos Conducted by Yale University and the French Academy of Inscriptions and Letters. Preliminary Report of Fourth Season of Work, October 1930–March 1931.* New Haven, CT: Yale University Press, 1933.

Beck, Edmund. *Des heiligen Ephraem des Syrers Hymnen de Nativitate (Epiphania).* CSCO 186. Louvain: Secrétariat du CorpusSCO, 1959.

Beck, Roger. *The Religion of the Mithras Cult in the Roman Empire.* Oxford: Oxford University Press, 2006.

Beckwith, John. *Early Christian and Byzantine Art.* London: Penguin, 1970.

BeDuhn, Jason David. "Manichaean Asceticism." Pages 122–30 in *Religions of Late Antiquity in Practice.* Edited by Richard Valantasis. Princeton, NJ: Princeton University Press, 2000.

Berger, Pamela. "The Temples/Tabernacles in the Dura-Europos Synagogue Paintings." Pages 123–40 in Brody and Hoffman, eds., *Dura-Europos: Crossroads of Antiquity.*

Bernard, John Henry. *The Odes of Solomon.* Cambridge: Cambridge University Press, 1912.

Bisconti, Fabrizio. "La Madonna di Priscilla: Interventi di restauro ed ipotesi sulla dinamica decorativa." *Rivista di archeologia Cristiana* 72 (1996): 7–34.

Blaising, Craig A., and Carmen S. Lardin, eds. *Psalms 1–50.* Ancient Christian Commentary on Scripture. Downers Grove, IL: InterVarsity, 2008.

Bonneau, Normand. *The Sunday Lectionary: Ritual Word, Paschal Shape.* Collegeville, MN: Liturgical Press, 1998.

Bosio, Antonio. *Roma Sottorranea opera postuma di Antonio Bosio Romano.* Rome, 1632.

Bradshaw, Paul F. *Reconstructing Early Christian Worship.* Collegeville, MN: Liturgical Press, 2010.

————. *The Search for the Origins of Christian Worship: Sources and Methods for the Study of Early Liturgy.* 2nd ed. Oxford: Oxford University Press, 2002.

Bradshaw, Paul F., Maxwell E. Johnson, and L. Edward Phillips. *The Apostolic Tradition: A Commentary.* Edited by Harold W. Attridge. Hermeneia. Minneapolis: Fortress, 2002.

Braund, David. "River Frontiers in the Environmental Psychology of the Roman World." Pages 43–47 in Kennedy, ed., *Roman Army in the Near East.*

Breasted, James Henry. *The Oriental Forerunners of Byzantine Painting: First-Century Wall Paintings from the Fortress of Dura on the Middle Euphrates.* Oriental Institute Publications 1. Chicago: University of Chicago Press, 1924.

Brock, Sebastian P. "An Archaic Syriac Prayer over Baptismal Oil." *SP* 41 (2003): 3–12.

————. "Anointing in the Syriac Tradition." Pages 92–100 in Dudley and Russell, eds., *Oil of Gladness.*

————. *Bride of Light: Hymns on Mary from the Syriac Churches.* Rev. ed. Piscataway, NJ: Gorgias, 2010.

————. "Early Syrian Asceticism." *Numen* 20 (1973): 1–19.

————. "The Epiklesis in the Antiochene Baptismal *Ordines.*" Pages 183–218 in *Symposium Syriacum 1972.* Orientalia Christiana Analecta 197. Rome: Pontificum Institutum Studiorum Orientalium, 1974.

————. "Fire from Heaven: From Abel's Sacrifice to the Eucharist. A Theme in Syriac Christianity." *SP* 25 (1993): 229–43.

————. *The Harp of the Spirit: Eighteen Poems of Saint Ephrem.* London: Fellowship of St. Alban and St. Sergius, 1983.

————. *Hymns on Paradise.* Crestwood, NY: St. Vladimir's Seminary Press, 1990.

————. *An Introduction to Syriac Studies.* Piscataway, NJ: Gorgias, 2006.

————. "Mary and the Angel, and Other Syriac Dialogue Poems." *Marianum* 68 (2006): 117–51.

————. "Passover, Annunciation and Epiclesis. Some Remarks on the Term *aggen* in the Syriac Versions of Lk. 1:35." Pages 1–11 in *Fire from Heaven: Studies in Syriac Theology and Liturgy.* Variorum CS863. London: Ashgate, 2006. Repr. from *Novum Testamentum* 24 (1982): 222–33.

————. "St. Ephrem on Christ as Light in Mary and in the Jordan: *Hymni de Ecclesia* 36." *Eastern Churches Review* 7 (1975): 137–44.

————. "Some Early Syriac Baptismal Commentaries." *Orientalia Christiana Periodica* 46 (1980): 20–61. Repr. in *Fire from Heaven: Studies in Syriac Theology and Liturgy.* Variorum CS863. London: Ashgate, 2006.

Brock, Sebastian P., and Susan Ashbrook Harvey. *Holy Women of the Syrian Orient.* Transformation of the Classical Heritage 13. Berkeley: University of California Press, 1998.

Brody, Lisa R. "Yale University and Dura-Europos: From Excavation to Exhibition." Pages 17–32 in Brody and Hoffman, eds., *Dura-Europos: Crossroads of Antiquity.*

Brody, Lisa R., and Gail L. Hoffman, eds. *Dura-Europos: Crossroads of Antiquity.* Chestnut Hill, MA; Chicago: McMullen Museum of Art; dist. by University of Chicago Press, 2011.

Brown, Peter. "In Gibbon's Shade." *New York Review of Books* 23 (April 15, 1976): 14–18.

Brown, Raymond E. *The Gospel According to John I–XII.* Anchor Bible 29. New York: Doubleday, 1966.

Butcher, Kevin. *Roman Syria and the Near East.* London; New York: British Museum Press; dist. by Getty Publications, 2003.

Campbell, Alistair. "Dying with Christ: The Origin of a Metaphor?" Pages 273–93 in *Baptism, the New Testament and the Church: Historical and Contemporary Studies in Honour of R. E. O. White.* Edited by Stanley E. Porter and Anthony R. Cross. Journal for the Study of the New Testament Supplements 171. Sheffield: Sheffield Academic Press, 1999.

Cartlidge, David R., and J. Keith Elliott. *Art and the Christian Apocrypha.* London: Routledge, 2001.

Cavallo, Guglielmo. "The Purple Codex of Rossano: Book, Object, Symbol." Pages 27–32 in *Codex purpeus Rossanensis: Commentarium.*

Charlesworth, James H., ed. and trans. *The Odes of Solomon.* Oxford: Clarendon, 1973.

Chi, Jennifer Y., and Sebastian Heath, eds. *Edge of Empires: Pagans, Jews, and Christians at Roman Dura-Europos.* New York; Princeton, NJ: Institute for the Study of the Ancient World; dist. by Princeton University Press, 2011.

Clark, Elizabeth A. "The Celibate Bridegroom and His Virginal Brides: Metaphor and the Marriage of Jesus in Early Christian Ascetic Exegesis." *Church History* 77 (2008): 1–25.

Clédat, Jean. "Le monastère et la nécropole de Baouit." *Mémoires publiés par les Membres de l'Institut Français d'Archéologie Orientale du Caire* 12 (1904): 13–29.

Codex purpureus Rossanensis. Rossano calabro, Museo dell'Arcivescovado. Commentarium. Roma: Salerno editrice; Graz: Akademische Druck- u. Verlagsanstalt, 1987.

Codex purpureus Rossanensis. Rossano calabro, Museo dell'Arcivescovado: vollstän-dige Faksimile-Ausgabe im Originalformat der Handschrift. Roma: Salerno editrice; Graz: Akademische Druck- u. Verlagsanstalt, 1985.

Constas, Nicholas. *Proclus of Constantinople: The Cult of the Virgin in Late Antiquity.* Leiden: Brill, 2003.

Cumont, Franz. *Fouilles de Doura-Europos.* 2 vols. Paris: Geuthner, 1926.

Dale, Thomas E. A. "The Power of the Anointed: The Life of David on Two Coptic Textiles in the Walters Art Gallery." *Journal of the Walters Art Gallery* 51 (1993): 23–42.

Daniélou, Jean. *The Bible and the Liturgy.* Notre Dame, IN: Notre Dame Press, 1956.

Davies, W. D., and Dale Allison. *The Gospel According to Saint Matthew.* 3 vols. International Christian Commentary. Edinburgh: T and T Clark, 1997.

Davis, Stephen J. *The Cult of St. Thecla: A Tradition of Women's Piety in Late Antiquity.* Oxford: Oxford University Press, 2008.

Day, Juliette. *The Baptismal Liturgy of Jerusalem: Fourth- and Fifth-Century Evidence from Palestine, Syria and Egypt.* Hampshire: Ashgate, 2007.

de Strycker, Émile. *La forme la plus ancienne du Protévangile de Jacques.* Brussels: Bollandistes, 1961.

DeConick, April D. "The True Mysteries: Sacramentalism in the *Gospel of Philip.*" *VC* 55 (2001): 225–61.

Demus, Otto. *The Mosaics of San Marco in Venice.* Chicago: University of Chicago Press, 1984.

Dinkler, Erich. "Die ersten Petrusdarstellungen: Ein archäologischer Beitrag zur Geschichte des Petrusprimates." *Marburger Jarbuch für Kunstwissenschaft* 11/12 (1938–39): 1–80.

Dirven, Lucinda. "Paradise Lost, Paradise Regained: The Meaning of Adam and Eve in the Baptistery of Dura-Europos." *Eastern Christian Art* 5 (2008): 43–57.

———. "Strangers and Sojourners: The Religious Behavior of Palmyrenes and Other Foreigners in Dura-Europos." Pages 201–20 in Brody and Hoffman, eds., *Dura-Europos: Crossroads of Antiquity.*

Dodd, Erica. *The Frescoes of Mar Musa al-Habashi: A Study in Medieval Painting in Syria.* Toronto: Pontifical Institute of Mediaeval Studies, 2001.

Donfried, Karl P. "The Allegory of the Ten Virgins (Matt 25:1–13) as a Summary of Matthean Theology." *JBL* 93 (1974): 415–28.

Drake, H. A. *In Praise of Constantine: A Historical Study and New Translation of Eusebius' Tricennial Orations.* Berkeley: University of California Press, 1976.

Drijvers, Han J. W., ed. *The Book of the Laws of Countries. Dialogue on Fate of Bardaisan of Edessa.* Rev. ed. Piscataway, NJ: Gorgias, 2006.

———. "Early Forms of Antiochene Christology." Pages 99–113 in *After Chalcedon: Studies in Theology and Church History Offered to Professor Albert van Roey for His Seventieth Birthday.* Leuven: Dept. Oriëntalistiek, 1985.

———. "The 19th Ode of Solomon: Its Interpretation and Place in Syrian Christianity." *Journal of Theological Studies* 31 (1980): 337–55.

Dudley, Martin, and Geoffrey Russell, eds. *The Oil of Gladness: Anointing in the Christian Tradition.* Collegeville, MN: Liturgical Press, 1993.

Du Mesnil du Buisson, Robert. "Inscriptions sur jarres de Doura-Europos." *Mélanges de l'Université Saint Joseph* 36 (1959): 1–50.

Dunning, Benjamin H. *Specters of Paul: Sexual Difference in Early Christian Thought.* Philadelphia: University of Pennsylvania Press, 2011.

Durand, Jannic, et al., eds. *Armenia sacra: mémoire chrétienne des Arméniens (IVe–XVIIIe siécle). Catalogue de l'exposition, Paris, Musée du Louvre, 21 février–21 mai 2007.* Paris: Somogy, 2007.

Dyson, Stephen L. *Ancient Marbles to American Shores: Classical Archaeology in the United States.* Philadelphia: University of Pennsylvania Press, 1998.

Edwell, Peter M. *Between Rome and Persia: The Middle Euphrates, Mesopotamia and Palmyra Under Roman Control.* London: Routledge, 2008.

Ehrman, Bart D. *The Orthodox Corruption of Scripture.* Oxford: Oxford University Press, 1993.

Eliot, T. S. *The Complete Poems and Plays: 1909–1950.* New York: Harcourt, Brace & World, 1971.

———. "Letter to Marquis Childs." *St. Louis Post-Dispatch,* October 15, 1930. Included in "American Literature and the American Language." *Washington University Studies, New Series: Literature and Language,* no. 23. St. Louis, MO: Washington University Press, 1953.

Elsner, Jaś. *Art and the Roman Viewer: The Transformation of Art from the Pagan World to Christianity.* Cambridge: Cambridge University Press, 1995.

———. "Cultural Resistance and the Visual Image: The Case of Dura Europos." *Classical Philology* 96 (2001): 269–304.

———. *Roman Eyes: Visuality and Subjectivity in Art and Text.* Princeton, NJ: Princeton University Press, 2007.

Ernst, Allie M. *Martha from the Margins: The Authority of Martha in Early Christian Tradition.* VCSup 98. Leiden: Brill, 2009.

Evans, Helen C., and Brandie Ratliff, eds. *Byzantium and Islam: Age of Transition, 7th–9th Century.* New York: Metropolitan Museum of Art, 2012.

Ferguson, Everett. *Baptism in the Early Church: History, Theology, and Liturgy in the First Five Centuries*. Grand Rapids, MI: Eerdmans, 2009.

Fernández-Marcos, Natalio. "David the Adolescent: On Psalm 151." Pages 205–17 in *The Old Greek Psalter: Studies in Honour of Albert Pietersma*. Edited by Robert J. V. Hiebert, Claude E. Cox, and Peter John Gentry. Sheffield: Sheffield Academic Press, 2001.

Février, Paul-Albert. "Les peintures de la catacombe de Priscille, deux scènes relatives à la vie intellectuelle." *Mélanges de l'École Française de Rome, Antiquité* 71 (1959): 301–19.

Fine, Steven. *Art and Judaism in the Greco-Roman World: Toward a New Jewish Archaeology*. Rev. ed. Cambridge: Cambridge University Press, 2010.

———. *Sacred Realm: The Emergence of the Synagogue in the Ancient World*. Oxford: Oxford University Press, 1996.

———. *This Holy Place: On the Sanctity of the Synagogue During the Greco-Roman Period*. Notre Dame, IN: University of Notre Dame Press, 1997.

Finkelstein, Louis. "The Birkhat Ha-Mazon." *JQR* New Series 19 (1929): 211–62.

Finn, Thomas M. *Early Christian Baptism and the Catechumenate: West and East Syria*. Message of the Fathers of the Church 5. Collegeville, MN: Liturgical Press, 1992.

Francis, James A. "Biblical not Scriptural: Perspectives on Early Christian Art from Contemporary Classical Scholarship." *SP* 44 (2010): 3–8.

———. "Visual and Verbal Representation: Image, Text, Person, and Power." Pages 285–305 in *A Companion to Late Antiquity*. Edited by Philip Rousseau. London: John Wiley, 2009.

Furley, W. D. *Studies in the Use of Fire in Ancient Greek Religion*. New York: Arno, 1981.

García Martínez, Florentino, and Eibert J. C. Tigchelaar, eds. *The Dead Sea Scrolls Study Edition*. 2 vols. Grand Rapids, MI: Eerdmans, 1997.

Garitte, Gérard, ed. *Traités d'Hippolyte sur David et Goliath, sur le Cantique des cantiques et sur l'Antéchrist*. CSCO 264. Louvain: CSCO, 1965.

Gascou, Jean. "The Diversity of Languages in Dura-Europos." Pages 75–96 in Chi and Heath, eds., *Edge of Empires*.

Gelin, Mathilde. "Histoire et urbanisme d'une ville à travers son architecture de brique crue: l'Example de Doura-Europos." Ph.D. diss., Université de Paris, 2000.

Geyer, Paulus, ed. *Itinera Hierosolymitana, Saeculi IIII–VIII*. Corpus Scriptorum Ecclesiasticorum Latinorum 39. Prague: F. Tempsky, 1898.

Goodenough, Erwin R. *Jewish Symbols in the Greco-Roman Period*. 13 vols. New York: Pantheon, 1953–68.

Grabar, André. *Les Ampoules de Terre Sainte*. Paris: C. Klincksieck, 1958.

——. *Christian Iconography: A Study of Its Origins*. Bollingen Series 35. Princeton, NJ: Princeton University Press, 1968.

——. "La Fresque des saintes femmes au tombeau à Doura." *Cahiers Archéologiques* 8 (1956): 9–26.

Green, Arthur. "Judaism for the Post-Modern Era." The Samuel H. Goldenson Lecture. Cincinnati, OH: Hebrew Union College Press, 1994.

Gregg, Robert C., ed. and trans. *Athanasius: The Life of Anthony and the Letter to Marcellinus*. Classics of Western Spirituality. Mahwah, NJ: Paulist Press, 1980.

Grégoire, Henri. "Les Baptistères de Cuicul et de Doura." *Byzantion* 13 (1938): 589–93.

Griffith, Sidney H. "Asceticism in the Church of Syria: The Hermeneutics of Early Syrian Monasticism." Pages 220–45 in *Asceticism*. Edited by Vincent L. Wimbush and Richard Valantasis. Oxford: Oxford University Press, 2002.

Hahn, Cynthia. "Loca Sancta Souvenirs: Sealing the Pilgrim's Experience." Pages 85–96 in *The Blessings of Pilgrimage*. Edited by Robert Ousterhout. Illinois Byzantine Studies 1. Urbana: University of Illinois Press, 1990.

Hano, Michel. "A l'origine du culte impérial: les autels des Lares Augusti. Recherches sur les thèmes iconographiques et leur signification." *ANRW* 2.16.3 (1986): 2333–81.

Harkins, Paul W., ed. and trans. *St. John Chrysostom: Baptismal Instructions*. Ancient Christian Writers 31. Westminster, MD: Newman, 1963.

Harris, J. Rendel. "Tatian: Perfection According to the Saviour." *Bulletin of the John Rylands Library* 8 (1924): 15–51.

Harvey, Susan Ashbrook. "Syria and Mesopotamia." Pages 351–66 in *The Cambridge History of Christianity: Volume 1, Origins to Constantine*. Edited by Margaret M. Mitchell, Frances M. Young, and K. Scott Bowie. Cambridge: Cambridge University Press, 2006.

Havrelock, Rachel. *River Jordan: The Mythology of a Dividing Line*. Chicago: University of Chicago Press, 2011.

Heine, Ronald E., ed. and trans. *Homilies on Genesis and Exodus*. Fathers of the Church 71. Washington, DC: Catholic University of America Press, 2010.

Hersch, Karen K. *The Roman Wedding: Ritual and Meaning in Antiquity*. Cambridge: Cambridge University Press, 2010.

Heyn, Maura K. "The Terentius Frieze in Context." Pages 221–33 in Brody and Hoffman, eds., *Dura-Europos: Crossroads of Antiquity*.

Heyne, Hildegard. *Das Gleichnis von den klugen und törichten Jungfrauen: Eine literarisch-ikonographische Studie zur altchristlichen Zeit.* Leipzig, H. Haessel, 1922.

Hill, Robert Charles, ed. and trans. *St. John Chrysostom: Commentary on the Psalms.* 2 vols. Brookline, MA: Holy Cross Orthodox Press, 1998.

Hilsdale, Cecily J. Review of Gerasimos P. Pagoulatos, *Tracing the Bridegroom in Dura. Speculum* 85 (2010): 718–20.

Hinnells, John R. *Mithraic Studies. Proceedings of the First International Congress of Mithraic Studies.* 2 vols. Manchester: Manchester University Press, 1975.

Hoffman, Gail L. "Theory and Methodology: Study of Identities Using Archaeological Evidence from Dura-Europos." Pages 45–69 in Brody and Hoffman, eds., *Dura-Europos: Crossroads of Antiquity.*

Hopkins, Clark. *The Discovery of Dura-Europos.* Edited by Bernard Goldman. New Haven, CT: Yale University Press, 1979.

———. "Excavation Daybook, 1931/2." Dura-Europos Archives, Yale University Art Gallery, New Haven, CT.

Hopkins, Susan. *My Dura-Europos: The Letters of Susan M. Hopkins, 1927–1935.* Compiled by Bernard M. Goldman and Norma W. Goldman. Detroit: Wayne State University Press, 2011.

Hunt, E. D. "Were There Christian Pilgrims Before Constantine?" Pages 25–40 in *Pilgrimage Explored.* Edited by J. Stopford. York: York Medieval Press, 1999.

Hunt, Lucy-Anne. "The al-Muʿallaqa Doors Reconstructed: An Early Fourteenth-Century Sanctuary Screen from Old Cairo." *Gesta* 28 (1989): 61–77.

Hutton, Jeremy. *The Transjordanian Palimpsest: The Overwritten Texts of Personal Exile and Transformation in the Deuteronomistic History.* Berlin: Walter de Gruyter, 2009.

James, Simon. "Dark Secrets of the Archive: Evidence for 'Chemical Warfare' and Martial Convergences in the Siege-mines of Dura-Europos." Pages 295–317 in Brody and Hoffman, eds. *Dura-Europos: Crossroads of Antiquity.*

———. *Excavations at Dura-Europos 1928–1937: Final Report VII. The Arms and Armour and Other Military Equipment.* London: British Museum Press, 2004.

Jastrzębowska, Elżbieta. "New Testament Angels in Early Christian Art: Origin and Sources." *Światowit* 8 (49)/A (2009–10): 153–64.

Jeanes, Gordon. "Baptism Portrayed as Martyrdom in the Early Church." *SL* 23 (1993): 158–76.

Jefferson, Lee M. *Christ the Miracle Worker in Early Christian Art*. Minneapolis: Fortress, 2014.

———. "Superstition and the Significance of the Image of Christ Performing Miracles in Early Christian Art." *SP* 44 (2010): 15–20.

Jensen, Robin Margaret. *Baptismal Imagery in Early Christianity: Ritual, Visual, and Theological Dimensions*. Grand Rapids, MI: Baker Academic, 2012.

———. "Early Christian Images and Exegesis." Pages 65–85 in *Picturing the Bible: The Earliest Christian Art*. Edited by Jeffrey Spier. New Haven, CT: Yale University Press, 2007.

———. *Living Water: Images, Symbols, and Settings of Early Christian Baptism*. VCSup 105. Leiden: Brill, 2011.

———. *The Substance of Things Seen: Art, Faith, and the Christian Community*. Grand Rapids, MI: Eerdmans, 2004.

———. *Understanding Early Christian Art*. London: Routledge, 2000.

Jeremias, Joachim. "ΛΑΜΠΑΔΕΣ Mt 25.1, 3f., 7f." *Zeitschrift für Neutestamentliche Wissenschaft* 56 (1965): 196–201.

Johnson, Lawrence J. *Worship in the Early Church: An Anthology of Historical Sources*. 4 vols. Collegeville, MN: Liturgical Press, 2009.

Johnson, Maxwell E. *Images of Baptism*. Forum Essays 6. Chicago: Liturgy Training Publications, 2001.

———. *The Rites of Christian Initiation: Their Evolution and Interpretation*. Rev. ed. Collegeville, MN: Liturgical Press, 2007.

Jones, Siân. *The Archaeology of Ethnicity: Constructing Identities in the Past and Present*. London: Psychology Press, 1997.

Jones, Simon. "The Womb and the Spirit in the Baptismal Writings of Ephrem the Syrian." *SL* 33 (2003): 175–93.

———. "Womb of the Spirit: The Liturgical Implications of the Doctrine of the Spirit for the Syrian Baptismal Tradition." Ph.D. diss., University of Cambridge, 1999.

———. "Wombs of the Spirit: Incarnational Pneumatology in the Syrian Baptismal Tradition." Pages 99–113 in *The Spirit in Worship, Worship in the Spirit*. Edited by Teresa Berger and Bryan Spinks. Collegeville, MN: Liturgical Press, 2009.

Joosten, Jan. "The Dura Parchment and the Diatessaron." *VC* 57 (2003): 159–75.

Kaczynski, Rainer, ed. *Taufkatechesen*. Fontes Christiani 6. Freiburg: Herder, 1992.

Kaizer, Ted. "Religion and Language in Dura-Europos." Pages 235–53 in *From Hellenism to Islam: Cultural and Linguistic Change in the Roman Near*

East. Edited by Hannah M. Cotton, Robert G. Hoyland, and Jonathan J. Price. Cambridge: Cambridge University Press, 2009.

Kennedy, David L. "The Cohors XX Palmyrenorum at Dura Europos." Pages 89–98 in *The Roman and Byzantine Army in the East*. Edited by Edward Dabrowa. Krakow: Universite Jagellane, 1994.

———, ed. *The Roman Army in the Near East*. Journal of Roman Archaeology Supplementary Series 18. Ann Arbor, MI: Journal of Roman Archaeology, 1996.

Kilpatrick, George D. "Dura-Europos: The Parchments and the Papyri." *Greek, Roman, and Byzantine Studies* 5 (1964): 215–25.

Klauser, Theodor, ed. *Reallexikon für Antike und Christentum*. 25 vols. Stuttgart: Hiersemann, 1950–.

Klijn, A. F. J. *The Acts of Thomas: Introduction, Text, and Commentary*. Novum Testamentum Supplements 108. Leiden: Brill, 2003.

Knipp, David. *"Christus Medicus" in der frühchristlichen Sarkophagskulptur: Ikonographische Studien der Sepulkralkunst des späten vierten Jahrhunderts*. Leiden: Brill, 1998.

Kollwitz, Johannes. "Bezeihungen zur christlichen Archäologie." *Jahrbuch für Liturgiewissenschaft* 13 (1933): 311.

Korol, Dieter, and Jannike Rieckesmann. "Neues zu den alt- und neutestamentlichen Darstellungen im Baptisterium von Dura-Europos." Pages 1612–72 in *Ablution, Initiation, and Baptism: Late Antiquity, Early Judaism, and Early Christianity*. Edited by David Hellholm, Tor Vegge, Lars Hartman, and Øyvind Nordervall. Berlin: Walter de Gruyter, 2011.

Korol, Dieter, and Matthias Stanke. "Gehen die David- und Goliath-Darstellungen im 'Baptisterium' von Dura-Europos sowie im Vatopedi Psalter 'auf den gleichen Archetyp' zurück? Neues zum ursprünglichen Aussehen und zur Deutung der Darstellung im 'Baptisterium.'" Pages 131–53 in *Syrien und seine Nachbarn von der Spätantike bis in die islamische Zeit*. Edited by Christine Strube, Ina Eichner, and Vasiliki Tsamakda. Wiesbaden: Reichert, 2009.

Kosmin, Paul J. "The Foundation and Early Life of Dura-Europos." Pages 95–110 in Brody and Hoffman, eds., *Dura-Europos: Crossroads of Antiquity*.

Kötzsche, Lieselotte. "Die Marienseide in der Abegg-Stiftung Bemerkungen zur Ikonographie der Szenenfolge." Pages 183–94 in *Begegnung von Heidentum und Christentum im spätantiken Ägypten*. Edited by Dietrich Willers. Riggisberger Berichte 1. Riggisberg: Abegg-Stiftung, 1993.

Kovacs, David, ed. and trans. *Cyclops; Alcestis; Medea*. Loeb Classical Library. Cambridge, MA: Harvard University Press, 1994.

Kraeling, Carl H., with a contribution by C. Bradford Welles. *The Excavations at Dura-Europos, Final Report VIII, Part II: The Christian Building.* New Haven, CT: Dura Europos Publications; New York: J. J. Augustin, 1967.

Kraeling, Carl H. *The Excavations at Dura-Europos Conducted by Yale University and the French Academy of Inscriptions and Letters. Final Report VIII, Part I. The Synagogue.* Edited by Alfred R. Bellinger, Frank E. Brown, Ann Perkins, and C. Bradford Welles. New Haven, CT: Yale University Press, 1956.

———. *A Greek Fragment of Tatian's Diatessaron from Dura.* London: Christophers, 1935.

Labourt, Jerome. *Le Christianisme dans l'Empire Perse sous la Dynastie Sassanide (224-632).* 2nd ed. Paris, 1904.

Lafontaigne-Dosogne, Jacqueline. "Iconography of the Cycle of the Life of the Virgin." Pages 161–94 in vol. 4 of *The Kariye Djami: Studies in the Art of the Kariye Djami and Its Intellectual Background.* 4 vols. Edited by Paul A. Underwood. London: Routledge & Kegan Paul, 1975.

Lampe, G. W. H. *The Seal of the Spirit.* 2nd ed. London: SPCK, 1967.

Lampe, Peter. *From Paul to Valentinus: Christians at Rome in the First Two Centuries.* Edited by Marshall D. Johnson. Translated by Michael Steinhauser. Minneapolis: Fortress, 2003.

Lamy, T. J., ed. *Sancti Ephraem Syri, Hymni et Sermones I.* Mechelen, 1882.

Langner, Martin. *Antike Graffitizeichnungen: Motive, Gestaltung und Bedeutung.* Wiesbaden: Reichert, 2001.

Lassus, Jean. "La maison des chrétiens de Dura-Europos." *Revue archéologique* (New Series) 1/2 (1969): 138–39.

Lattke, Michael. *Odes of Solomon.* Edited by Harold Attridge. Translated by Marianne Ehrhardt. Hermeneia. Minneapolis: Fortress, 2009.

Lawrence, Marion. *The Sarcophagi of Ravenna.* New York: College Art Association of America in conjunction with the Art Bulletin, 1945.

Layton, Bentley. *The Gnostic Scriptures.* New York: Doubleday, 1987.

———, ed. *Nag Hammadi Codex II,2-7.* Leiden: Brill, 1989.

———, ed. *The Rediscovery of Gnosticism: Proceedings of the International Conference on Gnosticism at Yale, New Haven, Connecticut, March 28-31, 1978. Volume 1: The School of Valentinus.* Studies in the History of Religions 41. Leiden: Brill, 1980.

LeBohec, Yann. *The Imperial Roman Army.* London: Routledge, 2000.

Leriche, Pierre, Gaelle Coqueugniot, and Ségolène de Pontbriand. "New Research by the French-Syrian Archaeological Expedition to Europos-Dura

and New Data on Polytheistic Sanctuaries in Europos-Dura." Pages 14–38 in Chi and Heath, eds., *Edge of Empires*.

Leroy, Jules. *Les manuscrits syriaques à peintures conservés dans les bibliothèques d'Europe et d'Orient*. 2 vols. Paris: Paul Geuthner, 1964.

Levine, Lee I. *Ancient Synagogues Revealed*. Jerusalem: Israel Exploration Society, 1982.

———. *From Dura to Sepphoris: Studies in Jewish Art and Society in Late Antiquity*. Journal of Roman Archaeology Supplements 40. Portsmouth, RI: Journal of Roman Archaeology, 2000.

Leyerle, Blake. "Landscape as Cartography in Early Christian Pilgrimage Narratives." *Journal of the American Academy of Religion* 64 (1996): 119–43.

Lieu, Samuel N. C. "Rome on the Euphrates: The Final Siege of Dura-Europos." Pages 33–35 in *Aspects of the Roman East: Papers in Honour of Professor Fergus Millar FBA*. Edited by Richard Alston and Samuel N. C. Lieu. Studia Antiqua Australiensia 3. Turnhout: Brepols, 2007.

Loerke, William S. "The Rossano Gospels: The Miniatures." Pages 109–55 in *Codex purpeus Rossanensis: Commentarium*.

MacCormack, Sabine. *Art and Ceremony in Late Antiquity*. Transformation of the Classical Heritage 1. Berkeley: University of California Press, 1981.

Madigan, Kevin, and Carolyn Osiek, eds. *Ordained Women in the Early Church: A Documentary History*. Baltimore: Johns Hopkins University Press, 2005.

Maertens, Theirry. "History and Function of the Three Great Pericopes: The Samaritan Woman, the Man Born Blind, the Raising of Lazarus." Pages 51–56 in *Adult Baptism and the Catechumenate*. Edited by Johannes Wagner. Concilium 22. New York: Paulist Press, 1967.

Maier, Jean Louis. *Le baptistère de Naples et ses mosaiques*. Freiburg: Éditions universitaires, 1964.

Mann, J. C. "The Frontiers of the Principate" *ANRW* II.1 (1974): 508–33.

Mathews, Thomas F. "The Annunciation at the Well: A Metaphor of Armenian Monophysitism." Pages 343–56 in *Medieval Armenian Culture*. Edited by Thomas J. Samuelian and Michael E. Stone. Armenian Texts and Studies. Philadelphia: University of Pennsylvania Press, 1984.

———. *The Clash of the Gods: A Reinterpretation of Early Christian Art*. Princeton, NJ: Princeton University Press, 1993.

Mathews, Thomas F., and Avedis K. Sanjian. *Armenian Gospel Iconography: The Tradition of the Glajor Gospel*. Washington, DC: Dumbarton Oaks Research Library and Collection, 1991.

McCarthy, Carmel, ed. and trans. *Saint Ephrem's Commentary on Tatian's Diatessaron.* Journal of Semitic Studies Supplement 2. Oxford: Oxford University Press, 1993.

McCauley, Leo P., ed. and trans. *The Works of Saint Cyril of Jerusalem.* 2 vols. Fathers of the Church 64. Washington, DC: Catholic University of America Press, 1969.

McDonnell, Kilian. *The Baptism of Jesus in the Jordan: The Trinitarian and Cosmic Order of Salvation.* Collegeville, MN: Liturgical Press, 1996.

McGowan, Andrew. *Ancient Christian Worship: Early Church Practices in Social, Historical, and Theological Perspective.* Grand Rapids, MI: Baker, 2014.

McVey, Kathleen E. *Ephrem the Syrian: Hymns.* Mahwah, NJ: Paulist Press, 1989.

Meeks, Wayne A. "The Image of the Androgyne: Some Uses of a Symbol in Earliest Christianity." *History of Religions* 13 (1974): 165–208.

Metzger, Marcel, ed. *Les Constitutions Apostoliques.* SC 320, 329, 336. Paris: Cerf, 1985–87.

Meyer, Marvin, and Richard Smith, eds. *Ancient Christian Magic: Coptic Texts of Ritual Power.* San Francisco: HarperSanFrancisco, 1994.

Mignana, Alphonse, ed. and trans. *Theodore of Mopsuestia, Commentary on the Lord's Prayer, Baptism and the Eucharist.* Woodbrooke Studies VI: Christian Documents in Syriac, Arabic, and Garshani. Cambridge: Heffer, 1933.

Millar, Fergus. *The Roman Near East 31 BC–AD 337.* Cambridge, MA: Harvard University Press, 1993.

Miller, James Edwin. *Thomas Stearns Eliot: The Making of an American Poet, 1888–1922.* University Park: Pennsylvania State Press, 2005.

Millet, Gabriel. "La parabole des vierges à Doura et el-Bagawat." *Cahiers Archéologiques* 8 (1956): 1–8.

Moss, Candida R. *The Other Christs: Imitating Jesus in Ancient Christian Ideologies of Martyrdom.* New York: Oxford University Press, 2010.

Murray, Robert. "Mary the Second Eve in the Early Syriac Fathers." *Eastern Churches Review* 3 (1971): 372–84.

———. *Symbols of Church and Kingdom: A Study in Early Syriac Tradition.* 2nd rev. ed. Piscataway, NJ: Gorgias, 2004.

Myers, Susan E. "Initiation by Anointing in Early Syriac-Speaking Christianity." *SL* 31 (2001): 150–70.

———. *Spirit Epicleses in the Acts of Thomas.* Wissenschaftliche Untersuchungen zum Neuen Testament II 281. Tübingen: Mohr Siebeck, 2010.

Nelson, Robert S. "Empathetic Vision: Looking at and with a Performative Byzantine Miniature." *Art History* 30 (2007): 489–502.

———. *Later Byzantine Painting: Art, Agency, and Appreciation*. Variorum Collected Studies. Aldershot: Ashgate, 2007.

———, ed. *Visuality Before and Beyond the Renaissance: Seeing as Others Saw*. Cambridge: Cambridge University Press, 2000.

Neyrey, Jerome. "Jacob Traditions and the Interpretation of John 4:10–26." *Catholic Biblical Quarterly* 41 (1979): 419–37.

Nissinen, Martti, and Risto Uro. *Sacred Marriages: The Divine-Human Sexual Metaphor from Sumer to Early Christianity*. Winona Lake, IN: Eisenbrauns, 2008.

Nitsche, Stefan Ark. *David gegen Goliath: Die Geschichte der Geschichten einer Geschichte. Zur fächerübergreifenden Rezeption einer biblischen Story*. Altes Testament und Moderne 4. Münster: Lit Verlag, 1998.

Olin, Margaret. "The Émigré Scholars of Dura-Europos." Pages 71–94 in Brody and Hoffman, eds., *Dura-Europos: Crossroads of Antiquity*.

Omont, Henri. *Evangiles avec peintures byzantines du XIe siècle*. Paris: Berthoud Frères, 1908.

Pagels, Elaine H. "The 'Mystery of Marriage' in the *Gospel of Philip* Revisited." Pages 442–54 in *The Future of Early Christianity*. Edited by Birger A. Pearson. Minneapolis: Fortress, 1991.

Pagoulatos, Gerasimos P. *Tracing the Bridegroom in Dura: The Bridal Initiation Service of the Dura-Europos Christian Baptistery as Early Evidence of the Use of Images in Christian and Byzantine Worship*. Piscataway, NJ: Gorgias, 2008.

Palbry, Geri. "The Origins of Marian Art in the Catacombs and the Problems of Identification." Pages 41–56 in *The Origins of the Cult of the Virgin Mary*. Edited by Chris Maunder. London: Burns & Oates, 2008.

Pallas, Demetrios I. *Synagoge Meleton Byzantines Archaiologia (Techne—Latreia—Koinonia)*. 2 vols. Athens: Syllogos Hellenon Archaiologon, 1987–88.

Parker, D. C., D. G. K. Taylor, and M. S. Goodacre. "The Dura-Europos Gospel Harmony." Pages 192–228 in *Studies of the Early Text of the Gospels and Acts*. Edited by D. G. K. Taylor. Society of Biblical Literature Text-Critical Studies 1. Atlanta: Society of Biblical Literature, 1999.

Pelikan, Jaroslav. *The Light of the World: A Basic Image in Early Christian Thought*. New York: Harper, 1962.

Penn, Michael. *Kissing Christians: Ritual and Community in the Late Ancient Church*. Philadelphia: University of Pennsylvania Press, 2005.

Peppard, Michael. "Illuminating the Dura-Europos Baptistery: Comparanda for the Female Figures." *Journal of Early Christian Studies* 20 (2012): 543–74.

———. "New Testament Imagery in the Earliest Christian Baptistery." Pages 169–88 in Brody and Hoffman, eds., *Dura-Europos: Crossroads of Antiquity*.

———. *The Son of God in the Roman World: Divine Sonship in Its Social and Political Context.* New York: Oxford University Press, 2011.

Perkins, Ann. *The Art of Dura-Europos.* Oxford: Clarendon, 1973.

Perler, Othmar. "Zu den Inschriften des Baptisteriums von Dura-Europos." Pages 175–85 in *Epektasis: Mélanges patristiques offerts au Cardinal Jean Daniélou.* Edited by Jacques Fontaine and Charles Kannengiesser. Paris: Beauschesne, 1972.

Piédagnel, Auguste, ed. *Jean Chrysostome: trois catéchèses baptismales.* SC 366. Paris: Cerf, 1990.

Pierce, Mark. "Themes in the Odes of Solomon and Other Early Christian Writings and Their Baptismal Character." *EL* 98 (1984): 35–59.

Pijoan, Joseph. "The Parable of the Virgins from Dura-Europos." *ABull* 19 (1937): 592–95.

Pollard, Nigel. "The Roman Army as 'Total Institution' in the Near East: Dura-Europos as a Case Study." Pages 211–27 in Kennedy, ed., *The Roman Army in the Near East.*

———. *Soldiers, Cities, and Civilians in Roman Syria.* Ann Arbor: University of Michigan Press, 2000.

Puthuparampil, James. *The Mariological Thought of Mar Jacob of Serugh (451–521).* Piscataway, NJ: Gorgias, 2012.

Quasten, Johannes. "Das Bild des Guten Hirten in den altchristlichen Baptisterien und in den Taufliturgien des Ostens und Westens." Pages 220–44 in *Pisciculi: Studien zur Religion und Kultur des Altertums.* Edited by Theodore Klauser and Adolf Rücker. Münster: Aschendorff, 1939.

———. "The Painting of the Good Shepherd at Dura-Europos." *Medieval Studies* 9 (1947): 1–18.

Rahmani, L. Y. *The Museums of Israel.* London: Secker and Warburg, 1976.

Rajak, Tessa. "The Dura-Europos Synagogue: Images of a Competitive Community." Pages 141–54 in Brody and Hoffman, eds., *Dura-Europos: Crossroads of Antiquity.*

Reardon, B. P. *Collected Ancient Greek Novels.* Berkeley: University of California Press, 1989.

Reeve, M. D. "Medea 1021–1080." *Classical Quarterly* 22 (1972): 51–61.

Richter-Siebels, Ilse. "Die palästinensischen Weihrauchgefäße mit Reliefszenen aus dem Leben Christi." Ph.D. diss., Frei Universität Berlin, 1990.

Rogers, Guy MacLean. *The Mysteries of Artemis of Ephesos: Cult, Polis, and Change in the Graeco-Roman World.* Synkrisis. New Haven, CT: Yale University Press, 2012.

Rostovtzeff, Michael I. *Dura-Europos and Its Art.* Oxford: Clarendon, 1937.

Rostovtzeff, Michael I., Alfred R. Bellinger, Frank E. Brown, and C. Bradford Welles, eds. *The Excavations at Dura-Europos Conducted by Yale University and the French Academy of Inscriptions and Letters. Preliminary Report on the Ninth Season of Work, 1935–1936. Part 3: The Palace of the Dux Ripae and the Dolicheneum.* New Haven, CT: Yale University Press, 1952.

Rostovtzeff, Michael I., Frank E. Brown, and C. Bradford Welles, eds. *The Excavations at Dura-Europos Conducted by Yale University and the French Academy of Inscriptions and Letters. Preliminary Report on the Seventh and Eighth Seasons of Work, 1933–1934 and 1934–1935.* New Haven, CT: Yale University Press, 1936.

Russell, Michael. *Palestine, or the Holy Land.* New York: Harper, 1835.

Rutgers, Leonard V. "Dura-Europos: Christian Community." *Religion Past and Present.* 14 vols. 4th ed. Edited by Hans Dieter Betz, Don S. Browning, Bernd Janowski, and Eberhard Jüngel. Leiden: Brill, 2008.

Sanders, J. A. *The Psalms Scroll of Cave 11 (11QPsa).* Discoveries in the Judean Desert 4. Oxford: Clarendon, 1965.

Schiller, Gertrud. *Ikonographie der christlichen Kunst.* 5 vols. Gütersloh: Gütersloher Verlagshaus G. Mohn, 1966–1991. Translated by Janet Seligman: *Iconography of Christian Art.* 2 vols. London: Lund Humphries, 1971.

Schoff, Wilfred H. *Parthian Stations by Isidore of Charax: An Account of the Overland Trade Route Between the Levant and India in the First Century B.C.* Philadelphia: Commercial Museum of Philadelphia, 1914.

Schumacher, Walter Nikolaus. *Hirt und "Guter Hirt": Studien zum Hirtenbild in der römischen Kunst vom zweiten bis zum Anfang des vierten Jahrhunderts unter besonderer Berücksichtigung der Mosaiken in der Südhalle von Aquileja.* Rome: Herder, 1977.

Serra, Dominic E. "The Baptistery at Dura-Europos: The Wall Paintings in the Context of Syrian Baptismal Theology." *EL* 120 (2006): 67–78.

Seston, William. "L'Église et le baptistère de Doura-Europos." *Annales de l'École des Hautes Études de Gand* 1 (1937): 161–77.

Shoemaker, Stephen J. "Between Scripture and Tradition: The Marian Apocrypha of Early Christianity." Pages 491–510 in *The Reception and Interpretation of the Bible in Late Antiquity: Proceedings of the Montréal Colloquium in Honour of Charles Kannengiesser, 11–13 October 2006.* Edited by Lorenzo DiTommaso and Lucian Turcescu. Leiden: Brill, 2008.

———. *The Life of the Virgin.* New Haven, CT: Yale University Press, 2012.

Silvas, Anna. *Gregory of Nyssa: The Letters.* VCSup 83. Leiden: Brill, 2007.

Snyder, Graydon F. *Ante Pacem: Archaeological Evidence of Church Life Before Constantine.* Macon, GA: Mercer University Press, 2003.

Sperry-White, Grant, ed., *The Testamentum Domini: A Text for Students, with Introduction, Translation, and Notes.* Nottingham: Grove, 1991.

Spinks, Bryan. "Baptismal Patterns in Early Syria: Another Reading." Pages 45–52 in *Studia Liturgica Diversa: Essays in Honor of Paul F. Bradshaw.* Edited by Maxwell E. Johnson and L. Edward Phillips. Portland, OR: Pastoral Press, 2004.

———. *Early and Medieval Rituals and Theologies of Baptism: From the New Testament to the Council of Trent.* Hampshire: Ashgate, 2006.

Squire, Michael. *Image and Text in Graeco-Roman Antiquity.* Cambridge: Cambridge University Press, 2009.

Staats, Reinhart. "Die törichten Jungfrauen von Mt 25 in gnostischer und antignostischer Literatur." Pages 98–115 in *Christentum und Gnosis.* Edited by Walther Eltester. Beihefte zur Zeitschrift für neutestamentliche Wissenschaft 37. Berlin: Töpelmann, 1969.

Stauffer, Annemarie. *Textiles of Late Antiquity.* New York: Metropolitan Museum of Art, 1995.

Stern, Henri. "Les peintures du mausolée de 'l'exode' à el-Bagawat." *Cahiers Archéologiques* 11 (1960): 93–119.

Strugnell, John. "Notes on the Text and Transmission of the Apocryphal Psalms 151, 154 (= Syr. II) and 155 (= Syr. III)." *Harvard Theological Review* 59 (1966): 257–81.

Teicher, J. L. "Ancient Eucharistic Prayers in Hebrew." *JQR* New Series 54 (1963): 99–109.

Terian, Abraham. *Armenian Gospel of the Infancy: With Three Early Versions of the Protevangelium of James.* Oxford: Oxford University Press, 2008.

———. *Macarius of Jerusalem, Letter to the Armenians (A.D. 335): Introduction, Text, Translation, and Commentary.* Crestwood, NY: St. Vladimir's Seminary Press, 2008.

Thomassen, Einar. *The Spiritual Seed: The Church of the "Valentinians."* Nag Hammadi and Manichaean Studies 60. Leiden: Brill, 2006.

Tkacz, Catherine Brown. *The Key to the Brescia Casket: Typology and the Early Christian Imagination.* Christianity and Judaism in Antiquity 14. Paris: University of Notre Dame Press, Institut d'Études Augustiniennes, 2002.

Turner, H. E. W. *The Patristic Doctrine of Redemption: A Study in the Development of Doctrine During the First Five Centuries.* London: Mowbray, 1952.

Turner, Victor. *The Forest of Symbols: Aspects of Ndembu Ritual.* Ithaca, NY: Cornell University Press, 1967.

Turner, Victor, and Edith Turner. *Image and Pilgrimage in Christian Culture: Anthropological Perspectives*. New York: Columbia University Press, 1978.

Udell, Jennifer. "Times of Day and Times of Year on Athenian Vases." Ph.D. diss., Institute of Fine Arts, New York University, 2012.

——. "Torches, Nocturnal Wedding Processions, and Legitimacy: Reexamining the Nuptial Associations of Paris Taking Helen from Sparta Depicted on Makron's Skyphos in Boston." Unpublished paper presented at the Annual Meeting of the Archaeological Institute of America, January 3–6, 2013. Used by permission of the author.

Usener, Hermann. *Religionsgeschichtliche Untersuchungen. Erster Theil: Das Weihnachtsfest*. Bonn, 1889.

van Dijk, Ann. "The Angelic Salutation in Early Byzantine and Medieval Annunciation Imagery." *ABull* 81 (1999): 420–36.

Van Rompay, Lucas. "Memories of Paradise: The Greek 'Life of Adam and Eve' and Early Syriac Tradition." *Aram* 5 (1993): 555–70.

van Rooy, H. F. "The Message of a Number of Psalms as Interpreted in Syriac Psalm Headings." *Skrif En Kerk* 19 (1998): 653–63.

——. "Psalm 151 in Three Syriac Psalm Commentaries." *Zeitschrift für Alttestamentliche Wissenschaft* 112 (2000): 612–23.

Vermaseren, M. J., and C. C. Van Essen. "The Aventine Mithraeum Adjoining the Church of St. Prisca." *Antiquity and Survival* 1 (1955–56): 3–36.

Vikan, Gary. "Art, Medicine, and Magic in Early Byzantium." *Dumbarton Oaks Papers* 38 (1984): 65–86.

——. *Early Byzantine Pilgrimage Art*. Rev. ed. Dumbarton Oaks Byzantine Collection Publications 5. Washington, DC: Dumbarton Oaks Research Library and Collection, 2010.

——. "Pilgrims in Magi's Clothing: The Impact of Mimesis on Early Byzantine Pilgrimage Art." Pages 97–107 in *The Blessings of Pilgrimage*. Edited by Robert Ousterhout. Illinois Byzantine Studies 1. Urbana: University of Illinois Press, 1990.

——. "Two Byzantine Amuletic Armbands and the Group to Which They Belong." *Journal of the Walters Art Gallery* 49/50 (1991/92), 33–51.

Volbach, Wolfgang Fritz. *Elfenbeinarbeiten der Spätantike und des Frühen Mittelalters*. 3rd ed. Mainz: Von Zebern, 1976.

von Spengel, Leonhard. *Rhetores graeci*. 3 vols. Leipzig: Teubner, 1853–56.

Vööbus, Arthur. *Celibacy: A Requirement for Admission to Baptism in the Early Syrian Church*. Stockholm: Estonian Theological Society in Exile, 1951.

Wander, Steven H. "The Cyprus Plates: The Story of David and Goliath." *Metropolitan Museum Journal* 8 (1973): 89–104.

Ward, Seth. "Sepphoris in Sacred Geography." Pages 391–406 in *Galilee Through the Centuries: Confluence of Cultures*. Edited by Eric Myers. Winona Lake, IN: Eisenbrauns, 1999.

Weisman, Stefanie. "Militarism in the Wall Paintings of the Dura-Europos Synagogue: A New Perspective on Jewish Life on the Roman Frontier." *Shofar* 30 (2012): 1–34.

Weitzmann, Kurt, and Herbert L. Kessler. *The Frescoes of the Dura Synagogue and Christian Art*. Dumbarton Oaks Studies 28. Washington, DC: Dumbarton Oaks, 1990.

Wellen, G. A. *Theotokos: Eine ikonographische Abhandlung über das Gottesmutterbild in frühchristlicher Zeit*. Utrecht/Antwerp: Uitgeverij het Spectrum, 1961.

Welles, C. Bradford. "The Gods of Dura-Europos." Pages 50–65 in *Beiträge zur alten Geschichte und deren Nachleben: Festschrift für Franz Altheim zum 6.10.1968*. Edited by Ruth Altheim-Stiehl and Hans Erich Stier. Berlin: De Gruyter, 1969.

———. "The Population of Roman Dura." Pages 251–74 in *Studies in Roman Economic and Social History in Honor of A. C. Johnson*. Edited by Paul Robinson Coleman-Norton. Princeton, NJ: Princeton University Press, 1952.

Welles, C. Bradford, Robert O. Fink, and J. Frank Gilliam. *The Excavations at Dura-Europos, Final Report V, Part I: The Parchments and Papyri*. New Haven, CT: Yale University Press, 1959.

Wharton, Annabel Jane. *Refiguring the Post Classical City: Dura Europos, Jerash, Jerusalem, and Ravenna*. Cambridge: Cambridge University Press, 1995.

———. "Ritual and Reconstructed Meaning: The Neonian Baptistery in Ravenna." *ABull* 49 (1987): 358–75.

Whitaker, E. C. Revised and expanded by Maxwell E. Johnson. *Documents of the Baptismal Liturgy*. 2nd ed. Collegeville, MN: Liturgical Press, 2003.

White, L. Michael. *Scripting Jesus: The Gospels in Rewrite*. San Francisco: HarperCollins, 2010.

———. *The Social Origins of Christian Architecture*. 2 vols. Harvard Theological Studies 42. Valley Forge, PA: Trinity, 1996–97.

Wigtil, David N. "The Sequence of the Translations of Apocryphal Psalm 151." *Revue de Qumran* 11 (1982–84): 401–7.

Wilkinson, John. *Egeria's Travels*. 3rd ed. Oxford: Aris & Phillips, 1999.

———. *Jerusalem Pilgrims Before the Crusades*. Warminster: Aris & Phillips, 1977.

Wilpert, Josef. *Ein Cyklus christologischer Gemälde aus der Katakombe der Hl. Petrus und Marcellinus*. Freiburg, 1891.

———. *Die gottgeweihten Jungfrauen in den ersten Jahrhunderten der Kirche.* Freiburg im Breisgau: Herder, 1892.

Winkler, Gabriele. "The Original Meaning of the Prebaptismal Anointing and Its Implications." *Worship* 52 (1978): 24–45.

Yarbro Collins, Adela. "The Origin of Christian Baptism." Pages 35–57 in *Living Water, Sealing Spirit: Readings on Christian Initiation.* Edited by Maxwell Johnson. Collegeville, MN: Liturgical Press, 1995.

Ysebaert, Joseph. *Greek Baptismal Terminology: Its Origins and Early Development.* Nijmegen: Dekker and Van de Vegt, 1962.

Zenger, Erich. "David as Musician and Poet: Plotted and Painted." Pages 263–98 in *Biblical Studies/Cultural Studies: The Third Sheffield Colloquium.* Edited by J. Cheryl Exum and Stephen D. Moore. Journal for the Study of the Old Testament Supplements 266. Gender, Culture, Theory 7. Sheffield: Sheffield Academic Press, 1998.

Zevros, George T. "An Early Non-Canonical Annunciation Story." Pages 664–91 in *Society of Biblical Literature Seminar Papers 1997.* Atlanta: Scholars Press, 1997.

Zimmermann, Ruben. "Das Hochzeitsritual im Jungfrauengleichnis. Sozialgeschichtliche Hintergründe zu Mt 25.1–13." *New Testament Studies* 48 (2002): 48–70.

Subject Index

Page numbers in italic type indicate illustrations.

abecedaria, 46–47

Abraham, bishop of Nisibis, 106

absolutes, 196

absolution, 97, 193

Acts, book of, 97

Acts of Thomas, 21, 26, 28, 29, 96, 130; anointing and, 51–53, 54, 75, 137, 192; betrothal to Christ and, 132, 133; Christ the Physician and, 96, 97, 99; Christ the warrior and, 83–84; Greek and Syriac versions, 231nn15,16

Adam and Eve, 192, 193, 203–11; Marcion's teachings and, 207; Mary's purity overturning curse of, 132, 153, 193, 211; Pauline interpretation and, 206, 208; primordial disobedience of, 205; reunion in paradise of, 138, 210; separation of, 131; as symbol of new creation, 204; Syrian theological dominant images of, 210

Adam and Eve (Dura-Europos baptistery painting), 20, 28, 43, 100, 145, 203–9, *204, plate 6;* altered perspective of, 205–9; as inset in shepherd and flock painting, 100, *101,* 203–4; interpretation of, 205–6

Adelphi sarcophagus (Syracuse), Annunciation depiction, 165

adoption, as initiation metaphor, 55

afterlife, 108, 127, 152. *See also* Last Judgment; salvation

Albright, William F., 27

Alexander the Great, 5

alphabet inscriptions. *See* inscriptions

Ambrose of Milan, 103, 104

American Oriental Society, 25

American Schools of Oriental Research, 25–26

ampullae, 119, 183, 185

amulets, 96, 188, 189, 190; Annunciation silver armband, 168, *168,* 186

androgyny, myth of primal, 208

angel Gabriel. *See* Gabriel

Anne (mother of Mary), 152, 159, 187

Annunciation, 41, 43, 45, 156, 158–82, 188, 189, 199, 207; Luke narration of, 159, 160, 216; pilgrimage and, 165, 166, *167,* 168–69, 185–89, *188;* Syriac ritual texts on, 193

Annunciation iconic tradition, 29, 43, 45, 50, 141, 159–79, 180–83, 193–200; allegorical interpretation, 174, 199; angel Gabriel inclusion, 195 (*see also* Gabriel); earliest extant examples of, 164, 165, 166, *166,* 172, 195–200; flower in vase and, 162, *163,* 169; as indoor domestic scene, 159, 160, 161, 162, *163,* 172, 188, 189; lines of incarnation indicated, 162, *163,* 172, 179–81, 182, 193; Mary's water pitcher and, 165, 169, 172, 174, 179, 187; transitional type, 186; tree sprouting and, 174; at water source, 158–62, 165, *166,* 172, 176, 181–82, 187, 189, 193–98, 214. *See also* woman at a well

Annunciation morphological variety: Ambiguous Rope-to-Vessel, *168,* 168–69, *169, 170,* 174, *175,* 176, 182, 186, 189; At the Spring, 165, *166,* 172, 176, 187, *188,* 199; At the Well,

285

Annunciation morphological variety
 (continued)
 Face-to-Face, 172–74, *173, 175,* 191; At
 the Well, Looking Back, 174, 176, *176,*
 177, *177, 178, 179;* Indoors while
 Spinning, Face-to-Face, 166, *167,* 182;
 Indoors while Spinning, Looking
 Back, 165–66, *167,* 172, 185, 186;
 Vestigial Vessel, *168,* 172, 186; With
 Spinning Tools, *171,* 171–72, 174
anointing, 22, 30, 33, 40–68, 87, 104, 140,
 151, 212; *Acts of Thomas* on, 51–53, 54,
 75, 137, 192; before baptism, 48, 53,
 54, 55, 56, 59–60, 66, 83, 103, 109,
 127, 131, 134, 155, 193; in bridal
 chamber, 41, 57, 59, 65, 122, 137;
 centrality in early Christian Syria, 41,
 49, 59–60, 85, 140, 145, 218; central
 meanings of, 56–57; changes in
 emphasis/meanings of, 54–55; of
 David, 49, *50,* 60, 62, 63–64, 65, 67,
 68, 82–83, 84, 86, 106–7, 149, 213;
 diverse functions of, 50–51, 53; Dura
 baptistery and, 108, 117, 131–32, 150,
 202; of forehead vs. full body, 83, 84;
 incarnation and, 155; as initiation rite,
 48, 50–63, 105, 155, 192, 213; of Jesus
 as Christ, 2–3, 55, 57, 62, 83, 86–87,
 90, 149; of kings, 41, 49, *50,* 51–53, 54,
 82, 83; noncanonical texts on, 51–53;
 of priests, 51, 54; primacy of, 51,
 56–58, 131; same-sex, 53–54; of the
 sick, 97; of soldiers, 41, 57, 59, 84, 85;
 "western" vs. "eastern," 55
anointing oil. *See* oil
Anselm, 198
anthropomorphic divinities, 165
Antioch, 10, 20, 21, 47, 51, 134, 135;
 ordines of its liturgy, 192–93
Antoninus from Piacenza, 187
Aphrahat the Persian, 26, 29–30, 82, 97,
 132, 133, 135–36, 146, 192; *Demonstra-*

tions, 136, 211; on virginity of Mary,
 153
apocrypha. *See* noncanonical texts
Apollo, 112
apologists, 121
apostles, 20, 57, 97; in Syria, 20. *See also*
 disciples; *specific names*
Apostolic Constitutions, 147
Apostolos-Cappadona, Diane, 122,
 132–33
apotropaic items, 46–47, 80
Apuleius, 124
Aramaic language, 6, 40, 51, 193
archers, 7, 9, 10, 84; mounted, 78–79, *79,*
 80
Arculf, 189
Armenia, 14, 29, 45, 47, 54, 55, 141, 161;
 Annunciation scenes, 165, 174, 179,
 181, 191; Christology, 174; nativity
 date, 56
Armenian Gospel of the Infancy, 161
army. *See* military; Roman army
Artemis, 15, 124
art historians: Annunciation portrayals
 and, 160, 162–63, *163,* 164, 181, 197;
 David portrayals and, 74–75;
 interdisciplinary approach, 33;
 interpretation of ritual spaces, 33–35;
 methodological changes, 4; postmod-
 ern epistemology and, 196–97;
 processional art and, 111–12, 127–28;
 ritual-centered visuality and, 32–40,
 195–98; text-image correspondence
 and, 195; and use of comparanda, 29
artistic motifs. *See* Byzantine art; early
 Christian art; *specific subjects*
asceticism, 30, 97, 106, 121, 135, 136, 137,
 139, 160, 184, 210–11. *See also* celibacy
Asclepius, 95
Assyria, 5, 20
astral powers, 46
Asturica (Astorga), Spain, 53

Atargatis, 14

Athanasius, 66, 67, 103, 234n59, 236–37n114

athletic events, 57, 59, 84, 101

atonement, 205, 206

Attridge, Harold W., 190

Augustine of Hippo, 103, 104, 127, 148

aurality, 36–37

Aurelian's column, 72

Aventine Mithraeum (Rome), 38, 112

Azzanathkona, 15

Bacchus/Dionysus, 112

Balaam, 164

baptism, 44, 81, 82, 84, 140, 150–52, 233n41; anointing prior to, 48, 53, 54, 55, 56, 59–60, 66, 83, 103, 109, 127, 131, 134, 155, 193; approved days for, 47; baptistery paintings' signification of, 108; biblical betrothal scene linked with, 197; birth mysticism, 192, 198; bridal chamber metaphor for, 135, 147; celibacy and, 135, 136; descent of Holy Spirit and, 155; early Christian meaning of, 95, 105, 134, 140, 155, 156, 157–58, 182, 205, 218, 228n73; Gregory of Nazianzus on, 58, 82, 134–35; healing miracle and, 95, 97–98; as illumination, 58, 134, 218; imagery of, 24–25, 28, 31–32, 33, 34, 39–40, 88–89, 122, 182, 192–93, 203–4, 212; incarnation and, 56, 58, 149, 154, 155, 193, 194, 199, 212; of Jesus, 55, 56, 58, 67, 120, 131, 149, 155, 169, 194, 209–10; military motif and, 233n44; in name of Christ, 59, 86–87, 103, 120, 151, 205; Pauline death mysticism and, 55, 89, 119–21, 131–32, 151–52, 205, 206; pilgrim tokens picturing, 185; Psalm 23 and, 87; as rebirth through water, 91, 208, 209, 212–13 (see also water); re-entry into paradise through, 207; Samaritan Woman and, 157–58, 195; shepherd and flock imagery and, 31, 87, 102–3, 105; solitaries and, 210–11; sphragis (seal) of, 59, 107, 190; spiritual marriage and, 133, 134; veiled sanctuary for, 147; virginity and, 141, 149; Wise and Foolish Virgins and, 134

Baptismal Imagery in Early Christianity (Jensen), 24, 203

"Baptismal Patterns in Early Syria" (Spinks), 155, 156

Baptism in the Early Church (Ferguson), 227n73

baptistery (Dura-Europos), 2–4, 21, 24, 40–43, 78, 80–81, 107–10, 197–203; artistic program of, 47–48, 86, 107–8, 139, 202, 203; Christian initiation procedure in, 22, 30, 149–50, 156, 211; continuing scholarship on, 28–29, 44; counterclockwise (right-to-left) processional movement around, 40–41, 93, 94; dominant symbols and traditions of, 42–43, 206, 218–19; eastern wall, 20, 42, 75, 86; font, 42, 99, 100, 108, 112, 140, 145, 147, 154, 156; font canopy, 144, 145, 147, 200; fresco fragments found in, 20 (see also Adam and Eve; David slaying Goliath; healing of paralytic; procession of women; shepherd and flock; walking on water; woman at a well); fresco motifs, 45, 49–50; full-length book on, 28–39; garden scene (see Adam and Eve); historical imagination concerning, 212, 218; ideographic images and, 107, 195; initiates (see subhead neophyte experience of); interpretive approaches to, 1–4, 27–28, 32–33, 39–40, 41, 45, 107–10, 111, 115, 117–19, 128, 140, 146,

baptistery (continued)
 195–201; isometric of, 18, *19,* 20; Jesus
 implicit/explicit depictions, 86,
 87–99, 107–10; marriage and wedding
 motifs, 42, 129, 154, 192, 214; missing
 wall, 115, 117; narrative imagery of,
 107, 108; neophyte experience of, 40,
 43, 46, 47, 88, 90, 110, 114, 210–12;
 northern wall upper panel scenes,
 41–42, 47–48, 58, 75, 86; *Odes of
 Solomon* and, 212–18; personal name
 graffiti found in, 22, 30, 40, 46–47, 68,
 114, 139; ritual-centered viewing of,
 32, 39, 45, 80–81, 195–98; salvation
 emphasis of, 43, 198–201; southern
 wall, 41, 48–49, *49,* 86, 91, 156,
 plate 3; southwest corner, 43;
 threshold of, 48, *48;* as tomb, 42, 154;
 upper vs. lower panel paintings,
 107–8; visual description of, 41–42;
 water imagery, 145; as womb, 43, 154
baptistery, Ravenna, 103, 112, 158, 166,
 183
baptistery, San Giovanni in Fonte
 (Naples), 158, 182–83, *183*
Bardaisan of Edessa, 20, 28, 106; *Book of
 the Laws of Countries,* 46
Basilides, 232n33
bathing ritual (wedding), 137
Bauer, Walter, 26
Bawit (Egypt), 62
Be'er, well of, 69, *70,* 146
bema, 135
Berenike (Egypt), 7
best man, as metaphor, 129, 130
Beth Alpha synagogue, 15
Bethesda, pool of, 41–42, 93, 95, 96, 98
betrothal at well, 158, 182, 190, 195, 197
"betrothed to Christ," 137
Bible, 30, 45; art illustrating, 31–34, 39,
 75–76, 108, 113, 195; King James
 Version, 129; shepherd and sheep

allusions, 101–4. *See also* Hebrew
 Bible; New Testament; *specific books,
 gospels, and persons*
Bibliothèque Nationale (Paris), 177
birth, 132, 138, 150–55, 193, 218; amulet
 and, 187, 189; conception and, 216; as
 initiation metaphor, 55, 209–10;
 oil-fire-water-Spirit connection, 58; as
 purpose of marriage, 151; rebirth and,
 22, 192, 209; from virginal womb,
 153–54, 216. *See also* pregnancy
birth of Jesus. *See* nativity
Bisconti, Fabrizio, 162
bishops, 97
"Blessed Is the Creator of Light" (hymn),
 194
Blessed Virgin. *See* Mary
Bobbio (Italy), token collection, 185, 186
bodily integrity, 30, 97, 208
bodily mortification, 122
Bodmer Papyri, 160
"Book of James." See *Protevangelium of
 James*
Book of the Laws of Countries (Bardai-
 san), 46
"Bordeaux pilgrim," 184
Bosio, Antonio, 164
Boston College, 28
Botticelli, 162
Bradshaw, Paul, 23, 24, 120; *The Search
 for the Origins of Christian Worship,*
 23
branding of property. *See* seal
Braund, David, 75, 77, 78
Breasted, James Henry, 12–13, 26; *The
 Oriental Forerunners of Byzantine
 Painting,* 27
Brescia Casket, 182
bridal chamber: anointing and, 41, 57,
 59, 65, 122, 137; Aramaic/Syriac word
 for, 193; Dura-Europos baptistery as,
 154, 214; entering of solitaries into,

211; "imagined," 138; initiation as, 138; literal vs. metaphorical, 135, 136–37, 147; Mary's womb as, 154, 199–200, 202; as metaphor, 129, 132, 135, 138, 214, 215; processions of virgins to, 42, 109, 122–23, 146–47; spiritual marriage in, 27, 44, 59, 109, 124, 127, 137–38; temple as, 199; union in, 151, 153

bride: of Christ, 132, 133, 139, 197; as initiation image, 28, 43, 109, 137, 138, 139, 147, 149–50, 190; male virgins as, 134, 140; Syrian church as, 192; virginity symbols, 127, 136. *See also* marriage; spiritual marriage

bridegroom, 126, 127, 129–30, 131, 133, 134, 136, 139, 146, 149, 154, 199, 203, 204, 215; as lamb of God, 108, 109; "wedding gift" of, 151

bridesmaids, 126, 127, 129

Britain, Middle East mandate, 11–12, 13

British Museum, 173

Brock, Sebastian, 57, 85, 98, 132, 140–41, 192–93, 211

Brooks, Phillips, "O Little Town of Bethlehem," 201

Brown, Frank, 14

Brown, Peter, 30

Buddhism, 58

burial, 33

burning bush, 102

Byzantine art, 29, 37, 45, 146; Annunciation iconography, 162, 176, *176,* 180; pilgrimage, 184–85

Byzantine Church of the Multiplication (Tabgha, Galilee), 143

Byzantine monastery (Chora, Istanbul), 77

Byzantion (journal), 39

Byzantium, 35–36

Caesar, Julius, crossing of Rubicon by, 77, 78

Callinicum, 21

Campbell, Alastair, 121

Campin, Robert, Annunciation Triptych, 162, *163,* 169

Cappadocia, 58

Carrhae, battle of, 77–78

Carthage, 21, 112

Cartlidge, David, 153

Cassiodorus of Vivarium, 103

catacomb paintings, 37, 38, 43, 96, 99, 112, 142, 164, 182

catechesis, 46, 47, 57, 59, 84, 85, 107, 139, 151, 152

Catechetical Homilies (Cyril of Jerusalem), 27

Cathedral of Our Lady of the Angels (Los Angeles), 37, 112

Cathedral of St. John the Baptist (Monza), 185

Catholic Church art, 113

Cavallo, Guglielmo, 143

celibacy, 97, 106, 132, 133, 135, 136, 137, 208–10. *See also* spiritual marriage

censers, 119, 183; Annunciation scene, 166, 172, 176, *176,* 185

Chalcedon Christology, 174

charity, 127

chastity, 106, 136

chemical warfare, earliest known use of, 11

childbirth. *See* birth

children of the resurrection, 211

chiliarch (military term), 8–9

chi-rho (sign of Christ) 104

chrism, 57, 131

chrismation. *See* anointing

Christ. *See* Jesus Christ

Christ Emmanuel and the Annunciation (Mar Musa al-Habashi), *181*

Christianity: contemporary church art, 112; as cross-centered, 198; derivation of word, 57; Reformation view of art, 196

Christianity, early. *See* early Christian art; early Christianity; Syrian Christianity

Christian "kiss," 137

Christmas. *See* nativity

Christmas carol, 201

Christogram, 104

Christology, 174, 233n39; exemplarist, 93

christos (anointed one), 51, 60

Christ the Miracle Worker in Early Christian Art (Jefferson), 96

Chrysostom, John, 27, 57, 84, 95, 140, 152; baptismal instructions of, 134, 135, 136; prebaptismal anointing and, 59–60; Psalm 45 commentary of, 148–50, 151; spiritual marriage and, 133–34, 138, 139

chuppah, 193, 215

church, Dura-Europos. *See* house-church

Church of the Holy Sepulchre (Jerusalem), 185

circumcision, Christian form of, 59

Clark, Elizabeth, 136, 139

classical imagery, 35, 100, 122

clay jar graffiti, 40–41, 47, 139

Clement of Alexandria, 53, 102, 109, 121, 124, 232n33

Cloisters Collection (New York), 162

Codex Alexandrinus, 234n59

Codex Purpureus Rossanensis (Rossano Gospels), 143–46, 215, *plate 8*

Codex Sinaiticus, 234n59

cohors XX Palmyrenorum. *See* Palmyra; Roman army

Columbia University, 25

Constantine the Great, emperor of Rome, 1–2, 38, 63, 184

Constantinople, 134, 135, 181

conversion, 58, 97, 99, 104, 120. *See also* initiation

Corinth, 7

covenant, 234n64

Crassus, Marcus Licinius, 77–78, 81

creation, 207, 208, 212

criophorus, 100, 102

Crosby, Margaret, 14

cross, 131, 185, 205; as central to Christianity, 198; pilgrim reverence for, 185; salvation through, 200; sign of the, 104–5; stations of the, 113; "true," 171, *171,* 184

crucifixion, 185, 198, 200

Crusades, 141, 181

cultic activity, 36, 60, 112, 124

Cumont, Franz, 13, 14

Cyprus, 181; plates of David's life, 236n110

Cyril of Alexandria, 103

Cyril of Jerusalem, 57, 58, 81, 95, 103, 105; baptismal catecheses, 151, 152, 233n51; *Catechetical Homilies,* 27; *Procatechesis,* 134, 147; spiritual marriage and, 133, 136, 138, 139

Damascus, 20

Daniélou, Jean, 73

Danube River, 75, 76, 77

Daphnis and Chloe, 122–23

David, 60–75; anointing of, 49, *50,* 60, 62–63, 64, 65, 67, 68, 82, 83, 84, 86, 106–7, 149, 213; art depicting, *74, 74–75,* 111 (*see also* David slaying Goliath); Codex Rossanensis on, 148; Cyprus plates of life of, 236n110; Dura synagogue depiction of, 49, *50;* election by God of, 67, 68; as king, 49, 60, *80,* 83, 86; many aspects of, 60–64, 67, 85, 95, 149; messianic tradition and, 56, 60, 64; as musician and poet, 74; narrative imagery and, 81; as shepherd-warrior, 41, 42, 44, 60, 62, 63–64, 65, 67, 68, 71–72, *72,* 78, 81, 86, 87, 102, 104, 106–7, 140; sling of, 72–73, *73,* 81, 236n110; as son of God, 62–63, 213. *See also* Psalms of David

Davidic descent, 62, 63, 64, 159, 191

David slaying Goliath (Dura-Europos baptistery painting), 20, 22, 28, 41, 49–50, 61–64, 68, 70–74, 72, 75, 85, 86, 140, 149, 150, 197, 202; interpretations of, 73–74, 82–83; militaristic indicators, 70–73, 74; psalms evoking, 66–67. *See also* Goliath

Davis, Stephen, 153

deacons, female, 53–54

Dead Sea Scrolls, 15, 66, 234nn59,60,63

death, 150–53, 205, 209; origin of, 131. *See also* funerals

death and resurrection, 3, 20, 24, 45, 55, 87, 89, 96, 97, 131, 136, 142, 192; in baptism with Christ, 205; crucifixion and, 185, 198, 200; Graeco-Roman antiquity and, 120; initiation and, 42, 120; myrrophores at empty tomb and, 31, 117–20, 122, 127–28; Pauline interpretation of baptism as, 119–20, 121, 205, 206; redeemed body and, 209; solitaries' anticipation of, 211; theory of procession of women representing, 118–21, 122

death mysticism, 55, 120–21, 131–32, 151–52, 198, 206

Decani church (Serbia), Annunciation scene, 174

Decius, emperor of Rome, 22

deities, 6, 7, 9, 14–15, 35, 36; death and rising of, 120; festival processions, 124; mythical unions between, 137; of water, 75, 165

demon possession, 97

Demonstrations (Aphrahat), 136, 211

devil, 82, 83, 84

Diana, 112

Diatessaron (Tatian), 81, 228n80; parchment fragment of, 26, 31, 40, 90, 93, 94, 96, 118, 128, 207, 216

Didache, 20, 51, 56, 63, 121, 157, 226n52

Didascalia Apostolorum, 27, 30, 53–54, 57, 64, 81, 97

Dio, Cassius, 81

Dionysiac processions, 38

Dirven, Lucinda, 9, 21–22, 28, 206, 207

disciples, 120; walking on water and, 86, 87–88, *88*, 90, 93

Discovery of Dura-Europos (Hopkins), 14

divine sonship, 52–53, 193, 213

Doctrine of Addai, 225n47

Documents of the Baptismal Liturgy (Johnson, ed.), 24

Dodd, Erica, 141, 172, 181

Domitilla, Catacombs of, 38

domus ecclesiae. See house-church

dove, 100, 180, 186, 212

Drijvers, Hans J. W., 216

drowning baptism, 89

"Dry Salvages" (Eliot), 76

Dura-Europos, 1–2, 143, 218–19; American and French archaeologists, 12–14; ancient evidence for names, 223n2; British soldiers' discovery of ruins (1920), 11–12; chemical warfare use, 11; Christian baptistery (*see* baptistery); Christian community, 11, 15, 20–22, 26–27, 40, 41, 43–44, 68, 73, 74, 79–81, 83, 207, 216, 226n61; Christian house-church (*see* house-church); Christian identity markers, 40; continued scholarship on, 28–29; as crossroads of antiquity, 15; *Diatessaron* fragment found at, 207; diversity of languages and practices, 6–9, 14–15; excavation final reports, 3, 4, 25, 26, 119; excavation sites, 1–18; excavation teams, 1–2, 13, 14; extensive findings at, 1–2, 14–15, 20; final destruction of, 10, 11, 14; founding, location, and history of, 5–6; as frontier town, 6–7, 22, 80–81; as Graeco-Semitic civilization, 13, 46;

Dura-Europos (continued)
 imagined size and significance of,
 224n8; intentional burial and, 5;
 Jewish community, 226n61; Jewish
 synagogue (see synagogue); largest
 building, 9–10; map, plate 2;
 militarized setting of, 7, 21, 41, 44,
 68–69, 78, 80, 85; Mithraeum, 9, 14,
 32, 38, 60, 61, 112; parchments, 13, 20,
 40, 118; as "Pompeii of Syrian
 Desert," 5, 11, 14; Roman era of, 6–14,
 21, 73; Sasanian siege-camp, 10; "Wall
 Street" remains, 11, 15; western city
 wall of, 6, 10–11, 68, 224n8; western
 vulnerability of, 10
Dux Ripae, Palace of the, 9–10, 79

early Christian art, 30–38, 143, 165,
 194–98; biblical images, 31, 33–34;
 characteristics of, 36–37, 100;
 classical imagery, 24; earliest images,
 68; haptic vs. optic viewing of, 39,
 113, 230n129; imagery of Christ's
 death, 55; incorporation motifs, 101,
 107; militaristic imagination and, 68;
 prominence of procession portrayals,
 37–38, 111–13; representation of
 myrrophores, 119; ritual-centered
 viewing of, 35–36, 196; ritual context
 of, 33–34; river of Eden, 144–45;
 salvation imagery, 87, 88; shepherd
 and flock as most familiar theme of,
 99–100, 104; textual analysis and,
 194–96
early Christianity: chastity and, 106, 136;
 chi-rho as Christ symbol, 104; close
 community bonds and, 22, 42;
 conversion basis of, 22, 26, 97; death
 and resurrection paradigm, 120–21; in
 early third century vs. late fourth
 century, 47, 55; eastern vs. western
 anointing rites, 55; expansion of,

20–22; as flock led by Christ, 103–4;
 initiation rite variety, 3, 22–30, 41, 42,
 45, 56–58, 65, 66, 104–7, 120–21, 140,
 202, 206, 211; instability of textual
 forms, 31; locality of liturgical
 traditions, 23–24; Marian devotion
 and, 159, 162; narrative sources, 212;
 nativity/Epiphany date, 56; only
 pre-Constantine extant church
 building, 1, 14–16; persecution
 cessation (fourth century), 55;
 pilgrimages to Holy Land, 183–90;
 precanonical and preconciliar texts,
 91; prominent theologians, 20–21;
 regional diversity of, 26–27, 120–21;
 Valentinianism and, 20–21, 109, 124,
 138–39, 226n53; wedding and
 marriage imagery, 129–33. See also
 Dura-Europos; early Christian art;
 Syrian Christianity
Easter, 3, 42, 47, 120, 121, 232n33
East Syria. See Dura-Europos; Euphrates
 River; Syrian Christianity
Eben-Ezer, battle of, 69, 69
Eden. See paradise
Edessa, 20, 225n47
Edwell, Peter, 10
Egeria, 57, 189
Egypt, 7, 20, 26, 53, 58, 62, 77, 153;
 Annunciation scenes, 165, 166, 168,
 168, 186
Ein Kerem, 186, 187
El-Bagawat fresco, 153
Eleusinian mysteries, 120, 124
Eliezer, 182
Eliot, T. S., 76, 77; "The Dry Salvages,"
 76
Elizabeth (mother of John the Baptist),
 Mary's visit to, 186–87
Elliott, Keith, 153
Elsner, Jaś, 34, 35, 36, 37, 124
empowerment motif, 45, 86, 98, 198, 218

empty tomb. *See* death and resurrection;
 tomb of Jesus
end of time, 108, 125, 126, 209, 211
enlightenment, 58
environmental psychology, 75–77, 78
Ephesians, Epistle to the, 151
Ephesian Tale (Xenophon), 124
Ephesus, 7, 124
Ephrem, 53, 57, 74, 82–83, 90, 95, 105–6,
 146, 195, 202–3, 233n30; baptism as
 second womb, 192; *Diatessaron*
 commentary, 96; as early Syrian
 Christianity source, 26, 29; Fire and
 Spirit and, 193–94; *Hymns on
 Epiphany,* 210; *Hymns on Nativity,*
 107, 161; *Hymns on Paradise,* 209, 210;
 Hymns on Virginity, 202; incarnation
 and, 199; "light from light" image,
 233n39; polysemic ritual texts and,
 197; on Rebecca and Laban, 158; robe
 of glory concept, 207; on Samaritan
 Woman, 157; on virginity of Mary,
 153, 191
Epiphanius, 159
Epiphany, 47, 56, 131, 135, 194, 210,
 232n33
Epistle of Barnabas, 121
Epistles of Paul. *See* Pauline epistles;
 specific epistles
Epistula Apostolorum, 109, 139
eschatology, 125–26, 132, 144. *See also*
 death; end of time; salvation
Estrangela (Syriac script), 57
Etchmiadzine Gospels, 172
eternal life, 144, 148, 154, 157, 214
Eucharist, 17, 47, 51, 52, 53, 80, 121, 131,
 141; Holy Spirit and, 193; Psalm 23
 and, 87; as sacrificial reenactment, 55;
 veiled sanctuary and, 147
eulogia, pilgrimage meaning of, 184–85
Euphrates River, 1, 5, 9–10, 12, 13, 21, 41,
 68; Romans and, 75, 77–78, 80–81;

walking on water symbolism and, 91,
 93, 213
Euripides, *Medea,* 122, 123
Eusebius of Caesarea, 63, 103, 108
evangelism, 34, 197
Eve. *See* Adam and Eve
evil eye, 47
"Exodus chapel" frescoes, 153
exorcism, 47, 55, 95, 97
Ezekiel, 102, 104

faith, 90, 93, 95, 190, 196
feminine Spirit, 192
Ferguson, Everett, 28; *Baptism in the
 Early Church,* 227n73
Fieschi Morgan Staurotheke, underside
 of lid, *171*
Final Judgment. *See* Last Judgment
Fine, Steven, 15, 225n43
fire, 58, 125; as Holy Spirit symbol,
 193–94, 200. *See also* illumination
firelight ritual (wedding), 122–35, 137
fish, 100
flasks, 185–86
flowing water. *See* "living" (flowing)
 water
forgiveness, Christian ritual of, 22
"Fountain of the Virgin," 160, 161
France: Dura-Europos excavations and,
 13, 14; Middle East Mandate, 11–12, 13
Francis, James A., 36, 37, 68
French Academy of Inscriptions and
 Belles-Lettres, 13
funerals, 33–34, 42, 51, 142

Gabriel (angel): absence in baptistery
 fresco, 195; in Annunciation
 portrayals, 159, 161, 162, *163,* 165, 166,
 167, *168,* 169, *170,* 171, *171,* 172, *173,*
 174, 177, *177, 178,* 179, 182, 185, 186,
 187, 188, 189, 191, 194, 196, 199
Galilee, 15, 184, 187

Galilee, Sea of (freshwater lake), 91

Garden of Eden. *See* Adam and Eve;
 paradise

Genesis, 58

gentiles, 22

Gladzor (Glajor) Gospels, 174, *175*

Gnosticism, 91, 109, 138–39

God: anointed one of, 57, 59, 62–63, 64,
 65, 67, 68, 90; enlistment in army of,
 82; Hebrew Bible metaphors for, 108;
 Marcionite duality of, 206, 207. *See
 also* divine sonship; Holy Spirit; Jesus
 Christ

gods. *See* deities

Golgotha, 151, 184

Goliath: images of, 31, 74, 78; as
 personification of passions, 82–83;
 tomb of, 185. *See also* David slaying
 Goliath

Goodenough, E. R., 15

Good Shepherd, 31, 101, 102, 103–4, 105,
 108, 205, 206, 209

good works, oil symbolizing, 127, 144

Gospel of James. See *Protevangelium of
 James*

Gospel of Philip, 21, 28, 30, 131; anointing
 and, 57, 137; bridal chamber as
 dominant symbol of, 138, 199–200;
 early Mariology of, 153; primal
 androgyne myth and, 208; sacramen-
 tal system and, 55–56; on spiritual
 marriage, 27, 137–38

Gospel of Pseudo-Matthew, 160–61

Gospel of Thomas, 26, 208, 211

Gospel of Truth, 26

Gospels, 89, 118, 120, 126, 196, 207,
 228n80; Annunciation account, 162,
 182; canonical narratives of, 31, 95;
 harmonization of (see *Diatessaron*);
 marriage motifs, 211. *See also specific
 gospels*

Grabar, André, 146

grace, 149, 213

Graeco-Roman world, 7, 13, 78;
 anointing and, 50; classical imagery
 and, 35, 100, 122; death and resurrec-
 tion and, 120; deities of, 6, 9, 15, 112;
 Hellenistic era, 5–6, 139–40; marriage
 and, 123, 124; processions and, 38,
 112, 124–25; virginity and, 132–33,
 139; visuality of, 35–36. *See also*
 Roman Empire

graffiti, Dura-Europos: figural, 78–80,
 79, 80, 113, 207; personal names, 22,
 30, 40, 46–47, 68, 114, 139

graffiti, pilgrim, 188

Greek language, 6, 8, 9, 46, 51, 53, 123

Greek Orthodox Church, 120

Grégoire, Henri, 39–40

Gregory of Nazianzus, "On Holy
 Baptism," 58, 82, 134–35

Gregory of Nyssa, 184, 208

Gregory the Great, Pope, 155

Griffith, Sidney, 106, 136, 210–11

Gundaphorus, King, 51–53, 104–5,
 231n15

Gundeshapur, Christianity brought to,
 226n60

Hahn, Cynthia, 190

Hammath Tiberias, ancient synagogue
 of, 15

haptic function, 147; optic distinction,
 39, 113, 230n129

Harvey, Susan Ashbrook, 96, 97, 208–9,
 215

healing, 24, 30, 45, 95–99, 189, 208, 218;
 absolution of sin and, 97; apostles and
 bishops and, 97; Christ the physician
 and, 41–42, 86, 96–99; divine vs.
 superstitio, 95; salvation as, 198; of
 soul, 97, 98

healing of paralytic (Dura-Europos
 baptistery painting), 31, 39, 44, 86,

87, 93–99, *94*, 213, *plate 5;* purpose of, 98–99

heaven, entry into, 127

Hebrew Bible, 49, 60, 207; betrothal at well accounts, 158, 182, 190, 195, 197; creation account, 207, 208; Masoretic Text, 66; metaphors for God, 108; military figures and, 70; shepherds and, 102, 104. *See also* Adam and Eve; David; David slaying Goliath; Psalms of David; *specific psalms*

Hebrew language, 6, 51; alphabet, 208; liturgical parchment discovery, 20

Helena (mother of Constantine), 184

Hellenistic era, 5–6, 139–40

Hera (neophyte), 40, 114, 140, 211, 218

Heraclius, Byzantine emperor, 236n110

hermeneutics, 197

Hermes (sheep-bearer), 100, 121

Herod, 186

Hesychius of Jerusalem, 103

Heyn, Maura, 113

Hippolytus, David and Goliath sermon, 73–74

History of Art (Pijoan), 128

Holy Land, 184–89, 190. *See also* Jerusalem

Holy of Holies, 200

"holy rider" image, 80

Holy Spirit, 24, 81, 103, 105, 121, 131, 212, 216; anointing by, 55, 127, 149, 155, 192; descent and embodiment in Mary's womb of, 56, 153–54, 155–56, 193, 194; fire as manifestation of, 193–94, 200; martyrdom and, 122; oil identified with, 41, 57, 58, 127, 192; recognition of, 155; Syriac liturgical rites and, 193. *See also* Annunciation; incarnation

Homer, 75; *Odyssey,* 60

homilies, 31, 32

Homilies on Genesis (Origen), 190–91

Homilies on the Virgin (James of Kokkinobaphos), 177, *178*

Hopkins, Clark, 1–2, 3, 14, 15, 86, 111, 203, 207; *The Discovery of Dura-Europos,* 14

Hopkins, Susan, 14, 225n38

house-church (Dura-Europos), 11, 14, 15–20, 203, 218–19; apotropaic magic bowl, 46–47; conversion from original house, 48, *49;* excavation final report (1967) on, 3, 4, 25, 26, 119; floor plan, *17;* graffiti, 22, 30, 40, 46, 78–80, *79, 80,* 207; hypothetical reconstruction with congregants, *18;* isometric, 18, *19,* 20; microhistory/interpretation of, 25; original house, 48, 49; outside, *16;* questions about, 203; ritual-centered visuality and, 34–35, 38, *39;* Roman military quarters and, 21; sources and, 29–30; synagogue relationship with, 20; uniqueness of, 2, 15–16; updated scholarship on, 44; wedding ring found in, 137; as world's oldest church, 22. *See also* baptistery

"hovering" of the Spirit, 58

Hunt, E. D., 184

hymns, 30, 194, 212, 215

Hymns on Epiphany (Ephrem), 210

Hymns on Nativity (Ephrem), 107, 161

Hymns on Paradise (Ephrem), 209, 210

Hymns on Virginity (Ephrem), 202

Iarhibol, 9

Iconography of Christian Art (Schiller), 199

iconostasis, 141, *142*

Ignatius of Antioch, 20, 56, 96, 121, 217

illiteracy, 46

illness. *See* healing

illuminated manuscripts, 30, 119, 145; Annunciation scene, 165, 171, 176–77, 180, 181; Codex Rossanensis, 143–46; Rebecca at well scene, 182

illumination, 30, 45, 56, 57, 131, 143–48,
 172–73, 182; baptism as, 58, 134, 218;
 as enlightenment, 58; incarnation
 and, 43, 161, 194, 199, 200, 202;
 initiation oil as source of, 50, 53, 58,
 90, 140; as motif of marriage, 130;
 salvation as, 198, 200. *See also* oil
 lamps; torches
*Image and Text in Graeco-Roman
 Antiquity* (Squire), 196
Images of Baptism (Johnson), 24
imagined marriage, 138
immortality, 125
imperial ceremony, 38–39
incarnation, 45, 150, 153–54, 155–56, 191,
 192, 193–94; baptism compared with,
 56, 58, 149, 154, 155, 193, 212;
 conception narrative and, 216;
 doubling as Mary's baptism, 193; as
 drop of milk, 215–16; emphasis on,
 198–201; illumination and, 43, 161,
 194, 197, 199, 200, 202; lines
 depicting, 162, *163*, 172, 180–81, 182,
 193; "living water" and, 214;
 restoration of primordial innocence
 by, 208; as salvation, 198, 200, 201,
 214; as sexless, 208; star signifying
 spark in body of, 181–82, 193, 194,
 199, 200; Syrian robe of glory motif
 and, 207, 209
incorporation motifs (early Christian
 art), 101, 107
initiation, 3, 4, 22–30, 32, 34, 36, 41,
 83–85, 97, 120–21, 128, 202; anointing
 rite, 48, 50–63, 105, 155, 192, 213;
 birth imagery for, 55, 209–10; bridal
 imagery for, 28, 109, 137, 138, 139, 147,
 149–50, 190; calendrical diversity of,
 47; celibate subgroup, 210; communal
 aspect of, 42; death and resurrection
 motif, 42, 120; death mysticism and,
 55, 120; Dura-Europos and, 40–47,

88, 90, 110, 111, 114, 149–50, 210–12;
 "dying with Christ" through ritual of,
 120; early Christian dominant
 symbols of, 218; evolution of rite, 57;
 feminine Spirit and, 192; healing and,
 42, 99; Holy Spirit and, 155–56, 192,
 193, 216; as illumination, 50, 53, 58,
 90, 140; incorporation symbols, 101,
 107; locality and, 22–24 (*see also*
 Syrian Christianity); marriage
 metaphor for, 109, 133–35, 139, 151;
 military motif for, 82, 83, 137, 233n44;
 neophytes and, 66, 104, 139, 140, 190,
 230n132; *Odes of Solomon* and, 43;
 paradise restored and, 43, 203, 209;
 Pauline interpretation of, 55, 131–32,
 208; pilgrimage compared with,
 189–90; processions, 40, 42, 47, 211;
 Psalms evoking, 65–66, 67, 81, 87,
 102–4, 109; ritual liquids for, 139–40;
 ritual logic of, 58; as salvation,
 198–201; seal (mark) of, 58, 59, 86–87,
 101, 104, 105, 106, 107, 108, 190;
 sourcebook of ancient texts on, 24; as
 spiritual marriage, 133–40, 141;
 spiritual pregnancy and, 43; symbols
 of, 25, 40, 41, 44, 59, 99, 109–10, 211;
 themes of, 213; third-century
 approved dates for, 47; torches and,
 124; types of, 24; updating of former
 consensus about, 45. *See also* baptism
innocence, 208
inscriptions, 1, 9, 46–47, 77, 103,
 230nn130–31
Iraq, 13
Irenaeus of Lyons, 21, 121, 198
Isaac, 158, 182, 190
Isaiah, 57
Isidore of Charax, 223n2
Isis mysteries, 120, 124
Israelites, 67, 78, 83, 92; anointing by, 49,
 50, 51, 54, 63, 86

Isseos the neophyte, 40–41, 42, 43, 47,
 86, 99, 114, 140, 211, 218; anointing of,
 156; as imagined female bride, 138–39;
 probationary period, 46
ivory book cover, Annunciation scene,
 165, 172, 198–200
ivory pyxis, Annunciation scene, 173

Jacob, 156, 158, 182, 190, 191
Jacob of Serugh, 30, 98, 191
James, 93, 120. See also *Protevangelium
 of James*
James, Simon, 10, 11, 226n58
James of Kokkinobaphos, *Homilies on the
 Virgin,* 177, *178*
jars of oil, 47, 48
Jastrzębowska, Elżbieta, 164
Jefferson, Lee, 95; *Christ the Miracle
 Worker in Early Christian Art,* 96
Jensen, Robin, 24–25, 28, 32–33, 34, 120;
 *Baptismal Imagery in Early
 Christianity,* 24, 203; *Living Water,*
 24; on shepherd and flock imagery,
 99, 101; *Understanding Early
 Christian Art,* 24
Jerash (Gerasa) excavations, 25, 38
Jerome, 139
Jerusalem, 134, 135, 174; baptism in, 47;
 Constantine refounding of, 184;
 healing of paralytic in, 93; pilgrimage
 to, 184, 185, 186, 198; procession of
 initiates, 47; procession of virgins to
 temple of, 153
Jesse, 63
Jesus Christ, 1, 20, 37, 88, 90, 93, 95, 111,
 126, 140, 141, 184, 203; anointing of,
 55, 57, 62, 83, 90, 149; baptism in
 name of, 59, 86–87, 103, 120, 151, 205;
 baptism of, 55, 56, 58, 67, 120, 131,
 149, 155, 169, 194, 209–10; baptisms
 by, 157; battle with "evil one," 83–84;
 birth of (*see* nativity); *chi-rho* as early

Christian sign of, 104; "daughter and
 bride" of, 151; Davidic descent of, 62,
 63, 64; death of (*see* death and
 resurrection); dedicatory inscriptions
 to, 30; diverse narratives about, 31;
 divine and human natures of, 174;
 Dura-Europos baptistery depictions
 of, 20, 41, 44, 86, 87–93, 107–10, 115,
 202, 213; empty tomb of, 2–3, 31, 42,
 44, 111, 117, 118–22; end of time and,
 125; as Good Shepherd, 41, 42, 44,
 86, 87, 100, 101, 102, 103–4, 105, 108,
 205, 206; grace of, 149; as healer/
 physician, 41–42, 86, 93–99;
 incarnation of, 56, 58, 153–54, 155–56,
 191, 200, 216; as leader and model, 93;
 "living water" dialogue, 156–57, 213;
 marriage imagery and, 28, 108, 126,
 127, 128–30, 133, 134, 136, 138, 139,
 151, 197, 204, 215; martyrdom as
 "dying" with, 121; messianic tradition
 and, 55, 56, 62, 64; military metaphor
 for, 83–84; miracles of, 24, 41–42, 44,
 45, 86, 87–93, 213; mother of (*see*
 Mary); myrrophore procession to
 tomb of, 2–3, 43, 44, 118–20, 122,
 127–28, 150, 154; New Testament
 metaphors for, 108; parables of (*see*
 parables); with Peter on water (*see*
 walking on water); Samaritan Woman
 and, 158, 177, 182, 183, 190, 197, 213;
 seal of, 25, 41, 58, 59, 86–87, 109;
 second coming of, 28, 127; Sermon on
 the Mount, 127; solitaries joined with,
 210–11; as Son of David, 62; as Son of
 God, 193, 213; spiritual marriage
 with, 129, 130–31, 132, 133, 138;
 water-related miracles of, 41–42, 44,
 86, 87–94, 95, 213; wedding at Cana,
 188; Wise and Foolish Virgins and,
 42, 109, 125–26, 143
Jethro, 102

Jewish community, 226n61

Jews. *See* Israelites; Judaism; synagogue

Joachim (father of Mary), 152, 159, 187

John, 57, 120, 192

John, Gospel of, 55, 88, 93, 94, 95, 118, 195, 216; Good Shepherd text, 31, 101, 102, 206, 209; "living water" and, 31–32, 191; rebirth and, 192; Samaritan Woman at Well and, 156, 158, 190

John Chrysostom. *See* Chrysostom, John

Johnson, Maxwell, 23–24, 54, 55, 56, 120; *Documents of the Baptismal Liturgy* (ed.), 24; *Images of Baptism*, 24; *The Rites of Christian Initiation*, 23

John the Baptist, 130, 141, 156, 186–87, 210

Jonah, imagery of, 34

Jones, Simon, 192, 209

Jordan, 25

Jordan River, 78, 165, 194, 209; baptism of Christ in, 55, 56, 58, 194, 209–10

Jordan River valley, 93

Judaism, 26, 91, 207, 226n52; anointing and, 50, 62, 63. *See also* synagogue

Judea, 6, 15, 184

Julian the Apostate, emperor of Rome, 74

Julius Terentius frieze, 7–8, *8,* 13, 38, 113

Jupiter Dolichenus, 60

Justin Martyr, 51, 121

Kilpatrick, George D., 226n61

King James Bible, 129

kings: anointing of, 41, 49, *50,* 51–53, 54, 82, 83; ritual symbols of, 65

kissing ritual (wedding), 137

Korol, Dieter, 28, 70–73, 74, 78, 89

Kraeling, Carl: academic career of, 25–26; Adam and Eve inset sketch and, 205, 206; artistic interpretation method of, 27–28, 195; David and Goliath image and, 61, 62; descriptive skills of, 26; *Diatessaron* fragment

publication by, 26; on Dura Christians, 21–22; Dura-Europos archaeological report (1967) and, 25, 26; female figure identification by, 28; house-church figural graffiti and, 79; potential extensions of research of, 27–28; procession of women interpretation and, 115, 117, 118, 119, 128, 140, 146; shepherd and sheep painting and, 99, 100, 101; sources and, 29–30; Walking on Water tracing and, 89, 90; Wise and Foolish Virgins Parable and, 134; woman at a well interpretation and, 156, 158, 180, 181

Laban, 158

lactation, 215–16

Lamb of God, 108, 109

lampade prima ("at the first torch"), 123

lamps. *See* oil lamps; torches

Lares compitales (Augustan Rome), 15

Lassus, Jean, 21

Last Judgment, 105, 126–27, 141, 144

Latin language, 6, 8, 58, 104; word for torch, 123

Lattke, Michael, 91, 92–93

laying on of hands, 97

Leachman, Gerard, 12

Letter to the Armenians (Macarius), 47, 56, 147

Levine, Lee I., 225n43

Leyerle, Blake, 188–89

Life of the Virgin (Maximus the Confessor), 161

light. *See* illumination

"light from light" image, 233n39

liturgy, 32, 38, 113; histories of, 27, 28, 30, 120–21, 128; locality and, 23–24; processional activity and, 112; Syrian early Christian diversity of, 55–56; visual exegesis and, 33–34, 36–37

Liturgy of Addai and Mari, 225n47
"living" (flowing) water, 24, 31–32,
 156–57, 158, 174, 191, 213, 217–18
Living Water (Jensen), 24
locus sanctus cycles, 185–86
Lord's Supper. *See* Eucharist
lost sheep parable, 87, 102
loutrophoros, 139–40
Lucian of Samosata, 20, 35, 37
Lucius Verus, emperor of Rome, 6
Lucullus, 77
Luke, Gospel of, 64, 102, 129, 186, 206,
 234n65; Annunciation story, 159, 160,
 216
Lutheranism, 196
Lutheran Theological Seminary, 25
Lyons, 21

Macarius, bishop of Jerusalem, 47; *Letter
 to the Armenians,* 47, 56, 147
Maccabees, 67
MacCormack, Sabine, 37–39
Macedonia, 5
Magi (three kings), 111, 194, 199
magic, 186
male celibates, 106
male virgins, 132, 134, 140
Mani, 106
Manicheans, 109; Psalm-Book, 109–10
Mann, J. C., 76, 77
Marcellinus, 66
Marcion, 206–7
Marian apocrypha, 159–60
Mariology, 153, 162, 215–16
mark. *See* seal
Mark, Gospel of, 88, 89; Codex
 Rossanensis containing, 143
Mar Musa al-Habashi church paintings
 (Syria), 141, *142,* 143, 148; Annuncia-
 tion scene, 172, 180, *181*
marriage: anointing and, 41, 57, 59, 65,
 122, 137; betrothals at wells accounts

and, 158, 182, 190, 195, 197; in
 birth-to-death progression, 151, 152,
 153; to Christ, 130, 136, 138, 139;
 commitment of, 211; fire ritual
 connection with, 125; illumination
 accompanying, 130; immortality and,
 125; incarnation and, 154; as
 initiation, 133–35, 139, 151; oil and, 51,
 122; paradise imagery and, 215; ritual
 signifiers for, 65, 122, 123, 124, 137,
 138, 139; royal, 148; as salvation
 symbol, 65, 108, 129, 198, 207–8;
 sexual vs. spiritual, 138 (*see also*
 spiritual marriage); shepherding
 juxtaposed with, 108, 109; Syrian
 early Christian motifs of, 30, 42, 45,
 130, 131–32, 134–36, 138, 192, 207–8,
 210; torches signifying, 122–23, 124,
 125, 134, 135, 137; veils signifying, 124;
 virginal, 127, 132, 136, 140, 210; Wise
 and Foolish Virgins and, 109, 146. *See
 also* bridal chamber; bride; bride-
 groom; wedding banquet; wedding
 guests; wedding procession
marriage bath, 140
marriage ring, 137, 168, *169,* 186
Martini, Simone, Annunciation
 altarpiece, 169, *170,* 182
martyrdom, 55, 121
Mary: Armenian church metaphors for,
 174; birth of Jesus and, 153–54, 201,
 216; consecration to temple of, 159,
 160; as counteracting curse of Eve,
 132, 153, 193, 211; Davidic descent of,
 159, 191; earliest securely dateable
 portrait of, 45; incarnation in womb
 of, 56, 58, 153–54, 181–82, 191, 193,
 194, 199, 209, 216; meeting with
 Elizabeth, 186–87; paradox of,
 199; parents of, 152, 158–59, 187;
 pilgrimages and, 185, 189; spark of
 illumination and, 202; veneration of

Mary (continued)
(*see* Mariology); virginal purity of, 25,
107, 132, 152–53, 160, 191, 193, 194,
199, 210, 211; Virgin and Child
depictions of, 161, 164; water symbols
for, 191; at well or spring (*see*
Annunciation iconic tradition;
Annunciation morphological
variety)
Mary Magdalene, 118, 122
"Mary silk" textile (Egypt), 165
Masoretic Text, 66
Mathews, Thomas F., 37, 112, 174
Matthew, Gospel of, 88, 89, 90, 93, 102;
Codex Rossanensis and, 143; Wise
and Foolish Virgins Parable, 125–29,
134, 196, 215
Maximian, chair (throne) of (Annuncia-
tion depiction), 171–72, 183
Maximus the Confessor, 161; *Life of the
Virgin,* 161
McDonnell, Kilian, 121
medallions, 166, 183
Medea (Euripides), 122, 123
Menander, 125
meshiach (anointed one), 60
Mesnil du Buisson, Robert du, 14
Mesopotamia, 6, 46, 158, 206, 207;
anointing and, 50
Messiah, Abdul, 1
messiah (anointed one), 46, 51, 54, 55, 56,
62, 64, 155, 190
messianic banquet, 110
metal flasks, 185–86
meta-narratives, 196
Methodius, *Symposium* of, 28
Metropolitan Museum of Art, Cloisters
Collection, 162
Middle East mandates (post–World
War I), 11–13
Midyat, Syro-Orthodox Diocese,
Annunciation scene, 173, *173*

Milan Cathedral, *166,* 199
military: anointing of soldiers, 41, 57, 59,
84, 85; as Christian progress
metaphor, 81–82; David the Warrior
and, 41, 42, 44, 60, 63–64, 65, 67, 68,
71–72, *72,* 78, 81, 106–7, 140; Dura
synagogue art and, 69, *69,* 70, *70, 71;*
early Christian art and, 68–69; female
"soldiers of Christ" and, 140;
incorporation motif and, 100, 107;
initiation motif and, 82, 83, 137,
233n44; as metaphor, 81–82, 83, 84,
108, 139, 149, 190, 218; mounted
archers/armed lancers, 78–79, *79, 80;*
shepherd's commitment compared
with, 108; slingers, 71–73, *73,* 81,
235n81; symbols of rituals, 65, 108,
137, 139. *See also* Roman army
milk, 215–16
miracles of Jesus, 24, 41–42, 44, 45, 86,
87–93, 213
Mississippi River, 76, 77
Mithraeum, 9, 14, 32, 38, 60, *61,* 112,
230n132
Mithras, slaying of bull by, 9, 60, *61*
Monza token (Italy), 185, 186, 187
mortality. *See* death
mosaics, 38, 112, 166, 177, 183
Moses, 63, 102, 104, 149, 158, 191; at well
of Be'er, 69, *70,* 146, 190
Moses the Ethiopian, monastery of,
141
Moss, Candida, 121
mother, Holy Spirit as, 192
Mount Carmel, 189
Mount of Olives, 184
Murphy, M. C., 12
Murray, Robert, 96, 147; *Symbols of
Church and Kingdom,* 192
Muslim conquests, 184
Myers, Susan, 53
Mygdonia, 130–31

myrrophores, 117–20, 122, 205; procession in early morning, 127–28; variant descriptions of, 31, 118–19

mystery cults, 120, 124

Mystery of Oil, 84

mystical marriage. *See* spiritual marriage

Na'aran, ancient synagogue art, 15

Nag Hammadi codices, 26, 27, 131

Narsai, 57, 137

Nathan, 102

nativity, 160, 164, 182, 186, 191, 198–99, 216, 232n33; depictions of, 165; Epiphany and, 47, 56; hymns, 107, 161, 215; Magi (three kings) and, 111, 194, 199; pilgrim souvenirs picturing, 185; as popular Christian holiday, 200–201

"Nativity of Mary." See *Protevangelium of James*

"Nativity of the Blessed Mary and the Infancy of the Savior" (Pseudo-Matthew), 160

nature, 86, 89, 90, 95

Nazareth, ancient wellspring, 189

Nelson, Robert S., 34, 36, 37

neophytes, 66, 104, 139, 140, 190, 230n132. *See also* initiation; Isseos the neophyte

"new age" spirituality, 58

New Testament, 31, 60, 64, 88–89, 103, 125; empty tomb narrative, 119; marriage metaphors, 149; metaphors for Christ, 108; spiritual marriage, 129. *See also* Gospels

New York University, 28

Nicene Christology, 233n39

Nile River, 77

Noah, 33–34; "jack-in-the-box" style of depicting, 33

noncanonical texts, 21, 26, 29, 30, 32, 91; anointing and, 51–53; range of, 27. See also *Acts of Thomas; Gospel of Philip; Gospel of Thomas; Protevangelium of James*

"nursing on divine milk" metaphor, 215

Odes of Solomon, 26, 29, 43, 91–93, 192, 212–18

Odyssey (Homer), 60

oil, 22, 30, 33, 49, 140; chrism, 57, 131; clay jar container, 40–41, 47, 48, 139; clear container, 122, 144; empowerment over water of, 90; fire-water-Spirit-birth connection, 58; Holy Spirit identified with, 41, 57, 58, 127, 192; as invisible armor, 85; many uses of, 50–51, 52, 58; Mystery of, 84; sealing with, 139; symbolism of, 51, 127, 144, 202, 204; Wise and Foolish Virgins Parable and, 125–29, 135, 144. *See also* anointing; initiation; torches

oil lamps, 50, 53, 58, 128, 129, 185, 204

Old Testament. *See* Hebrew Bible

"O Little Town of Bethlehem" (Brooks), 201

Olympic Games, 84

"On Holy Baptism" (Gregory of Nazianzus), 58, 82, 134–35

"On Perfection" (Tatian), 81–82

optic-haptic distinction, 39, 113, 147, 230n129

Oriental Forerunners of Byzantine Painting (Breasted), 27

Origen of Alexandria, 55, 103, 121; *Homilies on Genesis,* 190–91

Orodes II of Parthia, silver tetradrachm of, 235n78

Orontes River, 77

Orpheus, 24

Orthodox Holy Week, 28

Our Lady of the Angels Catholic Cathedral (Los Angeles), 37, 112

Oxyrhynchus papyri, 96

Pacorus I, crown prince of Parthia, 81

Pagels, Elaine, 137–38

Pagoulatos, Gerasimos P., *Tracing the Bridegroom at Dura,* 28–29

Palace of the Dux Ripae, 9–10, 79

Palbry, Geri, 164

Palestine, 29, 134, 141, 143; Annunciation portrayals, 165, 166, 185; Christian initiation rites, 47, 55–58, 104–5. *See also* Holy Land

Palmyra, 6–10, 13. *See also* Temple of the Palmyrene Gods

Palmyrene Gate, 10, 14

Palmyrene language, 6, 9

parables, 98, 109, 136; of sheep, 87, 101, 102, 104, 105; of weddings, 130, 209, 214–15. *See also* Wise and Foolish Virgins, Parable of

paradise, 43, 91, 203, 206–9, 214–17; "neighborhood" of, 209; restoration of, 145, 153, 211, 216–17; reunion of Adam and Eve in, 138, 210; ritual return to, 206, 207–8; rivers and, 144–45, 216–17; salvation planted in, 216–17; wedding imagery for, 215

paralytic. *See* healing of paralytic

Parthians, 5–6, 10, 77, 81; cavalry, 78, 79, *80*

"pastor" (Latin term for shepherd), 104

Patrology (Quasten), 128

Paul: baptism metaphors, 55, 89, 119–20; "betrothed" to Christ and, 137; celibacy and, 136; creation account, 208; indeterminate sexuality and, 133; initiation metaphors, 55, 131–32; "pure virgin" category, 136; sacrificial atonement doctrine, 205; spiritual marriage and, 138, 139

Pauline epistles, 55, 120, 121, 151–52, 205, 206

Paul of Samosata, 20

Paulus, 22, 68

Pausanias, 35

Pearson, Henry, 1, 2, 14, 15, 16; *The Discovery of Dura-Europos,* 14

Pera Chorio (Cyprus), Annunciation at the Well image, 173–74

Persephone's return, vase paintings of, 124

Persian deities, 6, 14–15

Persian Empire, 71–74, 77–81, 236n110

Persian language, 6

Peter, 111, 115; walking on water with Jesus, 41, 86, 87, 88, *88,* 89–90, 91, 93, 95, 97, 98–99, 202–3

Peter the Deacon, 184, 189

Philip. See *Gospel of Philip*

Philistines, 63, 64

Philoxenos of Mabbug, 98, 192

Phraates III, king of Parthia, 77

physician, Jesus as, 41–42, 86, 96–99

"Piacenza pilgrim," 184, 187, 188–89

Pierce, Mark, 212

Pignatta sarcophagus (Ravenna), 166

Pijoan, Joseph, *History of Art,* 128

pilgrimage, 183–90, 198

pilgrim souvenir tokens, 30, 32, 33, 35, 114, 185–89, 190; Annunciation scene, 165, 166, *167,* 168–69, 185, *188; locus sanctus* cycle, 185–86; resurrection objects, 119

Pillet, Maurice, 14

Pistis Sophia, 152

Plato, 208

Plutarch, 124

Pollard, Nigel, 226n58, 234–35n66

polysemic ritual symbols, 195–98

polytheism, 36

Pompeii excavations, 5, 11, 14

Pompey, 77, 78

postmodern epistemology, 151, 196–97

pregnancy, 151, 187, 189, 192, 194, 216; spiritual, 43

priests, anointing of, 51, 54

primal androgyne myth, 208

printing press, 196

Priscilla, catacomb of, 164

Procatechesis (Cyril of Jerusalem), 134,
147

processional visuality, 37–39, 111–14, 153,
211; of virgins to temple, 152–54, 172.
See also wedding procession

procession of women (Dura-Europos
baptistery painting): 2–4, 20, 29, 39,
41, 45, 75, 108, 110, 111–54, 197, 202,
204, 206, *plates 1, 7;* current title
("Procession of Women"), 150;
description of, 2–3, 114–17, 144; as
dominant polysemic symbol in
baptistery, 111, 195; door bottom, 115,
116, 117, 128, 147, 148; first discovery
of, 2–3; haptic invitational function
of, 147; height of figures, 115;
iconographic comparisons of, 141;
identification debate, 28, 111, 117–18,
128–29, 146, 150, 154; identified as
consecrated virgins approaching
temple, 152–54, 210, 211; identified as
Parable of Wise and Foolish Virgins,
42, 119, 127–29, 135, 140–41, 144, 146,
147, 150; identified as wedding
procession, 42, 44, 65, 122–25, 140,
150, 154, 215; identified as women
approaching tomb of Christ, 2–3, 31,
42, 44, 111, 117, 118–21, 122, 127–28,
140, 146, 147, 150, 154; illumination of
Codex Rossanensis and, 143–48;
number of women, 118, 128, 143; open
door, 128; pairs of feet, 114, *115;*
right-to-left direction of, 40; scene
sequence reconstruction, *114;*
scholarly importance of, 111–12; as
torch-bearing, 2, 3–4, 75, 111, 115, 116,
117, *117,* 118, 119, 122, 128, 146, 200,
215; white partial structure, 2, 3–4,
111, 115, 117, *117,* 118, 128, 146, 200,

215; white veils and garments of, 4,
111, 115, 122, 127, 128

Proclus, 22, 30, 40, 68

Prometheus, 125

property, branding (sealing) of, 59, 104,
105, 109

Protestantism, 120, 196

Protevangelium of James, 152, 153,
158–60, 161, 189, 195, 199; alternate
titles, 159; on Elizabeth and infant
John, 186–87

Prudentius, 104

Psalm *23,* 42, 100; Christian interpreta-
tion of, 65–66, 87, 102–4, 105, 108,
109, 209, 213

Psalm *45,* 64, 65, 148–50, 151, 155

Psalm *89,* 62–63, 64

Psalm *151,* 66–67, 83, 234n59

Psalms of David, 41, 44, 62–66, 68, 81,
83, 106, 211

Psalms of Solomon, 91

Pseudo-Cyprian, 83

Purim panel (Dura-Europos synagogue),
38, 112

Quasten, Johannes, 58–59, 65–66, 102–3,
104; *Patrology,* 128

Rabbula Gospels, 182

Rachel at well, 158, 182

Rajak, Tessa, 20

Ravenna, 37, 166, 183; baptistery, 103,
112, 158, 183

Rebecca at well, 158, 181, 182, 195,
197

rebirth, 22, 192, 213. *See also* baptism

Red Sea, 92

Reformation, 196

refreshment motif, 45, 198

Renaissance, 35, 162

repentance, 157, 207

resurrection. *See* death and resurrection

Revelation, book of, 108

Revelation of James. See *Protevangelium of James*

Rhine River, 75, 76, 77

Richter-Siebels, Ilse, 176, 185

Rites of Christian Initiation (Johnson), 23

ritual, 22–25, 29, 30, 44, 56; anointing as important element of, 51, 56–57; art interpretation and, 34–38; and baptistery context, 32, 45, 80–81, 111; as context for art, 33–36, 108–9, 113, 196; explications of, 24–25, 27; influence of Wise and Foolish Virgins Parable on, 134; polysemic symbols of, 195–98; primacy of place and, 23–24; sealing unto Lord and, 190; shepherd and flock symbol of, 25, 99, 104–10; torches and, 124, 134; and woman at well context, 195–96, 197. *See also* baptism; Eucharist; initiation

ritual-context visuality, 33–40, 195–98; processional, 112

rivers: anthropomorphic deities of, 165; paradise images and, 144–45, 216–17; symbolic power of, 75–77, 98, 213; walking on water image and, 91, 92. *See also* Euphrates River; Jordan River

robe of glory, 207, 209

Roman army, 71–73, 77, 226n58, 234–35n66; Christian soldiers in, 21–22, 26, 226n60; Dura-Europos quartering of, 7, 8, 9, 14, 21–22, 44, 68, 78; slingers in, 72–73, 73, 74

Roman catacombs, 43

Roman Catholic Church, art of, 113

Roman deities, 15

Roman Empire: anointing and, 50; Caesar's Rubicon crossing and, 77, 78; Christian persecution and, 22; David and Goliath symbolism and, 75; Dura-Europos frontier and, 6–14, 21, 73; illiteracy and, 46; internal problems of, 10; Mithraic cult and, 32; Persian threat to, 71–72, 73, 74, 77–78, 80–81, 236n110; procession depictions, 38, 112; rivers as boundaries of, 75, 76, 77, 78; Sasanids and, 10–11; spiritual marriage and, 136. *See also* Graeco-Roman world; Roman army

Romans, Epistle to the, 55, 120, 121, 205, 206

Rossano Gospels. *See* Codex Purpureus Rossanensis

Rostovtzeff, Michael, 1–2, 5, 14, 27, 78, 79

royal wedding, 148

Rubicon, Caesar's crossing of, 77, 78

Rufinus, 58

running water. *See* "living" (flowing) water

sacraments, 24, 27, 37; anointing oil and, 52–53, 57–58. *See also specific sacraments*

sacrifice, 7–8, 8, 55, 205

St. Apollinaris Church (Classe), 37

St. Apollinaris Church ("Nuovo," Ravenna), 37; mosaics, 183

St. Gabriel's Orthodox Church (Nazareth), 189

St. Lupicin Gospels, 172, 182

St. Peter's Basilica, baptistery of (Rome), 103

saints: depictions of, 112; pilgrimage sites, 186

salvation, 12, 34, 39, 88–89, 98, 103, 202; through birth mysticism, 198; as bridal tent, 215; through cross, 200; death and resurrection and, 120; Dura house-church and, 43, 198–201; Dura synagogue and, 30; end of time and, 125; incarnation as, 198, 200, 201, 214; initiation and, 198–201; as "living"

water, 213, 217–18; marriage symbol-
izing, 65, 108, 129, 198, 207–8; as new
creation in paradise, 216–17; from
sin, 205, 206; virginity of Mary and,
153, 210

Samaritan Woman, 43, 44–45, 90, 156,
181–83, *183*, 190, 191; baptism imagery
and, 157–58, 195; identification as
woman at a well, 43, 44–45; Jesus and,
158, 177, 182, 183, 190, 197, 213;
"living" water and, 213; shift in
symbolic view of, 207; as virgin, 197

Samosata, 20

Samuel, 49, *50,* 63, 67, 82, 83

Sancta Sanctorum, Vatican, 172

San Giovanni in Fonte (Naples), 158,
182–83, *183*

San Marco, Museo di (Venice), Annun-
ciation scene, 177, *179*

San Remo, Treaty of (1920), 13

Santa Maria Antiqua (Rome), wall
painting, 172

Santa Maria Maggiore (Rome), Annun-
ciation mosaic, 166, *167*

sarcophagus, 3, 96, 117, 118, 128;
Annunciation scenes, 165, 166; white
structure in Dura procession of
women painting seen as, 146

Sasanid Empire, 226n61; cavalry, 78, 79,
79, 80; chemical warfare and, 11; as
Dura-Europos threat, 10–11, 14, 68

Satan. *See* devil

Saul, 64, 149

Schiller, Gertrud, *Iconography of
Christian Art,* 199

seal: of Christ, 25, 41, 58, 59, 86–87, 109;
of initiation, 58, 59, 86–87, 101, 104,
105, 106, 107, 108, 190; with oil, 139; of
pilgrimage, 190; proprietary function
of, 59, 104, 105, 109; of shepherd, 41,
59, 103, 104, 105, 109, 190, 213;
sphragis, 59, 190

*Search for the Origins of Christian
Worship* (Bradshaw), 23

second coming, 28, 127

Second Sophistic, 37

Seleucus I, Seleucid dynasty founding, 5

Semitic languages, 5, 40; right-to-left
directionality of, 93. *See also* Aramaic
language; Hebrew language

Sepphoris, 187, 189; ancient synagogue,
15

Septuagint, 60, 91

Sermon on the Mount, 127

serpent, 204, *204,* 205

Serra, Dominic, 28, 83, 128, 158

Service des Antiquités of Syria and
Lebanon, 2

Severus of Antioch, 103, 105

sexual continence. *See* celibacy

sexuality, 132–33, 138, 208–9

Seyrig, Henri, 2–3, 111, 119

Shapur I, Sasanid ruler, 10, 228n60

Sheol, 192

shepherd and flock (Dura-Europos
baptistery painting): 20, 24, 34,
86–87, 99–110, *101,* 112, *plate 6;* Adam
and Eve small inset painting, 100, *101,*
109, 203–4, 209; altered perception
of, 209; as baptistery central image,
31, 42, 87, 99–110, *101,* 112, 206, 213;
meaning of, 101–10, 209; as ritual
symbol, 25, 99, 104–10

shepherd with flock: biblical analogies,
101–2; as boundaries metaphor, 105,
106, 109; as frequent early Christian
art theme, 99–100, 104; David
portrayed as, 41, 42, 44, 60, 62,
63–64, 67, 68, 86; Gospel of John
and, 31, 101–2, 206, 209; as metaphor
of Jesus, 41, 44, 86, 107, 213; military
metaphors and, 106–8; parables of,
87, 101, 102, 104, 105; paradise image
and, 209; popularity as theme,

shepherd with flock (continued)
99–100; Psalm 23 and, 42, 87, 100,
102–4, 209, 213; refreshment of water
and, 213; salvation and, 108; seal
(marking) and, 41, 59, 103, 104, 105,
109, 190, 213; wedding metaphors
and, 108, 109, 110
Shoemaker, Stephen, 159, 161, 198
sign. See seal
silver tetradrachm (of Orades II), 235n78
Simeon Stylites (Syria), 186
Simon Peter. See Peter
sin, 205, 206, 207, 218; absolution of, 97;
cleansing and remission of, 155, 157,
158
Siphor, 105
Siseos, 30, 40
slingers, 71–73, 73, 81, 235n81
snake (in paradise), 204, 204, 205
Snyder, Graydon, 28
soldier of Christ, 140
soldiers. See military; Roman army
solitaries (sons of the covenant), 210–11
Solomon. See Odes of Solomon; Psalms of
Solomon
Sophia, 214
soul, healing/restoration of, 97, 98, 104,
199
Spain, 112
speaking water. See "living" (flowing)
water
sphragis (seal), 59, 190
Spinks, Bryan, 55–56; "Baptismal
Patterns in Early Syria," 155, 156
spinning, Annunciation scene, 165, 166,
167
Spirit. See Holy Spirit
spiritual healing, 97
spiritual marriage, 27, 44, 59, 109, 124,
129–40, 153, 200; initiation as, 133–40,
141; Mary and, 199; military metaphor
for, 139; as non-sex-specific, 139;

prevalence as early Syrian motif,
140; Syrian asceticism and, 136, 138,
141; as woman at a well motif, 190–91,
195
spiritual pregnancy, 43
spiritual womb, 193
spring: Annunciation depiction at, 165,
166; "living" water from, 213;
pilgrimage to, 187; women drawing
water from, 214
Squire, Michael, Image and Text in
Graeco-Roman Antiquity, 196
stamp. See seal
star, 3–4, 181–82, 186, 193, 194, 199, 200
stations of the cross, 113
Styx River, 78
Symbols of Church and Kingdom
(Murray), 192
Symposium of Methodius, 28
synagogue (Dura-Europos), 11, 15, 30,
225nn41,43; Christians and, 20, 26;
final archaeological report (1956) on,
26; image of Moses at Well of Be'er,
69, 70, 146; image of Samuel
anointing David, 49, 50; militaristic
art, 69, 69, 70, 70, 71; Purim panel,
38, 112; significance of finding, 15
Synoptic Gospels, 64, 67, 94, 118, 155
Syria, 6, 20–21, 45, 47, 143; deities, 14;
French post–World War I mandate,
13; iconography, 141, 142, 143;
influential Christians in, 20, 21;
Roman governorship, 77; Roman-
Persian hostilities and, 81; Sasanian
conquest of, 10; textual traditions,
83–84. See also Dura-Europos
Syriac Bible, 193
Syriac language, 6, 26, 40, 46, 53, 193;
Estrangela script, 57; messiah and, 51
Syrian Christianity, 20–22, 26–30,
206–19; Adam and Eve narrative and,
43, 206–11; Annunciation scenes and,

171, 172, 185, 193–94; anointing ritual and, 30, 41, 48, 49, 59–60, 85, 140, 145, 155, 193, 218; apocryphal *Acts,* 27; apostles and, 20; asceticism and, 30, 135, 136, 210–11; baptism and, 105, 135, 140, 155, 218; celibate boundaries and, 106, 135–36, 138; classic exposition of, 192; Codex Purpureus Rossanensis (Rossano Gospels) and, 143–48, *plate 8; Diatessaron* and, 26, 31, 81, 207, 216, 228n80; *Didache* and, 20, 51, 63; distinctive motifs of, 30, 96–97, 192, 218–19; Dura-Europos baptistery paintings relevance to, 202; earliest extant authored text and, 46; earliest extant ritual commentaries and, 85; earliest liturgical sources for, 51; healing and bodily health images, 30, 96, 97–99, 208; illumination and, 30, 143–46; incarnation and, 58, 193; initiation rites and, 22–30, 41, 47, 58, 64, 83, 84–85, 104–7, 136–40, 141, 147, 202, 206; Jesus' and Peter's miracles and, 41, 42, 91–93; liturgical diversity of, 55–56; liturgical sources of, 212–18; *locus sanctus* sites of, 186; Marcionite canon and, 206–7; Mar Musa al-Habashi church paintings, 141, *142*, 143, 148, 172, 180, *181;* marriage motifs, 28, 30, 42, 45, 130, 131–32, 134–36, 138, 192, 207–8, 210; marriage vs. celibacy and, 136; "Mary's new well" theme and, 191; *Odes of Solomon* and, 26, 29, 43, 91–93, 212–18; "robe of glory" motif and, 207, 209; Roman soldiers and, 20, 21–22, 26; salvation concept, 198, 202, 207–8; seal emphasis, 58, 86–87; solitaries (sons of the covenant), 210–11; spiritual marriage and, 138, 140, 141; "Vienna Genesis" illustrated manuscript and, 182; virginity motif,

30; Wise and Foolish Virgins model, 140–41, 211

Tacitus, 75, 160
Tatian, 20; "On Perfection," 81–82. See also *Diatessaron*
Tbilisi (Georgia), Annunciation scene on censer, 176, *176*
temple: Annunciation in front of, 199; veil of, 200; virgins dedicated to, 152–54, 159, 160
Temple of Apollo (Carthage), 112
Temple of Archers (Dura-Europos), 13
Temple of Artemis (Dura-Europos), 13
Temple of Bacchus/Dionysus (Spain), 112
Temple of Diana (Carthage), 112
Temple of the Palmyrene Gods (Dura-Europos), 7–9, 13, 14; altar of, 8–9; graffiti, 78, 113; Julius Terentius frieze, 7–8, *8*, 13, 38, 113–14
tents, second- and third-century portrayals of, 146
terracotta tokens, 183, 185, 186
Tertullian of Carthage, 21, 95, 104, 123–24, 138–39, 157
Testamentum Domini, 27, 30, 147
text-image relationships, 4, 31–40, 135, 195–96
Thaddeus (Addai), 225n47
Thecla, 153
Theodore of Mopsuestia, 57, 84–85, 107, 193; on prebaptismal anointing, 59–60
Theodoret of Cyrus, 103, 108
Theodotus, 109
Thomas, 97, 105, 130. See also *Acts of Thomas; Gospel of Thomas*
three kings. *See* Magi
threshold, crossing of, 189
tomb of Jesus, procession of women to, 2–3, 31, 42, 44, 111, 118–20, 127–28, 150, 154, 205; early morning and, 127; pilgrim souvenirs depicting, 185

torches: oil for, 50, 58, 122, 125, 127;
 spiritual marriage and, 132; virgins
 processing to temple carrying, 153,
 172; as wedding signifier, 122–23, 124,
 125, 134, 135, 137; Wise and Foolish
 Virgins carrying, 141, 142, 144, 148,
 149. *See also* procession of women
Tracing the Bridegroom at Dura
 (Pagoulatos), 28–29
Trajan's column, 72, *73,* 146
travel diaries, 184
"true cross," 171, *171,* 184
Turibius, bishop of Asturica, 53
Turner, Victor, 189, 195
Tychai (guardian spirits), 8, *8*

Udell, Jennifer, 123, 124
Uffizi museum, 162; altarpiece, 169, *170*
Understanding Early Christian Art
 (Jensen), 24
University of Chicago, Oriental Institute,
 12, 26
University of Pennsylvania, 25

Valentinianism, 20–21, 109, 124, 138–39,
 226n53
Valentinus, 20–21, 109
Valley of Dry Bones, 69, *69, 70, 71*
Van Rompay, Lucas, 209
vase paintings, 123, 124
Vatican, 172, 173, 177
veiled sanctuary, 147
veiled women, 4, 111, 115, 122, 124, 127,
 128, 152
veil of temple, 199, 200
Venice, 174
Veronica, 113
Vespasian, 235n81
Vestal Virgins, 152
Via Dolorosa, fourteen stations of, 113
"Vienna Genesis" (illuminated manu-
 script), 182

Vikan, Gary, 184, 186
Virgin and Child, 141, 164
Virgin Mary. *See* Mary
virgins: baptism and, 141, 149; as brides
 of Christ, 132, 133, 139; celestial choir
 of, 153; dedication to temple of,
 152–54, 159, 199; iconographic
 identifiers of, 122, 127; male, 132, 134,
 139, 140; marriage and, 127, 132, 136,
 140, 210; meaning of, 43, 135, 153, 202;
 procession to bridal chamber of, 42,
 109, 122–23, 146–47; procession to
 temple of, 152–54, 172; procession to
 wedding of, 42, 44, 65, 122–25, 134,
 140, 148, 150, 152, 215; Samaritan
 Woman as, 197; symbols of, 127, 136;
 Syrian motif of, 30; as transitional
 stage, 132–33; womb of, 153, 154. *See
 also* Wise and Foolish Virgins,
 Parable of
visuality, 33–40, 195–98; in antiquity vs.
 modernity, 36–37; ritual-centered
 processional, 112
Vööbus, Arthur, 136

walking on water, 41, 44, 86, 87–93, 95,
 97, 202–3, 213, *plate 4;* earliest extant
 depiction of, 87, *88,* 91; purpose of,
 98–99
warriors. *See* military
water: anointing and, 55, 66; Annuncia-
 tion scenes and (*see* Annunciation
 iconic tradition; Annunciation
 morphological variety); anthropo-
 morphic deities, 165; baptismal, 40,
 53, 57, 58, 66, 88–89, 91, 97–98, 100,
 104, 108, 109, 132, 140, 144, 155, 156,
 158, 192, 212–13; imagery, 34, 103,
 144–45; oil empowerment over, 90;
 oil-fire-birth-Spirit connection, 58;
 paradise and, 216–17; weapons of
 David and Christ "hidden in," 83. *See*

also "living" (flowing) water; rivers; well

Way, the, 93

wedding. *See* bridal chamber; bride; bridegroom; marriage; spiritual marriage

wedding at Cana, 188

wedding banquet, 108, 109, 110, 129, 138, 141, 142, 147, 148; as eternal life, 148, 214; parable of, 130, 209, 215

wedding guests, 109, 110, 130

wedding procession: Dura baptistery painting identified as, 42, 44, 65, 122–25, 140, 147, 150, 209, 215; at midnight, 133–34; significance of torches, 122–23, 124–25, 129, 134, 135, 137; of virgins, 42, 44, 65, 122–25, 134, 140, 148, 150, 152, 215

wedding ring, 137, 168, *169*, 186

Weisman, Stefanie, 69–70

Weitzmann, Kurt, 61, 62

well: biblical betrothals at, 158, 182, 190, 195, 197; Moses at, 69, *70*, 146, 190, 197; pilgrimage to, 187; pregnancy and, 191; rope-and-pulley system, 182–83; Syrian Christian motif of, 30. *See also* Annunciation iconic tradition; Annunciation morphological variety; woman at a well

Welles, C. Bradford, 21

"Werden casket" Annunciation scene, 165

Wharton, Annabel Jane, 39, 75, 107–8, 113, 128, 134, 195, 230n129

White, L. Michael, 28, 118; *The Social Origins of Christian Architecture,* 16

Whitman, Walt, 76

Wilpert, Josef, 96, 142–43, 164

Winkler, Gabriele, 54–55, 56, 120

Wise and Foolish Virgins, Parable of: allegorical interpretation of, 109, 119, 127–28, 132, 134, 138–41, 144, 211;

baptismal literature and, 134; Codex Rossanensis illumination of, 143–46, 215, *plate 8;* Dura procession of women painting identified as, 42, 119, 127–29, 135, 140, 144, 146, 147, 150; as eschatological judgment scene, 125–26, 144; as in Gospel of Matthew, 125–29, 134, 215; iconography of, 141–46, *142,* 148; influence on ritual imagination of, 134–35, 211; "interior glory" ascribed to, 148; intertextual meanings of, 148–49; Jesus' telling of, 125–26; as master motif, 134; original historical context of, 126; patristic commentaries on, 148–49, 150; popularity in eastern Christianity of, 140–41, 143, 211; as Syrian conceptual model, 211

woman at a well (Dura-Europos baptistery painting), 20, 28, 31, 134, 156–58, *157,* 161–62, 174, 177, 179–83, *180, plate 9;* argument against identification as Samaritan Woman, 43, 44–45, 156, 182, 190, 191, 209; argument for identification as Annunciation scene, 43, 45, *150,* 151–52, 156, 158, 159, 179–80, *180,* 181, 182–83, 193, 194, 195–98; biblical betrothal scenes of, 158, 182, 190, 195, 197; as dominant polysemic symbol, 195, 197; spiritual marriage and, 190–91

womb: baptismal font as, 192, 193; baptistery as, 43, 154; bridal chamber as, 154, 199–200, 202; Holy Spirit incarnation in, 56, 58, 153, 154, 162, 191, 193, 194, 200; virginal, 153, 154

women at the tomb. *See* myrrophores; tomb of Jesus

word, image and, 37

World War I, 11–12

Xenophon of Ephesus, *An Ephesian Tale,*
 124

Yale Divinity School, 25
Yale University, 1–2, 3, 14; Buckingham
 Chair of New Testament Criticism and
 Interpretation, 25; Department of Near
 Eastern Languages and Literature, 25
Yale University Art Gallery, 224n8;
 Dura-Europos collection, 3, 4, 14, 43,

119; Procession of Women placard,
 150–51
Yarbro Collins, Adela, 120

"Zebeinas," "tribe" of, 6
Zenger, Erich, 74–75
Zeus, 15, 126
Zevros, George, 160
Zipporah, betrothal to Moses,
 158

Index of Ancient Sources

Old Testament/Hebrew Bible

Genesis	58
1:27	208
2:10–14	144
24	158
Exodus	
3:1	102
17:1–7	249n143
Numbers	
7:19	247n101
20:7–11	249n143
21:16–20	250n155
24:15–17	164
1 Samuel	
16:1–13	49
16:10–11	63
16:12–13	63
17	62
17:19–30	63
17:34–36	63
18:7	64
2 Samuel	
12:1–15	102
Nehemiah	
3:1	239n24
Job	
14:9	234n58
Psalms	41, 62, 91, 209
2	64

2:2	64
2:5	64
2:6	64
2:7	54, 64, 81, 234n65
2:9	64
19:6	250n151
23 (22 LXX)	42, 65, 66, 87, 100, 102–3, 105, 108, 109, 213, 240n60
23:2	103
23:3	103
23:4	103
23:5	103
28:9	107
42	65
44:1 (LXX)	149
44:3 (LXX)	149
44:4 (LXX)	149
44:8 (LXX)	149
44:8–9 (LXX)	149
44:11	150
44:14a (LXX)	148
44:15a (LXX)	148
45 (LXX 44)	64–65, 148–51, 155, 234n55, 245n67
45:3–4	65
45:4–5	65
45:7–8	65
45:15	65
52:6c (LXX)	148
78:20	249n143
89:10	90
89:19–20	26–27, 62–64
105:41	249n143
114:8	249n143
128 (LXX 127)	66
127:3 (LXX)	66

Psalms (continued)

144 (LXX 143) 66, 83, 233n49

143:12 (LXX) 66

151 (LXX) 64, 66, 68, 83,
 233n49, 234n59

151:1 (LXX) 66

151:4–7 (LXX) 67

Isaiah

5:7 234n58

48:21 249n143

61:1 57

54:1–6 245n67

Jeremiah

2:2 245n67

Ezekiel

16:8 245n67

34:1–31 102

Hosea

7:13ab (LXX) 148

Joel

2:16 250n151

Sirach

24:3 214

New Testament

Matthew 143

2:16 186

3:17 234n65

5:14–16 247n101

7:12 127

9:1–8 239n26

9:15 245n68

13:43 247n101

14:22–36 88–90, 93,
 237n4

15:27 260n24

18:12–14 102

19:30 244n56

20:16 244n56

22:1–10 209

22:1–14 245n67, 245n74

22:10 245n69, 250n151

22:30 136, 211

24:36–44 126

25 250n164

25:1–12 125–26

25:1–13 119, 215, 245n71

25:6 127, 144

25:10 250n152

25:13 126

25:31–33 105

Mark 143

1:1 234n65

1:4–5 157

2:1–12 239n26

2:17 95

2:19 245n68

6:45–52 237n4

10:38 120

10:52 240n61

Luke 206

1:26–38 159, 216

1:35 193

1:39–56 186

3:22 64, 234n65

4:18 57

4:23 95

5:17–26 239n26

5:34 245n68

12:35–37 129

13:24 82

15:3–7 102

15:4–5 102

19:11–27 260n24

23:39–43 261n29

John	31, 156, 158, 191, 195, 206, 209
1	216
2:10	245n68
3	55
3:5	56–57, 157
3:29	245n70
4	31, 158, 190, 217
4:1	156, 252n7
4:14	157, 213
5:2	238n23
5:2–15	238n24
5:4	93
5:7	93
5:14	94
6:15–21	237n4
9	236n114
10	250n164
10:1–18	102
10:11–16	101
19:38–42	243n25
Acts	97, 240n61
Romans	
5–7	205
6	55, 121, 205
6:2–4	119–20
6:3–11	120, 232n25
6:4	55, 89
8:15	55, 243n36
1 Corinthians	
3:16	200
7:8–9	248n117
10:1–5	92
10:4	249n143
2 Corinthians	
11:2	136, 245n70, 246n96

Galatians	
3:27	251n171
3:27–28	208
3:28	133, 246n91, 246n92
4:5	55, 243n36
Ephesians	
5:25–27	251n178
5:32	151, 251n178
Colossians	
2:11–12	243n30
1 Timothy	
3:6	230n132
Philemon	
10	55, 243n36
Hebrews	
12:2	93
James	
5:14	239n41
1 Peter	
3:20	34
Revelation	
19:6–7	108
19:7–9	245n67
21:6	145
21:9	108
22:1–2	145
22:17	145

Early Jewish Writings

Numbers Rabbah	
7:19	247n101
11QPs^a 28.3–12	234n59

Early Christian Writings

Acts Thom. 21, 28–29, 51–54,
 57–58, 96–97, 129,
 132–33, 137, 192,
 231n15, 231n16,
 245n66
4 245n74
6–7 130, 245n73
10 239n39
14 130, 246n75
25 104, 240n70
26 105, 241n71
26–27 245n65
34 104–5, 240n70
34–36 51–52
37 239n39
39 83–84
42 239n39
47 237n2
50 84
65 239n39
66 237n2
95 239n39
124 130–31, 246n76,
 250n151
131 105, 241n72
143 239n39
155 239n39
156 99, 239n39,
 240n49

Ambrose of Milan
Ep. 40.16 226n57
Ep. 41.1 226n57

Antonini Placentini Itinerarium
 (It. Plac.)
3 257n128
4 187–88, 257n125,
 257n26
20 257n113
31 257n112

Aphrahat
 Dem. 136
 5.24 237n115
 6.1 246n85, 250n153
 6.6 132, 246n86,
 246n92
 6.7 211, 246n87, 261n35
 7.317–320 239n42
 18.8 247n104
 18.12 247n104
 23.9 239n41

Apostolic Constitutions
 147
 8.11.11 250n157

Arculf, *apud* Adamnanus (pilgrimage
 narrative)
 2.24 257n131

*Armenian Gospel of
 the Infancy* 161, 253n27

Arnobius the Younger
 Commentary on Psalms
 19:4–5 153–54,
 252n188

Athanasius of Alexandria
 In caecum a nativitate
 3 237n114
 Exp. in Psalmum
 22 240n63
 Letter to Marcellinus
 25 67, 234n57,
 234n59, 234n64

Augustine of Hippo
 Bapt. 1.4.5 233n44
 Ep. 185.43 233n44
 Serm. 43 148, 250n165
 Serm. 93.4 127, 244n58

Bardaisan of Edessa
 Book of the Laws of the
 Countries 46, 231n3,
 260n13

Clement of Alexandria
 Exc. 86 109, 241n85
 Paed.
 1.6 261n53
 1.9 240n58
 1.28 231n17
 Protr. 2.12 124, 244n51
 Strom. 1.21.145 232n33

Coptic Manichaean Psalm-Book,
 Part II
 170.16–171.24 109–10, 241n86,
 247–48n111

Cyprian of Carthage
 Ep. 73.22 83

Cyril of Jerusalem
 Bapt. Cat. (Catechetical
 Homilies) 27
 1.1 151, 251n179
 1.2 105, 241n73
 1.6 105, 241n74
 3.1 133, 246n93
 3.2 246n93, 251n178
 3.3 81
 3.16 246n93
 4.9 237n2
 5.7 238n11
 7.2 233n51
 12.23 233n51
 In paralyticum
 8–9 95, 239n29
 Procat. 57
 1 147, 250n161
 1.3 58, 233n39
 1.3–4 134, 246n97
 3–4 147, 250n161

Didache 20, 51, 56, 121,
 231n14
 7 217
 7.1–2 157
 9.2 63
 10 226n52
 10.6 63

Didascalia
 Apostolorum 27, 30, 57, 81,
 97
 9 64, 234n65
 16 53–54

Doctrine of Addai 225n47

Egeria
 Itin. 57
 36–37 257n113

Ephrem
 Commentary on the
 Diatessaron 239n27, 96
 4.11–12 237n115
 4.14 240n48
 12.7–8 90, 238n12
 13.1 239n28
 Homily on the Nativity
 2.1 194, 258n159
 Hymns Against
 Heresies 106, 241n77
 Hymns Against Julian
 1.1–2 235n84
 2.1 235n84
 Hymns on the Church
 36 256n95
 36.2–4 194, 258n161
 Hymns on the Crucifixion
 8.4 237n118
 Hymns on Epiphany
 3 105, 241n76
 5.10–11 82–83, 237n116

Ephrem (continued)

7.4	197, 259n170
7.20–21	252n8
8.22	231n17
15.40–49	258n160

Hymns on Faith

10.17	194, 258n157
40.10	193, 258n156

Hymns on the Nativity 210

7.8	107, 241n79
16.9	199, 259n179
16.11	193, 258n155
22.39	210, 261n27
22.41	161, 253n28

Hymns on Paradise

4.5	261n29
5.15	209, 260n24
10.14	209, 260n23

Hymns on Virginity

5	202–3, 259n1
5.4	90, 238n13
7.5	192, 258n148
7.7	192, 258n148
22.3	252n8
23.4	197, 259n171
23.5	197, 259n172

Nisibine Hymns

17.9	241n78
18.6	235n84
31–34	252n12
Serm. 2.4	250n153

Sermo de Domino nostro 192, 258n146

Ep. Barn. 121

Epist. Apost.

42–44	250n164
43	248n122, 250n165
43–44	109, 241n84

Eusebius of Caesarea

Laud. Const. 2.3	233n52

Comm. in Psalmos

22.5	108, 241n82

Gos. Phil. 21, 27, 30, 28, 55, 57, 153, 199, 208, 228n86, 245n66

37	240n68
47	240n68
58.10–13	258n158
65.1–26	248n117
66.4–7	138, 248n116
67.9–11	138, 248n118
67.27	131, 246n78
68.22–25	246n79
70.9–22	131, 246n79, 246n80
70–71	131, 246n82
71.3–10	199–200, 259n180
74.13–18	57, 233n36
74.18–22	137, 233n37, 248n112
77.7–11	132, 246n83
84.34	132, 246n84
85.10–12	200, 259n181
85.19–20	200, 259n182

Gospel of Pseudo-Matthew

9	160–61, 253n25, 253n26

Gos. Thom. 26

23	208, 260n18
48	260n17
49	261n34
75	250n153, 211, 261n34
106	208, 260n17

Gos. Truth 26
 31.28–32.17 240n54, 241n86

Gregory of Nazianzus
 Or. 5 30–31
 Or. 40 (On Holy
 Baptism) 58, 147,
 256n95
 17 82, 236n113
 46 134–35, 247n100,
 250n162

Gregory of Nyssa
 Ep. 2:15–16 184, 256n107
 De inst. christ.
 83.12 250n153
 Hom. op. 22.4–5 208, 260n21

Gregory the Great
 Ep. 67 155, 252n4

Hippolytus (attr.)
 *Homily on David and
 Goliath* 73–74
 5–7 235n83

Ignatius of Antioch
 Eph. 7.2 239n37
 Rom. 7.2 217, 262n63

Irenaeus
 Haer. 226n55
 1.13–21 226n55
 3.17.2 252n8
 4.38 261n53

Jacob of Serugh
 *Homily on the Healing of
 the Paralytic* 98, 239n46
 *On the Perpetual Virginity
 of Mary* 191, 258n141

James of Kokkinobaphos
 *Homilies on the
 Virgin* 177, 255n81

Jerome
 Ep. 69.6 252n8

John Chrysostom
 In act. apost.
 24–25 237n125
 Bapt. Instr. 84
 1.1 139, 248n124
 1.2 248n125
 1.3 133, 246n94
 1.4 133, 246n96
 1.4–16 133, 246n95
 1.6–8 251n174
 1.16–17 151, 251n178
 1.40 140, 248n126
 2.22 84, 237n122
 3.8–9 237n121
 3.11 84, 237n123
 10.16 240–41n70
 11.1 134, 247n98
 11.4 151, 251n177
 11.7–10 251n174
 11.9 251n178
 11.23 247n99
 11.27 84, 237n124,
 247n101
 12.30–35 237n125
 Exp. in Ps.
 1:257 149, 251n169
 1:257–84 149, 251n166
 1:261–62 149, 251n170
 1:269 149, 251n173
 1:279 149, 251n167,
 251n171
 1:279–80 151, 251n176
 1:283 149, 251n172
 5 251n178

John Chrysostom (continued)
 In paralyticum
 3 239n27

Justin Martyr
 Apol. 1.22 239n31

Liturgy of Addai and
 Mari 225n47

Macarius of Jerusalem
 Letter to the
 Armenians 47, 56, 147
 228.3–10 250n158
 284.5–24 231n6, 232n34

Maximus the Confessor (attr.)
 Life of the
 Virgin 19 161, 253n29

Methodius of Olympus
 Symposium 28, 245n66
 7 250n164
 7.2 250n165

Narsai
 Homily 221 248n113

Odes Sol. 29, 43, 91, 192
 3 214
 3.11 214, 261n46
 6 97–98, 213
 11.1 216, 262n60
 11.1–3 213, 261n42
 11.5–6 214, 261n43
 11.6–8a 217, 262n61
 11.7 213, 261n42
 11.17–19 217, 262n61
 11.23–24 217, 262n61
 19.1 216, 262n58
 19.1–5 215–16, 261n53

20 261n38
20.7–10 262n59
30 213
33 261n54
35 212
36 212
38 214, 216
38.15 214, 261n45
38.16–18 215, 261n47
39 92, 213, 214
42.7–8 215, 261n48
42.9 215, 261n49
42.15–20 261n50
42.19 215, 261n51
114 261n38

Origen of Alexandria
 Contra Celsum
 3.24 239n31
 Hom. in Cant.
 Cant. 1 240n61
 Hom. in Gen.
 10.3 252n12
 10.5 190–91, 257n137

Paulinus of Nola
 Ep. 32.10 249n144

P.CtYBR inv. DPg 24 (= P.Dura 10 = NT
 uncial 0212) 118, 207, 228n80,
 242n22

P.CtYBR inv. DPg 25
 (= P.Dura 11) 226n52

P.Oxy. VIII 1151 96, 239n32

Pistis Sophia 152
 3.112 251n182
 4.128 251n182

Proclus of Constantinople
 Homilies
 1.1 259n178
 2.7 259n178
 5.3 259n178

Prot. Jas. 153, 158–61, 189,
 195, 199
 7.2 152, 251n183
 10.1 152, 159, 251n184,
 252n15
 11.1 159, 252n16
 22.3 186–87

Ps.-Cyprian
 Adv. Jud. 16 83

Ps.-Philo
 L.A.B. 59–61 234n62

Shepherd of Hermas 121

Simeon of Mesopotamia
 Hom. 4.6 250n153

Tatian
 Diatessaron 26, 31, 40, 81,
 93–94, 118,
 128, 207, 216,
 228n80, 239n27,
 242n22
 On Perfection 81–82

Tertullian
 An.
 18 248n121
 32 124, 244n46,
 244n47
 Bapt.
 6 239n27
 9 252n8
 12 238n5

Nat. 2.14.42 239n31
Val. 226n55

Testamentum
 Domini 27, 30, 147
 I.19.46–47 147, 250n159

Theodore of
 Mopsuestia 59, 107, 233n44,
 241n80
 Bapt. Hom. 4.1 193, 258n150

Theodoret of Cyrus
 Interp. Ps. 22.5 108, 241n83

Turibius of Asturica 53, 232n19

Other Ancient Sources

Achilles Tatius
 Leucippe and Clitophon
 2.14.8 262n62

Ammianus Marcellinus
 Res gestae 23.5.3 224n23

Apuleius
 Metam. 11.24 124, 244n49

Caesar
 Bell. gall. 77
 4.16 236n95

Cassius Dio
 Roman History 81
 37.6 236n99
 40.18 236n100
 40.19 236n101
 49.20 236n108
 49.26 236n109

Diogenes Laertius
 Lives 3.2 250n152

Euripides
 Medea 122
 1021–27 243n41

Homer
 Od. 60

Libanius
 Orations 24.38 224n23

Longus
 Daphnis and Chloe 122–23
 4.40 123

Lucian of Samosata
 Peregr. 226n48

Menander Rhetor
 Peri Epideiktikōn
 400–401 244n54
 401.16–22 125, 244n54

404.15–32 244n54
409.10 244n54

Plutarch
 Luc. 24 236n98
 Mor. 81e 244n51

Qur'an
 2.138 240n68

Statius
 Silvae 4.8.59 243n43

Suetonius
 Div. Jul. 32 236n95

Tacitus
 Ann. 1.9.5 75
 Hist. 5.12 253n22

Xenophon of Ephesus
 An Ephesian Tale
 1.2 124, 244n52